The Live Art Almanac Volume 4

Edited by Harriet Curtis, Lois Keidan and Aaron Wright

Contents

Introduction

Introduction

Aaron Wright

Welcome to *The Live Art Almanac Volume 4*, an ongoing publishing project led by the Live Art Development Agency (LADA) that collects and disseminates 'found' writings about Live Art. Like the previous three volumes (published in 2008, 2011 and 2013), *Volume 4* draws from a varied pool of sources representative of the most absorbing, thought provoking and considered writings about Live Art and the wider cultural contexts it sits within. This fourth edition gathers writings by artists, scholars, curators, critics and others that were published, shared, sent, spread and read between January 2012 and December 2014. *Volume 4* takes forward a cultural dialogue started in *Volumes 1, 2 and 3* with the aim of being a useful resource and an enjoyable read for everyone from artists to academics, programmers to producers, writers to students and all those with a curiosity about contemporary Live Art practice.

As with the previous three volumes, the content for *Volume 4* was selected from materials collected following an open call for recommendations issued in early 2015:

We are seeking recommendations for material to include in the Live Art Almanac Volume 4. *The* Live Art Almanac *draws together all kinds of 'found' writing about and around Live Art from a wide range of sources – from more traditional forms such as magazine articles, newspaper reviews, transcribed interviews, or public lectures, to digital forms such as blog entries, Facebook pages and Twitter conversations, to less conventional forms of 'publishing' such as emails, diary entries and letters. It aims to be both a useful resource and a great read for artists, writers, students and others interested in the field of interdisciplinary, performance-based art throughout the world. If you've read something that engaged, provoked, excited or amused you, or made you rethink Live Art and radical performance then we want to hear about it.*

The recommendations that came in from this open call were complemented by submissions received from a range of artists, thinkers and producers from across the world that we had directly invited to nominate writings, and by a bank of 'found' writings that LADA had accumulated.

With *Volume 3* we had extended the reach of the *Almanac* by working with a host of international partners from five continents on the submission and selection of materials. This was a rewarding but labour intensive and time consuming process which ultimately delayed the publication date of *Volume 3* and starting our work on *Volume 4*. In response to this, *Volume 4* has taken a slightly different shape, featuring for the first time writings from a three, rather than two, year period, and, to speed up the editorial process, LADA has taken sole responsibility for making the final selections of content.

As with previous editions there was a great response to our call for submissions with an influx of great writing in a wide array of forms. By the submission deadline of 31 June 2015, we had over 150 reviews, obituaries, tributes, interviews, blog posts, speeches, press releases, Facebook posts, letters, open letters, fan mail, news articles, magazine features and more to work with. A noticeable shift in this edition is the inclusion of more mainstream press outlets, undoubtedly due to the rise in public prominence of performance art practices, resulting in the content being more varied than ever with major news brands sitting alongside niche blogs and private correspondence.

As with previous editions, *Volume 4* discouraged the submission of writings from academic publications, as it aims to complement the publishing work of scholarly institutions and journals by reflecting a range of contributions to critical discourses around Live Art. To this end we also stipulated a maximum word limit of 3,000 words.

With over 80 pieces, *Volume 4* is the biggest volume yet. This volume features writers from across the globe and articles about significant international issues from the USA to Taiwan, Poland to Afghanistan, Australia to Russia. Contributions from the UK still make up the bulk of the content reflecting the large number of submissions from the UK, the still primarily UK-based readership, and LADA's inevitable partiality.

Whilst we've remained as hands-off as possible in relation to the actual texts (no major updates or revisions have been made and most texts are reprinted here as found, bar correcting a few errors that slipped through when they were first published) we have, as with *Volume 3*, grouped articles within seven loosely themed sections: Locating Performance; Performance Under Attack; Speaking Up/Speaking Out; Show Me the Money; High Art in Low Places; Reviews; and Dearly Departed. Although too broad to be considered chapters, these sections do address recurring themes and, to an extent, reflect key moments in Live Art between the beginning of 2012 and end of 2014. However, the *Almanac* in no way aspires to be comprehensive or authoritative, and these sections should not be taken as anything beyond an attempt to make things slightly more digestible or coherent for the reader. Indeed there were hundreds of potential running orders and we therefore encourage you to dip into the *Almanac* in any way you want and to make links and connections that even the original writers could never have imagined.

In *Volume 3* we drew attention to the huge institutional shift towards the embrace of performance practices, perhaps symbolized best by the headline grabbing Marina Abramović. Three years on, this 'boom' in Performance Art within visual art contexts shows no signs of slowing. Performance Art is everywhere, with everyone from Jay Z to Shia

LaBeouf having a go, and gallerists falling over themselves to 'rediscover' the performance oeuvres of countless overlooked twentieth-century performance artists.

However, despite this embrace of performance practices, during this period we've seen performance artists come under attack like never before. From the detentions of Ai Weiwei and Tania Bruguera, to the court proceedings against Reverend Billy, from the incarceration of Pussy Riot and, as I write this, the unlawful arrest of Jelili Aitku and the attempted sectioning of Petr Pavlensky, performance artists are proving yet again that their work is relevant, powerful and deemed enough of a threat to the status quo to necessitate these (largely unsuccessful) attempts to silence them. In the section Performance Under Attack we shine a light on the plight of performance artists working at the edge of the 'law'. In a further sub-section we look more closely at what lessons can be learnt from one of the most headline generating performance events of recent years, Brett Bailey's controversial *Exhibit B*, which was shut down by the Barbican in London after a huge outpouring of public protest. The case generated much debate, and for *Volume 4* we have collated some of the most insightful writings to come out of the furor from varying perspectives, in an attempt, we hope, to continue this vital conversation.

In Reviews we focus on a handful of writings selected for their surprising, playful and thought-provoking approaches to Live Art, from the refreshing fanaticism of Megan Vaughan to the fittingly frustrating review of GETINTHEBACKOFTHEVAN's *Big Hits* by Andrew Haydon. In Show Me The Money we reflect on a string of recent discussions around pay, funding and ethics in the arts, from the perspective of the individual artist through to the institution. It's also timely to reflect on the notable performance figures we've lost over the period in question; in Dearly Departed key figures from Jennifer Doyle to Guy Brett reflect on the loss of some of our most brilliant performance peers. Further sections on Locating Performance, Speaking Up/Speaking Out and High Art in Low Places raise many of the issues central to the subversion and questioning of ideas of context, audience, value and worth, taste and politics that Live Art practices offer.

With the now vast amount of writing about Live Art, and fast, cheap and independent publishing options (such as print on-demand and online platforms), we've come a long way since the publication of *The Live Art Almanac Volume 1* back in 2008. The mainstream press and traditional media no longer has a stranglehold over what can and can't be published, or even what publishing could be. Despite receiving a vast amount of recommendations for *Volume 4* we know that this selection barely scratched the surface of the huge amount of performance writings produced within the timeframe. It's become impossible to stay on top of all the Live Art

writing being produced, and there are many brilliant texts that we've been unable to represent or completely failed to unearth. All of these things will inform our future approaches to the concept of the *Almanac*, but for now, we hope you enjoy reading *The Live Art Almanac Volume 4*.

The *Almanac* is only possible because of the interest and engagement of those who recommend writings for consideration. We want to thank you all and regret that we didn't have the space to include everything. Of course we are especially grateful to the writers and publishers who generously gave us permission to reprint their work.

February 2016

Locating
Performance

Producing with a Live Art Embrace

Joon Lynn Goh

The D-Word, a nitroBEAT and Barbican event
11th May 2015

Producing with a Live Art Embrace

An embrace of soil as a martyr's life is whispered into your ears
An embrace of discomfort as 2 women shake, distort and exhaust your assumptions
An embrace of the city's periphery, traced by a mass conga of teenagers and adults

Live Art is a research-based artistic practice, driven by artists and producers who work across art forms, contexts and spaces. Emerging from a convergence of practices across the visual and theatre arts over the last 30 years, Live Art began to articulate new ways of creating and talking about art that sat outside existing markets, traditions and discourses.

Live Art's history and continuing evolution embraces the edges and overlaps of artform & identity.
It embodies an ethos that encourages artists to go beyond category and containment.
In doing so, Live Art demonstrates an alternative attitude towards 'diversity' in times of fatigue.

I believe this attitude is the starting point of a cultural strategy – a strategy that looks beyond tick boxes, and compels artists and producers to continually interrogate the margins of their forms and themselves. It asks –

Are we reclaiming representation?
How are we holding space for challenging questions?
And in what ways are we shaping the role of art?

Reclaiming Representation

Often artists who locate themselves within the Live Art context define themselves, or are defined by society as different or outside the mainstream. The things these artists have to say may be difficult to hear or experience, but these voices weave a chronicle of living in the UK from the ground.

At In Between Time, we are drawn to Live Art because we believe in its ability to voice difference and to open up worlds to which we may never belong. The artists we come to work with often position themselves beyond and across definable mediums. They have backgrounds in multiple practices, or with little or no formal arts training, they have experienced multiple lives to which they are seeking forms to express.

In Live Art, artists often reclaim representation by using their bodies and stories as the material and site of their artistic expression. Performing your body or history can provide sites of the least restriction to contest society; where cultural and social inscriptions can be rewritten, multiple identities worn and discarded, and fractures in society embodied. In the words of Chicano artist, Guillermo Gómez Peña – 'Our bodies are occupied territories ... perhaps the ultimate goal of performance is to decolonize our bodies.'

In search of freer spaces, Live Art draws breadth and strength from a multiplicity of voices. These freer spaces evolve in the hands of artists themselves who strive to create new artistic languages to represent something they cannot do so elsewhere. This is a space where artists continue to negotiate gender and sexuality, ethnicity, physical ability, and status, as much as they mold artistic form into the durations, frames and spaces necessary to hold their voices.

Reclaiming the representation of both voice and form allow artists to speak to contemporary audiences with a sharper relevance. two years ago, at Fierce Festival in Birmingham, I was led into a pitch-black space to circle around the American artist, Heather Cassils. For half an hour, the flash of a camera was the only source of light and only means to see a fight between a single body and a tower of clay. Flash by flash, the camera began to build up images of Cassils; images that seared in and shuddered out of my retinas: an arm striking, a clenching jaw, a body of muscle and sweat in mid suspension. Cassils, who chooses not to use the pronoun 'him' or 'her', reveals theirself in a series of illuminations, versions of identity in action, never to be complete.

Reclaiming representation can also take place backstage and in the office. In Between Time's core team comprises of six women across two generations. None of us were raised in cultural circles where the arts felt like an option. Three of us worked in other sectors before the arts including science, law and real estate. One of us identifies with the LGBT community, another has Malaysian Chinese heritage, another works with a visual disability, and together we encompass however you define the migrant, working and middle class.

For reporting purposes, we name and enumerate some of this as 'diversity'. But there is something much more integral to who we are that has brought us together. I like to think of this as the same compulsions that have pulled artists towards Live Art practices, the same compulsions that make us challenge

traditional forms or the ownership of taste, and the same compulsions that make us champion artists who cannot bear to be contained.

Live Art is embracing and generative, and it is this DNA running through its blood, which demonstrates an alternative attitude towards 'diversity'.

It reminds us that reclaiming representation is a driving force of creativity that spans not only whose voice is on stage, but how the stage changes because of these voices.

As a strategy, reclaiming representation is a productive force.

It is how art evolves, how art retains contemporary relevance, and how art imagines a future.

Holding Space for Challenging Questions

If art can act as a space of valuable and necessary contestation, the questions we must next ask are – How is this space held for audiences, bystanders, and the public?

How is this space held for artists who need to say difficult things?

And how is this space held for ourselves. How can we stand behind what we have created?

IBT's philosophy is that everyone should have access to the most extraordinary and challenging contemporary ideas.

A large part of living up to this, involves tackling the responsibility we feel towards the audiences we engage with, to the artists we work with, and to ourselves.

We hold this space by creating context.

In Between Time is a biennale festival that occurs over two weeks, with an intense four-day programme across multiple venues and public spaces in Bristol. The framing of a festival has allowed us to create a particular invitation – an invitation that temporarily suspends daily life, heightens an appetite for the unknown, and provides the companionship of strangers and friends to build the significance of what you are watching.

In asking people to attend the festival, we ask audiences to trust that we have thought carefully about why and how we are presenting something, and do not expect to receive trust over night.

Questions that we often think about are whose voice we are giving platform to? How is this voice countered and expanded on by others so that no single worldview monopolizes?

We do not produce work to please, and do not pretend that art must find resolution. This is patronizing and inconsistent with the reality of what people experience in their daily lives and the extent to which we seek empathy with others. But we do think carefully about how audiences will receive a work.

Live Art is a training ground for producer muscles. If you are working with unconventional voices who sit across mediums, and where time, duration and location are not prescribed, how a work will be experienced is never taken for granted. This is a productive place to be because it puts you into the shoes of future audiences. And it is these audiences who are always present in the conversations you have with artists and partners.

We think carefully about how we communicate. Extended critical theory or rationale may underpin a work, but we choose to talk about art with a language that speaks emotionally and visually and asks for an open mind. We make our invitation as honest and generous as possible. In-depth conversations around challenging questions, we find, are more useful in open talks or informal and extended conversations.

The context we create is also shaped by others. We are producers who find strength within a community of peer organisations, independents and artists, who champion our work and support us as we do for them. Key support organizations such as the Live Art Development Agency also works alongside 25 producers across the UK to form the Live Art UK Network. This network is on the ground, and its publications, its advocacy and its activities create a critical context for us to operate.

We hold this space in collaboration with artists and ourselves.

With a programme of approximately 50 artists every two years, conversations with artists take place slowly. We begin a conversation by asking what is special about this particular relationship that an artist cannot do with another partner, and that we cannot do with another artist. We hope this engenders an honesty; from the ambitions and resources of both parties, to what we want to make happen together and to what we both may be risking. This could include physical and mental wellbeing of an artist and the journey and reactions of an audience, to how a volunteer encounters a complaint or how we work with the press and social media to manage publicity.

We believe that having these conversations enables both artist and producer to create a more robust context for a challenging work to exist.

At the point of presentation, when an artist is on stage or within the piece they are creating, we step out into the public. We become champion and mediator, holding a responsibility towards both artist and audience. Our main job is to hold a space that is as open hearted to a work as it is open minded to audience reaction.

In this space, we speak about the reasons for why we, as producers, stand behind a work.

In taking a stance, we interrogate our very own values in the face of differing opinions.

This interrogation, which takes place publically and internally, is a potent site. Like the history and ongoing evolution of Live Art, this is a creative space, which if we want to, has the capacity to embrace a multiplicity of voices, to encompass new artistic languages, and to discover partners that create a richer conversation.

In the last edition of In Between Time Festival this February [2015], we worked with artists who seek to activate more complex identities and relationships with society.

Trajal Harrell vogues the desires and aspirations of African-American and Latino LGBT communities in 1960s Harlem.
Jo Bannon opens up albanism through the mysteries a mother weaves to nurture a daughter.
Project O ask us to look and look again, exorcising our relationship with their bodies.
Ria Hartley questions why diversity excludes white, able bodied, middle class and heterosexual people.
Asher Craig recounts a life time of advocating for individual and institutional change in Bristol.

We do not label this programme with 'Black', 'BAME' or 'diverse'.

Instead, we seek to build welcoming spaces for artists and audiences to engage in challenging questions with compassion.

In situations of anger, fear or apathy, we do the only thing we know how to – and that is to create spaces that ask for permanent negotiation;

Permanent negotiation within ourselves and with others.

Shaping the Role of Art

Diversity may feel like an obligation, or a fashion trend, in one year and out the next.
But the multiplicity of our voices are not.

The embrace of Live Art tells me a different story.

It tells me that our voices are shaping the role of art into contemporary relevance, and pulling society into negotiation from the ground up.

An artist Brian Lobel once told me a strategy that he employs. He says – I'm not so stupid to think I understand everything. If it doesn't make sense, I ring up someone affected by my question, and we chat.

So I am trying to listen more to the ground –

More to when a young artist posts on Facebook – How do I retain my integrity?

More to when a battle-worn colleague says – We did that in the 90s whilst another says – Why is that relevant to me?

More to when groups put aside differences in tactics – and say how do we join up our initiatives?

More to when my gut says – Yes this is important. Let's talk.

'Producing with a Live Art Embrace' was originally presented by Joon Lynn Goh at The D-Word, a nitroBEAT and Barbican event, 11 May 2015.

Producing Potentials for Empowerment
Helena Walsh and Benjamin Sebastian

LABOUR is a touring exhibition of Live Art, featuring eleven leading female artists who are resident within, or native to, Northern and Southern Ireland. LABOUR interrogates the gendered representational frameworks prevalent within an Irish cultural context, that produce, limit and devalue, various forms of female labour. In each durational exhibition participating artists will perform simultaneously for eight consecutive hours, reflecting the duration of an average working day. Set within the shadows of Ireland's notorious Magdalene Laundries, LABOUR explores current shifts in the political and economic climate within an Irish cultural context.

Benjamin Sebastian – Through a meeting of minds and hearts, at a timely conjunction of various individuals' research and practices, the curators (Amanda Coogan, Helena Walsh and Chrissie Cadman) and myself (producer) were able to devise and implement a touring exhibition offering unprecedented exposure to some of the most dynamic and thought provoking live work, being made by women, coming out of an Irish cultural context, the inaugural launch of which took place at]performance s p a c e [.

]performance s p a c e [does exactly what it says on the tin. We continuously strive to maintain s p a c e where things can be performed: gender, politics, art, emotions, critique and life. We are sensitive and not censored.]performance s p a c e [acts as a point of synthesis and exchange, inviting, encouraging and nurturing those visual performance practices that may often find themselves outside-of, left-out-of or in-between other mediums, formats, dialogues and visual arts institutions. We are a s p a c e where those who (may or may not) find it difficult to have their work programmed, due to issues of duration, size, status, action(s) or politics, may take the time and space to create and explore their artistic endeavours. We do not ask permission. We are a space for process, a place for difficult, unresolved and evolving work.

Helena Walsh – LABOUR did not shy away from the traumas embedded within an Irish cultural context. Nor did it neglect the weight of oppression experienced by women historically. Those who trudged through the snow in London to experience LABOUR at]performance s p a c e[were not greeted with warmth. They were confronted with shivering, soaked, stained and soiled bodies. They encountered bodies engaged in restrained and regimented actions, as if endlessly caught in a repetitive grind.

Amidst the harshness of this grating atmosphere, however, there also emerged moments of lightness. The peaks and troughs in the communal energy during the eight-hour duration sparked occasions of loud connectivity, yet at other times, instances of collective silence. Within both the rising momentum of rhythmical rallying calls and the sharp falls into silent stillness, the potentials for developing communal strength and dialogue across the successive live exhibitions were ignited. It is through this capacity for activating multiple and new forms of expression and resistance, alongside the production of empowered discourses from and between live female bodies that LABOUR gains its performative power.

BS – I feel it is important for our audiences to acknowledge the origins and initial conceptualising of LABOUR. After reviewing the force of practices presented at Right Here, Right Now: Kilmainham Gaol, Dublin, I felt compelled to engage the practices, politics and emotions being emitted from this cultural setting. Through meeting Helena Walsh at various performance platforms – and again at]performance s p a c e [for an enactment of the installation by Alastair MacLennan (B E Y O N D N E C E S S I T Y) – I was directed towards 'Brutal Silences: Live Art and Irish Culture', (A Study Room guide commissioned by the Live Art Development Agency, co-authored by Ann Maria Healy and Helena Walsh), and experienced an instant affinity not only with the melancholic mood represented through documented photographs and film, yet also with a sadness and frustration at the apparent and profound occupation of women's bodies, time and space within many positions of an Irish historical context.

HW – In 'Brutal Silences', I selected a variety of performances from female practitioners who provocatively interrogate dominant cultural constructions of femininity and subvert the moral regulation of female sexuality. I contextualize these varied performances in relation to Southern Ireland's Magdalene Laundries, institutions of significance to contemporary discourses around gender and labour in an Irish cultural context. Since the closure of the last Magdalene Laundry in 1996, the women detained and forced to work unwaged in these Catholic-run, for-profit industrial laundries, as a form of penance for their supposed moral impurity, have battled to gain redress. The Irish state has been reluctant to acknowledge the injustice and trauma endured by these women. Following the intervention of the United Nations Committee Against Torture (UNCAT), the Irish government, in June 2011, initiated an independently chaired inquiry into these institutions.

BS – Coming from a (post)colonial heritage myself – and the personal is important here – and maintaining active solidarity with Feminist, LGBTQ and Occupy movements, I have been greatly influenced and moved by visual performance emerging from an Irish cultural context. As Assistant Director at]performance s p a c e [such influence has afforded me the pleasure of co-curating artists such as Helena Hamilton, Dominic Thorpe, Alastair MacLennan, Hugh O'Donnell & Sinead O'Donnell, while at the same time insisting upon an observation of the artist initiatives such as Bbeyond, The

Performance Collective & Platform Arts along with institution such as Catalyst Arts, PS2 and Golden Thread Gallery. It was at this point imperative for me that a focused attention was drawn more closely towards such practices.

HW – As is the case in a variety of cultural contexts, the world over, women in Ireland have fought for political autonomy. They have struggled to gain presence and occupy space outside of the limited positions designated to them by dominant patriarchal norms. Yet equally, within an Irish cultural context there are specific circumstances, conditions and ideologies that impact on issues of gender and labour. There is a force of live artists working within an Irish context who give body to these issues.

In bringing together a diversity of female live art practitioners working within or native to Northern and Southern Ireland, across three sites of geo-political relevance, LABOUR offered a timely platform for expanding explorations of gender and labour in an Irish cultural context. Significantly, I suggest, the broad consideration of these issues contributed by the eleven artists participating in LABOUR enables the traumatic histories and realities embedded in Irish culture to be directed towards the development of empowered feminist discourses.

Helena Walsh is an Irish live artist based in London. Helena is currently undertaking a practice-based PhD in the Department of Drama, Queen Mary University of London that explores live art, femininity and Ireland.

Benjamin Sebastian is an artist-curator based in London. He is assistant director at] performance s p a c e [which is the UK's only performance specific art space.

'Producing Potentials for Empowerment' was originally written by Helena Walsh and Benjamin Sebastian for *Exeunt Magazine*, 12 March 2012, http://exeuntmagazine.com/features/producing-potentials-for empowerment-labour-a-written-dialogue/

Programming Risk

Bojana Jankovic

Ahead of the second edition of Steakhouse Live, Katy Baird talks about the lack of risk-taking in London and considers whether artists know when to stop emerging.

Picture yourself a performing artist – not a classical actor, or a budding playwright – in a country with an ever-shrinking culture budget but an ever-growing number of people competing for the same chunk of money, space and audience attention. Making work inevitably gets stuck at the very end of a chronological to-do list; devising comes after networking, persuading venues to open their doors, free-cycling props, gathering Twitter followers, designing the flyers and luring the spoilt for choice audience into buying a ticket. Artist and activist Katy Baird has no illusions about the effort involved: 'You are expected to be a producer, tour booker, social media expert, application writer, funding writer, venue organiser, lighting designer, the list goes on and on. It is really tough and can sometimes seem overwhelming and never ending.'

Yet a year ago when Steakhouse Live, 'an artist collective creating and supporting experimental risk-taking performance' was born, Baird added 'producer' to her own list. She's hardly alone; the number of emerging artists pursuing a DIY approach to curating is on the rise. It's tempting to assume most artist-led initiatives are born out of frustration and a lack of support from traditional channels – Baird sums it up as artists recognising a vacuum and then promptly filling it. Steakhouse Live however took as much from the support artist or non-artist led initiatives can provide as it did from spotting the gaps in the existing infrastructure. 'At the moment there are a lot of fantastic platform events that are really supporting artists at the beginning of their career, like Arches Live and BUZZCUT in Glasgow, Hazard in Manchester, Tempting Failure in Bristol, Hatch in Nottingham,]performance s p a c e [in London and of course the SPILL National Platform in Ipswich to name a few. These and the many others up and down the country are brilliant opportunities for artists just starting out to not only develop and contextualise their practice but most importantly to meet other artists and organisations which will hopefully lead to further support in the future.'

Baird mentions only one London-based platform and it's no wonder: the ones outside the M25 are generally bigger, better known, and possibly more appreciated by artists for the support and exposure they provide. In the capital, performance and live art are surrounded by hundreds of other content providers, meaning venues dedicated to experimental art forms may decide to opt for the commercial and affordable within the radical. Artists based outside the capital, and those determined to experiment, often get left out, producing a worrying state of affairs that brought Steakhouse Live about: 'Unfortunately in London there seems to be less and less places to perform and less places

willing to take risks. I know so many brilliant artists that are just not getting programmed by venues in London and if they are programmed they are expected to do it for little money and be very grateful for the "opportunity". [...] We were totally inspired by all the other artist run spaces and festivals happening and just thought that rather than moaning about the lack of opportunities for us and other artists we would just do it ourselves.' That's not to say Steakhouse Live is curated only with the general lack of opportunity in mind: 'It's important for us that we embrace a wide range of artistic practices with Live Art, theatre, drag, sculpture, performance art, installation, video and dance, often all on the same bill. Promoters like Duckie and LUPA have been huge influences on us in this regard.'

For an artist-led initiative in its infancy Steakhouse Live had a bit of a grand opening. It occupied a known London venue with a core audience, sold out and delivered a programme that didn't fall into the trap of echoing half a dozen others. True to its word and instead of inviting household names hoping to pull the same old audience, Steakhouse Live imposed its own agenda of diverse, idiosyncratic artists it believed were not getting enough attention, and proved there was a tangible interest out there in more than just the usual players. The plan was to keep it to a one-off, but in the 12 months since Steakhouse Live has worked with Holloway Arts Festival, Hackney WickEd and Beacons Festival, delivering 7 events and as Baird points out 'most excitingly of all', collaborating with a grand total of 62 different artists.

This year's festival continues the curatorial train of thought of its predecessor, with a line-up of exciting names no one has had a chance to get bored of. Performance art icon Rocio Boliver/la congelada de uva is visiting with a piece that tackles the unfortunate intersection of consumerism and menopause; Liz Aggiss offers a glimpse into *A Bit of Slap and Tickle*, engaging with themes surrounding the ageing female body. Thom Shaw's *Drag Mountin* and Lucy Hutson's *Bound* promise very different approaches to drag and gender representation. Then there's Julia Wilson's exploration of relationship between Disney films and madness, F/K/Alexander's singing/noise event and, as a counterbalance, a far more contemplative hue by selina bonelli and Khiara Hewetson. Diversity – of professional status, styles, traditions adhered to – remains tangible and essential to the festival. Steakhouse is not tailored specifically to emerging, emerged or any other label of artists, though this year labels did play a part: 'I think that what can be the biggest challenge is how and when to take the next step and at what point do you stop "emerging" and just be an artist. This is something we have been thinking about a lot.'

While the performance discourse is overwhelmingly dominated by sustainability conversations, Baird's ideas on immediate improvements are simple and focused on widening the web within the niche art form. 'It would be great if there was a lot more communication between everyone, so that not only could we support and promote each other's events, but more importantly share information about artists and the best ways of supporting them and their work. I also get frustrated that there are so many totally amazing artists

from outside the UK that could come here much more often if there was more joined up thinking between venues and festivals – if they spread and share the cost and support. There is of course Escalator East and Live Art UK and other organisations that do this and do it well, but it still seems that not being in more communication with each other we are missing a trick.'

Sustainability however must be on the mind of Steakhouse Live and other similar platforms as they consider where they might go and how long the momentum can last without a substantial funding commitment. Baird is taking it one step at the time, enjoying the independence that comes from a lack of financial accountability, at least for the time being: 'It is true that everyone involved in Steakhouse does so in a voluntary capacity. The money we make through ticket sales or through support of partner organisations all goes directly to the artists. I imagine there will be a point in the very near future where we apply for funding or we receive bigger commissions so that we can pay the artists more as well as the Steakhouse Live team, but there is most definitely a certain freedom involved in doing it all ourselves – we are able to do what we want, when we want and how we want to do it. Also as an organisation that is just barely a year old at the moment for us it is all about working hard and building up the relationship and trust of our artists, audience and the organisations we have worked with and may reach out to in the future.'

'Programming Risk' was originally written by Bojana Jankovic in *Exeunt Magazine*, 27 August 2014, http://exeuntmagazine.com/features/programming-risk/

Do With Me What You Will:
An Exploration of Time and How We Share It
Richard Yap

Having one's scrotum pierced with needles or being restrained and spanked with a paddle is not everyone's idea of art, but for Sheree Rose and Martin O'Brien, those were just some of what went on during their 24-hour performance piece, "Do With Me As You Will," also known as "Make Martin Suffer for Art."

As the title of the performance suggests, guests were invited to literally do with Martin as they wished, the restrictions being that no bodily fluids be exchanged and no serious harm be inflicted on O'Brien. The program stated, "Everything done to Martin will be consensual," and that "there will be specific actions at various times, some dictated by the audience, some prearranged by Rose." To keep the experience democratic, the performance was free to the public.

"I'm like the conductor here," Rose said to the audience. "I'm orchestrating this but I want you all to be the participants."

Beginning at noon on Sunday, June 23, and going on until noon the following Monday, the dungeon room Hades at Sanctuary LAX played host to Rose and O'Brien's collaboration.

Rose, 70, a veteran of the performance art world and renowned in many other underground Los Angeles scenes, had guests do things ranging from spanking, flogging, needle play, to force-feeding and rope bondage. At the end of each hour, Rose would cut a tally into one of O'Brien's arms to mark the end of each hour.

O'Brien, 25, hails from London and this collaboration with Rose marks their fourth performance together and his debut in America. The two corresponded over e-mail for some time before ever meeting in person and share a bond over Sheree's late husband and former performing partner, Bob Flanagan. Flanagan suffered from cystic fibrosis and died from complications of the disease in 1996. O'Brien too suffers from cystic fibrosis.

"O'Brien could easily be Rose's son, and their performance dynamic has a hard maternal edge," said Jennifer Doyle in her June 21 kcet.org article, "Sheree Rose: A Legend of Los Angeles Performance Art." Doyle is not far off the mark in her assessment of Rose and O'Brien's relationship.

"I think the relationship with me and Sheree is quite motherly," O'Brien said.

The connection to Flanagan is prominent in this collaboration – the cage that O'Brien is put into when nothing is being done to him, was Bob Flanagan's.

It had gotten lost when Rose relocated to a smaller house. When she found out that it had turned up at Sanctuary LAX, she said she almost cried.

"I bought that for Bob for one of his birthdays," Rose said. "I think maybe his fortieth birthday, and it's been lost for many years and then it turns up here at the dungeon. So I thought, 'Oh what an opportunity to use the cage and have Martin come and use it as well.'"

At one point during the night, Rose has O'Brien read some of Flanagan's poetry and one of his journals as he sits in the cage.

Like Flanagan, O'Brien incorporates his disease into his performance work.

"I was really interested in pushing my body or using my body in a physical way so I started to think about ways I can use my body more and allow it to sort of be itself a kind of performance so I started working with physical endurance," O'Brien said. "You know, thinking about the ill body enduring in some way."

One of the side effects of cystic fibrosis is an excess production of mucous in the lungs. Sufferers of the disease must undergo certain kinds of physical exercises or therapies to get them to cough up the mucous, which can complicate breathing.

At one point during the performance, Rose demonstrated "pounding," a therapeutic exercise where she pounded on O'Brien's chest as he lay on a table. This loosened up some of the mucous in his lungs which he coughed up into a small jar for the audience to see.

The piece was the first time he and Rose have ever done a durational piece of this length, and the first time that they have ever allowed the audience this much control.

"I was quite nervous about it," O'Brien said. "I didn't really know what was going to happen." Neither did the audience.

"I wasn't sure what to expect because this is the first time I've ever witnessed anything like this in person," said David Lucien Matheke, 30, an artist and painting major at California State University Northridge.

"I've just been trying to take as much in as I can," Matheke said of his experience. "When Martin was getting his scrotum pierced to that board, I was standing there talking to him the whole time, [and] bottle-fed him some water. That was hard to watch."

Matheke also related to O'Brien because he too suffers from a genetic disease: X-Linked Agammaglobulinemia.

28

"Basically that means that I don't produce B cells on my own so every four weeks I have to get these infusions that take like six to eight hours of medications made from plasma extracts from like thousands of different people," Matheke said. "And I've been doing that since I was three."

Matheke's disease has also been a source of inspiration for his artwork – he uses blood as a medium for his paintings.

"The blood painting is kind of just to talk about universal connectivity and how I have all these different people passing through me from one month to the next so the chemical make up of my blood varies from one month to the next and I have to ask myself if that affects my beliefs, my moods, the energy," he said. "I'm really into energy and spirituality – like the connection between everything."

Matheke said that he would be leaving the performance with a deeper sense of connection.

"I feel like even though my interaction was brief, I'm taking away a connection, like a very personal, almost spiritual, connection with Martin and Sheree, even though I just met them."

For others, like performance artist Grace Hansmeyer, it was an opportunity to collaborate with Rose and incorporate BDSM into her work.

"I met Sheree last fall. I knew immediately I wanted to work with her in some way because we're both very interested in endurance based work," Hansmeyer said.

She contributed to this piece dressed in dominatrix gear and she force-fed O'Brien heart shaped cookies as he donned a slutty schoolgirl costume.

"I wanted to see a side of the masochist that you don't normally see – more childlike," she said. "I wanted to play with that clear your plate type thing that happens when you're a kid and you're not hungry and your parents are telling you not to waste food and you have to eat everything on the plate."

She also had a paddle with hearts on it that she would use to discipline him intermittently, and forced him to hold a butt plug fashioned from a ginger root in his anus, a practice called "figging" she said.

The figging was O'Brien's least favorite part throughout the 24-hour experience. "It burned!" he said.

Rose said she was concerned that the audience would not want to participate and that she would end up having to do everything while people watched, which she did not want to do.

"Everybody has been so helpful in this whole thing," Rose said to a wave of audience members. "Everybody so far has been remarkable with things that they've done – some things very exotic and wonderful, and some things mundane but that's the way it is, that's how life is, right? And that's how time is. And we're just filling our time here and the fact that you're spending your time with us here makes me feel very good inside."

Hansmeyer said she also enjoyed her experience at the performance.

"I met a lot of wonderful people and I had a lot of really beautiful conversations and working with Martin and Sheree really made me feel like I'd like to do more endurance based work as an artist incorporating BDSM into my work," she said.

It is this element of time and how it is spent and shared with others that Rose wants to impart with the audience.

"I'm a grandmother; he's a young man," she said. "I've lived a very long very full life. And so for me these years now – I just turned 70 – these years now are plus, they're bonuses. I'm healthy, I'm alert, I can do things, I have fun and I'm looking forward to this. This is a plus and a bonus for me. Martin is a very young man – he's 25 years old but he has a disease that might kill him by the time he's 30."

She said that this is why she kept the performance free and invited the audience to be performers, because as time and art are commoditized, it is up to us to decide what has value to us.

"We wanted to really take these 24 hours and make them meaningful for us and not as a spectacle necessarily, but showing we can use time to our own benefit," Rose said. "We don't have to be prisoners of time. We can use time and have fun with it, we can waste it, we can kill it, whatever we want to do – it's our time."

'Do With Me as You Will: An Exploration of Time and How We Share It' was originally written by Rich Yap for *Mountiewire*, 26 June 2013, http://mountiewire.com/archives/12495

Blackface At The Tate: Artist Larry Achiampong On Britain's 'Others'

Derica Shields

A man dressed in a sharp grey suit glides into view of the patrons at London's Tate Modern Gallery. They turn and stare as he, accompanied by a woman dressed in pink Americana, walks towards the gallery's Picasso Wing. He will sit there for an hour, balancing on his shoulders a head which entirely covers his own. The head is big and round, its blackness punctuated only by a pair of crimson lips.

This is Larry Achiampong, a British-Ghanaian artist who uses a range of media to reinterpret the visual and aural archives that he has inherited. In the past Achiampong has delved into the sounds of his upbringing by Ghanaian parents to create mixtapes *Meh Mogya* (*My Blood*) and its follow up *More Mogya*. Some of his most arresting visual work are digitally manipulated family photographs. In these, he overlays the faces of loved ones with the black head and red lipped motif that he calls "cloudface." His Tate performance piece brought cloudface to life for the purposes of the group show *Project Visible*.

In photo-form, Achiampong's "cloudface" is jarring. The intimacy of the family portrait, an index of black survival in a hostile 1980s Britain, is interrupted by the derogatory iconography of blackness that we associate with blackface performance, golliwog dolls and the pickaninny caricature. But this interruption serves an important purpose: to remind a forgetful British public about Empire, colonialism and its more domestic forms of racism, too. In Achiampong's words "just because Golliwogs and Blackface are not paraded in the way they were in the past, it doesn't mean the world has thrown that type of mentality to the dust. I think in the UK we are quite guilty of sweeping moments like these under the carpet in the hope that no one will unearth them."

This is a crucial moment to unearth them. In recent months the UK Border Agency has unleashed officers on train stations to stop and question people about their immigration status based on race and accent. Dawn raids continue unabated and the official discourse around immigration throbs with xenophobia, despite the very real human costs of European border policy. With his performance, Achiampong aimed to think "the experience of being categorized and treated like an alien based on the colour of my skin and my origins." Placing this overdetermined body in full view, Achiampong also calls our attention to the ongoing and relentless processes by which some people are marked as expendable, disposable and ungrievable "others".

Okayafrica: Can you describe your performance piece at the Tate Modern?

Larry Achiampong: I brought the original cloudface character (from the *LEMME SKOOL U* series) to life. He walked through Tate Modern from level 0 to level 2 and into the 'Poetry and Dream' display rooms. He then proceeded to one of the spaces containing painting and sculpture by Pablo Picasso and sat extremely still (resembling the original image) on a chair against one of the white walls for an hour. Following this the cloudface stood up and left the galleries via the same route.

OKA: What did you aim to communicate and did you want or anticipate audience engagement?

LA: I've created a few performance works that have been presented to large groups of people in the past (see *Jam in The Dark*) and whilst one imagines the event in advance there is no real way of anticipating how the viewer will respond to the work, nor should I want to unless it is actually part of the performance — I think you lose a certain energy. In terms of the cloudface performance it was not necessary to directly interact with the audience in an overly animated manner — cloudface's approach to the situation was to keep things minimal, including movements, pace and gestures. Cloudface's presence alone was enough to garner attention from the audience.

OKA: There's a fascination with audio and visual archives at the centre of your work. Why are you so interested in archives or looking at the past?

LA: I grew up at in a moment where the library as a physical place was very important for generating and disseminating information that you were unlikely to find anywhere else — the internet was not yet readily available to the masses in the way that T.V. was, so growing up with that aspect of society still very much intact I believe that interest in the archive, the story and the narrative naturally rubbed off on me.

The projects *Meh Mogya* and *More Mogya* came out of my interest in the audio archive, it's connections with one's heritage and how the classic sounds of highlife music might be re-presented today. I made certain that by producing these works they would be presented in the form of vinyl records to keep the dignity of the highlife legacy intact — additionally, the works are also available as downloads which is important to share ideas and information. That beauty of current technologies is that you can effectively spread a message using very little means.

200 libraries were shut across the UK in 2012 and that figure is set to increase to 300 in 2013. My generation is probably going to be the last to truly experience the library as a physical environment that you can visit in the UK. Don't get me wrong, I am hugely fascinated by what new technologies can bring with regards to instant on-demand information. But that tactile, intimate connection to a book draws me close to the mysteries contained within a

text. It's a different experience to reading via a backlit screen. The same goes for sound — the ritual that involves taking a vinyl out of the sleeve, placing it on the record deck and aligning the stylus with the groove... that ability to observe the artwork and liner notes. I mean, you can't do that with an mp3 can you?

I like the idea of digging something up that is hardly heard or talked of because history has forgotten. It allows me to have a conversation that reveals its relevance through my intervention with the material. I want to have important, necessary discussions regarding life, the human condition and, of course, I want to have fun whilst I'm making art. If I don't enjoy it I tend to put it to the side.

OKA: Going back to the black head with red lips, or, cloudface. Can you talk about your choice to work repeatedly with this distinctive motif?

LA: When I first introduced this iconography in 2007 with the series *LEMME SKOOL U* I hadn't figured out a name for the motif. I was interested in depicting the experience of being categorised and treated like an alien based on the colour of my skin and my origins. I instinctively used photoshop to create this very simple avatar and when I would present my work to young people they'd refer to it as 'cloudface.' I like the way young people interpret art — they apply a beautiful, creative, naivety that is usually lost by the time they reach adulthood — and they aren't afraid to share these ideas. The reason behind my choice to continue to use this iconography is simple: it's very relevant to the sociopolitical discussions taking place in and outside of the UK.

OKA: Cloudface brings to mind the golliwog and blackface. Is it your intention to evoke those allusions? Why impose that racist history on such personal images?

LA: The cloudface was partially inspired by the experience of seeing the Robertson's Golly mascot on marmalade jars as a child during breakfast and other family meals. I always associated the Golly with the perspective of what an alien might be in my youth. When designing cloudface I did further research on the Robertson's Golly character and found out that it was only discontinued in 2001, the company apparently retired the character not because of it's racist connotations, but that the company wanted to 'move with the times.' My inspiration for cloudface also comes from comics and anime; 'V' (from Alan Moore's *V for Vendetta*) in particular his Guy Fawkes mask (made famous through the Occupy Movement) and also Laughing Man from the *Ghost in The Shell* Series. By mixing these various elements I want to have a lasting relevant conversation about prejudice in it's many guises, just because images of Golliwogs and Blackface are not paraded in the way that they were in the past, it doesn't mean the world has thrown that type of mentality to the dust. I think in the UK we are quite guilty of easily sweeping moments like these under the carpet in the hope that no one will unearth them. Stare at a clown long enough and the jokes begin to disappear.

With the cloudface motif I see me working with images that include my family as a starting point for telling a story that will open up and become less about the singular moment and more about plural debates.

OKA: How did you find the images that you used in the *Glyph* series? And how did your relationship to the people in the photographs influence how you used the images?

LA: The images are from family photo albums — we have so many — and most if not all of the people in the images are relatives. I wanted to reveal the interior/exterior event. In some of the images people pose as if they are advertising a suit or dress in a catalogue. I asked my mother about the poses and she told me that at the centre were notions of the individuals' pride and self-respect. My mother would send these images with letters back home to Ghana letting the family know that all was well.

OKA: What was your experience of performing at Tate Modern? What were you hoping to communicate with your performance and what was the reality of the audience response?

LA: It was the most unique experience I've had presenting a performance to date — wearing the mask/helmet required special breathing and meditation techniques that I practised with the help of YouTube videos! Being under that helmet there was a cocktail of stifling, euphoric, blinding and exhilarating moments. One of the biggest thoughts that I had both before and during the performance was the possibility of failure — I knew that I was taking some risks with this performance and that it might not have been effective or successful... I could have passed out! To have all of these feelings and emotions churning through my body it was an enormous challenge to stay as still as possible during that hour.

But sometimes it is necessary to take some risks in order to bring something new, interesting and meaningful to the table. I couldn't tell you what was actually going on during the performance since I couldn't see a thing through that helmet but I did ask some people that I'd invited, what they thought of the work — there was a mixture of responses; surprised, uncomfortable, and overall fascination.

OKA: Why did you choose to stage the performance in a room full of Picasso?

LA: When I was planning the performance I instantly knew that by way of introducing him (beyond the original photograph work), in order for cloudface to thrive he needed a foundation within one of the gallery spaces that resonated most with him. That seated moment during the performance simply would not have been as effective without allowing the surreal, bold, tendencies that exist within his visage to communicate with specific artwork that was nearby. I scanned all of the galleries for that adequate vantage point

of execution. The room that held work by Picasso spoke in a way that the other rooms couldn't, both on a formal, conceptual and even cultural level.

OKA: It seems a lot of your work interrupts or disorientates by placing the out-of-the-ordinary within the ordinary...

LA: It must have been the endless hours of playing Super Mario Bros. videogames in my youth... I'm fascinated with the potential of providing an alternative outlook to that which might seemingly be mundane in order to spark up worthy conversation. The *Evening Standard* newsstand works offer a good example of the heist-like activity that I conduct in my practice. In order to challenge the status quo I intervene on a current state of affairs with a parallel universe type of story, something that might have a science fictional or comical edge about it which I then inject onto the newsstand headlines, but beyond the words there is something else going on. For some people life is about accepting, following and tolerating, for others it is about questioning that which exists. I participated in a group show a few years ago in Liverpool; when the show ended I had a flick through the comments book and noticed that an attendee had left a message for me reading "Larry Achiampong does my head in. I'd like to do his head in!"

'Blackface at the Tate: Artist Larry Achiampong on Britain's 'Others'' was originally written by Derica Shields for *Okay Africa*, 9 October 2013, http://www.okayafrica.com/news/larry-achiampong-cloudface-blackface-tate-modern/

Live Art and the Institution: Tate Tanks

Diana Damian

Tate Tanks are potentially a major institutional statement from one of the world's most visited galleries, keen to capitalise on the now historicized era of participation emerging within visual arts in the seventies. They are an interesting potential for live art and its relationship to the institution, but Tate's lack of engagement with the obvious cultural context which it is trying to capture is problematic. An institution making such a statement is symptomatic of a wider, problematic discourse between live art and cultural operators. So what then do the Tanks mean?

In Hudson, New York, Marina Abramović is developing *The Institute for Long Durational Performance Arts*, a laboratory dedicated to the preservation, teaching and research of performance art. *Performa*, a bi-annual of 'performance visual art', is an institutional engagement with a particular infrastructure of live art. PS1 functions as a dedicated venue for performance and live art, whilst MOMA and Guggenheim have dedicated themselves to the exhibition of live art since the early nineties. The British cultural landscape is no novice to live art; institutions such as the Live Art Development Agency have been creating and developing an infrastructure to support, preserve and engage with this ever-changing cultural cross-section; in addition, producing organisations from Artsadmin to Arnolfini, festivals such as SPILL or In Between Time, nomadic organisations such as Forest Fringe, have grown over the years, and serve as important players in the growing infrastructure of this landscape. This year, however, is the first in which a major institution – Tate Modern – is opening its doors and dedicating part of its remit to the collection and showcasing of live art. This holds the potential to be an important step in the history of British live art, but in its current portrait, it's a much more fragile and problematic institutional statement that seems to have chosen to deliberately omit any engagement with this growing infrastructure. So what does this mean, and how has this come to be?

Certainly live art has always had an confrontational relationship with the institution, both in its origins within both visual art and avant-garde theatrical practice, and by its very nature, as a public, subversive and nomadic form of art that seeks to engage directly with its immediate social and political context, be it in its capacity to empower a community or to create confrontational critique – from the work of Franko B to that of Bobby Baker. In addition, a cross-section of artists arising from a variety of backgrounds have chosen to engage with the politics of live art in a more lateral manner, and they play equal part in the construction of this cultural landscape. With a legacy which has been institutionalised by visual art history over time, from the work of Yves Klein or Chris Burden, as well as Marina Abramović, Orlan, Kira O'Reilly or Tehching

Hsieh, live art both functions within and in reaction towards institutions, bearing the confrontational weight of critique which naturally excludes the possibility of a localised, fixed and rigid home.

That being said, it's important to acknowledge the crucial role which institutions can play not only in creating an infrastructure for live art – and here Live Art Development Agency for example has been instrumental – but also in canonizing a practice which doesn't necessarily hold allegiance to the dominant visual art histories which seek to kidnap its legacy. Live art is a shape-shifting territory, and any institution that seeks to capitalise on this holds both important symbolic and cultural power, but also a weighty, convoluted historical discourse which it needs to de-tangle.

Designed by the Swiss duo Herzog and De Meuron, who are also behind Serpentine Gallery's most recent summer pavilion, Tate Tanks occupy the former oil tanks of the power station. A tank has been dedicated to permanent collections, and another serves as flexible performance space, whilst adjacent galleries connect the Tanks to Tate Modern's Turbine Hall, and a further, blocked off staircase leads to Tate's newer expansion, currently being constructed on top of the tanks themselves.

The concept behind these enormous industrial spaces is visible to the naked eye, and further emphasized with impressive architectural precision. The Tanks are vast concrete volumes, and where possible, this raw precision has been made visible by leaving, for example, numbers which have been located in the foundation itself, as well as the construction of a series of oblique concrete pillars that give the enormous foyer a direction and an angular precision. The difference in volumes and textures is emphasized through an engagement with the tanks' industrial history, with a small circular room made entirely out of metal walls, interrupted by thick, regular bolts. The foyer contains an in-built bar and provides access to all the spaces, a nomadic transition area. The main performance space's circularity is interrupted by four concrete pillars that frame a stage-like space, and supports a grid structure and a lighting box elegantly woven into the fabric of the space with little to no visibility.

The Tanks are industrial and precise, authoritative in their historical and functional weight, and clearly designed as a non-descript space without any historical affiliation to narratives outside of the building itself. With that in mind, they're no white or black box, but rest somewhere in the middle, creating a specific, if impressive and problematic context for showcasing live work. They are a living piece of documentation in their own right, conceptually referencing a visible history from industrial space to performance venue, whilst at the same time making interesting assumptions about what a twenty-first century museum space might just look like, and within that, questioning the role that such an institution devoting itself to the preservation of that which is considered to be ephemeral, might be.

The Tanks have launched with a 15-week festival titled *Art in Action*, capitalising on the participatory turn across a variety of artistic practices. Korean artist Sung Hwan Kim was invited to create a site-specific intervention in the collection Tank, Anne Theresa De Keersmaeker is re-enacting her canonical work *Fase: Four Movements to the Music of Steve Reich*, and the permanent collections are showcasing documentation and works from Suzanne Lacy and Liz Rhodes. In addition, the Tanks have programmed a series of symposiums exploring the relationship between the live and the material, and a smaller festival for young people.

It's an interesting if problematic mix of work not solely within the narrative reach which it promotes; from postmodern dance to transnational interdisciplinary work, and with a patchwork of collections that polarise from minimalist mixed media to documentation of a participatory event, the programme promotes a mix of discourses that serve as an imprecise curatorial landscape. *Fase*, for example, is a superb, if bombastic performance to warm up the Tanks' major space, a piece of living dance history that calls into its dramaturgy the nature of the space as well as references to a nexus of modern and postmodern vocabularies and philosophies of dance. Sung Hwan Kim's work calls on a transnational engagement with the biographical, with its character-based screen interventions, poetic in their cultural explorations, as well as totemic architectural constructions that break up the circular space. But surrounding this work is a curious sense of mythology, and an imprecise re-enactment of a period in modern and contemporary art that matches postmodern dance with abstract minimalism without any clear historical narrative. With dimly lit galleries, the sound echoing through the vast volumes of the Tanks, this sense of theatrical mystery seems to be in antithesis to the nature of the works themselves, and displaces the central position of identity politics which some of the works so crucially touch upon. It's clear that the spaces naturally house precise, canonical works, but they also open up room for the wider live art historical discourses to invade and permeate an important audience- and these are not present in a more tentative curatorial exercise that seeks to provide space for landmarks within the clear domain of visual art.

What the Tanks are lacking is an acknowledgement of the field's subversive totality, its deliberately slippery, cheap aesthetics and non-institutionalised discourses that could have provided a real provocation to the space. Where is the queer art, the body-based work, the high impact site-specific projects, the social and political experiments that have provided live art with such a potent canon, the essential documents that ought to have a presence on this site?

Over the period of one year, from September 2011 to September of this year [2012], Tate Modern organised an interdisciplinary research initiative that sought to examine the ways in which performance and performativity have been present within and shaped contemporary art. With academic and practical strands, the project was an important step in the institution's engagement with the wider cultural and academic landscape of performance,

but its echoes are faint in the cultural politics which the Tanks seem to have engaged in. With sociality as the key term of exploration, with the Turbine Hall being occupied by over one hundred volunteer performers in Tino Sehgal's Unilever Commission, with an accompanying festival for young people and a longlist of participatory projects, it seems striking that the Tanks have made an incomplete gesture in examining and foregrouding the role of the institution in engaging with the social and in turn, the presence of the social within contemporary artistic practice. Instead, the iconic and intriguing spaces dominance displaces any clear threads within the chosen works, and constructs a set of problematic narratives that displace participation as a cultural device.

Most importantly, Tate's lack of engagement towards the field which it is trying so hard to capitalise on is particularly problematic and an interesting conflictual cultural statement. Neither institutions like LADA or Artsadmin have been consulted, nor organisations such as SPILL, Arnolfini or Live at LICA, major players in the current shape of the live art field in the UK. So the Tanks have then chosen to publicly omit the rich culture from which they might eventually draw from, seeking to capitalise on the dominant live art narrative entering from the visual art field, perhaps if only to continue a process of canonisation which seeks to promote a more linear, visual history of such practices that ground the work in dominant artistic outputs of the seventies and eighties.

Tate Tanks are an institutional proposition; by inherently questioning and taking a stance on the ways in which a twenty-first-century museum might engage with the rich landscape of performance and live art, the institution has chosen to sediment its identity in a problematic nexus without transparently engaging with its immediate cultural context, or considering the ways in which live art's own history reflects on its relationship with the institution. If *Art in Action* engages with participation as a dominant cultural device, then the Tanks have displaced the politics of such a gesture, closing rather than opening the doors to this intriguing and authoritative space. That being said, they have the potential to be a significant cultural enterprise that can not only provide an important space for the canonisation of live art practices, drawing from the wide-range of interdisciplinary references, but also support a growing cultural infrastructure and bring new and significant audiences to the shape-shifting artistic practice.

'Live Art and the Institution: Tate Tanks' was originally written by Diana Damian Martin for *Exeunt Magazine*, 8 August 2012, http://exeuntmagazine.com/features/live-art-and-the-institution-tate-tanks/

Under the Hollywood Sign

Dino Dinco

Introduction

A dispatch from Los Angeles, California follows from the book I'm writing on recent West Coast performance art practice, a survey of some of the makers, curators and scholars who reside in the major art centers at North America's western edge. I'm exploring modes of practice, thinking, curating and scholarship that emerge from this geography, perhaps specific to this geography, investigating what it means to live and make work in San Francisco, Tijuana, et al. I'm looking at how particularities of these cities inform how and why the work is made, including specifics of lifestyles and economies, for example, as well as community (dis)engagement, funding resources, ethnic-class-gender identities, local arts institutions and their faculty, nightclubs and alternative spaces, etc. Some Los Angeles performance art and dance makers, for example, make a living by choreographing dance routines for some of pop music's biggest selling artists. Commercial choreography is their 'day job' that supports their art practice, an economic and creative opportunity specific to Los Angeles as a world entertainment center. (For over 15 years, my main side hustle has been ghostwriting treatments (aka pitches) for directors of TV commercials and concepts for music videos, alongside my work in arts education.)

Mariel Carranza, Performance Encounter

This dispatch chronicles a Sunday evening gathering of performance makers who assemble(d) in Hollywood (the Los Angeles neighborhood, no more, no less) to spontaneously perform only for one another.

The invitation from performance artist Mariel Carranza arrived in a brief email:

Dear performer friends,
I had shared with you my intentions to gather a group of performers
to perform spontaneously at a given space and time.
There will be no audience nor documentation.
You can bring some materials although you should not prepare in advance.
Performance should manifest at the encounter.
Where your vulnerability became your guide.
Where the notion of failure or achievement is irrelevant.
and dinner will be served afterwards

Mariel Carranza and I first met when I was asked to curate the 2010 winter fundraiser for the non-profit art space, LACE (Los Angeles Contemporary Exhibitions). Known for consecutive years as *Lust for LACE*, the annual benefit typically offered literary readings, film screenings, live music and performance.

LACE, now in its third location, has been operating for 38 years and has occupied a unique role amongst spaces in which to experience contemporary art in Los Angeles. Founded and managed by artists in 1978 in a space above a bridal shop in downtown Los Angeles, LACE continues to be one of the city's most vital art spaces, now located on Hollywood Boulevard's Walk of Fame amidst garish wig and costume stores, trinket shops, throngs of tourists and a number of Church of Scientology outposts. LACE has exhibited the visual, performative and otherwise difficult to categorize work of over 5,000 artists, including those whose practice is often identified as transgressive and experimental. Many of the most celebrated and influential artists in the U.S. from Los Angeles and beyond have exhibited work at one of LACE's addresses.

For the 2010 incarnation of the winter benefit, LACE chose to focus solely on performance art and asked me to be its curator. When assembling the roster of artists for the event I renamed *GUTTED*, I came across Mariel Carranza and her work.

Peruvian born and raised, Mariel immigrated to Los Angeles where she raised her family. She received an MFA in Sculpture at UCLA, studying under Charles Ray, Paul McCarthy, Chris Burden, Nancy Rubins, Tom Marioni and George Herms. Her MFA thesis was a sculptural piece in which Mariel suspended herself in a harness, able to swing between and strike two taut membranes, each one stretched across a simple, outward-facing wooden cone, much like a set of drums. In this sleek, minimalist construction, Mariel embodied both pendulum and noisemaking clapper, a particularly poignant design as Mariel was born with a congenital hearing disorder.

Mariel creates durational performance pieces that often involve the repetition of a physical action over many hours, sometimes days, and typically while fasting. In her performance at LACE for *GUTTED* (2010), Mariel used blue chalk to inscribe the walls of a large gallery space, from ceiling to floor, parallel row upon row, with the phrase, *I am the witness*. In an earlier work, she modified the existing architecture of a gallery space by "knitting out" each corner with raw Peruvian wool, again working from ceiling to floor over the course of many days, subsisting only on a mixture of water, lemon juice, maple syrup and cayenne pepper. Mariel finished the piece by knitting herself into a "cocoon" in the center of the room's new configuration. Through physical repetition, Mariel enters a type of autopilot; her mind quiets, it "empties," working in a moving meditation. Mariel feels that the essence of her work lies within this gradual process of physical exhaustion and absence of thought, or at least it's where it begins to take off, an alchemy of spirit, vapor and energy.

In early 2012, Leo Garcia, Artistic Director of Highways Performance Space (Santa Monica, CA), asked Mariel to present two consecutive nights of performance. Highways was founded in 1989 by performance artist Tim Miller and writer Lynda Frye Burnham. (In 1978, Frye Burnham, along with Steven Durland (to whom she is married), founded and edited the highly influential Los Angeles based performance art journal, *High Performance*). Mariel invited a number of her performance friends, myself included, to perform simultaneously with and around her in an ensemble piece she titled *Construal*. I interpreted Mariel's call into this collaboration as an opportunity to craft a performance that not only addressed my relationship with Mariel, but to directly reference her body of work.

The turnout for the first night of *Construal* was lighter than Mariel had expected and this led her to think about the role of anticipation – anticipation of spectators, of an audience. At one point, she told me later, she remembers turning around to take in all eight performers who were simultaneously engaged in their work around her and her feeling overwhelmed. In that moment, it occurred to her that what was taking place *between and amongst* the performers was the art – and the absence of much of an audience was what allowed this to be clear.

Mariel soon after met Boris Nieslony, one founder of the European performance collective, Black Market International, in Cologne, Germany, where Nieslony is based. It was here where Mariel was exposed to BMI's performance philosophy and methodology, manifested in their ensemble-style, openly collaborative performances they call *encounters*.

Impressed and inspired, Mariel's experience with *Construal* at Highways coalesced with her exposure to BMI's performance practice. Upon returning home, she chose to launch a similar kind of performance *encounter* at her home in Hollywood.

Driving to Mariel's house, I thought about taking a shower upon arrival to get started, despite having just showered at home. I wasn't sure why or what it could lead to and I was also trying to not think much about it at all, as her instructions were to *not* prepare.

My lifelong experience with performance – witnessing, making, curating – has largely involved the presence of an audience, of varying and unpredictable sizes. It's not my interest here to argue whether or not spectators play active roles in a performance, nor if performances and actions are "complete" only with the presence of an audience. I was intrigued by the idea of performance makers coming together to work spontaneously, simultaneously as performers and spectators. I was also curious to how an encounter such as this one might inform my relationship to performance, including the possible re-orientation of how spectators fit into the equation.

Rafa Esparza and I arrived at the door of Mariel's building just behind Allison Wyper and Ladan Yalzadeh. Allison is a recent graduate of UCLA's Department of World Arts and Cultures/Dance (known at the time of her graduation as simply, Department of World Arts and Cultures). In addition to her own performance work, Allison is affiliated with La Pocha Nostra, the performance collective founded in 1993 by Guillermo Gómez-Peña, Roberto Sifuentes and Nola Mariano in California. I've curated Allison's work in the past, including *Witness*, her piece that addresses torture, domination and spectator complicity, typically performed for and with a single spectator. Ladan's background includes acting for live theatre.

We joined Asher Hartman (a painter, playwright, performer and medium – the psychic kind) along with Mariel inside Mariel's kitchen. From 2000 to 2005, Asher co-directed Crazy Space, a now-defunct gallery in Santa Monica, CA dedicated to experimental visual art and durational performance. It's where Mariel performed several of her early works.

As mentioned, the book that I'm writing will address some of the who's, why's and how's of living and making performance work in West Coast art centers. It's worth noting here that among the artists gathered for Mariel's encounter, Rafa Esparza was the only Los Angeles native of the group, born and raised in Pasadena, a small city within the greater Los Angeles metropolitan area. He studied locally and graduated from UCLA's School of Art and Architecture in 2011. I was born in rural Pennsylvania and left my parents' home at the age of 14, joining relatives who moved to Los Angeles over a decade before me. At different times, Allison and Asher both came south from Northern California to study at UCLA, Ladan to Los Angeles from Iran, and as mentioned above, Mariel from Peru.

Mariel had stripped bare her dining room, creating a familiar white cube. The floor is concrete. Dressed in loose, white cotton (Mariel's performance uniform), she walked to a corner of the room, sat on the floor and closed her eyes. She spread her legs as wide as she could and opened her arms so that each one met a wall, expanding herself to fill the space. She began to move her arms parallel to the floor so that they met in the middle before returning them to the wall. I sat on the ground, looking at the floor and occasionally at the other performers, who were now spread throughout the room. As Mariel continued to move her arms and legs back and forth, her eyes closed, it appeared that most of us were thinking, planning a move.

I thought about the yogurt parfait thing that I had bought at a café on the way to Mariel's, something I couldn't eat while driving my car and was now on Mariel's kitchen counter. I walked to the bathroom, stepping over Allison, who had installed herself within the doorframe along the floor. I stripped off my clothes and showered.

Aside from being independently wealthy, it's hardly possible to sustain oneself based on the income from performance art. All of the artists at the encounter

have some type of job that supports their practice (and in Mariel's case, her family) and most have multiple sources of income. Mariel owns and operates a busy hair and beauty salon near her house. It's adjacent to Tailwaggers & Tailwashers ("a full-service pet store"), and equidistant to an upscale supermarket and the Church of Scientology Celebrity *Centre* International. Her shower is loaded with good-smelling hair products. As I bathed for the second time within the hour, I wondered if this second shower was a pre-performance pseudo-ritualized shower, or whether the shower itself was part of the performance chronology. I rinsed and turned off the water. After I slid the shower curtain aside, I walked back to the performance area without toweling off, trailing water across the floor.

Stepping over Allison once again, I chose a spot in the middle of the room near the patio door. I have a vague recollection of the other performers. As no one had been making much noise, I can't recall what she or he had been doing. I crouched down and through a lazy, slow, reverse push-up, came to rest in a prone position on the cool concrete floor, my arms folded under my head. I slid a hand under myself, adjusting my balls so that my pelvis wasn't crushing them, until I was comfortable.

I closed my eyes and just felt. The chilly floor. My skin. The length of my body. Water moving across my skin as I shifted slightly. I opened my eyes, closed them and opened them again, seeing rivulets of water trickling down and across my arm, zigzagging through the hairs like a pinball making its way through the machine. I shut my eyes and continued to feel the water – the sensation just felt more *interesting*, somehow.

I decided that, along with the natural process of evaporation, the collective exhalations of the other performers would dry my skin. Once dry, maybe that's when I would get up.

I heard Mariel in the corner, past my head, making noises on the walls. Slapping them. Thumping them. Just behind and over me, a woman's voice was speaking in Spanish and by the cadence of her voice, I guessed that she was reading from a book and that even if not fluent, she knew how to pronounce the words.

I felt fingers – or toes – pressing on my toes and when gauging their length, I was pretty sure they were women's toes.

I heard Asher's raspy voice over my back, speaking in his characteristic and often-repetitive patter when he's engaging his mediumship. I remained motionless as I felt fingers – I guessed Asher's fingers – touch various points on my back, maybe hitting some of the moles on my skin.

The fingers touched different nodes of my spine and the contact felt nice, tender. Admittedly, I like being touched. I started to hear the sound of scissors

cutting something and I guessed maybe it was fabric or someone just using them to create that sound. With eyes closed still, I wondered what Rafa was doing and where he was.

As Asher continued to speak about something that I now can't remember, I also wondered how fast I was drying off. I do remember that his fingers were on my spine and he mentioned how he'd like to "leave the subject," but that he could not. He repeated this phrase many times, occasionally changing where his fingers met my spine.

I thought of Luis Buñuel's film, *The Exterminating Angel*, in which an invisible force initially prevents the guests of a formal dinner party from leaving the dining table, then later, from leaving the room, to the point where they became anxious, aggressive and manic, ultimately turning on one another.

Mariel began repeating a Spanish name – a man's name – and a title of what was maybe a story from the same book I might have heard being read from earlier. Maybe she was saying *llamas* (you call) or *llavas* (you take or carry).

Scissors. Spanish. I kept my eyes closed. Someone walked nearby ringing a small bell. I shifted my body a bit, but didn't feel any water moving on my skin. I remained there for another minute and was ready to change. I thought about the yogurt parfait thing in the kitchen.

Using my arms, I raised my upper half from the floor, separating myself from the water stain left from my body. I stood, feeling little streams of water slide down my skin and onto my feet. I walked into Mariel's kitchen, naked, with goose bumps.

I found the yogurt parfait thing on the counter. Balling my hands into fists, I prepared to carry it into the performance area using only my mouth. As I stood in Mariel's kitchen, naked, I wondered if she had given her adult daughter, Cathy, who also lives there, a heads up about the encounter.

The parfait was blocked by a couple of heavy water glasses that I first had to nudge aside with my face before locking onto it with my teeth and lips. With it hanging from my mouth, I gently walked in measured footsteps to the performance space, arriving to see Ladan and Asher crossing paths in the middle, Asher talking in a hushed voice.

I slowly lowered myself into a crouched position near a white wall, dropping the parfait the last 18 inches to the floor, hovering over it on my hands and knees. I removed the lid of the cup with my teeth and flung it to the side, dipping my tongue into what seemed like pure granola. As I made my way through the relentlessly dry cereal, rolled oats stuck to my lips and started scratching my throat. I wondered when I'd hit some yogurt. Finally, the tip of my tongue slid against a smooth plastic floor, revealing that a clear plastic cup

separated granola from yogurt. I heard sounds around me – someone ringing
a bell, low voices – but I was focused on consumption. I finished the last of the
granola before using my teeth to remove the secret cup.

In comparison to the dry granola, lapping up the yogurt was a treat. It was
cool, silky and easy to swallow. I took my time, discovering and thoroughly
chewing each piece of fresh strawberry I encountered. Yogurt and saliva
saturated my moustache and beard. It clung to my chin, my nose, my cheeks
and the smell started to make me nauseous.

I arrived at a point where my face was too big for the cup. My tongue couldn't
reach the yogurt, but I had more to eat. An image of a street dog popped into
my mind. I again made my hands into fists and started to squeeze the plastic
parfait cup to raise the level of the yogurt. (I felt clever doing this – like
raccoon clever). I squeezed, licked and swallowed, adjusting the angle of my
head, the cup, my fists, to continue eating. When squeezing the sides of the cup
stopped working, I mashed the cup against the floor with a single fist to work
the last bit of yogurt out of the cup and onto my tongue.

I surveyed the smashed, empty cup on the floor, its sides lined with streaks of
yellowish yogurt residue. I felt a little rush of success, of completion. Crouching
over the cup on Mariel's cool concrete floor, naked and on all fours with sticky
yogurt smeared across my face, I saw again the image of the street dog.

I looked up for the first time in about 20 minutes.

Across the room, Rafa held a pair of scissors and had chopped off the hair that
had once grown to the middle of his back. I walked over to him, squatted down
and wrapped my arms around him. I took the scissors and evened out the
rough patches he had missed. Bits of Rafa's black hair stuck to my hands, arms
and chest. When I finished, I kissed him on the neck and silently walked to the
bathroom to shower.

As I toweled off, I noticed Allison's dress on the counter and carefully put it
on. I took the towel and wrapped it around my head like a turban. I entered
the performance area with a single goal: to catch Allison off guard and make
her laugh. Everyone but Allison noticed, smiled, giggled. Allison, however,
was naked and crawling around the floor, face down, cleaning the floor with
a bath towel. (I will, someday, write a text on the popularity of cleaning as
performance action). I changed position. I walked through the space. I thought
that either she wasn't letting on that she saw me in her dress or that she really
was immersed in getting the floor clean.

I felt done – and satisfied – with the day's encounter. I returned Allison's dress
to the bathroom and put on my own clothes. Rafa and Ladan were standing
at the kitchen sink, Rafa turning a glass in his hand while Ladan pressed her
tongue against its side, creating a high-pitched tone.

I grabbed a glass of wine. As I moved through the performance space on the way to the patio, Mariel and Asher were suspending a lime between them, using only their foreheads. At any time, the lime could have shot out from between them, causing their faces to painfully collide into one another.

I sat on the patio, drinking wine and listening to the stirrings from inside Mariel's place. Rafa came outside a bit later, then Allison. We didn't talk much, even when Mariel and Asher finished and appeared.

We assembled in Mariel's kitchen for dinner. Mariel had made *ají de gallina*, a traditional Peruvian spicy chicken stew, as well as a vegetarian version. There were salads and bottles of wine and sweets and coffee for dessert. Yet still, we mostly spoke of things other than our performances or about the performances of others.

Rafa and I live together and curiously, he and I didn't speak much about the performance encounter – what we had individually done, saw, thought; not during the drive home, nor for several days after.

Coda

The encounter that Mariel organized instigated my re-considering the role of spectators within the context of performance, particularly in contrast, when the spectators are simultaneous performers. It was refreshing to perform with the absence of cameras and hence, the conscious absence of documentation, save for our mind/body memories, as well as this text, a mediation of my memory. More broadly, our encounter made me consider if the "conventional" performance art set-up, with performer performing for a stationary audience, pushes the experience closer towards the genre of theatre, and even more so, closer towards entertainment.

Dino Dinco is an independent performance art curator and maker, as well as a director of film and theatre, and arts educator. He is currently writing a book on contemporary performance art practice that occurs in major cities along the West Coast of North America, from Vancouver, Canada, south to Tijuana, Mexico. This survey will largely be ahistorical and non-scholarly, using artist and curator interviews and localized dispatches to encapsulate a history that's been and being created in the most recent years, and that comprises a specifically West Coast performance art discourse and practice. www.dinodinco.com

'Under the Hollywood Sign' was originally commissioned by Tessa Wills and Doran George as guest co-editors of *Dance Theatre Journal* 25:2, and written by Dino Dinco, republished by Tessa Wills 2014 at http://tessawills.com/under-the-hollywood-sign/

Alphabet of Festivals

Tim Etchells

Wednesday, 29 February 2012

Late at night, after the show's ended and a quick drink in the bar at the theatre where your performance was, you set off obediently in search of the festival centre. Everyone said you should go there, towing the line about chances to meet audience and other artists. Not far, they said. Not far. Not too far. In any case it's easy – a blob of luminous green marks its place on the map at the back of the Brochure. You walk. Consult the map. Walk again but after 15 minutes maybe more it's clear that from this map whole parts of the city are omitted and in any case it's not to scale. Crossing the ring road or the river there's a winding trek up hills or down blind alleys before, eventually, on the point of giving up and back to Ibis, you find it. The festival centre is a subterranean space most likely, dark anyway, with a DJ playing too loud music vibrating the air of an empty dance floor. The intern who collected you hours or days ago at some early airport pick-up looks exhausted and distracted not to mention surprised to even see you as she makes her way out of the door and exits the exact moment of your arrival. No one else seems to be here. Or just a few people. Scraps of humanity washed up in small groups against the walls. You recognise a couple of guys, you think they might be Latvian, possibly the technical crew of that heavy metal political puppet Company talking to another guy – an actor maybe Spanish working with that French company – who you vaguely remember meeting at an artists breakfast at another festival in Reykjavik or Berlin. You order drinks, pay and then remember that there are free drink tokens in the festival pack. Too late. You pack around a table as far away from the music as possible. The walls are sweating, even though the place is empty. You drink the drinks. A guy comes over and says great, thanks, he really liked the show but the more he talks the more you realise that he's not actually talking about your show – the scenes he's describing are from something else by somebody else. The guy drifts off and few of your colleagues leave but you decide to stay for one more drink. a decision you soon come to regret as the conversation from your remaining colleagues descends into a tangled rant about a part of the show that isn't really working anymore, people complaining and vaguely accusing each other in a combination of circles and different directions. It's 3 in the morning, or 4 even, when you finally rise to retrace steps towards Ibis or Novotel, walking the streets and hoping against hope for a taxi, trying as you do so to make an Alphabet of Festivals.

A – Audience

As in who are you talking to anyway?

Who are you talking with?

Who's coming, who's walking through
the doors?

B – Bar. The Festival Bar, the centre stained
with a luminous green.

C – Community

Connection. Community. The possibility of
community – in the world, in the city, across
the city, in the theatre or performance space.

Belonging. The possibility of belonging. From
the perspective of artists and audiences.

To be part of something

To take part in something

To see something

To share something

To share questions and frame answers
about something.

What is it to belong?

Here in that space – the space of the theatre,

or in the larger space of a festival programme:

(what you are working on is)

The formation of temporary community

The time of the festival itself unfolding,
negotiating its way into the city, into dialogue
with audiences, and the idea of what's possible.

Or D. Doubt.

Could you make a festival of doubt?

Or E.

A Festival of Excess?

Or of Erasure?

Or of Exhaustion?

Or of Ecstasy?

Or F – Fear? Or Forgetting?

Aren't all festivals anyway a kind of forgetting?

Or Fame? Or a Festival of the Fortunate?

Or a Festival of Flies? Or of Fiction?
Or of Flying?

Or of Fake Smiles?

And then G.

Gathering.

The way we're gathered, here.

But for what? And with and for whom?

The Question Being – for any Festival, after all

Exactly What to Celebrate

What to mark

And with and for whom to Mark It

Around what to Convene

To speak back to Community again

And how to celebrate also

That we gather is great, of course but given
that we do so,

with what purpose, with what aim?

Forgetting the alphabet for a moment,
but still walking.

Out there somewhere

Or in here somewhere, coming from out
there somewhere

Or out there somewhere, coming from
in here somewhere

There is

an idea

of what is possible.

And in one sense the purpose of festival
is to change that idea

I mean

by festival

the idea of what is possible is changed,

That in and thru festival new things
seems possible

Or that old things seems impossible

Or that a new kind of perception seems possible

Or that an old kind of imperception or ignorance or ignore/ance seems impossible

That's pretty much the main purpose of art too by the way

In case someone doesn't know that.

Another way to saying

A festival is a machinery for listening

But also a machinery for speaking

But also a machinery for making space in which others can listen

But also a machinery for making space in which others can speak

Festival has to listen

To the city / neighbourhood / place it's in

Could be a country or a street corner or a countryside

Trying to hear, sensitise, trying to listen or divine somehow,

Trying to take account or take stock of that place, its particularities

but at the same time as deeply listening and listening deeply

festival speaks out loud and into the city

should speak strongly

and in speaking changing it

and in speaking re-seeing it

as in another function of art

re-versioning or

when you festival you dream / re-dream the city

rewrite

remix remake

and you have to have guts for that

I mean a sharp tongue for festival speaking as well as keen ears for festival listening

Brain for processing.

Get back to the alphabet.

H. H. Nothing. H.

Really nothing for H ?

Perhaps Hope perhaps?

Or Home.

You are not even half way home and anyhow home when you eventually reach it this festival night will only be a hotel. You have come to the place where the road bridge crosses back into the city. You and your straggling companions are the only traffic. Foot-traffic by the dual carriageway, under the high sodium street-lamps and the rain that starts to fall.

You stick on H and go back to Hope, perhaps.

What you hope for, is that festival might be a place more of questions than confirmations.

It's a good thing to be part of something

To take part in something

To see something

To make or share something

There's nothing wrong with Joining In.

But these days, after all, everyone wants you joined in, connected, networked, on the team and on-side, in fact everyone wants you to participate. Even the bank wants you to follow it on Twitter, the Petrol Station wants Five Minutes of Your Time to Tell it What You Think. Every purchase involves joining a 'community'. You're never just buying stuff after all – you are expressing yourself. You are curating your life. You are adding value. Just remember. You are taking part, making a difference. With every purchase you are buying into something, joining a club, connecting, plugging in friends, even making new friends. Capitalism is so much more than product now, don't you find?

What you might reasonably hope then is that Festival

That Art itself even

Might offer something other than the kind of manufactured belonging

the kind of value added fog of pseudo-together-feeling and association those guys

Over at cognitive capitalism are so good at these days

Larding it over every purchase

what you might hope

 (you're still in the alphabet)

(and you're still walking back into town)

What you might Hope

is that the sharing in those spaces of Art and Festival

might be more about

questions than anything else

that there in that space

of Art and Festival

we might encounter

not just who we are, who we already know we are

and how we like to come together

but instead a chance to focus on

what we might be

or what we are frightened we might be

or what we accuse each other of

or what our doubts are

our grey areas

or what our edges, gaps or borders might be

there are some things, many things, after all that the bogus community offered by capital

in its endless tawdry inventiveness of what can be bought and what can be sold

does not offer

and it's those things, those kinds of things, you might really hope to Festival.

You're wishing that it were possible to Festival not so much

the ease of comfort and manufactured belonging

as Dissent. Debate and Difference.

Rift. Rupture and the Irreconcilable.

You miss the unresolvable.
The incommensurable.

The problem – framed in art and Festival – that can't be resolved. The problem that knots and tangles the room, that stays with people, tangles after them, flowing, wrapping, warping and haunting and cajoling them on the street.. A Festival of ghosts and Tangles in fact. A Festival of Knots. A festival of fools dreaming tangles and questions. A festival of the anguished.

You miss the absolutely Awkward and the Belligerent.

Since there's really too much P for Polite in cultural space which clamps down the possible

Rather than expanding it.

And at heart you're concerned with what our possibles are and our how our current impossibles might become possibles and politics

And besides,

By this time. 4 maybe 5am you are arrived at the Ibis/Novotel/Holiday Inn/Premiere Inn/Maritim/Mercure/or whatever it is and you have pretty much abandoned the alphabet since your more and more, or more or less, runaway train of thought is not helped by it's constriction construction.

There in the lobby of the hotel, standing against a backdrop of Muzak from speakers you ask the Night Porter his opinion, his advice and the guy behind the counter looks up from his computer (inevitably Facebook) and looks you straight in the eye.

He says:

There is currently a blurring or overlap between lifestyle/cognitive or experience capitalism and the kind of scenarios and offers once generated exclusively by the space of art. Where once we pitched the live arts especially against capital – championing their ephemerality, their capacity for individualisation and their interest in the generative possibilities of social network and encounter, now these things, these interests – once radical – are the meat and potatoes of public facing capitalism.

You say – You are everywhere invited to participate?

He says: Yes precisely. But there is a problem in the terms of the offer.

The elevator pings. As if ushering you to bed, as if asking you, please to step out of this strange space but before you can leave the night porter pauses then says:

In the offer there is an insistence on, or pull towards, a definition of community as non-conflict – a pull towards consensus and affirmation rather than dispute. That is capitals need. Its demand, its move – to assert the possibility of endless growth and acquisition.

Yes, you say.

He says:

Capitals' continuing expansion and extension into the social sphere sells us ourselves back to ourselves, diverting us from the real questions about what we lack or about the things we have but do not need. We are not to argue over priorities. Or to question our own or others certainties, narratives, truths. Community (the kind bought and sold out there in the marketplace), must, in other words, cohere. And we must belong.

You say – There is a pull there though – it is great, isn't it, to be together?

He says:

Yes. But we need to think also about what keeps us apart.

And we need to remember that belonging, properly, cannot be purchased.

Participation and belonging are not objects – they are not things which can be achieved solidly or owned concretely – they cannot be acquired, they are processes which need to be worked at, lived in and through... processes which along with togetherness, sharing and mutuality also involve difficulty, dissent, and disagreement, hard work, uncertainty, doubt and dispute. They flow. They alter. They contradict. They involve tension and change.

Yes. You say. Or maybe.

He says:

A promise of belonging that does not insist on (acknowledge, offer or make space for) process, dispute and dissent is basically a false promise – an offer of supposed benefits without the true troubles, responsibilities and relations implied by those terms.

Yes, you say. Or no. Or maybe.

The elevator pings again and you take it.

In the morning you call reception. The Night Porter answers, but is leaving, heading out to his day job at another hotel. You say wait, wait a moment; these are the Festivals of which I have been dreaming.

A Festival Of Slow Time

A Festival Of Mischief

A Festival Of Madness

A Festival Of Forgetting

A Festival Of Freedom

A Festival Of War

A Festival Of Summer & Winter

A Festival Of Lies

A Festival Of The Predictably Unpredictable

A Festival Of Hope

A Festival of Intransigence

A Festival of Free Fall

A Festival of Revolution

A Festival of Coincidences

A Festival of Second Chances

A Festival of Speaking in Tongues

A Festival of Ghost Ships

A Festival of Nonesense

A Festival of Heartbreak

A Festival of Statutory Requirements

A Festival of Shivering

A Festival of Shimmering

A Festival Of Private Conversations

A Festival Of The Never Seen Before

A Festival Of Booze

A Festival of Festivity

A Festival Of Memory

A Festival Of Barking Dogs

A Festival Of The Unknown

A Festival Of The Inevitable

A Festival of Magic

A Festival of Idiots

A Festival of Bad Driving

A Festival of Bald Men

A Festival Of Emptiness

A Festival Of Youth

A Festival Of Europe

A Festival Of Afterwards

A Festival of Before

A Festival of In-Between

A Festival of Circular Arguments

A Festival of Love

A Festival Of Falling

A Festival Of Night Terror

A Festival Of Anti-Terror

A Festival Of Sleeping Audiences

A Festival Of Ambience

A Festival Of Sponsors

A Festival Of Sponsors-Shit

A Festival Of Trepidation

A Festival Of Stasis

A Festival Of The Known

A Festival Of The Dismal

A Festival Of Screaming

A Festival of Bad Jokes

A Festival Of The Dangerous

A Festival Of Flesh

A Festival Of Heat

A Festival Of Experimental Surgery

A Festival Of Gunshots

A Festival Of Colonies

A Festival of Car Alarms

A Festival Of Oppression

A Festival Of Champagne

A Festival Of Spring

A Festival Of Water

A Festival Of Fire

A Festival Of Fracture

A Festival Of Fault Lines

A Festival Of Subterfuge

A Festival of Forgery

A Festival of Games

A Festival of Data

A Festival of Dada

A Festival of Mazes

A Festival of Robots

A Festival of Solutions

A Festival of Waiting

A Festival of Impatience

A Festival of Age

A Festival of the Almost Impossible

A Festival of the Also-Rans

A Festival of the Borrowed

A Festival of the Dead

A Festival of Explosions

A Festival of Implosions

A Festival of Industry

A Festival of the Wrong Things

A Festival of Bad Timing

A Festival of Goodbyes

A Festival of Graffiti

A Festival of Whispers

A Festival of Dreams

A Festival of Wasteground

A Festival of Smoke & Mirrors

A Festival of Ice

A Festival of Public Laughter

A Festival Of Shit & Piss

A Festival of Shadows

A Festival Of Blood Tests

A Festival Of Rules

A Festival Of Waste

A Festival of Secrets

A Festival Without Sense

A Festival Without Artists

A Festival Without Programmers

A Festival Without Audience

A Festival Without Programme

A Festival Without Venues

A Festival Without Borders

A Festival Without End

'Alphabet of Festivals' was originally written for The Future of Festivals - A symposium organised by LIFT and the Jerwood Charitable Foundation on 28 February 2012. It was published by Tim Etchells at timetchells.com, 29 February 2012, http://timetchells.com/notebook/?month=2&year=2012

LUPA11 Brings Performance Art to a Garage in Bethnal Green

Joanna Kindeberg

It is chilly as the dark falls over east London. Strange sounds are coming from the back of a council estate where a group of people have gathered, suspiciously gazing at a garage door.

"Has it started?" someone asks, as others are hushing for the yet scattered groups to be quiet. Some seem to know what to expect, but not the group of first-comers who are looking around restlessly.

The music seems to have stopped as three people appear, one with a dog in his arms. "Welcome to LUPA11!"

Speaking are LUPA's three organisers, Jordan McKenzie, Rachel Dowle and Kate Mahony. LUPA – which stands for 'lock up performance art' – takes place on a Friday night once a month behind an estate in Bethnal Green.

The garage doors opens as a woman in an electric wheelchair appears. Dressed in black bin bags, her hair is a vibrant red and she is wearing goggles. There are giggles and a sense of awkwardness as she steers into the crowd, which sheepishly moves out of the way.

"ARE YOU GUYS EXCITED?" screams her companion, dressed in Olympic sportswear. A third woman is franticly placing post-it notes on people's chests; "legend", "commitment" and "disciplined" – there is certainly a sense of Olympic hysteria to the piece.

It gets very crowded as the audience is asked to enter the garage. While the door closes, droning music is playing loud. As the hysterical sports-woman shouts ("are you having FUN?!") everyone acts obliged until someone panics when smoke appears from a machine. Out on the street again people laugh, perhaps out of relief.

"Performance art has an interactivity and sincerity for me" says Kate Mahony. She joined the LUPA crew after appearing in the second session in October 2011.

"We wanted to have a space where performance could be seen and encourage others that they can create and show work without the help of a gallery space. It's quite an old punk kinda DIY ethos".

Mahony was studying BA art practice at Goldsmiths at the time, while McKenzie and at the time member Aaron Williamson had contacts who were

more established in the art scene. "It made us able to curate a kind of inter-generational pop-up performance art show where there is no hierarchy".

A few latecomers have now joined. There is upbeat music as a young man begins to undress. While he pours what seems to be oil over his naked torso, a second man joins in. Dressed only in shorts, they are tapping their feet whilst watching the quiet crowd. A group of local teenagers hurry past, leaving a rude comment hanging in the air.

Without warning the undressed men clash, and start to violently wrestle. It doesn't take long until they are down on the ground – since when did the music change to a classical piece? It feels nothing but surreal. An onlooker runs out to remove a broken bottle from the ground, but blood is already trickling from their backs.

Soon one of the men is in the power of his opponent. The punishment is to get completely naked, but he doesn't seem to mind. Perhaps it is as someone comments: "probably all a set-up".

"Performance art provokes discussion – and that is what the best kind of art is, a discursive platform to share ideas", says Mahony.

While she arranges who will be performing, she is often clueless as to what will happen during the night. "LUPA is always a mixed bag and I like not knowing what to expect, but I love being as innocent as the audience!"

Dressed in white long shirts and clown-ish make up, "JB&the Bubbles" are a stark contrasts to the performances so far. In a grave manner the trio perform a choreography to Madonna's "Frozen". In the finale, colourful liquids are squirted from the inside of their shirts and as they step out to the audience it becomes clear that packs of Capri-Sun have been taped to their chests.

LUPA runs only for an hour and generally has four performances a night. The organisers have no money for a website but use social media and word of mouth to promote the events.

"We have had a lot of interest from people from all walks of life and backgrounds. It is great to have a fantastic pool of performance artists to work with" says Mahony.

She is clearly happy about its success, but emphasises that the most vital part is for performance art to be accessible.

"Anyone can come along, the local residents of the council estate are invited and for them it may be their first experience of the medium. The fact that it is live makes it quite fun and less alienating and cold than a lot of art I see out there at present."

The final act is not in or outside the garage, but on top. Bill Aitchison, a slim middle-age man, is sitting next to a portable gramophone player, his legs dangling from the garage roof.

A nipping chill sets in as he plays vinyl records that have been important in his life, all followed with a personal anecdote.

As Clive Dunne's 1971 hit "Grandad" plays, time for the evening seems to have run out. But organisers bow in for another few minutes as the audience is now shyly humming along to the chorus.

If there had been a sense of tension behind James Campbell estate earlier in the night, it seems to have faded. As LUPA11 comes to its end, and most of the crowd move on to the local pub, even the accidental audience seem happy to have been caught up in the experience.

Performing in LUPA11 were: Less, Katherine Araniello and guest artist Anne Redmond and Marja Commandeur, John William Fletcher and Stuart Doncaster, JB&the Bubbles (Josh Breach, Gabriel Duckles and Sorcha Mae-Stott Strzala) and Bill Aitchison.

'LUPA11 Brings Performance Art to a Garage in Bethnal Green' was originally written by Joanna Kindeberg for *East London Lines*, 18 October 2012, http://www.eastlondonlines.co.uk/2012/10/pop-up-performance-from-the-lupa-garage/

Amusing and Delicious Art

River Lin

Night Market Theatre is a real stall in the night market. Curated by Yoyo Kung and Juan Chin of Prototype Paradise who collaborated with UK artist Joshua Sofaer as artistic director, Night Market Theatre juxtaposes art and business as contemporary performance practice. It borrows the format of night market trading: the stall, the façade, the menu, and the queuing system, and is located in the Zhiqiang night market in Hualien, Taiwan.

Artists have become the stallholders serving performances which you can't quite take out or eat in but are nevertheless made for you in real time as you savor and experience them. With a sign that reads 'Night Market Theatre', the design of the stand attracts the general public. The conventional stall from which food would be provided to customers has been transformed into a miniature stage. The sense of drama has been heightened by two layers of black curtains, in what looks like the styling of a traditional Taiwanese puppet theatre. This theatrical stall in a jungle of food booths becomes a spectacle, and makes people aware that something interesting and out of the ordinary might happen.

The performance begins. People congregate around the booth discussing the 35 dishes with unusual titles made by 8 artists, such as 'Eat Your Sorrow', 'Bitchy', and 'Sissy gets you high'. People are startled when a woman orders the performance 'The Emperor is Coming'. A performer hands her a handmade traditional Chinese crown, then hits a gong and shouts: 'The emperor is coming!'. Out of nowhere, the entire company gather round the audience member, kneeling down around her and shouting 'A thousand blessings upon your majesty'. The performer hints that perhaps the audience-emperor should give the order for her ministers to stand. She does so and her assembled subjects fade away. The woman is embarrassed and amused. People clap and laugh and instantly get the concept of this dish and what Night Market Theatre is about.

Performances are delivered one after the other over the coming hours, while the audience busy themselves cheering, taking photos, filming and laughing, in the air filled with the smell of BBQ and fried chicken. The enjoyable atmosphere reminded me of traditional open-air Taiwanese opera or puppet performance although I could sense that what Night Market Theatre was doing was different. Some questions came to mind. Why is it necessary to be in a night market? Is it a sort of environmental theatre*? How is it different from street theatre? What would happen if we changed the location to a creative market? How can we view Night Market Theatre as site-specific art?

Let us examine how Night Market Theatre functions. Performers as stallholders stand by the counter and take the orders from the audience, giving them a numbered queuing card. Performers may introduce and recommend some dishes to you but still you have no idea about what you are going to get. You have to wait after ordering until your number is called. You go to the frame of the stall, the curtain opens, and now you get to see who is the artist/stallholder/chef for you. You pay. The artist presents a performance for you, the duration of which could range from 30 seconds to 5 minutes. The dish here is a participatory one-to-one performance aiming to create a personal, sensory and intimate experience. Not only is the audience member expected to interact with the artist but also to complete the performance with their collaboration. Sometimes the outer curtain is shut and sometimes it is open. This brilliantly transforms the area from an intimate private space to a border space somewhere between private and public. Then there is an opportunity for people to watch at a distance.

In the performance 'Bitchy', for instance, the outer curtain was open. After receiving the payment, the performer began to insult the audience member in public. At first the audience may well feel confused or shocked. The person on the receiving end of this abuse is also the person who is in the condition of making the performance workable. The wider public is invited to witness the changing process of the audience member's emotional reaction: being upset, confused, embarrassed, laughing, or angry. Or, in the performance 'Embrace' the outer curtain is shut. The artist came round from behind the stall to where the audience member was standing, and the public could only peep at the lower part of their two bodies below the curtain without fully accessing what they were doing. The audience members become additional performers and the one-to-one interactions subtly shift. The operation of opening or closing the outer curtain encourages visitors to become a certain kind of audience in relation to the public realm as well encouraging them to become participants in the performance scene.

In terms of the artistic strategies here, the 'general public' who go to the night market is conceived as the target audience that every performer tries to work with. The approach of Night Market Theatre has left behind the stereotyped language of traditional theatre. Artists take social interactions in daily life, such as telling a story, singing, dancing, party games, fortune telling, and massage as a point of departure to devise their performances, which aim to be accessible to everybody. Building up performances within the social context of ordinary night market life was the aim. It was fitting then, that the duration and price of performances were 'bite-sized', and the costumes and props handmade, and low tech. These devices combine to reveal an understanding that Night Market Theatre revolves around the night market as a specific site, rather than the space of a black box.

Interestingly, artists as stallholders sell their own bodies as an art meal. They use their bodies to create performance in which there coexist many possible meanings. They invite the audience to participate with their bodies too,

creating an interactive process that refers to the state of social relationships in daily life. If strolling in a night market to buy and eat food is the social life-style in Taiwan (or in Asia more generally) from the outsider Joshua Sofaer's view, then from concept to practice, we can see Night Market Theatre as an art intervention in civic culture that has brilliantly engaged artists and audiences to re-experience the social interaction as contemporary performance. It leads us to rethink how art is something that comes from, and is part of, our everyday life.

Theatre makers have been trying to leave the black box. Audience development and marketing strategies have become trendy ways of trying to get attention. It seems Night Market Theatre has managed to inadvertently generate and realise the campaign slogan: The whole city is a theatre. It has successfully integrated site-specific audience participation and social interaction. As participatory performance practice in a local neighbourhood, Night Market Theatre is a remarkable cross-cultural collaboration.

*Environmental theatre is a branch of the New Theatre movement of the 1960s that aimed to heighten audience awareness of theatre by eliminating the distinction between the audience's and the actors' space.

'Amusing and Delicious Art' was originally written by River Lin in *art plus taiwan*, no. 38, December 2014, pp. 50-53, http://www.riverperformance.com/review/nightmarkettheatre/

On Making Performance Visible

Diana Damian

We can think of performance as a frame for disclosure, as opposed to a space of representation. In cinema, we embody experience through the gaze, perceiving it as a unitary event mediated through the screen. This has certainly impacted on our understanding of spectatorship – we perceive the live encounter as external to us, despite its lack of containment. Just consider the extent to which practitioners have tried to challenge this boundary, and relocate us within the theatrical experience, as opposed to outside of it. Our relationship to performance is fragmented, displaced by collectivity and constrained by cultural assumptions. If, in Deleuze's words, art "is not a matter or reproducing or inventing forms, but of capturing forces", why are we so concerned by labels as models of reduction of the experience of a performance? Does calling a piece of theatre 'immersive' suggest a particular mode of spectatorship? Liveness is not external, yet it seems that, in contemporary practice, the process of categorization of theatre and performance is constantly attempting to externalize and domesticate performance in all its manifestations.

The problem of labels and categories feels outdated at a time when hybrids provide far more space for discourse than the rigidity of traditional frameworks. This, in part, has to do with the fact that within contemporary culture, labels have come to limit our understandings of work instead of promote it, being the result of convoluted art histories and public misappropriations. Even more problematic is the fact that a significant area of contemporary performance culture is rendered literally invisible in the public realm simply due to the fact that discussions hide in various obscure sections of newspapers and blogs (inaccessible outside of specialized publications and niche sites), or are considered not relevant to existing frameworks.

If the art world has readily embraced live events, performance-based exhibitions and interdisciplinary work, the theatre world has been far more reluctant to do so. The US has also been more open to these changes: publications like *The Village Voice*, *New Yorker* and even *The New York Times* attempt to cover a larger span of performance art in all its cross-disciplinary manifestations, and they dedicate a specific section of their publication for this purposes.

The question of just what distinguishes a work of theatre from a work of performance or the experimental from the avant-garde tends to get in the way of developing coherent ways of reading performance. Take, for example,

61

the discussion stirred by Michael Billington's recent overview of experimental theatre as part of his A-Z of Modern Drama. For one thing, the historical period being looked at is rendered unclear: Billington is providing a brief assessment of the contemporary experimental theatre landscape whilst referring precisely to *modern* readings of the field.

For Billington, experimental theatre has become apoliticized in contemporary culture: "what we are witnessing, I suspect, is the 'institutionalisation' of experiment in a way that minimises its threat." He associates experimental theatre with developments in twentieth century performance culture that steered away from naturalism; his definition of what constitutes radical work, as that positioned outside of the 'mainstream', is problematic in relation to what's going on in experimental theatre now. After all, we're talking about a label whose meaning is displaced by contemporary associations and implications, not an immutable, quantified form of theatre. As Chris Goode explained in the comments that followed Billington's piece: "how do we recognize the experimental, given that, [...] the very last thing 'experimental' can be is a description of a particular aesthetic." Andy Field also responded by saying that "talking of 'experimental theatre' is like trying to play a game in which everyone has their own very different set of rules and even the pitch itself is a palimpsest of contradictory markings."

This isn't merely a problem of definitions, it is a symptom of just how little attention mainstream criticism has paid to the development of performance as a field, and the implications this has on critical language itself. A similar problem was recently pointed out by Contemporary Performance Network pitching a discussion on exactly what industry giant RoseLee Goldberg means when labelling Peforma11, a performance biennale she curates in New York, as "visual art performance", a term eagerly appropriated by a *New York Times* journalist in her review of the biennale.

Indeed, what does visual art performance mean? For most people, absolutely nothing. That has partly to do with the convoluted relationship between visual art and performance, in which the latter displaces authority out of the hands of the former. In Performa's case, the term is clearly a sophism that serves as an attempt to carve out a context for live art that doesn't hold formal constraints within its discourses. This brings forward the question of exactly how can we make a growing area of performance visible without being reductionist?

The main issue remains on how to question the constant interchangeability of terms like experimental, avant-garde, immersive, intimate etc; terms that only hold meaning in specific contexts and limit the possibilities of work to mean and exist in different contexts at the same time. It is impossible to ignore just how easy it is to kill off the discussion surrounding a production simply by the vagueness of its label.

Antony Gormley and Hofesh Schechter's piece *Survivor* which recently played at the Barbican Theatre was mostly reviewed in the Dance section of most newspapers, probably because Shechter is most known for his work as a choreographer. Yet the piece barely featured any dance. Likewise, where would you place, for example, Forest Fringe's upcoming season of work at the Gate Theatre without denigrating the individual performances with some ill-informed label? Where would you put public projects such as Performance Matters?

Part of the problem I suspect lies with the lack of an appropriate language for theatre criticism to articulate discussions of these forms of work, which might explain why they are so absent from mainstream media. Perhaps there's also the potency of discourses occurring within the fields themselves; for example, the brilliant work done by the Live Art Development Agency in attempting to publicize discourses on performance, collaborating with both artists and writers in thinking about appropriate methodologies (you can read their online publication *In Time* here: http://www.thisisliveart.co.uk/publishing/in-time-a-collection-of-live-art-case-studies/).

Yet the discussion of genres, forms and categories should be one dominated by possibility and an openness to question contemporary understandings, seeking to recontextualize and challenge common doxa instead of supporting its vagueness. If we consider work to not fit into standardized cultural frameworks, then we need to engage in a questioning of those frameworks.

In the past 30 years, the UK has seen a proliferation of performance through live events, exhibitions, festivals, community projects and interdisciplinary endeavours, formal collaborations that seek to relocate the performance paradigm in various sites whilst engaging in a wide range of cultural, social and economic dialogues. Should we not try to venture outside common theatrical routes – and tropes – in order to render these manifestations more visible to the public?

'On Making Performance Visible' was originally written by Diana Damian Martin for *Exeunt Magazine*, 2 February 2012, http://exeuntmagazine.com/features/on-making-performance-visible/

Bodies? On? Stage? Human Play of Forced Entertainment

Jan Suk

I

Dear Tim,[1]

I am writing from a train. I am on a train which is taking me to see the second world premiere of your latest show, *The Coming Storm*. To be honest, I am presenting this letter here and now as my paper for the CDE conference in Mülheim am Ruhr, Germany, called *Bodies on Stage*. It is 9th of June 2012, 10.30.

I am talking at the conference and blindly hoping to publishing in a peer-reviewed journal, so forgive my episodic attempts at academic allusions and telling you about things you already know. Like in your shows or writings, Tim, nevertheless, trendy words and phrases of academia such as *simulacra*, *deterritorialisation*, or *rhizomatic* might intertwine with low-brow expressions like *fuck*, *cunt*, or *postdramatic*.

Tim, I want to write about the stage and the body, and I would also like to tell you about the vulnerability, fragility, mistakes, and failures, which I find most fascinating in your work. It is in fact a failure which brought me here. Failure or coincidence: that you cancelled your show *Tomorrow's Parties*, which I was originally planning to see and write about; this failure has brought me here. By *here* I mean the presence of my corporeal body on this very train, or this very room, and into this very letter. The work of Forced Entertainment is often considered to be very here and now. Let me remind you here of the context from which I approached your work initially, which is, rather than new British theatre, perhaps, "now" British theatre.[2] Instead of theatre, perhaps, let me use performance art here, or Live Art, the platform which like your pieces focuses on the physicality of the body on stage. It makes me think of your stand-up aesthetics of a lonely and weak body on a stage addressing the audience; often failing to entertain or communicate anything.

1. Dear reader, the letter is purportedly addressed to Tim Etchells, the artistic director of Forced Entertainment, a cutting-edge British experimental theatre group. If you want to recreate the live performance, while reading the letter aloud with a slight Czech accent, you should ideally listen to two songs: the first one is "A Few Thoughts about Time" by John Avery; the second song is "Together We Will Live Forever" by Clint Mansell. Both songs are supposed to be looped. Thank you for the perusal of this footnote. You may return to the text now.

2. I am trying hard not to use the word *new* here; these are "now" media (Wyver 76).

Your coexistence with fringe projects that can be pigeonholed as Live Art accentuates the contemporary anti-as-if and here-and-now-for-you tendencies. The plethora of approaches towards performance of your compatriots, such as the bleeding pieces of Franko B, the distinguished dances for sale by La Ribot, or the durational public space invasive interventions of Lone Twin, to name just a few, makes me wonder if your work stands to be classified Live Art-ish, or whether you personally prefer to stick to the term *theatre*.

Tim, as time is passing by, my train from Prague is nearing Dresden, the station where I change trains. We are passing a spectacular landscape. Like in your works, outside my train window, so many unique lives parade, so many stories appear and vanish. In contrast to theatre in a more-or-less traditionalist understanding, Live Art performance mainly does not present the illusion of events, but rather presents actual events as art. I wonder what you would make of the label *performance theatre*, meaning a renewed emphasis on process, which enhances the non-reproducibility of the artwork; or, to put it differently: that it cannot be *reimagined* even though it is restageable (Bailes 21-22). Or do you care at all?

Life passing by outside the train window makes me think of your earlier performances. What crosses my mind first is the story behind *Speak Bitterness* (1994), a show you produced both for theatre (as a 90-ish-minute piece) and as durational six-hour performances. Particularly the pictures of Hugo Glendinning, the company photographer-in-chief, taken during your rehearsals, without looking through the camera: the subjective rendering of the photographs as if to reveal the dynamic, overtly fragile, and human-scale force in the ghosts of your bodies on stage. The photographs also testify to the way you devise your work. Actually, with these images in mind, I embarked upon the idea to create a text as a letter to you, which, like your work as I perceive it, mixes the highly visceral personal micro-narratives fidgeting on the border of your personal biographies, or "borrowed and second-hand identities" (Shaughnessy 133). What is striking about your work is the interplay between the real and fictitious, the imaginary, or, as you put it, "the summoning of presence in the context of absence" (Etchells, "Step" 10). But I still wonder whether implementing Hugo's highly subjective way of responding to your work proves helpful.

Tim, the idea of reality and confession in your work brings back memories of my journey this morning. Waking at *4:48*, packing my stuff, kissing my three children and wife goodbye, taking a four-kilometre hike through the woods to the nearest bus stop in a tiny village to catch my bus to a bigger town, there change to Prague to deliver me to your performance, *The Coming Storm*, in Braunschweig. In the morning, as I made my way through the forest, I was watching the sky and the coming storm; I took a picture which I attach; the accumulated clouds filled me with expectations, as you can guess. Yes, eventually I got soaked before reaching the shelter of the bus stop. Now, as my clothes are drying on my skin, my anticipation of tonight's show is rising. The only thing I learned about it comes from the press release published 6

February 2012. It promises a thought-provoking mixture of deep contemplative entertainment intertwined with forced shallow bullshitting on stage. For the sake of the other listeners and readers, let me partly quote it here:

> In this new work international innovators Forced Entertainment follow the lead of their 2009 performance *Void Story* and turn their attention to narrative – deconstructing and reconstructing something like a ghost story to test the limits of the form. Employing devices from amateur dramatics, puppet theatre, song and naive dance, they tell an epic story that is resolutely too big for the stage. This unwieldy narrative is absurd, contradictory and might fall apart at any moment as it is overwritten, reshaped and cannibalised. In a style as inventive as it is clumsy, wrong-headed theatrical tricks take their place alongside broken dances, live music and increasingly frantic attempts to illustrate this blackly comic and haunting tale. (Forced Entertainment 1)

The ghosts in both your story and the photographs remind me of the fact that throughout your 27-year oeuvre, Forced Entertainment actors have retained their civilian names. Therefore, the often experienced notion of *ghosting*, coined by Marvin Carlson, which is the projection of the spectators' previous experience of the actor in a different role (8-12), collapses entirely in your works. On the contrary, by always learning something new about the people in your next shows, the spectator adds new layers or juxtaposes the levels of meaning and enhances the aforementioned permanent interplay between hereness and thereness, reality and artifice, presence and illusion, certainty and provisionality. Therefore, I would like to drag your projects into postdramatic territory. Your work promises a mixture of failure, mistakes, irrationality, thus evoking feelings of sympathy rather than empathy as well as boredom. I would call this controllable uncontrol, meaning that your devised performances are entirely improvised in rehearsal and fully scripted at the end. The excessive control, I believe, also brings about a failing anticipation of spontaneity.

Your penchant for the use of the naive, amateur, or absurd seems to be given justice in the new production. As I have learned researching your work, Tim, you are well aware of the possibilities of space. In your ongoing photography project with Hugo Glendinning, called *Empty Stages*, you plainly expose the sheer potentiality of stage space as magical as well as practical and everyday-ish. These photographs, I dare say, also illustrate succinctly the way you work – your method of "staring at the space, or stage, with all your stuff in or empty, because at the beginning [you] are always stuck" (Etchells, 'Devised Theatre'). The stage for you is a container of possibility, like life, I would argue. I value the way you experiment with making things rub against each other, especially the moments of silence, the nothings you start your shows with. I am convinced they are to do with stage possibilities. Also in your devising process, Tim, you recycle your ideas, music, lines, or videos; you stitch them together without any rules.

II

Dear Tim,

I am writing to you from a train again. I am heading towards Mülheim/
Ruhr Hauptbahnhof, from there to get to the conference venue at a tram stop
ominously called Mourning or Meaning or Moaning – I forget.[3] Yesterday, I
finally saw *The Coming Storm*. Similar to the storm in my home village I was
describing earlier, your performance brought no real storm either. I cannot
help replaying the expectations I had of the "epic story too big for a stage."
I expected a bit more drama-wise; last night, I missed the spontaneous fuck
and cunt in your work: last night I experienced how you pushed the limits but
only within your aesthetics. I lacked something more in-yer-face, original;
it appeared as if you live your life on stage not for the stage. As if you do not
care, or are getting old, or both, I am worried whether for your bodies on stage
really matter to the audience. Last night I saw a sequence of provocation &
fun, yet without much extra liveness behind. The life within appeared to be
weary or ennui as if in a controlled isolation.

Nevertheless, what I found highly symptomatic about the piece as far as
bodies are concerned was that the audience at the Staatstheater Braunschweig
had to go through the backdoor corridors in order to sit on the stage, where
the seats were located underneath a mass of cables, lights, projectors, fog
machines. I found this shift or transformation from auditorium to stage highly
entertaining when bearing in mind your interest in space and audience, whom
you like to call "witnesses." As I already observed, you often speak of the
space as of a potentiality, and the theatre of yours can be described as filling
the potentiality with people, or stories. Somehow the audience thus comes
to coexist in the potentiality of that stage. Speaking of the audience, what I
also realised last night was that you fundamentally split the audience into
granulised individuals.

At the beginning of your "epic" piece, you filled the stage with stories. The
bodies of your six actors on stage (all five veteran actors joined by Phil,
who had already collaborated with you in *The Thrill of It All*, 2010) basically
produced beginnings of stories, some of which were highly spectacularised,
impossible (especially Phil's), some a bit dull, civil, boring (Richard's). What
I immediately noticed was the resemblance to your earlier projects (e.g. *And
on the Thousandth Night…*, 2000, a durational piece where actors are asked to
produce any kind of story but never finish it since they are interrupted). What
I missed in the diverse applications of your so-called narrative kaleidoscope
was a feel of spontaneous improvisation or organic stage fortuity.

After witnessing your body of work in Braunschweig, I also realised that I am a
traffic-light ignorant. I kept crossing the road on red and enjoyed watching the

3. Dear reader, as this is an academic paper committed to The Truth, I have to inform you
that the correct name is, unominously, Monning.

faces of the waiting German pedestrians opposite, puzzled, hesitating whether to join me or reprimand me or something else. Tim, I realised that in this way, your work is also traffic-light ignorant. You kind of walk around freely in order to provoke. Sometimes, like last night, I feel perplexed by your work. At times, I feel like crying with laughter at some stories, for instance when Cathy's question: "If this were a Hollywood film, which actor would play the part of ...?" makes Richard tell the story that Nicole Kidman phones him at Brad Pitt's flat to inform him that Richard's mother has just died. Sometimes, I feel embarrassed and bored by the predictability, mundanity, and the sheer length of some scenes. After your *Spectacular* show in Dresden in 2009, I am not sure if you remember, I told you over a glass of wine, drunk, that I found the piece too much, too long, too boring. Maybe since then you have stopped replying to my emails. I also recall your interview with Aleks Sierz for *TheatreVoice* where Aleks points out the excess of time you spend on a scene. You did not seem particularly pleased then, either. It made me feel sorry for you. Tim, I wonder, do you enjoy watching your audience, uncanny, discomforted?

This morning, I began to feel more sympathetic towards your aesthetics of ghostly dilapidated and anonymous hotel rooms. Leaving the most expensive accommodation of my life, a single room at the Stadthotel Magnitor with only cold water in the shower and hot water in the washbasin, I realised how funny yesterday's story by Terry was. She was telling a story of her return to the empty hotel room and having a phone call from her boyfriend, knowing already that something had gone wrong. The more I recollect, the more entertaining I consider Robin's intervention, in which he asked Terry to change the characters from her story: from boyfriend to first her sister, then to Elton John, Angela Merkel, Vladimir Putin, Bashar al-Assad, to finally Barack Obama, who, instead of bad news, was producing only strange unintelligible sounds between laughter and crying. I considered the anonymity of a phone call to an anonymous hotel room utterly compassionate. So I felt sorry for Cathy spending fifteen minutes describing what is happening on stage in her far-from-perfect Russian. In fact, I feel I am doing the same here. Forcing some other people to listen to me for 15 minutes or to spend even more time reading, as I try to describe what happened on stage in a foreign language. Such forced entertainment. So much like: the tyranny of theatre as space.

Last night, *The Coming Storm* summoned again the idea of *Speak Bitterness*, which basically is a six-hour medley of confessions. Confessions of a day-to-day character, e.g. "We held each other's hands," "We looked at the pictures of rare skin diseases," or "We farted on the first date," to ones of a most ridiculous nature, such as "We crashed the spaceship on purpose," or "We knew that a professional foul inside the 30-yard box could lead to a penalty, but in the 83rd minute we felt there was no choice – some of us went one way and I went the other, sandwiching the bloke and bringing him down hard – the referee was a Hungarian and never saw a thing." Yesterday, the show made me think of the *We* of the confessions and the imaginary link between the audience, your bodies and your body of work in-between. I admit, it could have been me who "smiled in the ID line, or was often seen on the background of other

people's snapshots." Was it my neighbour who "had HUNGER for breakfast and STARVATION for lunch," or "was a suicide bomber"? Or "fucked around" or "killed the first daughter of all English greengrocers in an attempt to avoid any unfortunate recurrences of the last 10 years"? Maybe my neighbour did, because like me, she was taking meticulous notes during all of the performance, which drew my attention to her. What is more, she really was attractive, but as in your performance last night, I will not tell the ending here.

In a way, your show made me also think of my own human scale, my mortality and loneliness. In a way, it made me realise a certain similitude between the loneliness of an academic paper giver as well as the futility of the academic endeavour to produce solutions, explanations, reasoning, or reconciliation, in a way. A lonely body on an empty stage. I feel almost happy to suggest the slight absurdity of theorising on performance art. It is nicely visible in the complexity of rhizomatic artistic attempts to deterritorialise and granulise the creative landscape of contemporary performative strategies. A Jacques-in-the-Box: Lala Cancan and DerriDada, if you would pardon my French. Such Sisyphean labour, naturally, is shadowed by the antagonistic tendency of academia to deliberately reterritorialise these trends by pinning them down.

I am aware of the fact that you have always sat inside the theatre as a slightly alien presence, and this has continued until today; and your feelings towards what theatre is and what it can be have been in a slightly ambivalent or even antagonistic relationship (Etchells, 'Devised Theatre'). But what I would like to argue is that theatre as a space and as a theoretical concept plays a seminal role: as both the physical edges (or boundaries if you will) and the temporal edges of the conventional 60-to-90-minute performance time. The negotiations of these spatial and temporal edges are also the negotiation of the border between art and life, given the aforementioned way your actors 'act.' Therefore, I would like to finally suggest the implementation of another strategic term, Life Art, meaning the process-based and -driven activity challenging the boundaries between the theatrical and the everyday, in other words, between art and life. Nevertheless, I am perfectly conscious of the perilousness of the term.

Life Art, the way I see this umbrella coinage, operates threefold: 1) to make me understand and excuse yourselves for what you are doing. Hence I am convinced your performances are honest, groundshaking, kind and sympathy-provoking, no matter how tiresome and frustrating they appear. 2) To describe how your projects embrace your aesthetics presencing yourselves on stage and blur your biographies with stage identities. And finally, 3) to tick another box in My Academic Coinages.

My conclusion therefore suggests that the constant presencing of your bodies interestingly projects your life onto the spectator, to a certain extent, naturally. This projection implies the necessity for the implementation of new terminology, given the fact that Forced Entertainment operates as a creative force that strives to fill the stage with life. Your devised work committed to

theatre, I am convinced, is a case study in provoking questions about reality on stage in theatrical terms or frames. Your epic bullshitting too large for a stage still gives me hope that my punk-academic serendipitying and epic attempts on this very stage (of academia/art/life) are the same: fragile, fleeting, and irreversible, like yours. The duration of your life within art as well as art within life (similar to my activities here) need not be forcefully revolutionary or ground-breaking but can at least attempt to feel enjoyable and entertaining, life-like. The application of the Life Art framing underpins the human play of your (Tim Etchells/Forced Entertainment) and my body? on? stage?

Dear Tim, I will remain forever your humble servant and devoted critic,

Best,

Jan[4]

{Note: Tim Etchells has never replied to this letter; nor has Terry O'Connor, who willingly asked me about the letter at the *Perform Repeat Record* book launch at Live Art Bistro, Leeds, 29 June, 2012. Finally, the paper roused controversy among German scholars responsible for editing the CDE journal; eventually the paper was two times rejected despite numerous attempts to rewrite it and calls of its support amongst more down-to-earth, sympathetic or visionary members of German punkacademia, namely Anette Pankratz and Ariane de Waal. Thanks.}

Works Cited

Primary Literature
Speak Bitterness. Dir. Tim Etchells and Forced Entertainment. 1994. DVD.
The Coming Storm. Dir. Tim Etchells and Forced Entertainment. Staatstheater Braunschweig, Braunschweig. 5 June 2012. Performance.

Secondary Literature
Bailes, Sara Jane. *Performance Theatre and the Poetics of Failure: Forced Entertainment, Goat Island, Elevator Repair Service*. New York: Routledge, 2011.
Carlson, Marvin. *The Haunted Stage: The Theatre as a Memory Machine*. Ann Arbour: University of Michigan Press, 2001.
Etchells, Tim. 'Devised Theatre.' Archa Theatre, Prague. 20 September 2011. Lecture.
---. "Step off the Stage." *The Live Art Almanac*. Ed. Daniel Brine. London: Live Art Development Agency, 2008. 7-16.
Forced Entertainment. '*The Coming Storm* Press Release.' *Forced Entertainment Website* 2012. 24 August 2012 <http://www.forcedentertainment.com/page/3021/Press>.

4. The research for this article was generously granted and completed within GAUK project number 396211 supported by the Faculty of Arts, Charles University in Prague.

Shaughnessy, Robert. *Shakespeare Effect: A History of Twentieth-Century Performance*. London: Palgrave Macmillan, 2002.

Sierz, Aleks. 'Interview with Tim Etchells.' *TheatreVoice* 2 November 2010. 24 August 2012 <http://www.theatrevoice.com/2588/tim-etchells-of-forced-entertainment-on-their-latest-hit>.

Wyver, John. 'Live at UK: Keynote Presentation.' *The Live Art Almanac*. Ed. Daniel Brine. London: Live Art Development Agency, 2008. 73-78.

'Bodies? On? Stage? Human play of Forced Entertainment' was originally written by Jan Suk, 9-10 June 2012, additional comments added on 22 December 2012; previously unpublished.

The Performer in Live Art

Laura Burns

27 November 2012

How we conceive of originality is always a contested and sometimes avoided topic. It seems that we praise and look for the radical, especially in live art, whilst acknowledging that the individual performer is constantly in dialogue with influence and tradition, and the notion of anything being entirely 'original' is a fallacy. I am less interested in arguing about whether works are original or not, and more interested in questioning how our approach to originality is coloured by our cultural context, and how that in turn, influences our conception of the figure of the performer in live art.

At SPILL Festival, the landscape was marked with traces of origins – director Robert Pacitti's origins and return to Ipswich itself, SPILL's commitment to supporting new work and originating conversations, and the works themselves that sought out new processes of meaning-making. 'Originality' as a forward movement, already seemed in dialogue with 'origins' and looking back, returning to the source. Some works recalled and were in dialogue with an ancestry of live art, whilst questions of originality arose in the SPILL Think Tank sessions. Namely originality was discussed in terms of live art's intention to create new ways of challenging boundaries and audience-artist relationships.

I felt as though many of the works did this by using the body as a site for processes and a landscape for politics. Pieces such as Ruth Flynn's *Diary* broke expectations and barriers to the audience set up by the artist herself, through the volatile eruption of her body and language. Artists such as Bean, Nicola Canavan and Elena Molinaro used the body as material, confronting audiences with the visceral, live act of performance. These performances seem to fulfil live art's intention to confront and subvert traditional roles of artist or performer; in doing so, the performers themselves seem to become the site of originality, perhaps producers of originality. I can't help wondering what the political and cultural implications of this might be, especially when it seems in conflict with the sense that 'to originate' is to go back to the source, to the starting point, to reveal what is already there.

So what happens when traditional cultural roles are adopted within this context? Tim Bromage's *Untitled* blended poetry, magic and folklore. As he took on a series of roles that re-established traditional artist personas, he challenged what may have become a conventional way of thinking about what is challenging, and what is original. Bromage opened his performance standing at a microphone, reciting a poem underneath a single spotlight. He then performed a series of magic tricks, before singing a folksong about a seamstress who sewed up her husband so that he wouldn't beat her. He went

on to methodically stick strips of blue gaffa tape to his face, leaving only his mouth and eyes uncovered. He finished the set with another spoken word extract, again standing at the microphone.

The performance seemed to defy live art's notion of newness, of pushing boundaries of performance. In the context of a contemporary festival of performance, in which narrative was often broken and fragmented, history upturned and questioned, bodies left bleeding and static noise buzzing, a performance of romantic poetry, magic and an unaltered folksong was one of the most radical things I'd seen all week. Is the potential for a work to challenge, more about context than it is about originality? Or was there some dynamic that Bromage was tapping into, that subverted notions of ownership and thereby presented new ways of conceiving of originality?

The language of Bromage's material – narrative, traditional, familiar – against a wider live art tradition that often breaks apart that language, and against the framework of his own performance, made his actions politically and aesthetically charged. To me they spoke of the position of the artist or performer themselves, and the political implications of the performance of folklore. Bromage stepped into traditional roles of the poet, magician and folksinger/teller, all of which rely on craftsmanship and speak of an era in which art was craft, and craft was often anonymous. Framed within performance art which prioritises intention, immediacy, concept and process over craft or product, Bromage seemed to be breaking the rule of live art to break rules! If these cultural figures were not anonymous, they were often carriers of tradition rather than producers of original works.

Epic poems often arose from oral storytelling culture, in which ownership and authorship were negated; similarly folk culture and the passing on of folktales generates a dynamic whereby the song or story is more important than the performer of it. A magician's craft is about the magic; whilst the magician's persona is often a charismatic one, it doesn't get in the way of the magic. Likewise the storyteller doesn't get in the way of a good story. In a sense, these traditional figures from an ancestry of art, folklore, entertainment and culture, were vessels through which the material would be passed.

The implications of a lack of ownership are inherently political, pointing towards the communal culture of collective meaning-making processes, rather than the production of art from an independent or 'original' individual. When the latter is often praised on accounts of pushing boundaries in new ways, perhaps the act of stepping out of the way of that which is being carried through, is radical in the context of Western society's emphasis on the individual rather than the collective.

In contrast, the confrontation of the performer's body in live art as the site of processes and production of meaning, situates the performer themselves in the centre of the artwork, more a stone in the river, than a channel for the water. Not that the subject of the artist obstructs the art, but often bodies become

written on, dwelt in, part of the processes of breaking open these familiar roles. In works such as Elena Molinaro's, the performer's body becomes material and landscape for challenging politics of ownership over bodies. In doing so, the 'I' and the figure of the performer becomes the site and reason for politics of self and identity to play out. Power structures are confronted and revealed, with the performer remaining central to the challenged stereotype or politic.

Bromage uses and juxtaposes both dynamics within the framework of his piece. Singing the folksong he becomes an anonymous carrier of tradition; masked in tape, he is both anonymous and ritualistic, recalling and performing the anonymity of his act, whilst simultaneously making his body the site of this process. He combines the role of the artist in live art as embedded in the process of his meaning-making, whilst embodying the traditional role of a carrier of culture and tradition. One claims presence and reveals ownership politics, the other claims anonymity and collective cultural processes. The meeting of the two seems like a fearless rejection of pursuing originality, one that is, paradoxically, original.

The word 'original' stems from oriri, meaning 'to rise, become visible, appear'. To make something appear, is to already have the thing exist. To be radical, is to return or come from the fundamental, the root or origin. This spiralling movement backwards and simultaneously forwards over time, finds originality occurring through ways of revealing, where the artist or individual cannot always claim authorship over that which is being revealed. These ways of revealing and returning are radical when framed in such a way as to reveal something not only about themselves but about our ways of reading.

Take John Jordan's Clandestine *Insurgent Rebel Clown Army*: the traditional role of the clown, like the joker or trickster, is often to stir things up, to upturn notions of morality. Yet in certain contexts this figure is comfortable as well as provocative and revealing. As a complicit audience, we know how to laugh – or cry – at the clown; that is not to say he/she is not a complex character, but often the archetype is established in terms that the audience can predict and respond to accordingly. However, in the context and language of protest, and against a not immediately complicit audience – the police – the figure of the clown becomes unreadable, and therefore a politically potent and radical figure, shedding light on and changing the rules of the game. The traditional role of clown as trickster is reclaimed and re-triggered. Likewise, the folksong Bromage sings tells of a seamstress who sews up her husband in order to teach him a lesson about beating her. This in fact enables her to beat him. The act of sewing in one context is domestic and contained, yet within this context the act is used to subvert power structures and gender politics.

It seems appropriate therefore, to recall traditions in which the purpose of art and story was to carry meaning, with the performer being the carrier, not the producer, nor the sole holder of meaning. The travelling poet or bard, magician and storyteller literally carries their craft over physical distance,

as well as carrying the story or song into being. To use traditional material is also to pay homage to craftsmanship, whilst at the same time acknowledging an oral culture which could be said to be in direct dialogue with the actions of live art that seek to bring processes back to the live and immersive present. The purpose of orality, be it through magic, poetry, storytelling or singing, is to journey collectively through an event, to be co-creators in bringing what is already there, into being. It is inherently performative, and perhaps a direct ancestor of live performance.

In turning away from a cultivation of product or object, has live art made the performer themselves the product of the performance? I mean this in terms of the performer's concept, the performer's idea, the performer's originality. Is this what we are looking for when we watch live art? When the unaltered singing of a folksong strikes me as radical because it is clearly a recitation of material not originating from the artist themselves, this question naturally arises. Whilst live art attempts to reclaim processes over product or object of production, are these performances of process themselves becoming art objects? I don't think yes is necessarily the answer to these questions, but I believe they are worth asking, and works such as Bromage's *Untitled* are integral to their questioning. The place of folklore as material within these contexts seems an apt choice for performance and art that seeks to dismantle power structures and challenge elitism. The dialogic nature of Bromage's piece through the proliferation of voices he adopted, spoke also of a plurality and a history bigger than that of the individual.

Perhaps in a quest for finding new ways of challenging artist-audience relationships, ways of seeing that are illuminated in archetypal roles of artists, craftspeople and folk carriers, are being forgotten. What is original may already be, and newness and originality don't always go hand-in-hand. If we conceive of originality in terms of revealing that which is already there, perhaps we will be inclined to revisit the origins of performance, and shed light on ways of seeing that challenge our conception of what is new, original and challenging. From a context of live art that seeks to push boundaries by reclaiming process, and subverting politics of power and ownership, the stage seems set for these two traditions to be in more dialogue.

'The Performer in Live Art' was originally written by Laura Burns for *Exeunt Magazine*, 27 November 2012, http://exeuntmagazine.com/features/the-performer-in-live-art/

(After) Love at LAST SIGHT.....Nezaket Ekici

Shaheen Merali

After reading Charles Baudelaire's poem, *To a Passer By*,[1] the Berlin-based philosopher, Walter Benjamin, came upon the concept of Love at last sight in his book *A Lyric Poet In The Era Of High Capitalism*.[2] Baudelaire's poem, was the catalyst for Benjamin to think further about the mundane encounters in the crowded streets of large cities. He furthered Baudelaire's idea by suggesting "The delight of the city-dweller is love – not at first sight but at last sight."[3]

It is this notion of living in cities, which are fast becoming the chosen place for millions of people all around the world, co-habiting, gathering together, working, shopping, travelling, seeing, loving and hating. A gross mixture of emotions reflects the pleasures and desires as well as the conditions, which create feelings of alienation and distrust. Benjamin suggests that the attraction we feel in the city is sometimes a flicker of hope in "the final farewell that coincides [...] with the moment of allure."[4] A brief moment, a glance, an acknowledgment of the place of desire is surpassed by the next event, for the city is like open doors, on entering the next portal, we forget our last encounter.

It is with these two ideas that the first solo exhibition by the Berlin-based performance artist, Nezaket Ekici, (born in 1970, Kırşehir, Turkey) was convened in London; the idea of the allure in the brief glances in the streets around the world and the place of love or desire as a cultural atmosphere. Her performance works are not illustrative of desire nor an estrangement but rather processes – often exhaustive in their duration – that use humour, lots of energy and repetition to create a vision that unfurls a border. Sometimes the performances verge on the painful to watch; absurd encounters but ones that help her to reach a place that she calls her "creative space". She states "I aim to create art where all of the elements are connected together to form an absolute work of art."

The Stuttgart-based philosopher, Andreas Dammertz, has written "Performance is perhaps the only art in our modern Times that is able to describe the fast turning World – Performance, having the same speed as the world today by focusing on the Moment."[5]

1. Charles Baudelaire's poem, *To a Passer By is part of a larger section of his Les Fleurs du Mal entitled "Tableaux Parisiens"*. First published in 1857.
2. Walter Benjamin, *A Lyric Poet In The Era Of High Capitalism*, Translated from the German by Harry Zohn. Verso, 1992.
3. Ibid.
4. Ibid.
5. Unpublished correspondence, between the author and the quoted party.

In these creative spaces many alluring moments can be recognised; secrets are unveiled, fragments released, abject relics confounded, layers of fetish exposed and cultural heritage is disturbed by slapstick. These are the modern times that have no limit to their velocity and maybe it is only snatching the opportunity to encapsulate some of them in the performative realm that will allow us a further understanding of the evolving, revolving realities which we call living. In this way we only have a moment to establish an emotional bond as our muse disappears, seeing it passing by and loving it at last sight. These moments remain as our muse.

The exhibition, *(After) Love at last sight*, presents over 13 years of performance works as videos, accompanied by varying scale of photographic works including *Emotion in Motion* (2000), *Blind* (2007), *Madonna* (2008), *Tube Dolomit* (2009), *Border Inside* (2011), *Human Cactus* (2012) and *Disappear* (2013). The earliest work, *Emotion in Motion*, first performed in 2000, was performed by the artist in the gallery, its residues remaining in the space with a documented video-performance from its latest incarnation. The performance duration was three days, wherein Ekici covered an installed living space, filled with personal objects and accessories with kisses. The trace of the lipstick formed a patina of affection or possibly the veil of consumption that she exposed. The work conveys many layered meanings but what remains embedded in the audience's mind is an act normally associated with love and greeting being twisted into a never-ending moment of torture in her attempt to cover the whole space. A powerful process reminds one of the pain and often duress of love and its universal worship. The walls, the furniture and the clothes all turn lip red, a triumphant memento mori to desire and the beginning of the end of love at last sight.

The influential essayist, Susan Sontag, once wrote "the only interesting answers are those that destroy the questions"[6] and in a further text suggested "Contemporary art, no matter how much it has defined itself by a taste for negation, can still be analyzed as a set of assertions of a formal kind."[7] It is with these two differing notions that I intend to discuss each work by Nezaket Ekici, the two statements require us to think about the place of images as positions or suggest how sometimes answers precede a question. Artistic images are meant to contain content and to be recognised as readings in the contemporary artspeak, a relation built often on unraveling art's cryptic analysis of society. Of course the second quote reinstates contemporary art's ideological relationship to taste, its analytical observations and its demands almost always conveyed in a form to be heard, seen, felt and understood within the 'prescribed' public realm. The prescription is based on understanding narratives, which inevitably makes reference to meaning, whilst the artist

6. Susan Sontag http://www.susansontag.com/SusanSontag/books/againstInterpExcerpt.shtml
7. Susan Sontag, 'The Aesthetics of Solitude' in *Studies of Radical Will*, chapter 1. New York: Farrar, Straus and Giroux, 1969; Anchor Books, 1981; Picador USA, 2002.

often obscures instant recognition by obfuscating the complete meaning, a second formalisation that Sontag refers to as taste or analysis.

Many of the performances by Ekici fall neatly into the second statement for her works are initiated primarily as performances – a set of articulations wherein the artist often remains central to the image and the body its main focii. In many ways when one views photographic images of artists in the modern era, Picasso, Matisse or even Pollock, the photographs depict them with a brush or a stick with charcoal on its tip or a dripping brush aligning the active body/mind to make its mark on a flat surface. The flat surface is where for many traditional artistic practices the image materialises – in the making from the body and the mind an image externalises itself.

In the case of performance the artist and their body remain within the work or often is the work, turning *the making* into the medium. They become the medium and the medium's fluidity helps transcend the borders and boundaries of the studio practice. The studio often expands into the public sphere.

The selected media, the performative, often precludes the presence of the artist and the audience in creating the work. Most performances negate or present the art beyond the object, arriving through its negation into a visually charged space of the spatially cultural.[8] The history of the performance in this way controls how we receive the message as part of its discourse or as witnesses in the space. It constructs particular frames of time and access through memory that profoundly shifts the potential of how we understand or comprehend the context.

In many ways, in its production, performance is the contra-management of our consumption in an image-based economy, often experimental in its demands to be released of the burden of a devolved aesthetic. Performance emancipates and resists those liberal markets that anticipate art as an object, is suspicious of products rather than being a process of observation. Interestingly, other traits of late twentieth century works of art, including installation art, have been ambitious in pushing mainstream art to its limits. This systematic transgression, these ephemeral encounters, displaced as site-specific works, comprehensively and gradually adulterate the hackneyed art dialectal.

In selecting the works for the exhibition, a chronology allowed for some of the above concerns to be presented in the works of Ekici. Her steady ambition to commit to re-performing became a central axis of the exhibition. One of her earliest works, *Emotion in Motion*, first performed in 2000, was selected and, over a period of three days, was carried out in a pseudo living space

8. "You have to love dancing to stick to it. It gives you nothing back, no manuscripts to store away, no paintings to show on walls and maybe hang in museums, no poems to be printed and sold, nothing but that single fleeting moment when you feel alive."
The Dancer and the Dance: Merce Cunningham in Conversation with Jaqueline Lesschaeve,
238 pages, Marion Boyars Publishers Ltd, 2000 (first published 1 July 1991).

organised by the artist. Although the space was sparse and mainly white, its domesticity full of daily accoutrements and furniture, including a ghetto blaster and dresses slung against the wall, all inanimately seemed to be waiting for its owner. Ekici approached the space in a manner suggesting finding a long lost friend, leaning against the fabricated dry walls, often prostrating herself on her knees, spreading her hands outwards to gently kiss its mundane surface. Her loving, intense gesture is repeated and, in a short while, the wall is covered in an array of kisses, from whence she moves onto the sofa, sitting against its moulded seat, then onto the sideboard with photographs of her family, all the while kissing their surfaces. The cushions are soon covered in lipstick stains, the objects turning into fetish. Ekici arches over the chairs, tables and lampshade, extending her mouth as far as humanly possible. Sometimes the kisses are like those on a cheek, gentle and swooning, at other times frigid or maniacal. *Emotion in motion* is an intense, almost great, act of forgiveness that sometimes one wishes would end. After three days it does end – with almost all the room covered in lipstick stains, her mouth in pain and the audience left evaluating their experience of an exhilarating hasty landing.

The second work in the exhibition entitled *Blind*, has only been performed twice; the first time in Stuttgart and the second time at ArcoMadrid. It is for good reason it has not been performed often as it remains Ekici's toughest and most gruelling work. With the aid of an assistant, the artist is covered from head to toe in a thick plaster cast. The only parts of her body that remain uncovered are her arms, one hand clutching a short handle sledgehammer and the other a chisel. As a head-cast is placed over her head and shoulders, the joint begins to dry. The artist hits the chisel placed against the region of her chest with the hammer, in attempting to break out of this semi-mummified state.

It is with every beat on the head of the chisel that we become witness to her survival in this adverse condition. We became mass participators, caught in a relationship between spectators and witnesses. In remaining neither and both, we are included in this spectral reality, aware of her arms flagging under this duress, her power to strike decreasing as she tries to free herself from this entrapment. We are roped into this choking sweating reality, a metaphorical battlefield, questioning the very act of spectatorship whilst understanding the symbolic image of suffocation. We witness a moment that will not let go, an opportunity wherein this feminine body and the convergence of self motivation/ breath / freedom could be forsaken any moment and become a postmortem. Her every slam on the head of the chisel releases her body from this captive state, her life eventually freed by hard effort, as she glides over the remains of her plaster cast into the silenced audience.

The third work in the exhibition has a similar iconographic relationship to the efforts of the artist performing in a confined space, within a process that seems painful in a bid to create a joyous light. In *Madonna*, Ekici stands on a white pedestal, wearing a white satin dress, holding two sticks with candles attached at their ends, stretching over her head, arching at times and cringing with pain she tries to keep a set of 37 candles above her alight.

The protective glasses stop the hot wax entering her eyes, but her arms, her back and her face start to get covered in droplets of wax that land as long as she keeps the candles lit above her head. The thirty minute performance, illuminated by a strong spotlight, disallowing us to escape her every movement, her Madonna moment, is alive with pain as she tries to reach the symbolic sky that lights our World and keeps us warm. There is great strength in this work, strength in her tender act to remain attentive as well as dismissive of the pain displaying the very qualities we mythologically attach to the image of the Madonna. As Sontag had suggested in the earlier quote, Ekici is asserting her formal understanding of Madonna and making it her own version, including the pain and joy of lighting the universe.

The fourth work, *Tube Dolomit*, is one of her recent works with costume; costume not as a canvas but as the most important aspect of the performance. A red satin cocktail dress finally covers her full body, including the head with over 2 meter long sleeves, that she twists and flings from herself into the air. This performance is based on Otto Dix's painting of Anita Berber, painted in the heyday of the Weimar Republic's reign of 1925. The painting was, and sometimes still is, considered to be the embodiment of the femme fatale in the heyday of the twenties; the dancer and actress are painted in a tight, red dress. The cultural significance remained with Ekici and her silent observation created a singular act, committed to wearing the red dress and in a sense consumed by its allure and history. The performance starts with Ekici wriggling into the dress, disappearing within it and the performance reminds us of the celebratory form riddled as the history of art and its particular penchant for the femme fatale figure.

Border Inside, is another performance like *Emotion in Motion*, that uses the mouth and lips as the central site for the work. *Border Inside* requires 11 hours of chewing gum, to make a map of the United States of America against a pane of glass. The action defines the work and the image – in chewing the gum, turning its constituency from a solid form to a greater plasticity, it provides an iconic way to visit one of the United States familiar exports, gum. Although gum has been in existence for thousands of years in North Africa, it is the consumption of all things American, its lifestyle, its products, its culture and its attitudes that Ekici is interested in exploring. In making a map of one of the most known outlines on the world map, she allows us to understand how at ease we remain with its borders and the USA as an image and a cultural form.

The American satirist and novelist, Gore Vidal, once stated "Until the rise of American advertising, it never occurred to anyone anywhere in the world that the teenager was a captive in a hostile world of adults."[9] It is with the encroaching aspects and greater effects on global youth culture that its

9. Gore Vidal, *Rocking the Boat*, Vidal's first collection of essays, gathering many (but not all) of the essays and reviews he had written between 1951 and 1962, 300 pages Published 1963 by William Heinemann (first published 1 July 1962)

boundaries seem porous yet, on an infrastructural level, it remains bounded by conservative values backed by a collective nationalism that has made it more morally indifferent than exceptional as a collection of states.

The penultimate work in the exhibition, *Human Cactus*, is not so much a political project as the stylistic adventure of a determined plant. Ekici, dressed in a fantasy tight dark velvety green dress, high collared and covered in 4,000 toothpicks, walks onto the stage. Holding stones that make an instant desert-scape, she starts to walk with tiny steps to climb into the awaiting terracotta pot. The popular plant is best found domesticated in its terracotta pot where it is watered and grows in a desire for the light of the strong sun.

Ekici mimics the plant's life, watering herself with a cold shower that spills over her head from an aluminium watering can. Her performance literally destroys the answer to the serious question embedded in its Chaplinesque slapstick treatment of our ignorant treatment of nature. She demonstrates the controlling drive to domesticate that which was created to be segregated and independent from our civilising desire to cultivate everything within our reach.

In encouraging us to examine our records in detail, in this case by caricaturing a desert plant found in many suburban homes across the world, Ekici directly speaks to us about the absurd, speculating that in our laughter is a guilt tinged with dead and abandoned lives, both mobile and made immobile.

The final work in the exhibition, *Disappear*, performed in 2013, is a reminder of the poetic desperation expressed by the German poet, Johann Wolfgang von Goethe, in his East West Divan "...finding oneself in eternity, the individual will not hesitate to disappear...".[10] In *Disappear*, the eternity allows us to revisit the Benjaminian notion of the muse in the urban sprawl, its fleeting glance, the loss in the multitude and a sense of one's own melancholic life. *Disappear* finds many symbolic moments as it turns from a vivid boat ride into a macabre mis-en-scene. The performance emphasises choreographic movements of entrapment as the final aesthetic turns into a suffocating end to the sense of time and lack of space that she composes and within which she drowns.

The rise in the obsession with our psychic lives, the perplexing realities of the wounded and serious mediations on our current asymmetry with nature are all part of *Disappear*. The performance begins with Ekici paddling a small plastic dinghy into the middle of a vast, deep lake, where she changes her sporty outfit into a fine dress and a pair of brown stockings, donning a pair of killer stiletto heels, applies a foundation cream and rouge make-up, stares in the mirror and dresses her hair, in a surreal scene reminding one of an East European film. The performance is a portrayal of a character, a desperation

10. Johann Wolfgang von Goethe translated by Martin Bidney, *West-East Divan: Poems, with "Notes and Essays": Goethe's Intercultural Dialogues* (Global Academic Publishing Books).

that had seeped into her relationship to her surroundings. The enclosing waters' depth seems to trigger a desire to change her life's narrative.

The performance is both constructed as a narrative with a beginning and a plotted end and is a description charged with a tense plot, finishing with a casualty. We realise the fate of her frustration as she starts to kick the floating craft, the plastic bouncing back to shape, but as the act gets more violent and the heels of her stilettos become more effective, the water seeps into the vessel.

Eventually it collapses from her undoing its buoyancy and we see the figure drowning in her place, which is both her connection to and disconnect from life.

In *Disappear*, as in other works, we meet the archetypes that Ekici describes so well. Complicated life stories emerge, reflections on life as moments of being. This set of personal mythologies is based on observing the world at the time of the turn of the century. Ekici offers her audience the opportunity to realise in her creative spaces the potential to acknowledge and heal our social and archetypal relationships. These observations granted by muses, the strangers in our everyday that bequeath the twin flames of the imagination with which they grace our lives.

It is in this moment that Ekici's performances make a composite of the after-effects of love at last sight, as Hannah Arendt once said of "directly speaking to each other" and Benjamin had concluded, all other noise is a distraction when confronted by love, even momentarily with what is actually here now! The moment is all and all is the moment.

'(After) Love at Last Sight.....Nezaket Ekici' was originally written by Shaheen Merali for (After) Love at Last Sight, Nezaket Ekici, PI Artworks, London, 12/12/2013 – 15/02/2014. Part of the text from the essay used in the Press Release on http://www.piartworks.com/english/sergiler_cc.php?recordID=127

Marcia Farquhar *The Long Haul*, Palo Alto, June 2013.

Geraldine Harris

I can't believe I had to go all the way to California to see a show by UK-based Marcia Farquhar. Although I met her a few years back, and Marcia is well known and respected by other live and performance art practitioners, I had not previously encountered her work. This is partly perhaps because, as she remarked in the course of the eleven hour durational *The Long Haul*, she has not been 'written about' and further, 'has no archive'. As a result I am not certain how long she has been making work or exactly when (as indicated in *The Long Haul*), she studied at the Slade School of Art. While information on her website refers to work made in 1996, since my guess is that she graduated around the late 1970s/early 1980s, her career as an artist must go back much further.

Marcia arrived at Stanford University in Palo Alto still breathless from the Venice Biennale, where she performed *Acts of Clothing*. *The Long Haul* picked up some material from this piece which she seems to return to and re-work fairly regularly. In fact it was primarily modelled on the 30 hour durational performance she gave as part of the celebrations for the 30th Anniversary of the National Review of Live Art in Glasgow in 2010.

I do not normally possess either the mental attitude or physical stamina for the long haul of durational performances, so I popped into this event, scheduled against an extremely wide choice of papers and other performances, planning only to watch an hour or so; especially since a heat wave rendered the venue extremely hot and stuffy. Unexpectedly, I found myself making it the focal point of the day, so that even with frequent breaks I must have seen around half of it and still have lingering regrets over the parts I missed.

Marcia sometimes describes herself as a conceptual artist, sometimes as a 'confabulist', which actually amounts to much the same thing but this latter seems more apt to me because it sounds more entertaining. *The Long Haul* was unquestionably a 'confabulation'. Basically, although she made various incursions into other activities (dancing, showing a short film about an earlier performance, reading out the opening scene from Beckett's *Happy Days* and an article about sleep) for most of the eleven hours (the span of her plane journey to California) Marcia told stories. These were autobiographical and prompted/illustrated by articles of clothing from her distinctive 'retro' wardrobe, or the various other props (books, photos, make- up, a sheet, torches, e-cigarettes, and her collection of vinyl '45' records) that she brought with her.

I missed the very start of the show when apparently she played the Sex Pistols' version of 'God Save the Queen', and when I entered the space she was wearing a tartan flamenco dress in honour of her Scottish/Spanish heritage and speaking about family Christmases when she was growing up. Amongst other

things, this focused on an exuberant aunt whose husband was decapitated in India, and this story thread climaxed with Marcia giving a demonstration of her (very) untrained version of the flamenco; a dance she says, particularly suited to older women.

Over the course of the next few hours family stories continued to feature alongside tales of encounters with strangers at the dry cleaners or on the bus, or stories relating to people she met growing up in her mother's boarding house in London's then more genuinely 'bohemian' Chelsea of the 1970s. These figures include David Bowie, Jonny Rotten, famous psychiatrist R. D. Laing, various faded and fading actors and actresses, including one bed bound ex-film starlet who passed her days smoking and drinking whisky and looking at her cuttings. These stories in turn opened up onto those involving other stars such as Vivian Leigh and Ava Gardner, who I am not sure Marcia *did* actually meet.

Marcia admitted that some of the material has been planned while other parts are more spontaneous and reactive. For instance, despite stating several times that she dislikes 'audience participation', the format of the show was affected by the movement of the spectators as she stopped to greet them as they entered the space, get them up to speed on the substance of the particular anecdote she was telling, or said goodbye as they left.

Similarly, although several times she insisted that she is 'dedicated to a punch line', these tales unfold by means of numerous diversions, digressions and distractions, producing shifts of emotional registers between the comic, the tragic and the bathetic, piling up a mass of detail but leaving some information hanging, assumed or mentioned fleetingly in passing. This provides a sense of contiguous connection between these stories, and simultaneously, one of dizzying uncontrollable complication, and this is re-enforced by the process of coming in and out of the show.

This 'story so far' technique used when new spectators (or returnees) entered the space actually left a keen impression that something interesting and vital has been missed but as exemplified by these episodes, more than anything else it was Marcia's relation to the audience which provided a structure to the piece as a whole.

However, there were also some running 'themes' that emerged at least for parts of the day. In the morning she declared that she wanted to 'recalibrate hope' and this seems connected to issues of mental health and to the challenges of the (gendered) process of aging (the long haul?). Marcia, who has recently gone Monroe-style bottle blonde, clearly has no intention of fading quietly into the scenery with the on-set of middle age, or even at her most low energy moments during the course of this show. She is rightly annoyed to have been described in an otherwise positive review of her Venice performance, as 'bustling on' because this implies the opposite of her charm. Encapsulated by the quality of her wonderfully rich, gravelly voice and cut glass enunciation, this arises from the fact that like many of the figures in the stories she tells,

she exudes a highly theatrical glamour combined with a certain vulnerability, exacerbated in this case by the physical demands of the piece. Much of her material suggests a keen (and 'queer') pleasure in the superficial ruses and artifices of femininity, and she hints that in the past this has made her less than popular with certain types of feminists.

Yet, what I think actually makes her compelling as an artist, especially a *woman* artist (a figure so often historically trapped and constrained *by* femininity) but perhaps challenging to some feminisms, is that as signalled by her playing of the Sex Pistols at the end as well as the start of the show, she *also* exudes a sense of potential for anarchy. Notably, during the show Marcia sets up 'rules' (about the promise of a punch line, audience participation, or anonymising the names of people she discusses who are still living), and then proceeds to break them. In fact the persona that comes across in *The Long Haul* is one that is highly sensitive to others but who not so much *refuses* to play by the 'rules' of conventional behaviour (whether these are general social conventions, or those of the art world, or of 1970s and 1980s feminism, or indeed of autobiography, which is after all an attempt to impose narrative order on the chaos of our experience) but simply does not recognise them in the first place.

This is a source of her strength and glamour *and* of her vulnerability, and means that while there is little in the show that could be deemed shocking or transgressive, despite her warmth and humour, it is never 'safe' or 'cosy'. Rather, there is a feeling that she is dancing on an edge which at any moment she might step over, taking us with her into something even more chaotic and perhaps much darker, yet liberating. It is this sense of a tension on the brink of getting swept away to somewhere else in this eleven hour torrent of words that kept me watching and coming back to this fabulous confabulist throughout the long hot day in Palo Alto.

Geraldine (Gerry) Harris is Professor of Theatre Studies at Lancaster University. Her books include *Staging Femininities, Performance and Performativity* (1999), *Beyond Representation: The Politics and Aesthetics of Television Drama* (2006) and co-authored with Elaine Aston: *Feminist Futures? Theatre Theory, Performance* (2006), *Practice and Process: Contemporary [Women] Practitioners* (2007) and *A Good Night Out for the Girls: Popular Feminisms in Contemporary Theatre and Performance* (2013).

'Marcia Farquhar, *The Long Haul*' was originally written by Geraldine Harris in *Drama Queens Review*, 12 July 2013, http://dramaqueensreview.com/2013/07/12/marcia-farquhar-the-long-haul-performance-studies-international-2013-stanford-university-june-2013/

In Bed with a Domestic Extremist:
Mental, the vacuum cleaner, and Me

Maddy Costa

PLEASE NOTE: The following gives away an awful lot about about the vacuum cleaner's work *Mental*, which he's touring into 2014. If you'd rather experience the show knowing nothing, or at least with its surprises intact, it's probably not a good idea to read it until after you've seen it. Thanks.

We shuffle past the closed bedroom door, neatly lining shoes along the hallway wall, to a small, neat living room decorated with insurrectionist art and fabric owls. A cheerful, kindly woman offers tea and tiny carrot cakes, primly arranged on a tiered stand, and though the atmosphere is relaxed, an awkwardness hovers, as though we were gathered for the wake of a distant relation and weren't quite sure what our demeanour should be.

The bedroom, white with pistachio-green trim, is sparsely furnished. Disco sings sweetly from an old-fashioned record player. We snuggle against the wall beneath a giant duvet and slowly a hand emerges from the low bed before us, fingers wriggling as they test the air. Then a face, nervous but smiling. The body is very much alive: it's important to remember this, that we're beginning at the end, with James sitting with us, talking to us. We cling to this fact as his story unfolds.

<p style="text-align:center">*</p>

"I've never done anything like this before in my life. Never made a 'show'. It was a real experiment to try and do it. I'm more comfortable with it now. I've kind of gone, yeah, I spent nearly two years making this thing, I should show it to people."

Ten days before seeing *Mental*, I meet up with James-the-vacuum-cleaner-Leadbitter in his basement studio in the Artsadmin building, a square concrete room that might feel like a prison – the one small window is high in a corner, and barely lets in natural light – were it not for the homely clutter and art crowded around the walls. One painting, hanging above the two desks, stands out: a rectangular canvas, painted gold, with the words "Representative art is so 19th century" printed on it in stark black helvetica. In the corner opposite the window, a duvet is crammed in the space above a storage cupboard; beside the door sits the old-fashioned vacuum cleaner from which he takes his pseudonym. He rolls out a folding table for our tea; I sit in a black office chair that insists on spinning me away from him. He laughs: "That's my producer's chair. It's like: get back to the computer, get back to work."

Leadbitter started making work in 2003, shortly after his first stay in a psychiatric hospital. "The very first piece I did was called *Cleaning Up After Capitalism*: I had the vacuum cleaner, and wore a yellow bib with 'cleaning up after capitalism' on the back, and I'd go into public spaces or corporate

spaces, like chain stores, or the City of London, and do a cleaning act. I'd clean and engage people in conversation. A lot of my work was straddling performance intervention with direct political action." A lot of it landed him in serious trouble, too. In 2005, he was taken to court by Starbucks for a number of transgressions against its brand, which included defacing Starbucks coffee cups so the logo read "Fuck off" and setting up a website encouraging others to do the same. It's worth reading the "decision of independent expert" document commissioned as part of the case: Leadbitter's irreverence offsets the corporate humourlessness beautifully.

His protest came from a place of boredom: "I got bored with mainstream activism, I got bored with marching against the war in Afghanistan." And from cultural discussion around branding: "*No Logo* came out in 2001 and that was really influential. I started to read *Adbusters*, the Canadian magazine, and fucking around with billboards. Graffiti and street art really influenced me, that thing of: don't wait for the audience to come to you, take the work to the audience, go to the community and present your work to them, go to the contested spaces and make the work there. That always got me really excited."

But beneath the global-political was the local-personal. "Having gone through the psychiatric system, which felt very oppressive, often it was about creating a space of liberation through these performative acts. I often would look at advertising and feel really alienated, so it would be reacting against that, or challenging that kind of dogma. And I guess I was at a point in my life when, I was 23, I didn't really give a fuck about anything. Not I didn't give a fuck about *anything*, some things I really cared about, but I wasn't necessarily concerned with what would be the consequences of what I was doing. Also, the medical treatment that I'd got really didn't work, so this became my way of trying to make sense of the world, and make sense of these experiences I'd had in treatment and as a teenager."

In some ways, teenage Leadbitter was typical, at least of people who end up working in theatre. "I went to a really great youth theatre in Burnley, so I had that bug from an early age. I used to run tech for the whole youth theatre; my mum wanted me to be an actor but I preferred doing design." When it came to university, he opted for set and lighting design at the Central School of Speech and Drama: what a mistake. "I hated it: it was really conservative, and I should have gone to Dartington with my friend Robert." He dropped out after a year. But it wasn't just the course: the depression he'd started experiencing before university was worsening. He was already self-harming; now he was suicidal. And this is where *Mental* begins.

*

There were so many possibilities.

Running in front of a lorry.
Jumping off the roof.
Pills. Knives. Rope-lengths of fabric.

He tells us these stories surrounded by heavy wads of paper, piles and piles of documents, medical assessments, police records, obtained via the Freedom of Information act, each portraying a version of James Leadbitter, the slight man with tufty hair, twinkling eyes and an electric-blue dress scooping from his shoulders, who sits in his bed, in his own bedroom, sharing an outsized duvet with his audience. One by one he slips plastic sheets on to an overhead projector and reads from them the evaluations of doctors and nurses, the clandestine comments of police and their spies. If you're quick, you can read outside the highlighted sections, get a fuller picture. I notice with a catch of breath his birthday: 29th May, five days before mine. Fractured personalities written in the stars.

I don't remember all the details of the life he narrates – it's a few weeks since I saw the piece, and the intimacy of the environment precluded taking notes – but I remember vividly his demeanour. He has the campness of a late-night-telly light entertainer; the roguishness of a small boy doing something he knows he's not supposed to, face sparkling with pleasure in transgressing and being witnessed in his transgression. The line between performing himself and being himself is subtle, and will shift according to the perception of individual audience members: I feel he stands one side of it at the beginning, when he's talking himself into starting the show, the other in the fleeting moments when overcome by a memory of cruelty, or kindness. His inability to comprehend his treatment at the hands of powerful social institutions is ongoing and genuine. But always there is this levity in his narration, which comes from a place of generosity, a desire to support his audience as we listen and absorb.

The disco soundtrack, soft and radiant with love, gifts more lightness. One song repeats over and over:

Love is, love is the message that I sing to you
Love is the message that I bring to you

The contrast of that care with the official language of the documents is sharp. Here, Leadbitter is a number, a sequence of actions, a list of medication. His humanity is bypassed. Frequently *Mental* feels like a work not of individual autobiography but of exposure, indicting a society that practises institutionalised betrayal. No one who works at the hospital where he is first sectioned tells Leadbitter that it specialises in treating personality disorders. The more successful he becomes as the vacuum cleaner, the more rigorous and resourceful the police become in inhibiting his activities. It's not until he recognises a face on Channel 4 that he can explain this feeling of being targeted: the groups with whom he has been working have been repeatedly infiltrated. The police documents are packed with personal information: address, identity numbers, hidden distinguishing features such as the tattoo on his back that reads "our civilisation is fucked". They got that one wrong, says Leadbitter, mouth curled in a sardonic smile. He turns around, pulls up his frock; the light catches on the letters carved into his skin: "THIS CIVILISATION IS FUCKED".

*

"People talk about mental illness as this monolith, but it's as broad as any other – schizophrenia to anxiety is what cancer is to a common cold. It's not comparable, but, you know."

At the age of 19 – he's now 33 – Leadbitter was identified as experiencing multiple mental health problems: depression, general anxiety disorder, panic anxiety disorder. More seriously, he was diagnosed with borderline personality disorder. Only no one told him. "It's quite common if you have what's called a serious mental illness, so things like paranoid schizophrenia, borderline multiple personality disorder. For a long time they wouldn't tell you because the stigma of the diagnosis could be as bad as the actual diagnosis. I get that, but for me that's not the issue: the issue is how you inform the patient." He finally found out about two years ago, at the end of an assessment process, when he was handed a sheet of paper with his diagnosis and sent on his way. There's a painfully funny scene in *Mental* when he pulls a copy of *Borderline Personality Disorder For Dummies* (it genuinely exists) from under the duvet, one of many books he bought when trying to make sense of this new information.

Essentially, he was being medicated for a condition he didn't know he had, and that, says Leadbitter, "was really destructive. Because by the time I was 26, I'd got a job at the Royal Scottish Conservatoire in Glasgow, I was in a relationship, but I was still completely undiagnosed, and all of that crumbled in my hands. I totally destroyed it all because I didn't know what was going on. I didn't have the language to talk about it, couldn't reflect on it, you know?" He moved back to London and attempted to reconstruct his life, "in a way in which I could cope. I developed all these coping strategies, smoking a lot of cannabis." But they didn't work, and in 2009 he had a relapse and was back in hospital.

Acquiring and reading through the thousands of pages of medical notes written about him over that 14-year period has been "one of the hardest things I've ever done". Did he recognise himself in the descriptions he encountered? "It's really different. Some bits you're like, yes, that's so correct, and then other bits you're like, what the fuck are you talking about? *Who* are you talking about? It really depends on the person you're talking to, because there isn't necessarily a test for it, it's not like you can do a blood test and be told, you have bipolarity, it's so much to do with your own representation of your experiences, how you talk about your experiences." Which might be different on any given day, I note. "Exactly. Some days you can't even speak, and some days you're spilling rather than sharing."

I ask if there's a family history of mental illness; there is, but, he emphasises: "I don't buy that [mental illness] is just genetic or it's just social. I have a very strong attitude that anybody that wants to apply a simplistic model to mental health is getting it wrong, because it's infinitely complicated." Talking therapy – of which he is a staunch advocate – offers a brilliant insight into those complications, he argues. "Although it is utterly, utterly painful, and quite horrific at times, it's also a wonderful process of discovery, not just in terms of yourself and your mind but how that relates to the world that we live in and

how society functions. You learn that everything is so utterly complicated, there are no black-and white-situations."

<center>*</center>

The lights dim and Richard Hawley's voice, comforting as a sheepskin coat, croons in the darkness:

Roll river, keep on rolling
Ancient lady cold
I'm forsaken, lost and forgotten
Roll river roll

In James' bedroom, watching a shaky film of a tiny, adored figure walking in the middle of the street in a Glasgow full of snow, I absorbed *Roll River Roll* as a love song; it's only later, reading the lyrics, that I realise it's the ballad of a man about to drown. James' description of his post-relapse suicide attempt is delivered lightly, with a tender solicitude, for himself and his audience, but with every accruing detail it becomes harder to hear. He mentions the carrot cake he bought for his final meal and I remember eating mine before I came in and want to cry. He shows pictures of his room in the hostel he moved to after leaving the hospital, a safe house for people at risk of suicide, remembers the night in the kitchen when he had to resist the siren call of the knife drawer, and was held by a warden whose non-judgemental understanding cracked the ice of his benumbed soul, and we all want to cry, James too. Always there is the knowledge that he is here, telling us these stories; he survived and continues to survive. But it's the overwhelming awareness of the pain he has experienced that makes *Mental* so difficult to sit within. That, and the fact that he relives it, in front of an audience, night after night after night. That in itself feels like a kind of self-harm, and I don't know how he can do it.

<center>*</center>

"In the three hours leading up to the performance, it's very like, 'Am I really about to share all this stuff? Why am I doing this?' And then I start and do the show and afterwards I feel really icky."

One of the things I like about following the vacuum cleaner on Twitter – aside from his ongoing campaign against mental-health stigma, embedded in our culture in the abuse of words like mental, crazy, bonkers, nuts, which he attacks with weariness, fury and sparks of dry humour – is that every now and then he'll have a sharp little dig at conventional theatre. He looks a little shame-faced when I bring this up. "I'm not a big fan of what I call theatre-with-a-capital-T. I guess I struggle with a lack of legitimacy in a lot of these things: when you've been in a psychiatric hospital, you go to the theatre and, like, this doesn't compare. When was the last time you saw a mad person play Hamlet? And how amazing would that be? So yeah, I do bitch about it quite a bit.

"It feels like theatre hasn't quite caught up with visual-art theory, you know? Visual art has very much abandoned representative practice, but theatre is still wrapped up in that. When I do go to a theatre and see the things that I really love and get me excited or angry or upset, it's people speaking about their

personal experiences, like Kim Noble or Bryony Kimmings. The first time I saw Franko B – and we've worked together a bit – it really hit me: it wasn't just this pretending, it was very, very real. I can relate to that on a very personal level, but I also like that immediacy."

When performing *Mental* in cities other than London, Leadbitter always aims to find another bedroom to house it. His one experience of staging it in a theatre venue has confirmed to him how important that is. "I did it at the Tramway in Glasgow a few weeks ago, that was to 50 people, and it was really difficult. I don't think it ruined it, but it did change it quite a bit. I had to extend the range of my performance, some bits had to be a little bit bigger. At home I can be quieter, I have that real intimacy. It changed it for the audience, too: there's this bit in my story about the police coming into my bedroom to take me into hospital, that's much more significant when it's in my own bedroom."

The decision to stage *Mental* in a bedroom rather than an open social space like a theatre also demands that the audience travel somewhere unfamiliar – in my case, in the dark and on my own, which always generates mild anxiety in me. "There's a slight challenge in there," Leadbitter agrees. "That's something I found doing the show in Latvia, at this amazing festival called Homo Novus. A lot of people were coming to me afterwards and saying: 'I was really frightened about coming to see your show, I was going to be in this bedroom with this crazy person, the police say he's a domestic extremist, I was frightened! And then it starts and you just destroyed that thing immediately.' I hadn't really thought about it like that at all." But that's wonderful, I say. "It is! And it's nice to challenge that preconception of mental illness as well."

It was the second hospital stay that encouraged Leadbitter to reconsider his work, and made *Mental* possible. The difference, he says, was that the breakdown: "was really public. I was doing this big commission with Artsadmin, I had to drop that. That was really difficult, because I felt like I was letting them down. And I was Tweeting about it a bit at the time. It was this thing of going: this is so fucking intense for me. I was very close to dying on a few occasions."

"Actually, this is something that's really amazing: for me and a lot of my crazy friends, we all say this is our civil rights moment. A lot of us talk about coming out of the closet. It's this thing of going, fuck it, I'm not hiding this any more. So although it was very difficult, it had some positiveness to it. And it really changed the direction of the kind of work I was making. Also – I found this doing the *Mental* piece – coming out and going, OK, this is the shit I have to deal with in life, you get other people going, yeah, I can relate to your experiences, and these are my experiences. That solidarity is so, so empowering. When somebody says, I know what that's like, and you know they know what that's like, you go: OK, I'm not on my own, this person can genuinely relate to me."

"The language that people use is really, really different to when you're in hospital and you say to the nurse, I don't want to continue any more, I can't take it any more, and they say, we're going to help you get through this. The response is so different. It's little things like, I said to somebody I really want to self-injure, and they were like: have you tried putting elastic bands around your wrists? When you really want to do it, pull them really hard and flick them against your wrist. I tried it and it was great. Or I'm having a panic attack on the ward and an old guy comes over and calms me down in 10 minutes, no drugs, sat with me, held my hand. It's a really beautiful and amazing thing to have that solidarity and mutual care. More of that please."

Increasingly, his work seeks to create places in which solidarity, empathy and empowerment can flourish. Many audience-members have commented that they could do with sharing the cup of tea after *Mental*, rather than before, to decompress after inhabiting such an intense space; Leadbitter understands that need, but asks his audience to leave directly after the show, because he too needs space to look after himself and decompress. (This isn't a hard-and-fast rule, and compassion is exercised: the night I saw it, one member of the audience was so affected they left the bedroom, went straight to the bathroom and burst into tears; they were then allowed to stay in the empty bedroom until ready to face the night.) As quoted above, performing *Mental* makes Leadbitter feel "icky"; what pulls him through is the audience response, not in the room so much as in conversation, on email and on Twitter in the hours and days afterwards. People open up to him about their own experiences with depression, doctors, anti-depressants; they ask his advice; they tell him: "I can relate." In Latvia, he says, "a 19-year-old woman came up to me after the show and said, 'I've never said this to anybody, not even my parents: I have a psychiatrist. I've never told anyone and I've seen your show and I'm not embarrassed any more.' For all the difficult it is for me to do the piece, for that one person, I'm happy."

Prior to *Mental*, he made a piece called *Ship of Fools*, in which he turned his flat into a hospital for a month and sectioned himself. "The *Ship Of Fools* will function as an inter-section between mental sanctuary and creative liberty," he explained on his website. "As part of this time the vacuum cleaner seeks creative residencies at the *Ship Of Fools*: both artist and non-artists alike in an attempt to find creativity in madness." His next project takes that idea much further. "It's called *Madlove – A Designer Asylum*. I'm a big believer in the notion of an asylum, a safe place to go to experience madness, but it's going to be an asylum designed by mad people for mad people to experience madness in a more positive and less painful way. We're going to bring mad people together and people that work in the mental health industry, or people that are carers or that support people, and say: right, because psychiatric hospitals are so oppressive and so difficult to be in, let's redesign it completely. Let's think about what we need to go through this experience. It's still going to be painful, but let's change it. My producer has this really wonderful statement: it's putting the treat back into treatment."

I can't wait to visit.

*

Seeing *Mental* had and continues to have a profound effect on me. It's affected how I watch theatre: a few days after I was in Leeds and happened to catch the James Brining production of *Sweeney Todd* at West Yorkshire Playhouse; its first scene is set in an asylum, and it looked exactly like the asylum in Joe Hill-Gibbins' Young Vic production of *The Changeling*, right down to the individual gestures of the actors. I left at the interval, unable to watch any more, feeling no connection with what I was seeing. At the end of November I caught up with Hannah Silva's *The Disappearance of Sadie Jones*, a taut three-hander about a woman whose depression has led to anorexia; there was much about it, not least in the breakdown of language, that felt insightful, and yet part of me was troubled by the aestheticisation of this experience, particularly in a scene when Sadie kneels on a cabinet and slowly wraps a red chiffon scarf around her waist and wrist, delineating self-harm. In that moment, honesty was replaced by theatre.

Much like Chris Goode's *God/Head*, *Mental* has made me reconsider what it means to be honest. Now and then people commend me on the honesty of my writing and I feel quietly fraudulent, because I hide as much as I reveal. I come from a very old-fashioned culture that believes fundamentally in putting up a front; much as my family rail against its hypocrisy, it's coded within us and that's a hard habit to break. But it's also typical of me to interiorise everything: keeping a blog has been extraordinary in that respect, in reminding me that self-expression isn't just possible but OK.

Increasingly I'm interested in what it means to invite someone to listen to the voice that rattles around your own head. A lot of the work I've really cherished this year – *Mental*, *The Worst of Scottee*, Laura Jane Dean's *Head Hand Head*, Peter McMaster's *Wuthering Heights* – in some way or another does exactly that. *Head Hand Head* (which Chris Goode helped in shaping) really touched me: for maybe 40 minutes, Laura enacts the different obsessive compulsive routines that she has adopted over time to cope with the paradoxical trauma of being so terrified of dying that you're afraid to be alive. The voice that speaks to us is the same voice she hears inside her head. It felt like a privilege to be given access to something so private.

Mental felt like a privilege, too. I left it feeling intense gratitude towards James, for sharing his internal voices with me. I heard enough of myself in it that I've been galvanised into doing things I hadn't previously thought possible, into engaging in conversations that I hadn't previously been able to contemplate. The narrative of struggle, or not being able to cope, is still expressed so rarely that people are startled by it, or react negatively to it: we need to work together to support its honest expression, and through that change the social conditions that make struggle and the inability to cope so much a part of our lives.

*

"Do you feel in control?"

He shakes his head. A barely audible whisper: "No."

"What could be done for you to feel in control?

There's a small pause. "Well, I think that the art world needs to get a bit real about supporting disabled artists. Artsadmin are phenomenally great at it but I feel that a lot of the time me and my producer are really having to fight for the support I need to do the show; we're having to say: 'This is why it's going to be a bit more expensive, because somebody needs to help him and look after him.' So that could be better."

"Not being attacked by the state for being disabled would be a help: I'm going through the Atos process at the moment – Atos Healthcare are doing the whole welfare reform process – so I'm having to defend my benefits, it's really anxiety-provoking and the stigma is still really horrific. I've been assaulted coming out of the hospital, people have attacked me because I'm coming out of the psychiatric hospital. Casual use of the word mental, or the casual use of the word crazy, it hurts, it hurts when I hear it, so that's still difficult. It's difficult to have to go: listen, I don't want to be aggressive or assertive about this, but can you not use that word around me because it hurts.

"There are some really amazing people out there who get it. Without Gill Lloyd [co-director of Artsadmin], without Lois [Keidan, co-director of Live Art Development Agency], I would have stopped making work three years ago. Gill has fought, she's said: 'James, you need to keep going; I'll help you write an Arts Council application because you can't even read at the moment; if you've nowhere to go, sleep in your studio, don't worry about the rent, it's fine.' I was going to get kicked out of the homeless hostel I was in and the fact that she would stand by me and write to the council and say, 'You can't do this to somebody', that is phenomenal."

"The way I describe it to some people who I feel don't quite get it is: 'Imagine you're doing a show in a building and it's not wheelchair accessible, you wouldn't say to the person in the wheelchair, you need to build your own ramp to get into the building.' But often that's what happens to me: often, I have to explain that I need to bring two people with me, one to look after me during the show, one to look after me outside; I need a quiet dressing room because when it's noisy I'm going to have a panic attack."

"That's part of the battle and I'm prepared to fight for that, because it's not just for me: it's for every person who has a mental illness."

'In Bed with a Domestic Terrorist: *Mental*, the vacuum cleaner, and Me' was originally written by Maddy Costa for the blog *Deliq.*, 5 December 2013, http://statesofdeliquescence. blogspot.co.uk/2013/12/in-bed-with-domestic-extremist-mental.html

Working with stories of other people's traumatic experiences: Questions of responsibility as an artist

Dominic Thorpe

Through a process of self-questioning and reflection, artist Dominic Thorpe considers some of the responsibilities of the artist when working with stories of other people's traumatic experiences.

I sometimes make artworks dealing with other people's personal and traumatic experiences, including mental and physical ill-health, and various human rights abuses, often through direct engagement or collaboration with them. Doing this work feels important for many reasons, not least because art offers possibilities to open up necessary, wide-ranging and honest forms of interaction and discourse where existing forms can be narrow. I attempt here to articulate some of my thinking underpinning this element of my practice, and in so doing identify what I consider to be some of the responsibilities of the artist when working in this way.

Questions I regularly ask myself include: What right do I have to make artworks dealing with other people's difficult experiences, and why do I want to, given that I have not experienced such trauma myself? What and who is the work for? Is it needed? What will it achieve and are the outcomes quantifiable? What's the point if little or any change is generated reducing the numbers of people who have these experiences? If I don't make the work am I complicit in silence and therefore contributing to the problem? Taking chances and failing are important to discovery, so how can I work in ways that enable the freedom to create and discover while also being cognisant of possible significant consequences failure may have for other people?

It is important to try to understand how artworks can function in the communicating of such stories, because the risk of objectifying people only to benefit from their difficult experiences is very real, as is the risk of not realising that's what could happen. I don't want to have somebody else's story become only a source of entertainment. It is also important to acknowledge I have no ability and no desire to feel someone else's actual pain or distress, and I don't pretend to do so. Nor do I want to give an audience the impression that they will be made feel this way.

What is it about engaging with another person's story through an artwork that can offer a potentially more resonant experience than other means of encountering stories, such as being confronted regularly by tragic stories and images through the media? For me, experiencing a particularly affecting artwork can result in the internalising of another person's story in such a deep

and personal way that a connection is created with my own life experiences, thoughts, ambitions or emotions. In this way, artworks put us in the picture even as audience. They can force us to acknowledge our connectivity with each other's lives making it difficult or impossible to sustain a position of detached observer. When we gain more awareness of our individual positions in relation to the lives of other people, there are two obvious choices – to keep or change those positions. This gives art an important role when trying to understand and deal with systems of care, human rights abuses and personal tragedies.

I have a responsibility to collaborators, audiences and myself to be clear about my motives and ambitions for working in the way I do. The development of my own understanding is always central. I also try to become more personally connected with individuals and situations that cultural norms and social structures (such as the asylum services and our attitudes towards mental health) can keep us separated from. There may be many spoken and unspoken expectations and desired outcomes that all collaborators in an art project have. Trust is important and can be built through regular conversations and interactions where people develop a sense of what each other needs and feels. I have worked with people who wanted their friends to stop killing themselves. People who wanted to develop understanding about a particular subject. People who wanted their story to be told and heard. People who wanted to learn about more about art or just wanted something to do. People who wanted to access other sources of funding. People who wanted to stop feeling helpless. People who wanted to support others who may be going through a similar experience as themselves. People who didn't know what else to do.

Audience members also need to be considered as they may be affected by artworks for many reasons, including the actuality of their own lived experiences, and through empathy or compassion. I never aim to upset, but I realise this is a strong possibility given certain subject matter. Supporting an audience is important and clear publicity material, good and visible information wherever the work is shown and invigilators who understand the content can all help with this. Such mediation however should not be prescriptive to the point of diminishing the space for an audience to be surprised and to generate their own meaning from encountering the work.

Underlying all of this is a responsibility, inherent in art practice, to strive for artistic integrity and quality. Poor artistic merit must not be allowed to become a reason for people to ignore important subject matter. The artist, and their collaborators, also have to live with what they do. Of course many other questions could be asked and reflected upon seriously, including questions about representation, levels of collaboration, authorship and ownership. It has been my experience that informed and thoughtful enquiry in to how and why I work in the ways I do is crucial for supporting the development and integrity of whatever happens in my practice.

On a final note, making work in this way can be personally very taxing and emotionally draining. Showing and talking about work to colleagues in the arts is important and always helpful. Sometimes art projects result in visible changes and that is immensely rewarding. It can, however, be difficult to reach the end of a project only to find that little if anything has visibly changed. But that doesn't mean it was pointless. Small things do happen and small things need to constantly happen. They can surprise and transform, and at the very least they are what create the conditions for transformation.

'Working with Stories of Other People's Traumatic Experiences: Questions of Responsibility as an Artist' by Dominic Thorpe was commissioned by and first published on www.artsandhealth.ie in 2015. See www.artsandhealth.ie/perspectives www.dominicthorpe.net.

Outside the Box: Rethinking how Museums present Disability

Richard Sandell and Mat Fraser

Richard Sandell and Jocelyn Dodd, from the Research Centre for Museums and Galleries (RCMG) have been working closely with artist and performer Mat Fraser for the past two years. The research-led collaboration, supported by the Wellcome Trust, recently culminated in a series of cabaret-meets-lecture museum performances called *The Cabinet of Curiosities: How Disability Was Kept in a Box.*

A heady mix of research, visual culture, songs and an inspired rap, the performances explore the role that medical thinking and practice has played in shaping attitudes towards differences, and aim to challenge the way we think about disability.

Richard Sandell

Jocelyn and I first saw Mat live in 2005 when his show – *Thalidomide! A musical* – was on tour. Sitting in the audience, we experienced a powerful mix of emotions. We learned a lot about the story of thalidomide and along the way we were discomfited, shocked and angered. We also laughed.

We laughed a lot. After the show we sat in the bar listening to other members of the audience talk animatedly about the performance and we reflected on the marked differences between Mat's treatment of the subject matter and the way that a museum might typically tell the story of thalidomide.

Where museums have tended to be measured and cautious – anxious to present material in a balanced, often dispassionate way – Mat's approach was imbued with emotion, flagrantly personal and highly political. However, like museum presentations, it was also grounded in rigorous research. It was compelling, provocative and utterly memorable.

At that time our research was very strongly rooted in museum practice and although our topic was novel, our approach was largely tried and tested. We had become interested in understanding why disabled people – sometimes referred to as the largest minority – were largely absent from museum narratives. Why, at a time when museums were increasingly trying to represent more inclusive histories, was engagement with the history and culture of disability rarely tackled?

We set about investigating museum collections and were amazed by the volume and variety of objects and artworks we found – material that was strongly linked to disability but very rarely presented in a way that made those links visible.

Over time our research practice has become increasingly concerned not simply with understanding this phenomenon, but with effecting change – both in how museums present disability and in unlocking museums' potential for changing the way audiences (and society more broadly) think about disability. It was this ambition that led us to approach Mat in 2011 to explore the possibilities for collaboration.

Mat Fraser

When I first met Richard and Jocelyn, I was not even remotely familiar with the way museums approach their exhibitions. I did have a familiar sense of not belonging – feeling as if my perspective of being a disabled person was totally absent whenever an artefact to do with disability was presented in collections and exhibiting presentations. Museums, like many mainstream environments, don't show us as we really are, or were.

When they asked me to think about doing a show about the re-presenting of disability in museums, although it was very much outside of my experience, I jumped at the chance.

Both Richard and Jocelyn were and are clearly very at ease with all of the politicised and socially concerned aspects of disability, and have a comfort around the entire subject that is rare to find, certainly in such professions. So of course, when I started to do the actual research in the archives of the project's partner museums, I expected to encounter a more reticent, conservative and fearful ignorance, from both artefacts and staff.

Instead what I typically found was a rigorous enthusiasm for uncovering the past, redressing the medicalised past ways of disability representation, and an almost relieved excitement that their museum was taking part in this project. That they were medical and scientific museums made this all the more surprising, and welcome.

The biggest surprise in my discoveries was how many artefacts there are in the archives that don't just speak about disability; they veritably shout about them. Looking at all of these sometimes incredibly illuminating objects from the past kept focusing me on the general job at hand. I increasingly came to see this as helping people – the public, disabled people, museum curators, managers, medical students, doctors, scientists, everyone – to understand why things need to change, and to illustrate ways in which that might be possible (in a hopefully non-threatening way).

Thankfully, there was much evidence from previous museum experiments in this area to bolster and inspire what I was saying. My overall job was both brilliantly supported by the previous research and writing, and enormously helped by the enthusiasm from the curators and museums staff I was working with.

I still found it a challenge, and it really did help me develop as an artist, expanding my practice and reconnecting me with levels of academia I'd almost forgotten I could do. It also greatly expanded my demographic for audiences, but when all the dust settles on it all, what remains is the actual reality in society that these improvements are painfully overdue and that we need to keep working in this field to get the work done. It's something I hope, within the capacities of what I do and beyond them, I can be a part of.

Anatomy of fall ing

Amy Sharrocks

While thinking about falling, I fell over. I don't mean tripped or bumped, but properly crashed to the ground, hurting myself. It is still fresh months later, that awful feeling of falling, not just a little off-balance, but really out of control. I have seemed to live through the different stages of that fall many times since then... the excited run before, the trip, that elongated feeling of falling, the crash itself, followed by a pause to check everything was alright, then the feelings of shock and recovery. Quickly it became clear how much falling and failing get mythologised, romanticised as sites of potential, when they can hurt drastically. It also seemed to reveal an awful power in falling, a lure. It exerts a pull, alongside gravity, the question of 'what if...', to which we can occasionally be brave enough to respond.

Falling deals in the precariousness of life. More than that, it invites the risk in to our fragile bodies. It presumes a willingness to be vulnerable in the face of others' uprightness. It is a rehearsal for falling into death. There are many daily rehearsals: falling asleep ("I was just dropping off"...), or letting go of sentences, our meanings dropping out in an unfinished phrase or thought, an abbreviation that can pull us up short. Sometimes we catch ourselves in the very act of falling asleep, feeling the uncanny drop itself, and we can quickly pull back from the edge, aware of its cliff-face. A loss of words can be terrifying: facing the loss of meaning that accompanies the petering out of words, the hopelessness, watching as someone struggles for a handhold of sense in a growing miasma of fogged brainpower, facing their own chasm, an abyss of non-sense. Mind the gap. A gap that appears when we miss a word, or search for a name that doesn't appear, that is simply... gone. We each have our own rehearsals. Artists and performers risk silence and blank faces every time they face an audience.

This first stage of falling then: contemplating the drop. Preparing your mind and body to accept and allow in the fear, risk and potential for pain (and of pain). In many live falling works, it is this stage of the fall that is the longest phase. See Bas Jan Ader's *Broken Fall (organic)*, or *Nightfall* (you could look at many other of his works). For all of these, the lead-in to the title's fall takes by far the main part of the artworks, could arguably be the main event. The tense moments of waiting, knowing what is coming; watching while the artist approaches the moment of letting go, moves inexorably towards the fate he has set up. You have time to consider what he is waiting for, to feel him approach his 'right' moment... good god, what is he waiting for? Look at him in *Nightfall* in what may be his garage: he seems to be gearing up inside himself for the moment of most feeling, to wrest every ounce of emotion into this act,

to forcefully imbue the moment with its crux. He is prizing the act of letting go itself and is present within it wholeheartedly. There is a compelling 3-way relationship between the viewer, Ader and this moment. He is concentrated on his action, facing his crucial moment, but we are the invited witness, and he draws us in just as surely. With *Broken Fall (organic)* he and we are literally in suspense: we know he cannot hold on for very long, we see his occasionally desperate attempt for a better grip on the tree. We will him to hang on, but we will him to drop: we want to see what happens, too, to answer the 'what if...' that he has set up. We are complicit. It is difficult to look, but we cannot look away either. In Chris Burden's *Shoot*, the preamble or prologue (and it is mainly words we hear, on a black screen, as only the audio survives for this part) is 2 minutes long, the shot over in a flash of 8 seconds. Burden has contextualised the filmed instant by including the audio recording, complete with voiceover, in which he rehearses for double emphasis the words and actions to come. It is Edgar's visualisation of the drop to Gloucester (*King Lear*, Act 4, scene 6), building us up to the emergency. His desire to impress each detail upon us is manifest ("you'll hear the clicking of the camera... another thing to listen for..."), but it is the sense of space in the audio that feels most telling (coincidentally, the similar space of humanity going about its day that Edgar seeks to build)... the sense of people milling around the moment, dawdling, delaying the calamity even, until "Are you ready?", and the point of crisis arrives. As with Ader's films, the moment of the fall takes seconds, and there is little to no aftermath. Burden almost rushes off screen as if he no longer wants to be seen, and as with *Nightfall*, black engulfs us instantly.

Each falling artwork has to approach this threshold moment. The word threshold seems to include the desire to hold back, to hold on, to not cross over, which recalls Macbeth's sticking place,

Macbeth:
If we should fail?

Lady Macbeth:
We fail?
But screw your courage to the sticking place,
And we'll not fail.

Macbeth, Act 1, scene 7

Lady Macbeth charges him to screw his courage to the sticking place – but he cannot stick there. Unable to look only at the deed itself, Macbeth fixes on the consequences. His focus vaults over and lies entangled in the untrammelled horrors of the possibilities of his act. Ader and Burden are focused on the moment, staring down the barrel of a gun, looking at the drop and letting go. There is an inversion to follow here: 'if we should *fall*?' seems to be the question posed by each falling artwork, while we are now their accomplice urging them on – 'screw your courage up and we will fall' – gather ourselves and our courage together, let's fall and see what happens.

But with each letting go we have to face the fear that we may fall to pieces, that something will be broken and unrecoverable from... and if the worst happens, what then happens?

The step into the unknown, then, which may be the edge of a cliff. On October 14 2012, Felix Baumgartner made the highest fall ever (what a surprise that this was a record the Americans had been chasing since before 1960. It seems a little post-modern for that era's sensibilities). After the long wait to get up there, he has to stand on the threshold of the cabin door with his feet sticking out, and then fall forward. Stuntmen talk of falling as the art of landing safely; artists' practices seem to have entirely different emphases. Baumgartner frames his fall as a freefall, which seems to insist on retaining an element of control (the inference being that he can come out of this free fall when he chooses). But what is free about falling? The investment is huge. Newton's definition of freefall is a fall with only the force of gravity acting on an object. But the lure of falling seems to have its own, separate force, from inside us. There is something appalling about watching Baumgartner fall forward out of the cabin, as if it goes against the nature of things, transgressing a deep need to keep ourselves safe. What if the fall had not finished as planned, with a safe landing? How would we feel, being invited as witness to a man dropping to his death, which was a real possibility a minute later, as he spun out of control.

Watching Buster Keaton falling is joyful when young, but the same feats are uncomfortable to watch when performed at 55 and 65 years of age. The luxury of seeing someone else fall, from our position of relative stability, is undermined by worry, shaking our equilibrium, perhaps setting boundaries to our complicity. Is falling the preserve of youth? Is it just too dangerous when we are older – is there too much to lose? Are there falls that are just unbearable?

Orchestrated, planned falling as live art can be very different to the unexpected, shocking event of a fall in daily life. How, then, to approach and explore real falls, to provoke an accident, but not as some pared-down trip or jump? How to offer a level of real personal risk that seems a very necessary factor in an interesting artwork about falling, but not break something or die? To open oneself up to possible disaster, to court catastrophe even, but not to be obliterated. Each constructed fall seems to need some kind of emergency within it.

I made an early 8mm film, *Pulling the rug out*, in which I stand on a carpet and fall repeatedly as my friend tries to wrong-foot me. My friend is there as an outside agent to force the falls, in order to bypass my instinct for self-preservation. The work explores the accident, the shock and horror of real falls, the risk of pain. Unable to hurt myself, I wanted the decision to keep myself safe taken out of my hands. I had to be out of control. I didn't anticipate how much my friend would feel challenged to up-end me. The film shows how much the falls hurt, and after the second fall there is a little stocktaking from both of us, I put my hand up to catch my breath. I look uncertain; I (fleetingly)

consider stopping the piece. Then a competitive streak comes out in both of us. The pain focuses my mind. The film hazards the possibility of outwitting these rug-pulling hands of fate, and by the end, there is some kind of facility learnt, the power shifts, movements can be anticipated.

My young daughter saw my fall a while back. She saw the fear in my eyes, the dreadful gurn I made trying to avoid the floor coming at my chin. I saw her see me. I felt vulnerable, fragile, old, and took another step off my pedestal, showing her I am not always sure-footed, but can falter, and fall. It felt shameful, to fall in view of others. Yet in live artworks, the very vulnerability of the fall, the willingness to dive into that shameful moment, un-shames it and us. Kira O'Reilly's *Stair Falling* – with her bony body pressing into the marble stairs, red marks appearing – echoes many other (women's) falls. The slow motion reveals a mundanity to the drama, giving it resonances of the domestic, the repetition forcing some kind of routine to this extraordinary event, but also creates the riveting tension, and repositions the power. The vulnerability and bravery of this insistent continued falling, the personal nature of the moment, the openly offered views of her body, all conspire to turn the audience to voyeur, the repeated camera clicks an invasion. But this is already a mythology for me... I wasn't *there*...

Lucille Power's *Woman Falling*: hitting the deck again and again. The wooden floor wired for sound to accentuate the boards pounding as her body and head clunk over and over, the crowded audience gathering tightly round. Her men's underwear, slightly ill-fitting, serving only to accentuate a fragility in this world. Repetition as a process and tool to explore the act, to open it up for questioning, to face its fear, stare it down just as surely as Burden looks down the gun barrel. In *SWIM*, 50 people swam across London, diving and falling lemming-like into pools across the capital. The process of stepping off dry land offers a chance to wriggle out of gravity for a minute, unshackle our bonds. *SWIM* exposed the bravery of daring to change one's day completely, to attempt a new journey, to throw off one's usual uniform and routine and to run out into the capital in only a swimsuit, to swallow one's pride, loose one's shame, put our usually covered-up pasty rolls of British flesh on show. It drew on the lure of the fall as surely as the lure of water to pull us in. Someone afterwards remarked on the '*cosmic oddness*' of the piece, as if it threatened the 'nature' of things. Water offers relief from the relentless pull of gravity; we in turn looked at the landlubbers with sudden incomprehension, as if throwing oneself off dry land again and again all day was the only way to live. Bas Jan Ader's many falls: this tall, almost unbearably thin man, falling again and again, continually putting himself in jeopardy... until he falls into the sea and never recovers dry land. Perhaps art falls so that others don't have to.

After the fall and the crash, we need to be careful not to rush the recovery.

Feeling other eyes on us, we often hasten over this part, but it has much to offer, including a chance to question where this sense of shame resides. What do we know when we are prone on the ground instead of upright? 'Anyway,

I think with my knee', said Beuys, suggesting this change of viewpoint. Why is it framed as childish to fall, and becoming adult (growing _up_) as a stage of more sure-footedness? Perhaps we are ashamed to act as children, but are we sure we should know better? In the Western Christian framework our entire human existence is framed as a fall, so to reject our fallibility is to reject the very nature of our human-ness. Can we not forgive ourselves for being fallible? As with the joy of divesting clothes (we are back in that garden), perhaps we can rejoice in a freedom from uprightness.

In a live one-to-one artwork _drift_, I floated a boat on a swimming pool, and invited people to step off dry land and drift with me. Leaving the relative safety of their (upright, grounded) position, drifters were cradled in a post-fall state, 'berçant notre infini sur le fini des mers' [1] (a sense of rehearsal in the very ripples of the water). There was no script, and the conversation followed wherever the drifters led, whatever we noticed in that moment. One of the definitions of a drift is the difference between the size of a bolt and the hole into which it is driven, and these drifts offered a time between being fixed and formulated by others (with all the attendant horrors of that as outlined in _The Love Song of J Alfred Prufrock_, 'And when I am formulated, sprawling on a pin/When I am pinned and wriggling on the wall'). The drifts offered time to re-balance ourselves and re-manage our weight in the world. The only rule was that we could not push off from the side, so were unable to go at a chosen pace. We had to bear this change of pace, our loss of agency, which could charge the time with tension, instead an envisioned calm. At the very last moment Baumgartner gives a tiny push off from the cabin, as if he needs to go under his own impetus, be the agent of his drop, a last resistance to the passivity inherent in falling: it's not easy to let go. In Graeme Miller's _Track_, people are slowly pushed along a railway track, lying down, on their back. Horizontalizing people offers a different viewpoint – rest, recuperate, recover, reflect – suddenly you become aware of how much effort it takes to stay upright, to carry on... going on. Someone once burst into tears having only just got settled on my boat, saying, "It's just, you run and you run... around all day, and then you get here, and you think, 'what was it all for?'" _drift_ offered time in between, celebrating time out from our usual roles, gravity, time itself, allowing ourselves to go off-course, in unintended meanders. _Track_ and _drift_ both seem to offer a safe space to move together before the taking up again of our particular, chosen positions in the world. With _drift_ I offered a romance, not always a drama. I was a poor woman's Ellen MacArthur, never leaving the confines of a pool, never alone in my boat. Falling offers this same re-negotiation of our place in the world, but can be a shipwreck, with all attendant risks and adventure.

Falling is the jarring, difficult blow that links shame and daring to the nature of adulthood. It goes to the heart of our definition of humanity, insisting on our vulnerability, exposing the nature and complicity of an act of witness. Doris Humphrey talks of the upright as stability and safety, and the fall as adventure and progress: the whole of life a balancing act, the one just as necessary as the other. Exploring any pain in the fall helps question what and how we learn. It is in the nature of things to fall: by Newton's definition, the moon is also in freefall.

Music talks a lot about falling: falling in love, falling to pieces, free falling, its rhythms reassuring us of a return, or at least company along the way. Jefferson Airplane's *White Rabbit* sings of a freedom at the death of logic ('logic and proportion have fallen sloppy dead'), which offers the marvels of Alice's fall into Wonderland. Killing proportion and logic (scale, standing & position, reasoning, comparative and proper relation) offers a re-orientation. But their fall is drug-fuelled, urging 'Feed your head', a twist on the opening lines of Rudyard Kipling's *If...* (that paean to being in control of yourself): 'If you can keep your head while all about you/Are losing theirs'. So too, in his long manifesto poem, *What I believe*, JG Ballard states – 'I believe in the murderous intent of logic' – and to fall seems a battle cry against this lethal tyranny, an exhortation to a new life: the power of imagination free from adult reasoning. Ballard understood about the creative energy of falling and crashing. To fall becomes to fly, if only for a little while, and takes on infinite potential: 'I believe in flight, in the beauty of the wing, in everything that has ever flown.' Un-shamed, we can enjoy our glorious *fallibility*... as we step off into the unpremeditated and unknown. The flight is precious, and so is the painful return to gravity, the face in the dirt.

The Love Song of J Alfred Prufrock pulls back from the edge of falling time and again, deflecting from the crisis, retreats into somnambulence and ritual, refuses to bite and squeeze the moment, finds the question overwhelming, stymied by the possible consequences. He doesn't presume and doesn't dare. It is this daring that live artists do for all of us. We presume – we lay claim – almost an assumption of responsibility ('nous voulons/...Plonger au fond du gouffre' cries Baudelaire [2]). We suppose and take liberties. We are presumptuous. Falling unsettles all of our worlds. It disturbs the universe. We need to have the strength to force the moment to its crisis. And how should we begin? With a crash.

Amy Sharrocks

In November 2012 I organised a Study Room Gathering On Falling at the Live Art Development Agency (LADA). I would like to thank LADA and everyone who came for their input and contributions to the evening, which fed into this writing: Francis Alexander, Katy Baird, Emilyn Claid, Alice Colquhoun, Rosa Farber, Dorota Halina Gaweda, Lois Keidan, Debbie Kent, Dafne Louzioti, Claire Mander, Aicha Mehrez, Kerstin Moller, Mary Osborn, Helen Savage, Clare Thornton.

In 2012 Amy Sharrocks won the Royal British Society of Sculptors' Sculpture Shock award, and spent her residency there making work about falling.

References

Bas Jan Ader, (1971)
Broken Fall (organic),
Nightfall
Viewable online at http://www.basjanader.com/

Chris Burden, *SHOOT* (19 November 1971) F Space
http://www.tofu-magazine.net/newVersion/pages/ChrisBurden.html

William Shakespeare (1603-7)
Macbeth, Act 1, scene 7
King Lear, Act 4, scene 6

Buster Keaton *through the years*, a compilation of his falls by Cliff Cronan
http://www.youtube.com/watch?v=PwH8jkv2Hq0

Kira O'Reilly *stair falling* (2009)

Lucille Power, *Woman Falling* (2004)

Felix Baumgartner
http://www.telegraph.co.uk/science/space/9608084/Felix-Baumgartner-breaks-speed-of-sound.html

1
'Lulling our infinite on the finite of the seas'
Other translations have 'rocking', 'balancing', even 'swinging'.
Baudelaire (1857) *Le Voyage*, in *Les Fleurs du Mal*, trans. William Aggeler, *The Flowers of Evil* (Fresno, CA: Academy Library Guild, 1954)

Beuys, J. (1987), quoted in *The Connected Body?: An Interdisciplinary Approach to the Body and Performance*. Edited by Ric Allsopp and Scott deLaHunta. Amsterdam School of the Arts.

Amy Sharrocks
Pulling the rug out (2003)
SWIM (2007) photographer Ruth Corney, copyright Amy Sharrocks
drift (2009), photographer Ruth Corney, copyright Amy Sharrocks

Graeme Miller, *Track* (2010)
http://www.artsadmin.co.uk/projects/track

TS Eliot, *The Love Song of J Alfred Prufrock*, 1920
http://www.bartleby.com/198/1.html

Ed Caesar, *An Even Bigger Splash*, originally published in *The Independent* (16 July 2007), collected in *The Live Art Almanac*, published by the Live Art Development Agency, assisted by the University of Leeds (2008)

Jefferson Airplane, *White Rabbit* (1967)

Rudyard Kipling, *If...* (1895)
http://www.kipling.org.uk/poems_if.htm

J. G. Ballard, *What I Believe: Interzone*, #8, Summer 1984. A prose poem, originally published in French in *Science Fiction* #1 (ed. Daniel Riche) in January 1984.
Available online in original format at
http://www.jgballard.ca/uncollected_work/what_i_believe.html

2
'we wish to plunge/
To the abyss' depths', also variously translated as 'plunge into the void', and 'Dive to the depths of the gulf',
Baudelaire (1857) *Le Voyage*, in *Les Fleurs du Mal*, trans. William Aggeler, *The Flowers of Evil* (Fresno, CA: Academy Library Guild, 1954)

'Anatomy of Falling' was originally written by Amy Sharrocks and published in *Performance Research*, 18.4 (2013), 48-55, reprinted by permission of the publisher Taylor & Francis Ltd.

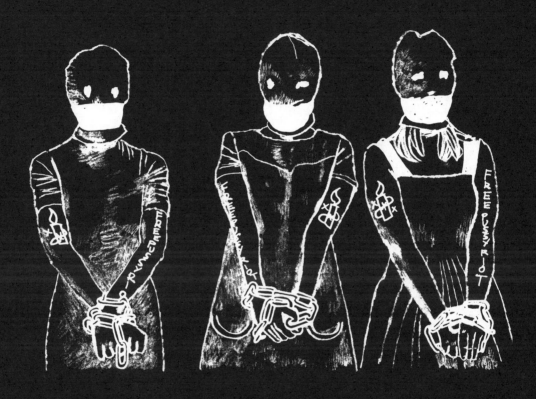

Performance
Under Attack:
Part 1

The State of Detention: Performance, Politics and the Cuban Public

Coco Fusco

The detention of Cuban artist Tania Bruguera and the Cuban government's actions to prevent her performance from taking place in Havana's Revolutionary Plaza have made international news headlines in the past week. Public outrage about the censorship of the performance and concerns about Bruguera's whereabouts have circulated in social media outside Cuba, but little in-depth consideration of the context and implications of the performance has been available in English. The treatment of the matter has been dominated by expressions of dismay that an internationally recognized artist would be detained over a performance and that (therefore) "Cuba hasn't changed" – i.e. that two weeks after the announcement diplomatic relations would be restored between Cuba and the US, and the Cuban government still does not allow its citizens to express their political views in public. While the detention of an artist should be cause for concern anywhere, the assumption that a government's policies and practices could be transformed so quickly is politically naïve or disingenuous.

In the aftermath of the December 17 pronouncements by Barack Obama and Raul Castro about a rapprochement between Cuba and the United States, Bruguera published a public letter to the two presidents and the Pope in which she proposed relocating her 2009 performance *Tatlin's Whisper #6* to the Plaza of the Revolution, thereby offering an open mic to the Cuban citizenry to express their views about their country's future. According to Bruguera, she was encouraged by friends to carry out her proposal. Calling her project *#YoTambienExijo (I Also Demand)*, she used internet platforms to launch her performance from outside the island and was supported by a number of dissident groups and opposition blogs. Bruguera then travelled to Havana on December 26 and was immediately summoned to a meeting with the director of the National Council of the Fine Arts, Rubén Del Valle, who made it clear that she would not receive authorization or support from official cultural channels. His position was made public in an interview released after the December 27 meeting, as was the Cuban artist and writers' union repudiation of Bruguera's performance. On December 29, Bruguera tried to obtain authorization to use the plaza from the National Revolutionary Police. Her request was denied. She made public her intent to continue with the performance without any official support, and was detained on the morning of December 30. Several dissidents who had expressed solidarity with Bruguera's project were either detained or placed under house arrest at the same time. Among them were Antonio Rodiles and Ailer González of Estado de SATS, blogger Yoani Sanchez and her husband Reinaldo Escobar, activist Eliecer Avila, photographer Claudio Fuentes, and members of the activist group The Ladies in White. Performance artist and poet Amaury Pacheco was also detained near his home in Alamar, though he had not expressed any intention

of attending the performance, and artist Luis Trápaga and filmmaker Boris González were arrested at the plaza. As of this writing, Pacheco and González remain in detention, together with a Cuban correspondent for the Madrid-based opposition blog Diario de Cuba and several opposition activists. Bruguera was released on December 31, but her passport was confiscated and, although she has not lived in Cuba for more than five years, she has been ordered to remain on the island for the next two to three months, while law enforcement determines whether or not to charge and try her for disrupting public order and resisting police. Since her first release, Bruguera has been detained two more times: first for calling a press conference and then for protesting the continued detention of some of her supporters (The most detailed and up-to-date reports on the detentions can be found in diariodecuba.com and 14ymedio.com).

The international outcry over of Bruguera's detention does not associate it with the December 24 arrest of another artist, Danilo Maldonado Machadoaka El Sexto, who was apprehended when he was on his way to stage a performance in Havana's Parque Central involving two pigs named Fidel and Raul. El Sexto has not been released and he was not granted an interview with state representatives prior to his arrest. This is probably due to the fact that he is not a member of the Cuban artist and writers' union and does not command the international press attention that would lead to a rash of unfavorable articles such as those generated by the censorship of *#Yo Tambien Exijo*.

Media coverage of Bruguera's performance in English, including a recent editorial in *The New York Times*, has expressed disappointment that freedom of expression was not respected and that opponents of the Cuban government continue to be subject to threats, harassment, and detention. For those who follow Cuban politics, this comes as no surprise. First of all, the Cuban government's control over culture, media, and public discourse has been absolute for more than five decades, and vague promises of change are not tantamount to actual modifications in law or policing practices. Second, the recent agreement to swap political prisoners and reopen embassies is not in itself indicative of a political transformation in Cuba – negotiations leading to the release of political prisoners have taken place since 1962 – in the immediate aftermath of the Bay of Pigs invasion – and talks leading to restored diplomatic relations have taken place on and off since the 1970s.

Deeper consideration of Bruguera's situation involves considering whether an artwork can effect political changes in the realm of civil rights and how an artwork might catalyze collective political action. The capacity for manifestations of "people power" to effect change depends on the participation of people in large numbers, and no artist or dissident group currently operating on the island has the capacity to marshal the Cuban citizenry. Cuba supporters contend that this is because of mass support for Cuba's existing government, while Cuba's critics argue that political will is suppressed by an authoritarian state. One of the main obstacles to the organizing collective political action outside state channels is technical, which is to say the weak

communication infrastructure in Cuba. It is the country with the lowest level of connectivity in the hemisphere. Any attempt to convene a large-scale public gathering in Cuba is thwarted from the onset, not only by the country's highly effective security apparatus, but also by the fact that the vast majority of Cubans lack access to the internet, cell phones, and home-based landlines.

Bruguera's reliance on the internet to convene the Cuban public has provoked a certain degree of skepticism from critics about her intentions. "The Cuban people" did not show up at the plaza and it is likely that most Cubans on the island have no idea of what *#Yo Tambien Exijo* is. Cuban dissidents supporting Bruguera have been quite vocal about their disappointment about Washington's decision to reopen diplomatic relations with Cuba. The dissidents see this as a capitulation to their government's interests, and Bruguera's performance has been interpreted by some of her critics as a means of interfering with the negotiations between the two governments. Although comparisons of Bruguera's project to Occupy Wall Street have been made, there is no evidence of widespread organizing in Cuba that parallels the kind of mass mobilization that preceded the 2011 occupations of New York's financial center or Tahrir Square. The only activist campaign that has been successful in drawing broad-based support for constitutional reform in Cuba was the Varela Project, spearheaded by Oswaldo Payá in 1998; the campaign was undermined by the arrests of numerous activists in 2003 and the death of Payá in 2012. State repression of protests in Cuba for the most part targets a small group of opposition activists, dissident musicians and artists, and the pattern of protest-repression-detention-release-protest has been repeating for several years without shifts in tactics on either side.

The state's response to Bruguera's performance combines usual and unusual elements for the Cuban context. No one in Cuba has the legal right according to Cuban law to use public spaces for demonstrations or cultural events without prior authorization – and it bears mentioning that similar restrictions exist in several other countries, including the United States. Such restrictions are strictly enforced with regard to actions in the Plaza of the Revolution, which is the Cuban equivalent of the White House lawn. The plaza is surrounded by key government offices and guarded round the clock and permissible activities are limited to tourists taking picture of Che's giant silhouette and official ceremonies. In 2011, a group of Cuban dissidents received sentences ranging from three to five years for distributing anti-government leaflets in the same plaza. The Ladies in White, an activist group led by female relatives of political prisoners, were forcibly dragged out of the plaza by police in 2008.

The rhetorical attacks that were launched this week in government sponsored blogs against Bruguera deploy sadly familiar and paranoid nationalist rhetoric – she has been characterized as an agent provocateur supported by counterrevolutionary exile forces, functioning under the influence of foreign trends (see here [http://www.cubadebate.cu/especiales/2014/12/30/uneac-no-es-un-perfomance-es-una-provocacion-politica/#.VthF6_mLSM8],

here [http://www.cubadebate.cu/noticias/2014/12/30/consejo-nacional-de-las-artes-plasticas-inaceptable-performance-en-la-plaza-de-la-revolucion/#. VthGFvmLSM9], and here [http://www.cubadebate.cu/noticias/2014/12/30/ las-encrucijadas-del-arte-y-la-politica/#.VthGOPmLSM9]). Cuban artists in previous eras who dared to carry out unauthorized performances in the street or in state galleries were also censored and detained: Juan Sí Gonzalez was stripped of his artist union membership, made subject to public censure, and detained in the 1980s for conducting political performances on Havana streets. Angel Delgado was imprisoned for six months in 1990 for defecating on a Communist party newspaper in a Havana gallery. And in 1991, after poet María Elena Cruz Varela penned a public letter to Fidel Castro calling for democratic reforms that was signed by ten Cuban intellectuals, she was dragged out of her house by police and taunted by a crowd of government supporters while pages of her political writings were shoved down her throat. Cruz Varela received a two-year prison sentence, as did two filmmakers who attempted to document her arrest.

The relatively brief duration of this week's detentions contrasts with Cuba's treatment of dissenting voices in previous eras. As has been pointed out by Cuban human rights activists, Raul Castro employs a different strategy for managing dissent on the island – detentions are shorter but the rate of detention has increased since 2008. The amount of international media attention given to the machinery of Cuban state repression has also increased, particularly in relation to internationally known dissident figures. Thanks to the growth of independent journalism and blogging about Cuba in the past five years, it is much easier these days for people outside Cuba to obtain information about the processes and procedures that constitute the exercise of state control. The interplay between cultural bureaucracy and state security in Cuba is more transparent than ever, but this has not prevented the state from using force against its opponents. That said, the rhetoric used by Cuban cultural bureaucrats has become more nuanced in recent years. State supported bloggers may rail against Bruguera as a counterrevolutionary, but National Council of the Fine Arts president Rubén Del Valle took great pains to explain that she is a "child of the revolution" who has erred by engaging in a "reality show" that is more of a political provocation than an aesthetic gesture – in short he displays a capacity for and interest in cultural interpretation. Nonetheless, Del Valle insists on the prerogative of the state to authorize all cultural activity and to keep Cuban art free of politics, as well as the supreme power of the government to orchestrate the transformation of US-Cuba relations.

While art world cognoscenti around the world have been venting on Facebook and circulating petitions regarding Bruguera's detention, and exiled Cuban intellectuals have been ruminating on the meaning of #Yo Tambien Exijo, little commentary has emerged from Cuban artists living on the island. After a deafening silence in the days prior to the performance, only a few artists have responded to press queries with terse expressions of regret about Bruguera's detention. Cuban National Arts Prize winner Lázaro Saavedra issued the

lengthiest public statement so far via his Galería I-mail on December 30, in which he critiqued Bruguera's performance as a miscalculated attempt at "aRtivist action" that preaches to Cubans about something they already know too well, i.e. the limits on their freedom of expression, and allows the artist to advance herself professionally with minimal risk, since she resides abroad and enjoys a kind of media coverage that serves as a protective shield. Saavedra claims he would have preferred that Bruguera create a temporary autonomous zone in which the voices of Cubans who live in Cuba and are not well-known artists could actually have been heard. It seems that Saavedra presumes that Bruguera's performance was supposed to reveal something unknown, or that placing the mechanism of repression under scrutiny in a performance is unnecessary if the Cuban people are already aware of how their government exerts control of them. There are too many examples of artworks that have called upon viewers to review the already known so as to see and understand it differently for such presumptions to be unquestionably sustainable.

While Saavedra rightfully draws a distinction between the meaning and effect of Bruguera's performance in and outside Cuba, he dismisses the potential worth of staging a media intervention from Cuba for a foreign audience beyond its uses for professional advancement. Cuba may be an island but its culture does not exist solely for local consumption. Bruguera's foreign audience is the only one at present that can easily consume the flow of information about her artistic proposals, political views, and serial detentions. The Cuban people remain outside the picture so to speak, but Cuba's status as an art world superpower comes under scrutiny. Cuba draws thousands of foreigners to its cultural events each year and the smooth functioning of its promotional machinery depends on approval from and alliances with foreign institutions, benefactors, art world luminaries and tourists. Cuban artists living on the island rely heavily on income from sales to foreigners. In light of the fact that in the past year, artists and arts professionals invited to biennials in São Paulo and Sydney have exercised political will by expressing their opposition to financing from governments and corporate sponsors whose practices they consider unethical, it may well be time for art world cognoscenti who have for so long been charmed by Cuba's eccentricities, anti-imperialist rhetoric, and relatively cheap art prices to consider what, beyond the convention of indignant public letters, might serve as a valid response to a state that imposes draconian measures to enforce its hegemonic control over public space and discourse.

'The State of Detention: Performance, Politics and the Cuban Public' was originally written by Coco Fusco in *e-flux*, no. 60, December 2014, http://www.e-flux.com/announcements/on-the-detention-of-cuban-artist-tania-bruguera-by-coco-fusco/

Afghan Artist Dons Armour to Counter Men's Street Harassment

Emma Graham-Harrison

It took a month for Kubra Khademi to get the armour made exactly to her design; hours spent with a quiet, patient metalworker who usually made stoves.

The performance artist was an unusual customer on a street of dusty workshops in Kabul, where she chose her craftsman for his lack of curiosity about the outrageous steel plates she sketched out.

In a deeply conservative country where women are expected to shroud their figure and almost every inch of bare skin beyond hands, face and feet, she wanted steel armour that slipped over and emphasised her breasts, belly, crotch and bottom.

"He was a quiet man," she recalls. "He didn't question me at first, maybe because of my attitude. Then he asked: 'What the hell is it?', because other people were asking him."

It was in fact part of a vanishing occurrence in the Afghan capital: a piece of performance art, planned by 27-year-old Khademi. The armour would be both protection and a defiant rebuke to the men whose groping hands and leering remarks make Kabul's streets uncomfortable for almost any woman who walks them unchaperoned.

It was also an almost unimaginable provocation in a city where pornography may be avidly consumed in private, but women's appearance is fiercely policed in public. Her performance lasted less than 10 minutes, but pictures soon ricocheted around social media, drawing anger and death threats – genuine worries in a country where women have been murdered for working as news anchors, actors and singers.

Like many artists, Khademi sees provocation as part of her work, though she is keen to underline that she is not making direct political statements.

"It was a performance. I'm not an activist, I'm an artist," she says. "My concerns in my work derive from my life, from my personal experience ... but I don't use words, I use my body and my space in time."

Past performances have explored her life as a refugee, shifting from Iran where she was born to refugee parents, to Pakistan where she won a scholarship for a fine art course.

In Lahore she set up home in the middle of the road, reading, listening to music, surrounded by possessions in her makeshift home until police came and removed her. For another piece, she shut herself inside a suitcase for several hours, and in a third suspended herself from a high ceiling over her audience.

When she graduated, she was drawn back to Kabul despite her parents' opposition. "I had to come back here – I belong here, I must live among my own people. I think my art needs it," she says.

But after several years studying and working in Pakistan she had perhaps underestimated quite how shockable her home country was. Afghanistan is a country where you can still risk your life for art; thrilling, perhaps, from a distance – but terrifying up close.

The armoured walk was a simple stroll down a main road in her neighbourhood, Koti Sangi. She had invited almost no media, and aimed it at the people who were harassing her and other women every day.

"I wanted these people to be my audience," she said. "I did it in Koti Sangi because it is a real place, to say what happened to me many times there, and the rest of Kabul as well."

Her audience, almost entirely male, threw insults and stones, and quickly gathered into crowds. Most seem to have missed her point, leering at her throughout, with some trying to grope her from behind around the armour. "I didn't feel anything, so it worked," she points out wryly.

When she jumped into a friend's waiting car to end the walk, men started attacking it, even jumping on top of it. Pictures and footage were online within minutes, as the audience had been a sea of mobile phones, and death threats followed soon after, warning Khademi that she was "a feminist activist who will be killed soon".

She has also received dozens of obscene messages, and doctored pornographic pictures. It all underlined Khademi's point about the terrible imbalance in Afghan society, but offered little comfort in the face of terrifying threats.

However, she would do it all again if she had a choice. "I don't have any regrets. One thing I'm happy about is everyone has a chance to tell me what they think of my work."

Despite her rejection of the "activist" tag, Khademi says her performance was rooted in painful personal experiences, and when asked about her artistic influences she cites political artists such as China's Ai Weiwei as well as legendary performance artist Marina Abramović.

When she first moved to Kabul in 2008, used to more liberal countries, she screamed at a man who tried to grab her bottom. She was shocked by the

response from other men nearby, who shouted obscenities back at her for daring to raise her voice.

It brought back memories of being groped as a child of four or five. "The only thing I thought to myself then was 'I wish I had steel underwear'. I never forgot that as I grew older, and thought about it until I made it real," she said.

She spent several days preparing for her eight-minute performance, but was taken aback by the ensuing furore.

"I knew there would be this kind of reaction, but I didn't realise it would be so extreme," she says. "I can't even go to my house. I wonder how long it will be before I can go back there, and it makes me sad."

She has already narrowly escaped an attack by three men, and is living like a fugitive, but has no plans to scale back her art or ambitions. "I would never be stopped ... artists can't be stopped. For now, I'm just waiting for this to die down."

'Afghan Artist Dons Armour to Counter Men's Street Harassment' was originally written by Emma Graham-Harrison for *Guardian*, 12 March 2015, http://www.theguardian.com/world/2015/mar/12/afghan-artist-armour-street-harassment-walk-kubra-khademi-kabul Copyright Guardian News & Media Ltd 2016.

Ai Weiwei is back in production with his Fake studio and his team of assistants. What does art mean now to the dissident?

Clarissa Sebag-Montefiore

When I sit down with Ai Weiwei, the first thing he does is aim his iPhone at me. We are in Ai's cathedral-like home-cum-studio, in the dusty village of Caochangdi, on Beijing's outskirts. Winter sunlight streams through vast windows into an expansive room, sparsely decorated with a large potted ginkgo tree and a headless Buddha. While the dimensions of his living space soar, Ai is trapped in a goldfish bowl. China's most famous dissident and artist is tagged by authorities wherever he goes – his phones are tapped, his home bugged. Outside his now iconic green gate, a surveillance camera bears down menacingly.

Somewhere, deep within the bowels of the Chinese Communist Party, Ai's life concurrently exists on film. But, with characteristic mischief, the artist has turned the table on his tormentors and provided them with what they want for free. While they record Ai, he records himself, relaying his movements (and those of people around him) to the world in a constant stream, via Twitter and Instagram. On this freezing January morning, as I wait for our interview to begin, he presses a button. Without asking, he takes my photograph and I become part of the media montage that is inextricable from the artist Ai Weiwei.

Ever since he was arrested and kept in secret detention for 81 days, in April 2011, Ai has been living in limbo. His company has been charged with tax evasion (economic crimes are routinely levelled against dissidents) and he's been investigated for pornography and bigamy, the latter a result of fathering a son from an extramarital relationship. Today, Ai can, within limits, move around China. But the regime has retained his passport, preventing foreign travel and making his exhibitions abroad – the only place he can exhibit – a logistical nightmare.

To object, he tethered a bicycle outside his studio last November. Every day, he places fresh flowers in its basket, takes a photograph, and posts the image online. This gentle protest, which offers a palate of bright relief against the polluted skies, will continue until his passport is returned. Till then, incessantly reminding the state of his presence has become his trademark tool. 'Today, protest doesn't have to be a walk on the street or hold[ing] a banner, but a statement of existing, repeatedly re-announcing your position,' he says, in accented English.

Ai's studio, called 258 Fake, has become China's equivalent of Andy Warhol's Factory. And Ai himself has increasingly taken on Warholian overtones: there is now little distinction between Ai the artist who creates artworks, and Ai the

dissident who gets beaten by the cops. (In 2009, police pummelled his face, causing a cerebral haemorrhage.) Both are merged in an ongoing performance in which the man has become the art, and the art is the man. 'Every image of him is part of this overarching public persona. And, in a way, that persona is his greatest artwork,' says Philip Tinari, director of Beijing's Ullens Center for Contemporary Art (UCCA).

Following Ai's arrest, work at the studio slowed to a near halt. But three years later, it is a hive of frenzied activity. The office door opens constantly as people come and go, letting in gusts of cold air. Assistants – Ai has 40 working for him, many of them living on site – tap away at computers under harsh strip lighting, wrapped in coats and scarfs. One Western girl discusses 'Fake', Ai's brand, loudly on the phone, a fat cat purring on her lap.

On the back wall is a list of names in tiny print. They record the identities of the 5,196 children who perished in the 2008 Sichuan earthquake. They died when their 'tofu-dreg schools' – so named because of the buildings' flimsy structures – collapsed. In his *Citizens' Investigation* project, Ai led more than 50 volunteers in a mission to uncover the victims' details, working in defiance of the local government, which had attempted to cover up its own incompetence. It was, Ai has said, perhaps 'the first large-scale... media-concentrated civil act in China'.

I ask if the government is still afraid of him. 'Afraid of me?' he says, stretching the last vowel to emphasise his incredulity. 'If I can freely express myself, they have reason to be afraid of me. But if my words cannot get on the [Chinese] internet or newspaper or any media, then why are they so afraid of me?'

Inside China, Ai's impact is neutralised: domestic media cannot mention his name. He talks about being officially cast as a 'disease', since the government worries that his calls for free speech and universal human rights might spread like a virus. In the West, he has become the cause célèbre of dissidence in China and is perhaps the country's most recognised global figure. Yet paradoxically, at home, most of the population has no idea who Ai is. He has effectively been eradicated from the public sphere.

For a minority of Chinese bloggers, activists, lawyers and other young savvy internet users, Ai is a beacon of resistance. Since his release, he says people stop him in the street to shake his hand. When he travels in China, he uses his Twitter account – he has more than 240,000 followers (though banned in China, Twitter can be accessed via a virtual private network) – to organise impromptu meals for his supporters. It is people such as these who, when Ai was saddled with a 15 million yuan ($2.4 million) tax fine, folded bank notes into paper planes and flew them over the walls into the 258 Fake studio.

At the heart of the matter is the Communist Party's shaky claim to legitimacy. 'You know, not my father's generation, not my generation, not even my son's generation will see voting,' Ai passionately says. 'So nobody can exercise

their rights in public, [have] public opinions, or give anything related to public expression. That indicates several things: first you [the Party] are not legitimate, you can never be confident... So that puts you on a very fragile base. This is a fundamental philosophical problem. China has an identity crisis and is not intending to fix it.'

His homely look – Santa Claus belly, bushy beard and brows – belies a steely personality

I first interviewed Ai in the summer of 2012. Afterwards I took his portrait at the request of the American newspaper I was writing for. It made me nervous: I was no photographer, and sheepishly admitted that I didn't really know what I was doing. Rather than roll his eyes, Ai patiently posed by the window, standing this way and that. When I was done, I showed him the images. 'See,' he said, touching my arm gently. 'You're good. You just need confidence.'

This time, a different Ai is on display. He seems bored, distracted. As he talks, he simultaneously takes, and then flicks through, snapshots of his cats (dozens, all fluffy and well-fed, live in the studio). At one point he lifts his body off his chair by his arms, and swings back and forth impatiently. Then he films me unprompted: it is a disconcerting moment. But then Ai is a complex character – charismatic, magnetic, playful, and with a razor-sharp wit. He can be uncompromising, even fierce. His homely look – Santa Claus belly, bushy beard and brows – belies a steely personality.

This can be switched on with surprising ferocity. When his son, now aged five, was a baby, Ai recalls being persistently followed by a man posing as a tourist. Finally, an exasperated Ai snatched away the man's camera and confiscated the memory card. He says that he wanted to be proved wrong, to be proved paranoid. But when he took the card home and plugged it into his computer, he uncovered a relay of his movements: 'The restaurant, the dinner I had yesterday, every room, the staircase, the cashier area, my driver sitting on the park bench, his shoes, also my child's [buggy].' Another time, he smashed a plain-clothes officer's phone. 'I kicked his ass. But he wouldn't even turn back his face because I was filming. He just walked away,' Ai says with a small satisfied grunt.

Surveillance has bordered on the absurd. Police have approached two of Ai's assistants, offering them cash to spy on the artist (they did not accept). 'I think, how ridiculous,' he says, leaning forward from his chair. 'I am seeking for openness and the exchange of ideas. I never want to hide anything.' Ai suggested to the police that instead they come and work as his assistants. 'If I can accept any student, I can accept you,' he told them, letting forth a great belly laugh at the memory. 'Just see how bad I am, report everyday, and you will get promoted.'

Ai grew up in exile in the wilds of China's far western Xinjiang province with his persecuted poet father. Ai Qing had been one of China's most prominent

literary figures but, like many intellectuals, he fell into disgrace during the Anti-Rightist Campaign of the late 1950s. The family was sent first to Manchuria, then to Xinjiang, where Ai watched his father reduced to cleaning toilets. During the Cultural Revolution, they spent five years on the fringes of the Gobi Desert living in an underground cave designed for farm animals. In 1981, with China still reeling from the social experiments of the Maoist-era, Ai left for America and the hedonistic verve of the New York art scene.

He stayed until 1993, returning to China only when his father became ill. 'Of course, nobody cares about you. [I was] very, very alone like a beast,' he says of his years away. Alone maybe. But, for the first time, Ai also practised total self-determination. Art gave him deliverance. 'I was forced to become [an artist] because the time when we grew up, the whole society was almost one set of values,' he says. 'And being an artist you can create another type of rules to look at, or judge, your actions. So that gave me some liberty.'

Ai became an artist 'to escape from politics'. He is only too aware of the irony that politics now consumes his art. When I question whether art can just be beautiful, he is flabbergasted. 'Wow, just beautiful. You mean, to please the mind or to please the eye? If it's just to please the eye... that's possible but normally you don't call it art. If the brain has to make some kind of judgment, then it always takes a stand. Art doesn't need to be political, but art is political.'

Within the global art scene, Ai straddles a unique space: somewhere between superstar artist, sacrificial freedom-fighter, and social media sage

In his book of quotations *Weiwei-isms* (2012), Ai writes that art is 'about freedom of expression, a new way of communication. It is never about exhibiting in museums or about hanging it on the wall... I don't think anybody can separate art from politics.'

It is a world-view that can verge on the dogmatic. In 2012, Ai wrote an opinion piece for *The Guardian* titled 'China's Art World Does Not Exist'. It was a scathing critique of a group exhibition of Chinese artists then showing at the Hayward gallery in London. 'In a society that restricts individual freedoms and violates human rights, anything that calls itself creative or independent is a pretence,' Ai railed. 'It is impossible for a totalitarian society to create anything with passion and imagination.' Art, he concluded, 'needs to stand for something'.

Tinari, the UCCA director, says: 'He is disappointed that artists have not stepped up in the same way that he has to what he considered a vile political situation.' But the article 'more or less claims that there were no real artists in China other than him. Which really was, for me, a bit of a disappointment. I've advocated his work for a long time, and I do believe he is one of the greats – if not the great – contemporary talents in China. At the same time, I think it's dangerous to start thinking that there is only one way to resist.'

Ai's courage, his absolute conviction about his chosen path, has separated him

from his peers in China, many of whom are eager to cash in on a now billion-dollar art industry, or are at least resigned to working within the constraints of the country. Yet his influence on the art scene cannot be overstated. 'It's like the question of: do you believe in God or not? It almost doesn't matter whether he exists because he looms so large,' Tinari says. And like God, Ai has his fair share of sceptics and scoffers. Critics believe that he plays up foreign sympathies and simplifies the complex reality of China today. Others pour scorn on his position in the West as a poster boy for resistance.

Still others criticise Ai for what they see as a continual stream of self-promotion and 'look at me' tactics on social media; examples include a cringeworthy video of him dancing *Gangnam Style* or Instagram pictures of him jumping around naked, his privates covered only with a stuffed toy. To his supporters, this is a small price to pay for someone willing to speak out. 'Yes, he is a self-promoter, as many artists are. But a big part of what he is promoting is trying to get you to engage and communicate. I don't think he needs to do it to raise the value of his art... There is plenty of money to be made as a darling in China without ruffling any feathers,' says Alison Klayman, director of the documentary *Ai Weiwei: Never Sorry* (2012).

Within the global art scene, Ai straddles a unique space: somewhere between superstar artist, sacrificial freedom-fighter, and social media sage. Growing up under Mao, information flowed only one way: from the Party to the people. For Ai, then, the fluid back-and-forth of social media offers utopian promise.

Yet it is mass communication – the use of art combined with micro-blogs to rally people behind a particular cause – that has proved particularly dangerous for Ai. In Maoist China, thought crimes against the state could be cause for jail or even execution. Today, artists and writers, though censored, are rarely locked up for their works alone. But calls for civil action, viewed as a threat by the Party, are seldom tolerated.

Despite his trials, Ai has produced prolifically and shown a talent for innovation and change. His works often question Chinese cultural pretensions and entrenched hierarchies. *Dropping a Han Dynasty Urn* (1995), in which he smashes a 2,000-year-old antique, gives an irreverent middle finger to China's claims to an unbroken civilisation of thousands of years. In an image of Tiananmen Square from a series called *Study of Perspective* (1995-2011) Ai went a step further and photographed himself literally giving the finger to a square that symbolises the Party's power and betrays its past bloodshed.

In *Weiwei-isms*, Ai called upon the people 'to be "obsessed citizens", forever questioning and asking for accountability'. He stands by his own words. Many of his works are inseparable from his activism (for example, *Snake Ceiling* (2009), a serpent sculpture made from children's backpacks was built to commemorate the Sichuan earthquake). But just as Ai promotes the very real weight of his social causes, he also, tongue in cheek, undermines his own position as an artistic poseur.

'How do you make your opinion legitimate or credible? I don't really know what I would become if I moved away'

Warhol once said of his paintings: 'There's nothing behind it.' Likewise, the name 'Fake' demonstrates a wry understanding of the flippant, often throwaway nature of art, subject as the market is to wild speculation. This can bubble to the surface. In 2012, I tried to guide the conversation away from Ai's imprisonment towards a show he had coming up in Washington DC. He protested tetchily: 'Back to the DC show? I already forget the DC show!'

If there is a thread holding his works together, it is his mixture of bold confrontation, intellectual playfulness, droll humour, and experimentation of form. Beauty is second to social critique. This is not to say that Ai eschews the aesthetic. Far from it. His dazzling *Sunflower Seeds* (2010), in which Ai filled the hallowed Turbine Hall of Tate Modern in London with millions of seed husks handcrafted in porcelain, was a searing indictment of mass production in China. It was also ravishing to look at.

When our interview is done, Ai invites me to eat at a local restaurant across the street from his studio. It's decked in vintage televisions and old rusty radios, and heaving with the lunchtime crush. Ai picks a selection of homestyle dishes: spicy Sichuan sausage, oozing with oil, fluffy stir-fried egg and tomato, cloggy shredded potato. He remains in a reflective mood, yet still holds court. While he talks to a local curator on his left, four or five assistants at the table with us largely eat in silence.

But the atmosphere is also festive. Ai calls out warmly to yet more assistants who settle at a table nearby and chats to a young hip designer he calls his 'niece' who sports a faux-fur jacket and giant sunglasses, giggling as she leans in. When I slurp up the remains of a bowl of noodles, he nods to me, impressed: 'Finished so much? You're great!' Such meals are commonplace. 'You go to dinner and there are 30 people at the table, every meal. And he pays for it all. His art is this incredible engagement, his art is everything. He's not fucking around, he really does care,' says the feted cinematographer Christopher Doyle, who worked with Ai on the music video *Dumbass* (2013).

Of course, spectators are essential to dissidents, as to artists. It is hard to tell with Ai if it is ego or selflessness, or a combination of both, that drive him forward day upon day, year upon year. If Ai could seek asylum abroad, it's doubtful that he would go. He is planning to open a studio in Berlin but is unlikely to move there permanently, even if his passport is returned. China is where he remains most relevant, and China feeds his creativity. 'How do you make your opinion legitimate or credible?' Ai asks. 'Actually I don't really know what I would become [if I moved away].'

Ai once admitted to the Chinese newspaper *Southern Weekend* that 'being threatened is addictive. When those in power are infatuated with you, you feel valued.' I ask whether that is still true. He thinks for a moment. 'When you feel

this kind of power, which affects so many people's lives, their happiness, their possibilities, their joy, and then you think you can shape that, and you have a way to change it, that is exciting,' he says.

But then he adds: 'Sometimes it feels so lonely.' How can you feel lonely, I protest, with all these people around you? The assistants, the friends, the foreign visitors, the hordes of social media followers, even the police and the authorities, all of whom, for better or worse, care where you are and what you are doing? 'I do, I do, I do,' he insists. 'People have good will to help you, but you still have to do the job. You have a certain vision or goal – a certain belief. You are doing it alone.'

'Ai Weiwei is back in production with his Fake studio and his team of assistants. What does art mean now to the dissident?' was originally written written by Clarissa Sebag-Montefiore in *Aeon*, 2 May 2014, https://aeon.co/essays/what-does-art-mean-now-to-the-mercurial-ai-weiwei

Reverend Billy Talen Faces a Year in Prison for Protesting in a Chase Bank

Peter Rugh

At 1 PM on September 12, performance artist Reverend Billy Talen and his Stop Shopping Choir walked into a JP Morgan Chase asset management bank on 52nd Street. and Park Avenue in Manhattan. Forty-five minutes later Bill and his musical director, Nehemiah Luckett, were getting handcuffed on an F-train subway platform by the NYPD with charges of rioting, menacing, and disorderly conduct. Now, Billy and Nehemiah are facing a year in prison.

In the complaint filed by the Manhattan District Attorney's Office, the bank's manager, Robert Bongiorno, said he saw "the defendants, along with approximately eight other people, [were] running about the bank while wearing frog masks." The frog people jumped on furniture and "repeatedly ran up to the faces of the bank's employees and customers while screaming, in sum and substance, 'WE ARE COMING FOR YOU!'"

Robert – who was reached by phone but refused to comment for this article – thought the bank was being robbed and, according to the DA, feared for his safety. He also told authorities that he "observed at least one customer or employee inside of the bank break into tears."

There are more than a few things Reverend Bill wants to clear up. For one, his choir was not wearing masks. Bill's legal council had advised against the choir covering their faces inside a bank. Those were toad-shaped hats over the choir's heads – the Golden Headed Toad of Central America, to be exact, which was last sighted in the cloud forests of Costa Rica in 1989. Climate changes in the toad's habitat are thought to have led to its extinction. The Golden Heads showed-up from beyond the grave at the exclusive Chase branch to warn the financial giant and the wealthy private investors that the midtown branch caters to that they (and all of us along with them) are next if they don't change their wicked ways.

Chase is a leading investor in greenhouse gas-emitting industries. The bank, for instance, lent or underwrote more than $8 billion toward coal extraction since 2005. Reverend Billy foresees a climapocalypse, a doomsday sponsored by the likes of JP Morgan and other backers of fossil-fuels, which are igniting an uptick in heatwaves, droughts, rising oceans, and storms like Haiyan.

"We could just see people putting money into the fossil-fuel cartel from those desks," Bill told me, this week as he fried eggs and sausage in a generous dousing of hot sauce at his apartment in Windsor Terrace, Brooklyn. Although he wasn't wearing his trademark white polyester suit and preacher's collar, he occasionally lapsed into the hemistich speaking rhythm of his alter-ego, "a reversed-out Jimmy Swaggart," as Bill put it.

In his youth, Bill tried his hand at Hollywood, but eventually became disgusted with the whole aspiring movie star scene. He moved to San Francisco and, in the late 90s, arrived in New York during the height of Mayor Rudolph Giuliani's reign. He came up with the Reverend character at a time when Starbucks were proliferating, Walmart was clawing at the gates of the city, and Disney had just opened a flagship shop in Times Square.

"We were anti-consumerists," Bill recalled of himself and the crowd he ran with back then, many of whom would eventually form the Stop Shopping Choir. "We were fighting the destruction of neighborhoods by chain stores and sweatshops union busting. We championed community gardens very early on and farmers' markets. We helped keep Walmart out of New York."

Spalding Gray was a huge fan."Don't ever stop preaching!" Bill said the late, great monologist told him. "'Even if there's nobody around. Preach to the supermodels on the billboards.'"

What started as pure satire, an evangelist exorcising Mickey Mouse from Times Square, became serious after 9/11. People from all walks of life began approaching the Reverend looking for spiritual guidance. In one instance, when the scent of the collapsed World Trade Center still hovered in New York's air, Bill was in costume, riding his bike over the Williamsburg Bridge when, before he knew it, he found himself with a girl crying in his arms. "I said to myself, 'Well, let's see. I'm an older person. I'm wearing this collar, which I bought for five bucks, but I'll just console people as best I can. That's all a religious person is. They might say that God gave them this calling. But that's all just... We know what that is."

After delivering thousands of sermons, Bill said he's learned, "You can tell a joke in the middle of a prayer and it doesn't make the prayer less powerful. A joke is not the same thing as disrespect."

He described what transpired in the Chase lobby as an "Earth invasion" – figuratively speaking. Nobody was harmed or physically threatened. "We told everybody in there we were conducting a protest and it would be over in 15 minutes. We didn't want anybody to be upset. People are so mesmerized by consumerism, when the choreography is broken, they don't know that to do. We've had souls saved on the spot and people run into the bathroom crying. It's all over the place."

Billy's attorney, Wylie Stecklow of the Wylie Law firm, described the charges as an "outrageous" attack on his clients' "expressive political activity."

Wylie explained that, by law, police cannot arrest a subject on misdemeanor charges, in Bill's case what would have amounted to trespassing, unless they catch the suspect in the act. They can, however, make criminal arrests without having witnessed the crime in question. Wylie believes the New York Police Department trumped up the charges in order to apprehend Bill and his choir director on the F train platform after the fact. And because Chase disapproves of the content of Bills' message, they are pressing ahead with the charges.

"You have a bank that is telling people, 'We don't enjoy your speech, so we are going to criminalize it,'" he said. "'We are going to take your very innocent speech and say that we fear for our safety.'"

Bill's been arrested dozens of times before for civil disobedience, but three nights is the longest he's ever been locked up. He has a three-year-old, so he's not exactly eager to go to go away for a year, but he's ready to take the case to trial if need be. "This our Pussy Riot at the high alter moment," he told me.

When, they're not jumping on the tables at banks, you'll find Reverend Billy and the Stop Shopping Choir leading revivals in theaters. Reverend Billy's quest for redemption is a recurring plot-line in their stage performances.

"I'm the best known person in the Church of Stop Shopping," said Billy. "I'm also a white, heterosexual male. Our story is that I'm failing all the time. I'm a failed prophet. I need the choir to come to my aid."

Right now, however, Billy's put his faith in the general public, asking them to be his salvation. He's launched a petition drive demanding the charges against him and his colleague, Nehemiah Luckett, be dropped. The letter to the DA has gathered more than 10,000 endorsements ahead of an evidentiary hearing, slated for December 9. The Reverend wants us to take climate change seriously, lest the human race go the way of the Golden Headed Toad. But, in the meantime, he's praying Chase and the DA's office will learn to a take joke.

'Reverend Billy Talen Faces a Year in Prison for Protesting in a Chase Bank' was originally written by Peter Rugh for vice.com, 4 December 2013, http://www.vice.com/read/reverend-billy-faces-year-in-prison-for-protesting-in-a-chase-bank

Earlobe-slicing artist Petr Pavlensky: 'I feel excellent'

The Russian artist talks about getting sent to the psych ward for his ear-chopping protest against state psychiatry

Marina Galperina

This Saturday, Petr Pavlensky climbed naked onto the wall of Moscow's Serbsky psychiatry centre and swiftly sliced off his right earlobe. The Russian artist stayed there, bleeding in the cold, completely silent and still for two hours. While he was forcibly removed, restrained and hospitalized, his statement against the psychiatric "institution" and the definition of the "norm" emerged online.

"Armed with psychiatric diagnoses, the bureaucrat in a white lab coat cuts off from society those pieces that prevent him from establishing a monolithic dictate of a single, mandatory norm for everyone," the *Guardian* quoted, tying in recent cases of politically inconvenient individuals being forced to undergo psychiatric evaluations at the Serbsky centre, including the captured Ukrainian air force pilot Nadya Savchenko and Bolotnaya Square anti-Putin protester Mikhail Kosenko. The same Serbsky centre is notorious for mass-diagnosing Soviet dissidents with "sluggish schizophrenia" before locking them away.

Previously, the artist had sewn his mouth shut, entangled himself naked inside a barbed wire cage and nailed his scrotum to the ground near the Kremlin – all very physical protest metaphors of submission to oppression. But it was his action *Freedom*, when he burned tires in the Red Square last February in homage to the Maidan protests in Ukraine, which had the Investigative Committee repeatedly trying and failing to have him declared insane.

Pavlensky was released yesterday. As he spoke to *Dazed* earlier today, he calmly explained how he penetrated the system to make the authority an active participant in the latest action. He laughed sadly when he described the conditions he saw inside the mental ward. He also made a few problematic declarations against the institution of psychiatry as a whole and the definitions of mental disorders. It was a nuanced and experiential critique, a bit of an Ouroboros. Draw your own conclusions. Or don't.

How are you feeling?

Petr Pavlensky: I feel excellent. Actually, there was no need for me to go into a hospital. It could have been fixed with a band-aid and I would have gone on with my day.

What happened after you were removed?

Petr Pavlensky: The action took place over two hours. It was quite cold. The representatives of authority were continuously trying to provoke me. When they put the mat down below, it was like placing food in front of someone on a hunger strike. The point was to endure. I was prepared to sit there all day. They pointed, cursed, shouted. But the mat was a distraction. They snuck up from the back, fell on me, twisted all my extremities. They placed me in handcuffs and tied my legs, strapped me to a gurney and lowered me off the wall with ropes.

How did you prepare?

Petr Pavlensky: I cut off my right ear lobe. It's a fragment, not a vital organ. I just needed to make sure that the knife was sharp enough, otherwise it would have caused me great suffering.

Why did you perform this action at the Serbsky centre, the site criticized specifically for its activities in the Soviet era?

Petr Pavlensky: We are currently in a state of total debauchery. It's nostalgic. There is a return to using psychiatry for political motives. These are Soviet methods, declaring that only those who are spiritually ill can oppose the future of communism. Currently, spiritual disorders and mental illnesses have absorbed the demons from the Middle Ages, and our faith in them. It's a new occultism: the union of the hammer, the sickle and the cross. Opposition is deemed either criminal or insane. But where is the mental illness? It's what is convenient; it is in service of stereotypes.

What about psychological help, as opposed to psychiatric treatment?

Petr Pavlensky: All of it is oppression to some norm, some stereotype and standard of normality. And these factors are controlled by the government. A person receives certain information – or propaganda – and that's how he forms his opinion. It is the framework that reinforces itself. Psychotherapists work towards normalization.

What if a person poses a danger to others?

Petr Pavlensky: I believe society can take care of that itself.

Your previous actions conclude in policemen arriving and removing you. As an artist, do you consider their actions as participatory in your performance?

Petr Pavlensky: Absolutely, that's part of it. My objective is to create a particular situation, using only minimal components... The government tries to make society and the individual into objects of their authority, to objectify them. My goal is to create situations which pull the governing bodies into it and objectifies them, when they intervene and develop the action, at the point when I am already not doing anything. I'm just sitting there, or lying down. I don't make another action or effort. I just stay still and not react, and they are forced to participate. That's one of the main elements — to make the instruments of the government powers produce the artwork. They can't neutralize me, really, because they are now performing in the action.

"I was given a proposition: if I just lie there and not say anything, they offered to take off the restraints" – Petr Pavlensky

When did you start speaking?

Petr Pavlensky: When my action came to an end in the hospital and I had to give my name and lawyer's number. That was after they injected me with something. Valium, I think? The doctor was very pleased reporting that that's what made me communicate. That's not true. The doctor decided I had some sort of mystery psychiatric disorder and needed further observation.

I was driven to a different hospital's psychiatric ward. A terrifying place, decripit. Dirty walls, peeling paint. There was a painting of a train. I got this sensation that it's all in a context of a day care center. I asked the doctor, why? "Well, so they can remember childhood, of course! When you were happy and taken care of. It's calming."

It's nonsense, of course. Half of the people there are drooling. I later found out that's called "passive" ("nonviolent"). The "passive" ones are basically vegetables. Once you do anything other than that, like start talking, asking questions or make any effort to assess your predicament, you're instantly labeled as "excited" ("violent"). I had a conflict with one of the staff within 20 minutes and they restrained me to the bed. I was given a proposition: if I just lie there and not say anything, they offered to take off the restraints. That's how it works.

There seems to be a direct parallel to the world outside, to individuals within a corrupt society. They are forced to conform to authoritative bodies so they can be "free", if they just stay down and don't say anything.

Petr Pavlensky: Yes, yes, yes, exactly. I came to understand the subtle parallel between the psychiatric staff's proposal and my ongoing case with the

Investigative Committee. The Investigative Committee has tried to get three separate courts to condemn me as insane (for burning the tires in the Red Square), but they just can't find a judge who would. I am required not to leave the city while I'm being investigated and ask for permission and papers if I must. Not restrained, but tied down nonetheless.

Funnily enough, I was able to wiggle out of the leg restraints under the blanket. The doctor and a group of staff came by and sat down, with the doctor's head quite within kicking distance. I showed the doctor that my legs were free... Look, I'm not going to try to hurt anyone, so what is the point? I talked to the doctor then, explained why I was doing this.

After that they picked a new tactic. They said I was in a severe, critical state and required life support. I was put into restraining clothing and transferred to an emergency wing. There was always someone in a room with me. They proceeded to terrify all the staff in the hospital, made a show of asking me not to damage or break anything because this is the life support section of the hospital; they are saving lives here, etc. At one point, a nurse tried to inject me with Haloperidol (an anti-psychotic). I didn't let him. He tried to put it into a vial of glucose to trick me. But I didn't let him.

I spent the night there. Another doctor came and talked to me. She said, "This is all very interesting. And strange." She didn't see that there was ever a need to transfer me to the life support wing out of the psychiatric hospital. She declared me "normal" according to the system of the psychiatric treatment. I didn't really need them to tell me because I reject their framework. I would have been ready in any case, even if that meant more time there.

"I am a perfectly ordinary person, just like everyone else in society. We are all governed by the same needs and desires, imposed by society... The government tries to instill in you that you cannot overcome this." – Petr Pavlensky

So, in this action, you critique the system by entering the system. Then you provoked the system to critique itself. Then you rejected that too, as part of the your critique of the system. It's a nice circle.

Petr Pavlensky: Yes, exactly. This is the work I do: interacting with the functions of power, the branches of its oppression. It's about penetrating their mechanisms and doing something with them. This is political action, to manipulate them into the action and drive forward the objectification as an art statement.

Are these actions part of a whole body or reactionary to current events?

Petr Pavlensky: I work in stages and I have to work in the informational field and keep working at it. It will never complete. This is my material. The government needs people as a biological material to build its authority. They

build societies where the individual can only function within that authority. It's a vicious cycle.

What if a person is suffering and asks for help? Every time we speak or I see you speaking in public, you appear seem strong, measured, in control. What about those who are not?

Petr Pavlensky: I am a perfectly ordinary person, just like everyone else in society. We are all governed by the same needs and desires, imposed by society. This is why I can talk about it. This is overcoming it. The government tries to instill in you that you cannot overcome this.

How can you help them though?

Petr Pavlensky: Well... In my practice, I am trying to help by setting a precedent. The government tries to neutralize the precedent by censoring it. Culture is a just a collection of codes.

But are you calling for shutting down the hospitals and letting everyone out, or are you primarily trying to demonstrate a precedent that would catalyze a different way of thinking?

Petr Pavlensky: Well, I am not calling to close the hospitals — that would be pointless. Shutting things down, getting things to open — that is a different mechanism. My objective is to make people question the psychiatric institution and the definition of the norm. If the definition of the norm is questioned, then it can no longer wield power over the people.

'Earlobe-slicing artist Petr Pavlensky: 'I feel excellent" was originally written by Marina Galperina for dazeddigital.com, 2015, http://www.dazeddigital.com/artsandculture/article/22278/1/earlobe-slicing-artist-petr-pavlensky-i-feel-excellent

Pussy Riot: The Jailhouse Interview

Michael Idov

They've become global heroes and foils to the macho rule of Vladimir Putin. But not even a two-year prison term can keep Russia's celebrated punk band muzzled. Michael Idov smuggled a few questions into the grrrls' gulag. Judging by their answers, the riot is just getting warmed up.

This year, Russia launched its first crossover pop stars since the days of Gorky Park – and it's done so by throwing them in jail. Pussy Riot, a feminist punk collective that staged guerrilla performances all over Moscow (culminating in a "punk prayer" in a cathedral, which got three of its members arrested), showed up on every front page from *Libération* to the *New York Post* and single-handedly revived riot-grrrl chic. Meanwhile, the fate of the three prisoners – Nadezhda "Nadya" Tolokonnikova, Maria "Masha" Alyokhina, and Yekaterina "Katya" Samutsevich – became an international cause, championed by everyone from Madonna to David Cameron. Sentenced to two years each on the absurd charge of "hooliganism motivated by religious hatred," the "girls," as everyone in Russia calls them, are getting by without the Internet, only vaguely aware of their global celebrity. *GQ* managed to correspond with them by slipping questions in with their lawyers. Katya's answers got confiscated. Nadya's and Masha's follow.

•••

GQ: What is your average day like now? How do you get the news from the outside?

Masha: They have small, medium, and large cells here. We're in three different small ones. Only the large cells have in-room showers; we get showers once a week. After 6 a.m., you're not allowed to sleep under a blanket. Theoretically, until lights-out at 10 p.m., you're not allowed to sleep at all, but in practice you can lie on top of the blanket and cover yourself with your coat. Nobody can explain why; the only answer you hear to any question is "That's the rule" and "We keep to a regimen here." Every day there's an hour-long walk in a "yard," which is a concrete box with two benches and a sliver of sky between a cement wall and a plastic roof. It's all "Hug the wall" this and "Hands behind your back" that. They search our cells regularly and confiscate our drawings and notes. Why? "The rules." Pretty much the only news we get is from federal TV channels. Only now do I realize the sheer amount of lies and censorship there. When you have the Internet, you don't feel it as sharply. But once a week our lawyers bring us different news, words of support, and that helps a lot.

Nadya: Prison is a good place to learn to really listen to your own mind and your own body. I've learned to read much more deeply, for instance. For four months, I had nothing to read but the Bible, so I read it for all four months – diligently, picking everything apart. Prison is like a monastery – it's a place for

ascetic practices. After a month here, I became a vegetarian. Walking in circles for an hour in that tiny dusty yard gets you into a pretty meditative state as well. We don't get much in the way of the news. But enough to get inspired.

GQ: A Moscow newspaper has printed a vicious article about how you're getting "VIP treatment" in prison, with massages and manicures.

Nadya: Did Auschwitz have VIP death lounges? If yes, then I suppose you can call our conditions VIP treatment.

GQ: Your closing statements in court, where you cite everyone from the Bible to Dostoyevsky to Socrates to Solzhenitsyn, have become instant classics. Some lines, like Katya's "We have already won" or Nadya's "People can sense the truth. Truth has an ontological superiority over lies" are now as famous as your songs. How did you manage to write these speeches with no access to any research? Were you at least able to coordinate them?

Nadya: Our trial, as you know, was designed to be as short as possible. The judge scheduled back-to-back court sessions from ten in the morning to ten at night. Then it took a couple of hours more to get us back to the cells. There, I would eat an orange, drink some milk, and start working on my speech by night-light. To get closer to the dim lamp, I would sit on an upside-down wash basin, right under the hooks where our clothes hang. After twelve hours at the courthouse and two transfers, I wasn't in the best of states. But it doesn't take that much effort to put truth on paper. Even if your head is splitting from exhaustion, it feels kind of nice to just let go and be sincere, to have an open soul. You can even allow yourself to be a kind of idiot, like Dostoyevsky's Count Myshkin.

Masha: Here in Russia, a prisoner has no Internet access, no computer, not even a typewriter, so I wrote everything by hand: many rough drafts and then a combined "clean" draft. We read some bits of our speeches to each other during the transfer, in the unventilated, smoke-filled prison bus.

Nadya: We didn't really coordinate with each other. After putting on performances together, we had learned to understand each other without words. But in court, we had some surprising coincidences. For example, Masha's statement and mine ended up using the exact same two quotations from the New Testament.

GQ: So, were you ready to end up in here when you put on the balaclavas a year ago?

Nadya: We knew we were in a kind of risk zone. But we deliberately did things that were peaceful and nonviolent and didn't even damage other people's property. We specifically made sure not to break any laws. When people asked us if we were afraid, we'd say, "We're not doing anything illegal – and if someone decides to put us in jail, they'll do it anyway."

We acted according to Paul Feyerabend's slogan: "Anything goes." From our very first performance on, we were shadowed by the so-called Tsentr E ["Center for Combating Extremism," basically a police unit designed for persecuting political opposition], but we decided to keep going regardless of the pressure. Anything goes.

GQ: Did you think that it would be specifically the church performance that got you arrested? Your Red Square show [where Pussy Riot performed a song titled "Riot in Russia – Putin Is Chickenshit" right by the walls of the Kremlin] seemed far riskier at the time.

Nadya: To be frank, we tried not to think about the possible arrests at all. If you start thinking about this sort of thing, you can't do anything political. Plus, we couldn't even imagine that the authorities would be so dumb that they would actually legitimize our influence by arresting us. Sure, Tsentr E tried to intimidate us by tailing us constantly. But unlike Putin, we're not chickenshit – so we didn't stop performing. The church performance was a perfect opportunity for Putin's apparatchiks to claim that our motives were religious intolerance and not political protest. This way our persecution could be framed as a righteous burning of blasphemers, as opposed to just stifling free speech.

GQ: "Pussy Riot" is a weirdly perfect band name, especially considering you're Russian. Who thought of this first?

Nadya: It's hard to even remember now. We were all in this near panic. We had just suddenly realized that there has never been a feminist punk collective in Russia and decided to create one right there. So we were all kind of manic and excited and came up with the name on the spot.

Masha: Everything is collective – the lyrics, the band name.

GQ: Did you know that your anonymous bandmates who are still at large would actually drop a single, "Putin Lights Up the Fires," on the day of your verdict?

Nadya: I had no idea. I was also pleasantly surprised when they blasted the single [outside the courthouse] during the verdict.

Masha: I had an inkling they would.

GQ: Were you surprised by the scope and the volume of Western support for you?

Nadya: I still can't shake the feeling that I've spent the last six months acting in a big-budget movie. The amount of Western support that we got is a miracle. I believe that if Russia had independent national media, our performance would be better understood at home as well. Right now we're

in hell here. It's hard living in a place where everyone can hate you because of something they heard on TV. That's why every gesture of support is so important and so much appreciated.

GQ: How and when did you find out that Madonna has performed "Like a Virgin" in a balaclava, with the words "Pussy Riot" on her bare body?

Nadya: On August 7, the judge suddenly ended the session at 6 p.m., not at 10 as usual. "She's going to Madonna's show," we joked as they took us out in handcuffs, with that police dog barking at us. Next morning, as we arrived to the courthouse, our lawyers ran to us with some blurry black-and-white photos of a half-naked woman in a balaclava, with "Pussy Riot" on her back. We're like, "Oh wow, that's cool." And our lawyers say: "You don't get it, this is Madonna!" "Wow, that's REALLY cool." That was all we could even say before the judge came in, and our useless trial began again.

GQ: Does it bug you as feminists that your global popularity is at least partly based on the fact that you turned out to be, well, easy on the eyes?

Nadya: I humbly hope that our attractiveness performs a subversive function. First of all, because without "us" in balaclavas, jumping all over Red Square with guitars, there is no "us" smiling sweetly in the courtroom. You can't get the latter without the former. Second, because this attractiveness destroys the idiotic stereotype, still extant in Russia, that a feminist is an ugly-ass frustrated harridan. This stereotype is so puke-making that I will deign to be sweet for a little bit in order to destroy it. Though every time I open my mouth, the sweetness goes out the window anyway.

GQ: This is perhaps an insensitive question, but what's more useful for the progressive movement in Russia right now: Pussy Riot at large or Pussy Riot in jail?

Nadya: We will know the answer only after the next wave of protests. I would love to see that, even imprisoned, we can still be useful and inspiring. In any case, I'm happy I got two years. For every person with a functioning brain, this verdict is so dumb and cruel that it removes any lingering illusions about Putin's system. It's a verdict on the system.

Masha: At large, of course. That's why the authorities don't want to let us out. But we still have things to say, and we still want to say them. And even locked up, we're not doing too bad of a job.

"We couldn't even imagine that the authorities would be so dumb that they would actually legitimize our influence by arresting us. Sure, they tried to intimidate us constantly. But unlike Putin, we're not chickenshit."

'Pussy Riot: The Jailhouse Interview' was originally written by Michael Idov for GQ.com, 24 September, 2012, http://www.gq.com/story/pussy-riot-prison-interview

Performance Under Attack: Part 2 Exhibit B

Exhibit B press release

Barbican

Exhibit B tackles controversial and sensitive issues; however I'd like to assure audiences that it aims to subvert and challenge racial or cultural Otherness, not to reinforce it.

Exhibit B involves performers demonstrating the brutal reality behind colonisation accompanied by text that reveals the historical context of each scenario. The piece aims to explore the relationship between Western powers and Africa, ranging from exposing the abhorrent historical attitudes to race during the colonial era to questioning how far our society has moved on by holding up a mirror to contemporary issues such as the current treatment of immigrants and asylum seekers. It provokes audiences to reflect on the historical roots of today's prejudices and policies and how these have been shaped over centuries.

Visitors to the performance are forced to confront the reality of this dehumanizing treatment with the performers directly meeting the eye of audience members. The reaction from those who have taken part in the piece has been very positive and the company who toured the piece internationally has collected many moving testimonies from these performers. The final room of the installation contains some of these testimonies, with performers reflecting on both their involvement in the piece and providing their personal experiences of racism and prejudice they've experienced in their own lives.

Previous performances of *Exhibit B*, such as in Amsterdam, Brussels and most recently Edinburgh, have attracted a diverse and politically engaged audience and it has been seen as a watershed work that provokes discussion about racism and the historical roots of prejudices. The reception from both audiences and critics has been overwhelmingly positive with the *Times*, *Guardian* and the *Evening Standard* all giving the performances in Edinburgh 5-star reviews and reflecting the power of the production in confronting "the appalling realities of Europe's colonial past" (*Guardian* review) while raising important contemporary questions about treatment of immigrants and the objectification of individuals.

The subjects tackled by the *Exhibit B* are of course hugely emotive and I would encourage you to experience the piece itself in order to fully engage with the content. As an organisation that presents an international programme to a diverse audience I can assure you that the neither the Barbican nor our

partners in this project, Nitro and UK Arts International, would programme a production that promoted racism in any way.

I do hope you are able to see this important work during its London run.

Best wishes,

Toni Racklin
Head of Theatre, Barbican

A further response from our partner in presenting *Exhibit B*
Brett Bailey's work focuses on human injustice and the abuse of power. It is a theme that runs through all his productions and is especially present in *Exhibit B*, which illustrates what happens when we objectify others, as a prerequisite of permitting atrocities.

Brett is a South African who has grown up in an environment which has repressed the majority of its people. As an artist, his impetus has been to unearth not just the injustices of apartheid, but to hold a mirror to the effects of European colonisation throughout the continent.

His work is neither sensational nor voyeuristic. It is powerful, responsible and extremely moving. The *Guardian* review calls it "unbearable and essential". It is both of these things.

UK Arts International has been presenting politically engaged and culturally diverse work since 1992. *Exhibit B* is no exception and I sincerely hope people will leave their prejudices on one side and experience this important piece of work.

Jan Ryan
Director – UK Arts International

Response from Brett Bailey, director of *Exhibit B*
Nowhere do I term *Exhibit B* a 'human zoo'. *Exhibit B* is not a piece about black histories made for white audiences. It is a piece about humanity; about a system of dehumanisation that affects everybody within society, regardless of skin colour, ethnic or cultural background, that scours the humanity from the 'looker' and the 'looked at'. A system that emphasises difference rather than similarity. A system that gave birth to the hegemonic regime of separation in which I grew up, and which continues to haunt the people of my country. The kind of systems we need to guard against.

Testimonies of performers who have previously taken part in *Exhibit B*

Lazara Rosell Albear
(performance artist and musician, Brussels)
Performing in *Exhibit B* was one of, if not the most, powerful experiences of my

career due to the combination of different factors. As a performer it was a big challenge to sit still for 110 minutes or more during a period of different days. This restriction may seem insurmountable but it's overcome by the realization that your real power comes from your soul, your heart and your state of mind and the connection between them.

There is also the factor that as a black person I'm not only representing my generation but all my ancestors and their pain and struggles which we carry, by way of saying, in our genes and are still feeling today, maybe on a less violent but subtle way, but nevertheless penetratingly deep. This becomes your backbone or the armour holding you and keeping you in focus.

Erasing the distances: another important aspect is the proximity with the audience and the quasi-individual contact with them. A contact that is made through the eyes. It's through the eyes that we perceive the world (among other senses). It was sometimes very confronting to experience some of the public reactions. But the thoughts of staying true to myself and of showing generosity and compassion and offering them a positive energy gave me strength.

They say the eyes are the windows to the soul. One really has to be honest and drop all the barriers (emotional, psychological, preconceptions, misconceptions) that block the radiance of the soul. The public should be able to perceive it too. One should become a mirror for the spectators. In a mirror you see your own reflection. We are all equal.

In the project we are playing a role but at the same time we are playing ourselves. This can be tricky, so one has to remind oneself of this fact. It was an amazing exercise. The breath, breathing deep was very helpful. It's also the air that we breathe that connects all of us. We are all sharing the same air.

I find that *Exhibit B* combines performance art, the visual arts, activism and spirituality in one project and this is a combination I had never experienced before. It made me grow not only as an artist but as a person in my daily life. The piece speaks about the future as well by making the audience conscious of lost or less known episodes of our collective memory with the hope that those horrendous times will never be back.

S.R. "Kovo" N'Sondé
(historian, academic, Berlin)
The human zoos in Paris, during the 1931 colonial exhibitions still have the record attendance for a public event. Millions of persons participated in this monumental and racist "mise en scène" which aimed to support the imperial and colonialist French ideology of the time. The irony is that the remembrance of human zoos disappeared from common memory until these last years. Fortunately Didier Daeninx in literature, Abdelatif Kechiche in cinema and Brett Bailey with *Exhibit B*, give keys to remember and think about what happened, not only in France, but in all the occidental world. Participating in

Exhibit B was for me not only a political act but also an existential experience: in the Berlin audience – mostly white and European – some persons full of culpability were trying to apologize, looking for compassion in my eyes. Some were crying, submerged in the cathartic dimension of the situation, and the beauty of the choir. Some others were still in search of alterity. Outside a Berliner activist association, black and white activists, were holding a protest against the event. There was a free debate after. I felt like an afro-punk star but I'm still happy that so many people felt concerned by such a serious matter. Anyway, there are still stolen heads of human beings in Paris, Berlin and London, so still a lot of work to do.

Veronica Booysen
(activist, social worker, originally from South Africa, now living in Ghent)
Performing in *Exhibit B* was a whole new confrontation with who I am as a person, my roots and my future. As I have been growing up in a protective environment, I never really felt the damage of what a system like Apartheid could cause. My parents always tried to protect us by not sending us to shops and sending us to schools where everybody was treated equally. Since I was 16 I finally entered the real world and immediately engaged myself to fight for what is right. At the moment I live in Europe and I am very much involved in local politics. I am candidate for the federal elections in Belgium.

I strongly believe that we are here to make a difference in what this shitty world can offer humanity. I was very fortunate to be chosen to be part of *Exhibit B*. Still think about my experience as one of the most intense experiences in my life, and I have had some intense experiences before, like living on the streets as a homeless person in Spain, being chased away with dogs and being hungry and having to beg for food. I wanted to do this to know what it is to be homeless and spit on...If I have to choose between a rich and luxurious lifestyle and a homeless and "poor" life, I choose the latter...

Cole Verhoeven (performer, activist, Amsterdam)
I was very skeptical of the work, the intention of the project and of the director for the greater part of the audition. I don't accept any work that feels stereotypical or exploitative in any way. Often performers on stage are enjoying themselves and the experience more intensely than the audience members. This piece is about being less comfortable but giving the spectator HUGE gifts: the gift of recognition of suffering, the gift of validating as opposed to denying black experience.... I also don't think I'll ever be a part of something so monumental. But for all the physical discomfort, the piece gave me a real injection of power, a booster shot, and ignited even more my activist spirit.

Junadry Leocaria
(dancer, Amsterdam)
I am proud to be part of *Exhibit B*, because this exhibit educates people and makes then aware of a painful history. A history that not many dare to tell but needs to be told so we know our ancestors story, how they sacrificed themselves knowing that one day we will be free and honor them. I believe

that *Exhibit B* is a healing process for the audience and for the actors because nobody walks out the exhibit untouched. It does something to you whether you like it or not.

Lucinda Sedoc
(performer, Amsterdam)
Exhibit B was more than a performance for me. It was for a few days my lifestyle. Working with Brett opened my eyes as a person. He showed us stories that need to be told, because nobody knew that they were there. I was a part of something that is not in books, maybe wasn't even on the news but it was there, it's all true. Being able to be a part of that was at first hard.

My story was the slave woman on the bed! At first I was mad and I hated every white man who looked me. But in due time, this hate became pride! Pride because I was not just a woman that was hurt. I was a woman who stood for something. I played a strong woman, a good wife and a good mother. People felt it, and I know this, because they were crying for me, and I would look back at them and tell them just with my eyes that it's ok! It's ok because they know now! It meant a lot to be a part of this project! And believe it or not, in all my theatre or stage or acting, performing *Exhibit B* was for me the best thing ever! I'm honoured that I was a part of this, *Exhibit B* is not just a performance this is life!

Gideon Everduim
(activist, performer, hiphop musician, Amsterdam)
Exhibit B is a journey not only for the ones in the installation, but also for the public, people who already knew the story of our ancestors, and people who never knew the Transatlantic slave trade story.

For them it's a journey of emotions where you at the end will strengthen yourself, go outside and share your emotions with family and friends. Going to work will never be the same because of the obligation you feel.

Because of the awareness of past, present and future coming all together this journey as a whole did so much for me as an artis tand forme as a human being!

I truly believe that the installations definitely change people perspective on how we treat each other.

Bernadette Lusakalalu-Mieze
(nurse, Brussels)
Exhibit B has awakened me about the horrors of the past that are part of our history, not only the history of black people but of white people as well. We live with this wound, on one side those who feel victims and on the other side those who feel guilty.

Joseph Kusendila

(film maker, performer, Brussels)
Exhibit B is strength, dignity, silence but also respect, love, passing through the time. I don't want to make a list of complaints, of stories. The only story that I have to tell is the one of History, the one that you have read.

William Mouers
(singer, Namibia)
I can honestly say that the experience has changed my life in such a meaningful way. Being from a small unknown country like Namibia, I have never felt more proud of my roots and where I'm from. Being part of the exhibition has taught me the value of friendships and what it means to be an individual coming from an oppressed past. I always thought that people from Africa had it worse than others. Although that may be true in some respects, I discovered that people from all over the world have had it bad in different situations. But it is how you as a person learnfrom that situation that counts the most. The exhibition has been a healing experience for me as well, it has taught me the value of forgiveness and what amazing bridges forgiveness can build for humanity. It provides us with a once in a lifetime chance to take hands and move towards a brighter future without allowing the past (no matter how hurtful it may be) to hold us back.

'*Exhibit B* press release' was originally written and published by the Barbican, London, 2014. Reprinted with permission from the Barbican and Brett Bailey./

Edinburgh's Most Controversial Show:
Exhibit B, a Human Zoo

John O'Mahony

It's the first Edinburgh rehearsal of *Exhibit B* and there's mutiny in the air. The work, a highly controversial installation by the South African theatre-maker Brett Bailey, is based on the grotesque phenomenon of the human zoo, in which African tribespeople were displayed for the titillation of European and American audiences under the guise of "ethnological enlightenment".

The zoos, which blossomed in the nineteenth century and continued right up to the First World War, sometimes took place in entirely transplanted tribal villages, but also in the freak show context of local fairs, where the infamous Hottentot Venus, as Sara Baartman was called, was poked and gawked at because of her large buttocks and "exotic" physical form. Perhaps the most extreme case was that of the Congolese pygmy Ota Benga who, in 1906, was put on display at the Bronx zoo in New York alongside the apes and giraffes. Bailey's installation aims to subvert the premise of the zoos by replacing its exhibits with powerful living snapshots depicting racism and colonialism: a black woman chained to the bed of a French colonial officer; a Namibian Herero woman scraping brain tissue out of human skulls; the slowly revolving silhouette of Baartman.

The only problem is that the young black performers, cast locally at every stop along the tour, aren't quite getting it. "How do you know we are not entertaining people the same way the human zoos did?" asks one. "How can you be sure that it's not just white people curious about seeing black people?" adds another. As the temperature in the room begins to rise, the group cries out in unison: "How is this different?"

As a director who has courted controversy at almost every step of his career, Bailey is no stranger to this kind of confrontation. A white South African from an affluent background, his only early contact with his black countrymen was as servants. But after the collapse of apartheid in 1994, he trekked off alone into the rural Xhosa villages where Nelson Mandela had grown up. Living for three months among sangoma shamans, he drew on African ritual and music as the inspiration for his first works: *Ipi Zombie*, in 1996, based on a witchhunt that followed the death of 12 black schoolboys in a minibus crash; and *iMumbo Jumbo*, a year later, about the quest of an African chieftain to recover the skull of his ancestor from a Scottish trophy-hunter.

His 2001 work *Big Dada*, which drew comparisons between the regimes of Robert Mugabe and Idi Amin, marked a shift into darker, grainier territory; and in 2006, with the unflinching *Orfeus*, he bussed his audience off to a post-colonial underworld of sweatshops and human trafficking. That was when he began to shun conventional spaces. "Theatres feel to me pretty antiseptic," he says. "Working in a deserted factory or a Nazi concentration camp, the associations are deeper and wider."

All this has led to a reputation as "Africa's most fearless theatre-maker", and eventually to *Exhibit B*, which will fill the vast cloistered space of the Edinburgh University library, not just with searing visions of past racism, but also with contemporary tableaux that Bailey calls "found objects". These are representations of refugees and asylum-seekers that link today's "deportation centres, racial profiling and reduction of people to numbers" to the dehumanising ethos of the human zoos.

Already seen in various European capitals, the work has proved incendiary, particularly in Berlin, where it caused fury among leftwing anti-racism campaigners, who questioned the authority of a white director to tackle the story of black exploitation. Bailey seems to relish the entire spectrum of reaction: "I'm creating a journey that's embracing and immersive, in which you can be delighted and disturbed, but I'd like you to be disturbed more than anything."

Back in the rehearsal room, sporting a striped beanie hat and a very pointy, ginger-flecked beard, the director looks somewhere between a new-age wizard and a children's TV presenter. His entrance is suitably dramatic, sweeping into the room unannounced to fix each performer in turn with a gimlet-eyed gaze. There follows a gruelling programme of psychological exercises to perfect the show's single dramatic device: the steely stare that each performer locks on to the spectator. "It's very difficult to get it right," he explains. "The performers are not asked to look with any anger at all. They must work with compassion."

All the while, Bailey is an uneasy, almost abrasive presence, making unhelpful comments about the revealing nature of the costumes and spouting the n-word provocatively in his clipped South African intonation. "He's a badass! He gets it done," says Cole Verhoeven, a previous performer, hinting that his spikiness may be a strategy to weed out the non-committal. "His intention is clear. And our intentions had to be clear in order to do the work with any authenticity."

But when one of the female performers breaks down in tears due to the intensity of the process, Bailey is quick to move in with gentle reassurance. And as the mutinous insubordination and squabbling reach fever pitch, his response is firm and decisive. "What interests me about human zoos," he tells the group, "is the way people were objectified. Once you objectify people, you can do the most terrible things to them. But what we are doing here is nothing like these shows, where black people were brought from all over Africa and displayed in villages. I'm interested in the way these zoos legitimised colonial policies. But other than that, they are just a catalyst."

To craft each living image in the installation, Bailey conducted intensive research, sometimes taking three months or more to build a single tableau from photos, letters, biographies, official documents, paintings. One of the most harrowing, titled *A Place in the Sun*, was extrapolated from an account he came across of a French colonial officer who kept black women chained to his bed, exchanging food for sexual services. "It's a picture of unimaginable

suffering," says Bailey. "She is sitting there looking in the mirror and waiting to be raped. It's the only way she can feed her family."

Perhaps the most chilling, though, is *Dutch Golden Age*, which combined Bailey's interest in still-life paintings with a court document detailing the horrific punishments meted out to escaped slaves. "Among the overflowing bowls of fruit," says Bailey, "we have a slave forced to wear a perforated metal mask covering his face and a pin going through his tongue. It is about the silencing of marginalised black voices, the silencing of histories."

And it was while sifting through thousands of photographs in the Namibian National Archives that Bailey found the subject that would be the climax of his work – the four singing decapitated heads of Nama tribesmen. "After the heads were cut off," says Bailey, "they were mounted on these strange little tripods that were custom-made. Then I found these songs that referenced the genocide of the 1920s. So it became a set of four heads singing songs and lamentations."

Bailey does not consider any of the pieces complete without the addition of the spectator – the labels on each work even mention "spectator/s" as one of their "materials". And they have found audience interaction to be a profound element. "We were playing a festival in Poland," says Berthe Njole, who had the part of Sara Baartman. "A bunch of guys came in. They were laughing and making comments about my boobs and my body. They didn't realise I was a human being. They thought I was a statue. Later, they returned and each one apologised to me in turn."

Bailey is unsure how the piece will go down in the UK, which has its own long and chequered colonial history. Cole Verhoeven certainly believes in Bailey's right to ruffle feathers in telling these uncomfortable stories. "*Exhibit B* is monumental," he says. "And Brett's whiteness perhaps gives him a degree of distance necessary for wading around in this intensely painful material."

But, looking back at some of his earlier work, Bailey is now the first to admit that pushing too hard and being too bold is an occupational hazard. "People have said, 'White boy, you are messing with my culture. You have no right to tell the story of our spiritual practices or our history, because you are getting it all wrong.' And I can't defend those works today in the same way I could back then. For all I know, I could look back at *Exhibit B* in 10 years and say, 'Oh my God, I am doing exactly what they are accusing me of.' But that's the risk you take. It comes with the territory."

'Edinburgh's Most Controversial Show: *Exhibit B*, a Human Zoo' was originally written by John O'Mahony for *Guardian*, 11 August 2014, http://www.theguardian.com/stage/2014/aug/11/-sp-exhibit-b-human-zoo-edinburgh-festivals-most-controversial Copyright Guardian News & Media Ltd 2016.

Exhibit B

Selina Thompson

Eurgh.

God, guys! I'm actually going to try and write something and be serious and coherent the whole way through, and not just dick about. I hate doing that. But I need to.

I'm in Edinburgh at the moment, with twofold intention. The first is to perform my show, *Chewing the Fat*, and to do standard Edinburgh stuff – look at everybody elses work, talk with people about work, sort of suss out what the craic is, what the little microcosm of an industry I'm in is up to. And the second is to begin the gentle, complex thinking needed for my next show. It's called *As Wide And As Deep As The Sea*. It's about Black British Identity. It's about how it's shaped and formed, and about its decreasing visibility. It's about my people, I guess.

"sometimes the beauty of my people is so thick and intricate. i spend days trying to undo my eyes so i can sleep." – Nayyirah Waheed.

As a part of that thinking, I went to see Brett Bailey's *Exhibit B*, which is a part of the EIF this year. I want to write my experience, and my thoughts of going, and experiencing this piece of work. This is not a review – because reviews require some measure of composure, objectivity and fairness, which I have no interest in applying in this case. And I think it's icky when artists review other artists' work. But I'm reading a lot of shit (yeh, I swore. Not a review!) about this particular piece of work, and I'm sick of it. So here's where I am.

1. Me and my producer read about *Exhibit B*. We are looking to see as much work on race as we can find at the Fringe between us. This work is fanfared. It is expensive. It has been made by a white man, with an all black cast. This disturbs me a little, if I am honest – BUT I don't think this disturbance is coming from a place I want to indulge. I am desperate to find a way of opening dialogue, and I think this attitude closes it down. So I resolve to go. Coincidentally, Emma and I go on the same day.

2. AT EIF, *Exhibit B* takes place in the Playfair Library Hall. Edinburgh is full of stunningly beautiful buildings, and streets that make you want to sing songs from my fair lady – to an extent that you sort of block them out as white noise. Having to seek out and come to this building stops you blocking it out. It's beautiful. Old Stone, Immaculately Kept Lawn, Pillars, Coats of Arms... it is wealth, and that sort of weird dignified pageantry that you get at old British

universities. It's beautiful. It is tradition. We all know what that tradition is steeped in. We line up, and are told that from the moment we enter, there will be silence. No talking. People ignore this instruction.

3. If you are interested, the ethnic breakdown of the audience on the day I go – me and one other black man, an asian family (mother, father, child) and everybody else is white. This is standard Edinburgh fare. Perhaps slightly more diverse than usual for an audience of about 20.

4. We enter a waiting space. There are chairs, which we sit in. The artist in me loves the theatricality of this bit actually (damn, I slipped into review..) BUT what is important here, is what you see. It's that wealth and tradition again. We are surrounded by images, of old white men. Massive portraits, hung everywhere you look. We see their profiles. They are painted in oils. These men have chosen how they will be remembered, and they have been remembered as human beings. Powerful human beings, surrounded by books, clocks, scrolls – signifiers of intelligence, dignity. As we walk up the stairs, up the red carpet, that is who watches over us.

5. I sit closest to the door, so that if I need to get out, I can.

6. Brett Bailey has written a programme. It is an odd document. He presents his body of work – which has 'always aimed to explode stereotypes of racial or cultural Otherness, not to reinforce them' as being 'antecedents' of the zoos and exotic spectacles of days gone past. He talks of being 'fascinated' by museum plaster casts of 'indigenous bushmen' as a child. He outlines, very clearly his intention:

'To scratch through conveniently forgotten archives of colonial history – forgotten by those who once held the colonies, that is – and to give iconic shape to some of the many ways in which Western Powers have dehumanized those that they have sought to plunder, to control, to exploit and to exclude. To dramatize the violence of a system that has debased the people on both sides of the glass of the display cases that it has erected'

5. I enter the Exhibit. I am the last to go upstairs, which I am relieved about. To begin with, I am overwhelmed by the pain of it. You are initially confronted by two people – a man, a woman. They are presented as though they are in a museum. They stand beside skulls, wax works of animals. They are both topless, and they look vulnerable. The look exposed. It hurts my heart to see them presented like that. And for a while, I cannot look at them and meet their eyes. I am hurt by it, hurt so bad. And that pain continues. Little clusters of people are stood around certain exhibitions... and it makes my body fizz with rage to see the cool calm, specatorship of it. The 'we are looking at art' faces.

One man is sat down, sucking the end his glasses, looking at three disembodied heads singing a lament.

The asian man puts his arm around his daughter – she is upset, and they leave.

Dotted throughout the exhibition are wooden plinths, with gold plaques, and on top of them, white marble busts of the head and shoulders of white men. There are security guards. They are all white too.

I cannot see the black man who was in the audience. Maybe he left before I got into the space.

6. But the longer I walk around the Exhibit, the less 'affected' I am by it, and the more irritated and angered I am. What is this piece FOR? Seeing black people, seeing African people – presented as bodies, rather than people: this is nothing new. Seeing those Black Bodies suffering, presented in unbearable pain and terror, this is NOTHING NEW. Black women as sex objects waiting to be raped, as anatomical specimens to be examined, as Mammys, as animals, seeing black men disembodied or presented as violent and frightening, in cages, with their bodies maimed, or without bodies at all, as four disembodied heads sing at the bottom of the exhibition – a mournful lament, of course, so that the whole space reeks of pity and shame and grief – seeing black history presented as though it began and will end with Colonialism – i.e. when white people come into the picture, is NOTHING NEW. It is not radical, it does not challenge me – actually, it doesn't challenge anyone really, because it feeds into a cultural narrative that is all too common. One in which pain and persecution is the only way in which we can understand the experience of blackness, one in which we fetishize the black experience as abject, and I am so done. So done.

7. Having discovered how done I am, I begin to look at the models, in their eyes, dead on. Because I wish to know what this piece has for me. If I am not someone who can be made to feel guilty by this work, what does it have to say? Nothing. I find that the performers cannot meet my gaze. They look at me – and their gazes confront – and I look right back. Their eyes drop. Perhaps I am too angry, and my anger is accusatory. I don't care. I move about the space angrily. I look at it all, I read it all. I am angry. It is lazy, it is indulgent – it reproduces without commentary, and nothing about it seems to stimulate discussion, or dialogue, epitomised by the fact that talking is banned, forbidden in the space. What about this work, is opening things up? What is it bringing to light, how is it getting us to talk, to make change, and make the world a better place?

8. Brett Bailey is in the space. It is the first day of the exhibition, so I guess this is fair. Most people there won't recognise him, I suspect, because they do not stalk people on the internet as hard as I do. He lingers around the exhibition, and watches our reactions. He feels like a voyeur, in that space, his space, oddly. When I leave the exhibition, I glimpse him sat in the disabled toilet watching people's faces as they leave. It occurs to me that a lot of this exhibition is about him, and his guilt. I feel like I ought to confront him. I don't.

9. We go through two rooms before we leave. The first is filled with little plaques from each of the performers, explaining why they chose to be in the work. I hate it. It feels like the artistic equivalent of somebody saying they can't be racist because they have a black friend. It also negates the fact that they are used simply as bodies within the work. They stand still. Say nothing. Their words and thoughts are excluded from the work, so that Brett Bailey can exorcise whatever demon it is that he is battling. In the final room, people are invited to write down how the work has made them feel. I am sickened by the premise of this – it feels like a giant group wank, everybody saying how powerful and important it is, and thanking Brett Bailey for making it. Eurgh. The rage is sort of clouding my eyes a bit, so I leave.

10. I call Emma, ask how she is. She tells me she feels full of grief and of guilt. We talk a little – me angry, she, still processing. Then she goes into her next show.

11. I talk with someone else about it. I tell them I think the work is shit. They tell me 'I'm angry though, and that that is a response, a potent and important one'. I wonder what sort of wonderland this person lives in, where they think that a black person being angry about the atrocities that have been committed to their ancestors is a shiny new feeling at the age of 24.

12. I have a drunken (extremely) conversation with another artist – who I trust – about it that night. I can't really remember what she says, but I feel a bit better afterwards. She questions whether other people – people who are not me, need to see that work, and need to feel guilty... she just ponders it, doesn't say it's an answer. I'm not sure. I don't think those images need seeing in that way, and I don't feel that presenting those images asks questions – the work feels like a blunt object, unseeing, concussing, with no nuance or subtlety. She signposts me to other works – *Süßer Duft* which I love (also by a white man).

13. Throughout my time in Edinburgh, I have been having conversations with an artist here whose work touches on race (though it's not really about that), which I struggled with. Literally ran from the space in tears at the end, and then woke up the next day, still in tears about it. He instigated a conversation with me about how I felt about it. He was fair, and he listened. It is a work I would like to see again. It is a work, that still bounces around in my head – words from it, images from it. It hurt – but it challenged. It has changed my thinking, in some small, subtle way. I want to wrestle with the questions that piece asks, and come to peace with it. I am a firm believer that conversations about race will always be painful in the world we live in. This is what makes them so urgent and so necessary.

14. There is a *Guardian* piece about the work – we are told it is controversial (this word makes me want to spit), There is this:

'The only problem is that the young black performers, cast locally at every stop along the tour, aren't quite getting it. "How do you know we are not

entertaining people the same way the human zoos did?" asks one. "How can you be sure that it's not just white people curious about seeing black people?" adds another. As the temperature in the room begins to rise, the group cries out in unison: "How is this different?"'

The tone of this journalist infuritates me – 'aren't quite getting it?' Get Out.

'Bailey seems to relish the entire spectrum of reaction: "I'm creating a journey that's embracing and immersive, in which you can be delighted and disturbed, but I'd like you to be disturbed more than anything."'

'All the while, Bailey is an uneasy, almost abrasive presence, making unhelpful comments about the revealing nature of the costumes and spouting the n-word provocatively in his clipped South African intonation.'

Eurgh. It's a repulsive article. http://www.theguardian.com/stage/2014/aug/11/-sp-exhibit-b-human-zoo-edinburgh-festivals-most-controversial You read it, you might find something in it that is useful.

I'm so exhausted by the whole thing – I'm going to stop writing now, which isn't a particularly strong conclusion, or powerful way to finish. But fuck it, I don't care, have my exhaustion, and my frustration, with work like this. With the way it is presented and the way people talk about it, and the relentlessness of it. I'm sick of it. I. AM. DONE.

And I'm going to be the change I want to see in the world and make something BETTER. Because this is bullshit.

'*Exhibit B*' was originally written by Selina Thompson for selinathompson.co.uk, and *Contemporary Other* issue 1, 12 August 2014, http://selinathompson.co.uk/exhibit-b/

Exhibit B: Artists Must Have the Right to Shock

Manick Govinda

It was a sad day for freedom when Brett Bailey's work was shut down by a mob.

London is the most exciting city in the world for art and culture. It's a cosmopolitan urban sprawl, vibrantly multiracial, tolerant and with space for all kinds of art and ideas, coming from all corners of the world. This amazing city cherishes artistic freedom and free expression as key rights.

Or so I, and others, thought. Sadly, however, our vision of London was somewhat shattered this week, when it was reported that a performance art installation conceived and directed by the South African artist Brett Bailey was cancelled in response to loud protests by 200 people outside the venue in which it was being hosted.

Programmed by the Barbican Centre but due to be displayed in the atmospheric, dark spaces of the Waterloo Vaults, the soldout event *Exhibit B* was scheduled to run for five nights for a very limited audience. Only 750 people would have got the opportunity to see this promenade-style performance. An exploration of racial tensions, and specifically of the nineteenth-century phenomenon of 'human zoos' in which people of African descent would be put on display for European viewers, the installation featured black actors in chains and in cages.

Tiffany Jenkins' review of the installation for *spiked*, from when it was hosted at the Edinburgh International Festival in August, captures very well what the work is like. I had a ticket for the 6:30pm slot at the Vaults this coming Saturday. But I have been denied my right to see the work, and I am angry about that. Fighting for freedom of speech, freedom of association and freedom of movement is a tough battle, usually involving coming into conflict with the authorities. But to find yourself fighting your fellow citizens, fellow Londoners, particularly sections of London's African-Caribbean population, whose protesting at the Vaults successfully halted *Exhibit B* on the grounds that it is offensive — well, that is an even more difficult battle, which induces frustration and dismay.

How could sections of our city's black citizens, and non-black citizens too, be whipped into a such frenzy of emotion over an artwork? Nearly 23,000 online petitioners, with the support of major trade unions, the National Union of Students' Black Students' Campaign and other black-interest groups, condemned *Exhibit B*. I was so appalled to see Unite the Union supporting the boycott of the installation that I have now cancelled my paid membership.

It's a sad day for freedom of expression when art is censored, whether it's by the state or by groups of outraged citizens. Some of the campaigners against *Exhibit B* have actually accused the Barbican of censorship. They use Orwellian doublespeak to argue that the real problem here is that black people have been censored from the Barbican's decision-making processes in relation to programming and curating, whereas if they had been involved they could have raised concerns about *Exhibit B* much earlier. For these shutters-down of *Exhibit B* to accuse others of censorship is surreal. Let me spell out what censorship is: the removal or destruction of things – books, movies, artworks, performances – that have been judged to be offensive or immoral. It isn't the Barbican that has indulged in censorship; it is its shrill critics, the protesters, the petitioners who very questionably presented their censorious campaign as a progressive 'anti-racist' initiative.

Exhibit B was removed because of an act of violation by the protesters. They prevented the paying audience from entering the Vaults. According to the Barbican's director of arts, Louise Jeffreys, they 'pushed forward, the barriers came over, they moved towards the doors, we tried to close the doors and we had to exert considerable pressure on the doors in order to get those doors closed... We had to chain the doors in order to make sure they wouldn't be breached.' The right to protest is very important, but this crosses a line: to attempt to enter private property and disrupt a performance on the basis that it is immoral is not protesting — it is censorship by a mob.

How could a performance about racism, performed by black British actors who have maintained a dignified defence of the artwork, be deemed racist by predominantly black protesters and anti-racist activists? Listening to the protesters, one could be forgiven for thinking Bailey had created a piece of racist propaganda dressed up as art, designed to recruit new members to a white supremacist group. Bizarrely, the protesters claim the Barbican is infused with 'white supremacist ideals'. I had no idea that neo-Nazis and KKK members were running the Barbican! Of course, they aren't; and of course, Bailey's work is far from racist. It is about shining an uncomfortable light on slavery and empire. To brand such art 'racist' is once again an act of Orwellian doublespeak.

It is a great disappointment that the Barbican pulled the performance. I sympathise with those who run the Barbican, who effectively found themselves under siege, but I wish they had put up a tougher fight. Because now that a major arts institution has given in to the demands of an unrepresentative group, we will likely find that freedom of expression is under even greater threat, as others try to shut down things that offend them. Throughout modern history, art has often tackled uncomfortable subjects, feelings and ideas. *Exhibit B* is no different and we should not have been denied our right to see and judge this work.

For me, one of the most disappointing things about this act of 'radical' censorship is that it has been led by an anti-racist movement that I was once

very actively engaged with. In the 1980s and 90s, I spent many an evening with comrades demonstrating outside council meetings, police consultation meetings and magistrates' courts, protesting against police brutality and racial attacks. For these activists now to describe an anti-racist artwork as 'racist' is baffling, and it is an insult to the real victims of racism, such as the immigrants incarcerated in detention centres across the UK.

These campaigners should heed the words of the great nineteenth-century American anti-slavery campaigner — and former slave — Frederick Douglass. In his pamphlet, *A Plea for Free Speech*, he said: 'To suppress free speech is a double wrong. It violates the rights of the hearer as well as those of the speaker. It is just as criminal to rob a man of his right to speak and hear as it would be to rob him of his money.'

We are being robbed of this right today. In the wake of the *Exhibit B* fiasco, it is particularly important for people of colour to uphold Douglass's enlightened principle that 'liberty is meaningless where the right to utter one's thoughts and opinions has ceased to exist. That, of all rights, is the dread of tyrants.'

Manick Govinda is convenor of the Manifesto Club's Visiting Artists and Academics Campaign (in a voluntary unpaid capacity).

'*Exhibit B*: Artists Must Have the Right to Shock' was originally written by Manick Govinda in *spiked-online*, 25 September 2014, http://www.spiked-online.com/freespeechnow/fsn_ article/exhibit-b-we-must-fight-for-the-right-to-be-offensive#.VWxn2ijNCZY. spiked is a current-affairs online magazine. spiked has firm principles based on a commitment to the ideals of human liberation. It champions free speech, open-mindedness and a human-centred morality.

BLOOD ON THE TARMAC

Brett Bailey

This morning, in a video clip on an online forum, I watched close-up footage of protesters engaging in struggle with French 'robocops' outside last night's performance of EXHIBIT B in St Denis, Paris. Someone fell. Someone was dragged away. The camera zoomed in on a splash of blood on the white paint of a road marking, and my blood ran cold.

On Thursday night, during the premiere, five protesters breeched the barricades, smashed through the glass doors of the theatre lobby, and charged into the auditorium before they were intercepted.

I watched the metal barriers being unloaded from trucks on Friday afternoon, dozens of them; I watched the battalions of black-clad riot police mustering; all with a sense of unreality.

How is this possible? That a performance work that decries the brutal policing of Fortress Europe is relying on the machinery of its uniformed protectors?

Before and during the performances of EXHIBIT B the lobby of the Théâtre Gerard Philipe (TGP) is like an operations room. The management and staff of TGP and Le 104 (the next presenter of the piece here in Paris) are abuzz; representatives from several anti-racist forums are in attendance in support of the performance, and ready to offer support to spectators who are deeply moved by it. Security guards, the mayor of St Denis, policemen, journos, audience...

I try to keep the cast calm. Almost all of them are from Paris. They are upset. Angry that people are so violently against their work. Angry that people want to stifle their voices. EXHIBIT B relies on a gentle, intimate regard between performers and spectators. Anxiety and excitement are counter-productive.

Outside, as darkness falls and the performers prepare to take up their positions, the protesters mass outside and the gendarmes line up: 250 policemen. We watch apprehensively through glass doors across a 20m belt of zigzagging barricades.

These protesters are people, as human and feeling as any of us. Many of them – and their defenders – are protesting because they are fed up with being second class citizens, fed up with institutionalized racism, fed up with racial profiling and humiliation in the streets and in the media, fed up with lack of access to opportunities, fed up with not having platforms to express themselves, fed up with being represented as 'other'.

They demand to make their views know: EXHIBIT B is racist; it reinforces stereotypes of black people as passive victims of colonialism; it is made by a racist South African. It must not be allowed.

Many others in the crowd, it would seem – and just as human and angry – are those who have been whipped up by manipulators whose intentions are violent.

In EXHIBIT B I investigate the way in which black people have been represented, objectified and dehumanized by racist systems in order to indoctrinate people; the way in which these racist systems continue to operate today, here in Europe; around the world.

I choose to portray black people in objectified form to demonstrate the violence of these systems. I opt to perform the work in utter silence, to emphasize how the voices of the colonized, the marginalized, the subjugated, are stifled.

I choose to depict some of the terrible atrocities of colonialism so as to expose the realities of what really went on during the so-called 'civilization of Africa' by Europe.

I choose not to represent the white perpetrators of these crimes directly, because white people have never been the dehumanized objects of such systematized racism.

In EXHIBIT B I instruct the performers not to take on the horrors and humiliations of the characters that they are playing, but to bring dignity to these people from whom dignity was stripped; to become monumental icons of remembrance to these people, communicating their power through their posture, their endurance and their unfaltering gaze.

I ask them to envision themselves as the spectators in this exhibition, gently watching the audience grapple with the horror of realizing the brutality of such a system. I want them to explode from the inside the stereotype of the passive, victimized black body.

But out there on the floodlit street, beyond the barricades, this is not understood. Those people have not attended the performance.

None of this is really about Brett Bailey or EXHIBIT B. This work is merely a sharp needle that pricks a skin bloated with fury, frustration and pain. The 'multicultural utopia' of Europe is a myth. The history textbooks still disguise the brutal systems of colonization and dehumanization as glorious endeavours of salvation, progress and philanthropy. Africa is plundered, raped, looted by global multinationals, just as it was by the imperialists of the 19th century. People have had enough.

Do I continue to stage the work in cities such as London and Paris? So many of those who have attended the work – black, white, brown – emphasize the importance of EXHIBIT B. Call it 'imperative', 'vital', 'life changing'; luminaries such as former French World Cup star Lilian Thuram, founder of the Lilian Thuram Foundation, Education Against Racism.

But having accumulated so much contagious online polemic from London it is now polarizing people, enflaming the far left and reconfirming the prejudices of the right. Is its presentation really justifiable?

A public debate at TGP, scheduled for last night, which would have featured viewpoints from across the spectrum – and in which I was to have participated – was cancelled because of the security situation.

We have managed to persuade a very small number of those who stood against the performance to attend it. They have emerged disturbed, moved, but acknowledging the value of the work and that it should not be closed down. The vast majority of those declaiming against EXHIBIT B, however, refuse to see it.

One of them apologises to me for the misunderstanding. Another, a member of the militant "Anti Negrophobe" group, says he wants to see the perpetrators of colonial crimes, but otherwise he "detects no vulgarity" in the piece, says that he can see it's not racist. He rambles at length about the lack of solidarity and community amongst the local black population, rootless, bewildered.

The outrage against EXHIBIT B is misdirected. Why oh why wouldn't these people attend the performance when we reached out to them time and again?

I empathize with the people outside there, raising their voices and their banners. My art stands for what they stand for. The installations in EXHIBIT B of racial objectification, dehumanization, marginalization and brutality are their stories.

Many of the 150 plus performers that have participated in the work in 17 cities stand for what they stand for. They have similar grievances and experiences. They are those people. Their testimonies of prejudice suffered are typed up and displayed in the final chamber of the exhibit.

I empathize, and I am saddened and horrified and angered at the violence playing out on the other side of the barriers. And I despise the unworldly platitudes of support posted on my face book page by white suburbanites who see confirmation of their prejudices in the actions of the protesters.

But I also believe in the right of artists to speak uncomfortable truths, and to challenge status quos. And to disturb. And to offend. I don't want to live in a society in which we silence ourselves in response to every politically correct outcry; in which artists are struck dumb by self-righteous mobs.

I regret that EXHIBIT B has polarized people. I regret that a multidimensional performance piece, which has meaning in the intimate dynamic interaction between performers and spectators, has been judged on the basis of 2-dimensional photographs.

I acknowledge that seeing a photograph of a shackled black woman and reading that it is the work of a white South African man can cause deep offence.

I wish that photographs of EXHIBIT B had not been published, and that the only access that people had to the work is through the living, vibrating, profound experience of recognizing the equality and humanity in us all, and the horrors of systems that continue to stifle this.

And I wish I knew that the man or woman who shed blood on the tarmac of St Denis on Friday night for what he or she stood for is okay.

'BLOOD ON THE TARMAC' was originally written and published by Brett Bailey on *Facebook*, 30 November 2014.

Exhibit B: Offensive or Harmful?

Ria Hartley
edited by Rachel Dobbs

It seems some integral contexts are missing from the debate surrounding the closure of *Exhibit B*, the controversial artwork by South African artist Brett Bailey, which restages the 'human zoo' practices that took place between the nineteenth and twentieth century. *Exhibit B* was programmed to open at the Barbican Centre, London, on 23rd September 2014 and the work was subsequently withdrawn after a protest took place outside of the Vaults on the opening night.

I have been reading critiques and opinions concerning the closure of the work at the Barbican centre, which came after an organised petition and protest led by journalist and activist Sara Myers, which became circulated as #BoycottTheHumanZoo campaign. Within the mainstream media representation of the campaign, the topic of censorship has dominated the debate, with very little engagement in the public's response to the work or the organisations, activists and artists that were actively vocal in expressing the deep rooted issues in the marketing and staging of this work within London, UK.

Some mainstream media comments I have read have made me feel uneasy and others highly concerned about the authors' perspectives, particularly those whom refuse to engage with the past and present colonial contexts which seem to be absent in the writing on this debate.

The missing societal contexts fundamental to this particular debate as I see them are; imperialism, white supremacy, capitalism, and patriarchy which culminate into the hierarchical system of oppression in which colonialism developed. The majority who are writing about the work are ignorant to the contexts in which we are existing, and contextualising the work from their own perspective without engaging in the wider social, political, cultural and historical narratives that surround this work. These narrow viewpoints are perhaps as harmful as the work itself, yet act as evidence to the dominant attitudes of those with voice within and on behalf of the arts and cultural sector.

The *Exhibit B* debate has exhausted the term 'censorship' and this topic has continued to be argued as the central concern of the debate. I believe in freedom of speech. I believe every human being has the right to speak and express themselves openly. I agree that art can (and should at times) be offensive, cause discomfort and raise difficult issues and that the artist has the right to freedom of expression in the work they produce and present. I don't agree with the censorship of art, but I have to reconsider this stance if the

artwork in question is potentially oppressive or harmful to society.

So before I continue, privilege MUST be recognised.

WE HAVE TO ACKNOWLEDGE that we live in an unequal society with
uneven histories
WE HAVE TO ACKNOWLEDGE that imperialism, privilege and supremacy
exists
WE HAVE TO ACKNOWLEDGE that power, privilege & influence are not
distributed equally in our society
WE HAVE TO ACKNOWLEDGE that racial oppression is still a global issue
WE HAVE TO ACKNOWLEDGE that the trauma of enslavement is still
present within the global diaspora
WE HAVE TO ACKNOWLEDGE that there has been no reparation for the
atrocities of enslavement
WE HAVE TO ACKNOWLEDGE racism is still an everyday occurrence
(subtle and explicit)
WE HAVE TO ACKNOWLEDGE that racial injustice is present and pervasive
WE HAVE TO ACKNOWLEDGE that this is a complex debate, multifaceted
and with nuanced voices.

We also need to recognise that although we use the term 'post-colonialism'
to mark a period which no longer holds imperialist power and control over
other 'races', ethnicities, cultures etc, (which I would contest) it would be a
huge injustice to assume that large communities of people do not experience
the overlaps of this still very recent history. It is within these contexts, and
with this recognition of privilege and the acknowledgement of oppression as
a persistent contemporary concern, that I want to discuss and think critically
about *Exhibit B* and the discourse that surrounds it.

In our libertarian democracy, political and personal freedoms are deemed to
be fundamental, with freedom of speech, expression and association at the
forefront of national and international law. These principles suggest that we,
as a society, participate as equals and that we should strive to promote respect
for all human beings, to secure and insure this equality. In fact, Article 1 of the
Universal Declaration of Human Rights, which explicitly protects our rights to
freedom of speech and expression, begins 'All human beings are born free and
equal in dignity and rights' (*UDHR*, 1948) However, if one is to recognise that
power, privilege and influence are not distributed equally in our society, that
we are not all born into the same position of freedom and equality, we all have
a responsibility to make sure our actions do not harm others. At times, this will
also mean that we need to take 'progressive measures' (ibid), as the *Declaration
of Human Rights* suggests, to ensure the rights of all people to dignity, self-
realisation and protection from persecution.

To discuss freedom of speech in relation to *Exhibit B*, we also need to address
'the harm principle'. This ethical consideration holds that 'each individual has
the right to act as s/he/they want, so long as these actions do not harm others'

(ibid) I would argue that this artwork, its staging and the marketing that surrounded it have the potential to do (and reiterate) psychological and social harm (which is comparable to violence and other forms of physical harm, and separate to offense or 'bad taste'). This harm is not just perpetrated against those whose cultural identity and history are directly depicted in the work (people of colour, descendants of colonised peoples, people of African and Caribbean identity and Heritage) but also has the potential to do harm to our society at large.

It seems that there has been little consideration for the harm caused by the restaging of the zoo. After a public discussion held by Nitro (now nitroBEAT), the organisation which caste the actors for the show, at the Theatre Royal in Stratford a day before *Exhibit B* was to open at the Barbican, no resolution was reached. Activist and lead campaigner, Sara Myres, stated very clearly her case against the work during the panel discussion, and the majority of the audience were vocally in agreement. The Barbican initially chose not to honor the request of the 22,000 campaign signatures protesting against the exhibition's opening, which asked for the work to be removed from the London area – that's 22,000 signatures that expressed the harm they felt the exhibition was causing. With no further conversations with those protesting offered, a picket and blockade was formed outside of the Vaults on the show's opening night and The Barbican took the decision to cancel *Exhibit B*'s five London performances, stating that "It became impossible for us to continue with the show because of the extreme nature of the protest and the serious threat to the safety of performers, audiences and staff".

What are the ethical responsibilities for artist and arts institutions in presenting work which has the potential to be harmful amongst communities?

The problem with the type of harm caused by *Exhibit B* is that if you're part of the dominant culture, you probably don't experience it. For example, microagressions, as defined by psychologist Derald Wing Sue, are 'brief, everyday exchanges that send denigrating messages to certain individuals because of their group membership' (Sue, 2010: 24). Most of the time, this kind of 'subtle violence' is not even intentional and can be carried out by the most well-meaning of people. Rather than outright, deliberate or intended bigotry, microagressions include repeating or affirming stereotypes about a 'minority group' (i.e. the positioning of otherwise underrepresented black bodies as 'enslaved', perpetuating victimhood), or statements that minimize the existence of discrimination against a 'minority group' or the real conflict between the 'minority group' and the 'dominant culture' (the sense, in the staging of this work, that issues of subjugation, discrimination and oppression are able to be presented by 'dominant culture' through their own perspectives yet when confronted by 'minority groups' are unable or refuse to engage with them). The most dangerous part of this is how unaware those perpetrating this 'subtle violence' are – they intend no offense and are unaware they are causing harm. Franz Fanon refers to this stance as 'playing the irresponsible game of Sleeping Beauty' (Fanon, 1961: 62) In this case the position of the 'Sleeping

Beauty' allowed for the 'dominant culture' and privileged voices premise to label the protesters for their resistance, rebuke the closure of the work, and term this as 'censorship', suggesting freedom of speech is something only the 'dominant culture' can claim – a remarkable insight into contemporary imperialist ideology.

We live in a society managed by gatekeepers, those in positions of power and authority (i.e. media, government, politics, publishing, broadcasting, policing, academia, cultural institutions), and those whose actions have the potential to significantly change that position. However, if gatekeepers (in the case of *Exhibit B*, both the artist and the institution's curators/programmers/directors/ critics) do not uphold in their ethical responsibility to engage with the missing context, made explicit by the public's reaction to the work, then they remain complicit in systemic oppression, which could also be regarded as a 'subtle violence' that maintains social inequality.

But the performers supported the piece, and they didn't think it was racist? And they're black... (i.e. I'm not racist I've got black friends!)

During the defense of *Exhibit B* against the public's criticism, some of the reflective statements written by the work's performers (included in the work) were quoted and the actors interviewed to give their opinions of the work. The implication throughout was that if this piece was 'racist' black/POC performers would not be involved with it and the use of the actors' statements felt like an attempt to further validate this.

There are problems with this use (and potential exploitation) of the performers' voices on a number of levels. Firstly, the performers were under contract (paid) as part of the piece and so would have a professional and financial stake in the piece going ahead. Secondly, they had auditioned, researched, rehearsed and performed these roles, and so would have a significant personal investment in the piece and are embedded in the experience (the performers after all are having a very different experience to that of the viewer). Thirdly, and most importantly, just because the performers supported this work, doesn't mean their voices represent all black/POC voices in the reading of this work.

It seems that Bailey (and all involved in the production) had good intentions for this work but failed to understand that the experience of this particular narrative, from the perspective of the 'dominant culture', is not 'universal' and that to present it as such is damaging and harmful. In a similar way, the presentation of the voices and experiences of the performers as representative of 'all black/POC voices' is flawed, damaging, exploitative and harmful as both an act of (micro)aggression and as a way to try and silence dissent.

Criminalising the protestors and claiming censorship

The narrative constructed by the Barbican and mainstream media used to justify the closure of the exhibition is a major concern. It seemed as if the protestors were scapegoated by being cast as criminalized protagonists to divert the attention away from of the main issues that were facing the Barbican, Nitro and the artist – that the work is not just offensive but (subtly) violent, exclusionary and oppressive. Protestors were described as "angry" "arrogant" and a "mob" and even "bullies" and "morons" and the language used in the Barbican's official statement on the closure of the show insinuated that the protests were 'extreme' and violent in nature, posing a 'serious threat' to the safety of performers, audiences and staff.

There is nothing new about the black/POC people being criminalized in society and so the irony here is that the work of art which intends to 'highlight historical racist practices' unintentionally highlights contemporary racist practices happening as a response to the work – the stereotyping of acts of protest by black/POC people as aggressive, threatening or criminal; the role of racial profiling in policing in the UK and elsewhere; and the institutional racism embedded in many of the established conventions of British society.

I feel that the re-focussing of the debate onto concerns around censorship is a final act of (micro) aggression and '(subtle) violence' by the parties involved in an attempt to silence the vital critical debate around the underlying issues that *Exhibit B* states it seeks to address.

So what now?

So where do we go from here? If we going to talk openly about colonial history and present art work about colonial history, then we need an open and critical discourse on privilege, particularly in the arts and cultural sector. My main concern is that the oppression felt by the surrounding communities about this work was not addressed with ethical care. On the contrary, I found the many reviews by critics in the media and the Barbican's responses and language used against the protestors in the resistance of the work unnecessarily divisive and ignorant. The withdrawal of *Exhibit B* could be understood as censorship or could be understood as a act of resistance to racial oppression.

As an artist I am highly concerned about what has surfaced from this debate. How can I trust my sector and those who are responsible leaders within venues and organizations, those who programme and fund work, or those whom have written on the work and the debate and made transparent their lack of critical awareness through their own privileged perspectives?

We know that our sector is predominately made up of those whom benefitted, and still benefit, from colonial history, and we need to establish a more diverse sector to ensure that this kind of '(subtle) violence' does not continue. Art should be given the opportunity to fail and I believe this piece has failed in its

intention, but through its failure it has opened a very important dialogue and one which the sector MUST ACKNOWLEDGE. A dialogue fundamental to the evolution of a fairer society and a call for a fairer and more diverse arts and cultural sector in the UK.

Colonial history has affected us all in different ways. There is social healing that needs to be done from the multiple narratives of British colonial history. I do not believe perpetuating shame is the way forward, because it continues to bypass the responsibility of the 'dominant culture'. At the same time we do need to acknowledge and understand the severity of what has been done. I feel it is important we now consider how our sector begin to work on these difficult issues and be accountable, responsible and ethical in how they are using their privileges.

We have to keep questioning the continuous rewriting of this history and not ignore the assumption that 'history' is something objective and true, rather than a set of convenient truths written by those in control of the status quo, and that historical narratives might be faulty and serve to reinforce discrimination even if that is unintentional.

Works cited
Franz Fanon, *The Wretched of the Earth* (1961).
Derald Wing Sue, *Microaggressions in Everyday Life: Race, Gender, and Sexual Orientation* (2010).

'*Exhibit B*: Offensive or Harmful?', was originally written by Ria Hartley and edited by Rachel Dobbs, September 2014.

Speaking Up,
Speaking Out

VENICE INTERNATIONAL PERFORMANCE ART WEEK
artists answer to the question
"What is Performance Art?"

Santiago Cao, Paul Carter, BBB Johannes Deimling, Francesca Fini, Helena Goldwater, Snezana Golubovic, Francesco Kiais, Jason Lim, Macarena Perich Rosas, Gonzalo Rabanal, Rebecca Weeks, and Alexandra Zierle

per•for•mance art [pəˈfɔːməns ɑːt]
noun
1. since years I ask myself what is *Performance art*, and still I don't know if a) it is an art. b) which are it's limits. c) if it has limits.
2. maybe the answer to this question is the lack of answer.

Santiago Cao, Argentina

per•for•mance art [pəˈfɔːməns ɑːt]
n **1.** a 'vessel' that frames, holds, marks and brackets an experience wherein anything can and does happen, where boundaries are blurred and traversed, portals are opened, where spaces, places and people are bridged. **2.** Inhabits the fabric of the live 'collective' moment, demanding presence, aliveness and self reflection from all 'participants' there and then. **3.** a 'space' to go someone else, to meet afresh, to re-envisage ourselves and our world, to journey to the edges of social, cultural, mental, emotional and physical boundaries. **4.** To experience *Performance art* is to experience the edge of knowing: to depart and to arrive, to collectively meet bare and stripped in the wash of the fabric of possibility and flux.

Paul Carter, UK

per•for•mance art [pəˈfɔːməns ɑːt]
n **1.** an art form, like *painting, drawing, writing, poetry, installation, video, photography, sculpture, architecture, object, theatre, dance, film, music.* **2.** a way to express thoughts and ideas in an artistic manner, a tool to create art. **3.** located within the broader field of *Action Art*, which historically emerged in Europe after the *Second World War.* **4.** the creative act of an artist in front of, or with an audience at a certain place/space/site and during a certain timeframe it forms the centre of attention. **5.** during its live process the artist and his actions are transformed into a general readable sign.

BBB Johannes Deimling, Germany/Norway

per•for•mance art [pəˈfɔːməns ɑːt]
noun
1. the best language to undermine and question the contemporary for its capacity to express the crucial truth of an action that takes place here an dnow, in which the 'actor' in the literal sense is simply himself.

2. a form of knowledge.
3. a therapy.

Francesca Fini, Italy

per•for•mance art [pəˈfɔːməns ɑːt]
noun
my body asking your body questions

Helena Goldwater, UK

per•for•mance art [pəˈfɔːməns ɑːt]
noun
1. alive
2. live.
3. life.

Snnezana Golubovic, Serbia/Germany

per•for•mance art [pəˈfɔːməns ɑːt]
noun
1. the fight with the angel.
2. a confrontation between ourselves, the occurance of the limit of our knowledge, and our becoming and pushing towards this limit.
3. a fight that is a dance, in which we ourselves become the limit in its happening, and we dance our coming towards the limit.

Francesco Kiais, Italy/Greece

per•for•mance art [pəˈfɔːməns ɑːt]
noun
a process which involves an artist through using his/her body to actualize his/her idea in real time and space. *a)* at times, during this process of searching, images of poetic significances are created.

Jason Lim, Singapore

per•for•mance art [pəˈfɔːməns ɑːt]
noun
1. life in itself.
2. not corresponding to any art form.
3. emerges from the memory of the body.
4. participates at the present as an anti-narrative language, with supreme coherence.

Macarena Perich Rosas, Chile

per•for•mance art [pəˈfɔːməns ɑːt]

noun

the creation of a space which allows us to work on our limits and to make free decisions so that from the achievable the improbably happens.

Gonzalo Rabanal, Chile

per•for•mance art [pəˈfɔːməns ɑːt]
noun
1. allowing for vulnerability, being present and achieving empathy.
2. achieving a transformative potential within works through taking risks.
3. *Performance artists* are like alchemists turning dirt and tears into gold.

Rebecca Weeks, UK

per•for•mance art [pəˈfɔːməns ɑːt]
noun
1. a shared extraordinary moment only fully experienced in the here and now.
2. a moment made of many facets of realities, blurring the boundaries between life and art.
Alexandra Zierle, UK

'VENICE INTERNATIONAL PERFORMANCE ART WEEK artists answer to the question "What is Performance Art?"' was originally written by Santiago Cao, Paul Carter, BBB Johannes Deimling, Francesca Fini, Helena Goldwater, Snezana Golubovic, Francesco Kiais, Jason Lim, Macarena Perich Rosas, Gonzalo Rabanal, Rebecca Weeks, and Alexandra Zierle for the 1st VENICE INTERNATIONAL PERFORMANCE ART WEEK, veniceperformanceart.org, December 2014.

THIS is Performance Art

Marilyn Arsem

Performance art is now.
Performance art is live.
Performance art reveals itself in the present.
The artist engages in the act of creation as s/he performs.
Performance art's manifestation and outcome cannot be known in advance.
Re-enactment of historical work is theater, not performance art.

Performance art is real.
Performance art operates on a human scale.
It exists on the same plane as those who witness it.
The artist uses real materials and real actions.
The artist is no one other than her/himself.
There are no boundaries between art and life.
The time is only now.
The place is only here.

Performance art requires risk.
The artists take physical risks using their bodies.
The artists take psychic risks as they confront their limits.
Witnessing a performance challenges an audience's own sense of self.
Sponsoring performance art, with its unpredictability, requires taking risks.
Failure is always possible.

Performance art is not an investment object.
The work cannot be separated from the maker.
It cannot be held.
It cannot be saved.
It cannot be reproduced.
Performance art is experience – shared time and space and actions
between people.
The record of performance art resides in the bodies of the artist
and the witnesses.

Performance art is ephemeral.
It is an action created by an artist for a specific time and place.
Witnesses are privy to a unique experience that will never happen again.
Performance art reveals the vulnerability of living.
Performance art reminds us that life is fleeting.
We are only here now.

THIS is Performance Art,' a manifesto written by Marilyn Arsem in January 2011, was originally posted on the *Infr'action Venice* website, and now appears online at *Total Art Journal* (http://totalartjournal.com/archives/4298/this-is-performance-art/), and on *Temporary Land Bridge* (http://temporarylandbridge.com/2014/02/09/marilyn-arsem-this-is-performance-art/).

Taxonomies of UK Performance Art: Absence, Eradication and Reclamation

Helena Goldwater

This is no ordinary situation for me. I'm an artist and don't call myself an academic. I don't tend to put myself forward for such things as conferences. And if I do speak, lecture, give a 'paper', I like to be funny – it's easier, I like to talk about my work (as artists like to), or other people's work, ideas around practice, the practice itself. But this time is different. This time I wanted to talk about something around practice, something that bothers me, the kinds of things I have discussions about with others in private. And so I wanted to jump off the deep end into a critical place, a risky place in an attempt to ask questions. There are unlikely to be any answers. So much has been said this last day and a half, about the good things going on which are important and which I value but it's important to be critical about what troubles us as practitioners, thinkers and doers. The critical is where the gaps are, the slippages and where the marginalised peek out from. And so...

The last 20-25 years in the UK has seen an amazing explosion of diversity within performance practice. Live Art has become an umbrella term for all forms of radical, experimental performance – from those coming from the body and performance art as a precise artistic form, to those coming from the theatre and drama, and meeting in a huge variety of territories, including those curated by programmers such as Helen Cole at IBT Bristol, organisations such as the Live Art Development Agency, and artists themselves such as those involved in]performance s p a c e [. The breaking down of definitions and boundaries is astounding and shows how positive change can come – a disregard for limiting boundaries of forms and yet whilst there is an erosion of definitions there hasn't been a complete erosion of discipline, for example, rigour and craft in the making of performance, or contextualisation, that is, at least certain histories.

Whilst I celebrate the excellence and commitment of individuals and communities in supporting, through action, live practice now, I have also seen a disregard of a certain strain of practice – the art formerly named 'performance art'. Mixing it up formally is always good but my concern here is the exclusion of certain types of work and its legacy.

Firstly, there has been a demise of poeticism in favour of the overt, explicit and accessible in performance – the extreme, the funny, the trashy, the performancey. In an age of overstatement where is the understated? In an age of the quick where is the slow? In an age of theatricality where is the minimal? These questions need time all of their own. For this paper I am focusing on my second concern – what happened to the historicisation of performance art in the 'Art world'?

It's not as though performance art has gone away, and even if it had, there's a whole swathe of work made here from the early 1980s to 2000 that is just absent from the institution, – by which I mean, for example, large-scale contemporary art museums and galleries, – and the academy, – by which I mean what is being taught in universities and written about by academics. There is plenty of support, and rightly so, for emerging and young artists but what about those who have paved the way and opened the doors to the now? The valuable contribution to the field by those older artists who have now been somewhat marginalised. There are little cross-generational through-lines. I don't see artists that influenced me still performing very much (in some cases not at all). I don't see their work in the Tate Tanks. There I see, albeit extremely important work, dance and video/film installation. The timeline that was up on the wall for a while at the Tanks stopped abruptly short of the last twenty years. Up until *A Bigger Splash* I had seen little of Stuart Brisley in the Tate. The premise of *A Bigger Splash* is in any case problematic in it's framing through Pollock and Hockney as you enter the exhibition, and stops short also of the last period in performance art history instead jumping into performance-related art that is not connected directly. *Live Culture* was a welcome foray in 2003 and included some current performance artists such as Hayley Newman. Tate Liverpool showed *Art Lies and Videotape: Exposing Performance* in 2003/4. But these were responses to the recent and/or the documentation of the live, and any older generational artists were the same names as usual. How much does the Tate purchase and document what has been going on? Are they archiving the work of, for example, Rose English, Brian Catling, Silvia Ziranek and Antony Howell? They are still out there, but I don't see how they have been included in these histories. Why can't the large institutions further consider British performance artists?

But I don't want to just single out the Tate. What about other major galleries? There have been excellent medium-scale exhibitions such as *Live Art on Camera* at Space, London and the John Hansard Gallery in Southampton in 2007/8. But this was concerned with documentation and not showing live works, and only a few were UK artists, which doesn't make them less exciting and important shows but still leaves some issues unresolved. And what about academia? There are hundreds of books about Live Art but few about UK performance art. To what extent is performance art part of Fine Art teaching? Drama departments seem to have developed an interest in picking up alternative performance strategies where Fine Art has dropped the ball. Performance art is hardly even used as a term anymore but nobody declared its death. It's become a term of the past not the present. I'm not really interested in holding onto terminology for the sake of it but dropping it feels like colluding with the disappearance of artworks, deleting certain living practitioners, and accepting it is now no longer part of art history.

One major reason for the exclusion of performance art from the gallery and institution is the YBA/Brit Art movement, which began its meteoric rise in 1988. The Art world was so preoccupied with this that everything else going on fell by the wayside. In considering the Artist as celebrity and capitalist project

anything that was complicated financially and not an object became easier to ignore. Art as a commercial currency has definitely lessened intellectual discourse. Performance included in these large institutions has been quite slight on that front and more interested in the quirky and entertaining.

But I know it's not simple, a case of binary positions. In being excluded from the gallery, performance artists sought out different contexts – self-help – and so encouraged inadvertently its own omission. Or indeed they chose to experiment in other contexts for positive reasons, such as a problem with the white cube space as constraint. And of course, presenting radical work as if it is historic artefact also has its problems. By definition if you make radical practice then being welcomed into the institution is fraught and probably unlikely. However the institution does show some work that can be considered in such a way, so why not extend to include as much as it can of that which has been ignored?

There are some who have shown an interest in the understated, the slow and the minimal in performance art, such as Home London in the 90s and curators like Blair Todd at Newlyn Art Gallery. They have pushed the boat out with an openness towards not knowing, that is, "here's a space would you like to make/show a piece?" without a fear of the definitions. And a good example of a creative curatorial project in a large public gallery was *Notes on a Return* at the Laing Gallery in Newcastle in 2009. Curated by Sophia Hao, the exhibition focused on UK performance artists Rose English, Nigel Rolfe, Mona Hatoum, Bruce McLean and Anne Bean, who performed at Laing in the 80s, and asked "how do we remember?".

Whether there is now the beginning of an accurate or piecemeal re-dressing of the omission of performance art in the UK can be debated. Artists and curators keep trying to raise their head above the parapet. Fiona Templeton and New Work Network curated *Bodies of Memory* for *Acts of Legacy* last year, which saw performance artists re-enact or recollect memories of performances past. Held in the Turner galleries at Tate Britain it was programmed as a side event to a larger programme for Late at Tate. Brisley seemed absent from the public until very recently when his work was shown at England & Co Gallery, Peer and soon Mummery and Schnell. Richard Saltoun and Karsten Schubert have just shown documentation of the work of Rose English and Rose Finn-Kelcey in *Taking Matters Into Our Own Hands*. Ironically, having pointed a finger at the art market, it seems that commercial galleries are picking up on performance artists.

If you look abroad interest in performance art seems to have remained consistent, the urgency to consider art that comes from the body in all its formal diversity. The work of International Performance Art Event in Singapore, Performatorium in Regina, Canada, and El Palomar in Barcelona who are looking quizzically at big museums and their lack of critical awareness. The recent 1st Venice International Performance Art Week curated by Vest and Page was testament to such a gallery-based context with very

diverse work from all over the world. Discourse was raised by the work itself. There was talk about problematics such as those I am raising here, but we also talked about the work and what it was about. Vest and Page curated work by long standing artists such as Boris Nieslony, Ilja Soskic and Yoko Ono, through the generations to current UK performance artists like Zierle and Carter, and Weeks and Whitford, to students from a Venetian art school, and even allowed impromptu un-programmed performances from young artists who were helping with the event.

Why are these examples successful? They engage with a diversity of aesthetics and formal decisions, there's a respect for the elders in history and a respect for the content by the curators. But these are not the institutions. These are artist-led or by curators with an engagement with performance art, and where it's not all about business.

So how can things change? I would like to see curators, programmers and academics engage with the understated, the slow and the minimal that still exists in performance art, and re-visit the 80s and 90s and see just how seminal it was. I think history is important in shaping the future. Perhaps there are changes afoot. But the eradication of past contributors to the history of art can only be reversed if curators, gallerists and academics know their history and consider their roles in 'authenticating' it.

Post-script, 2015:

This paper was written as a provocation. For me, conferences and symposia should be for argument, debate, challenging and posing questions about the state of things. Not because I enjoy discord, but because I want to understand why we find ourselves where we do, what contexts exist, are encouraged or omitted, and how we can move forward with knowledge.

Since writing this in 2013, there are signs that, in terms of a consideration of UK performance art past and present, the tide may be changing further for the better. As is usual in a time where we are seeing a blatant return to cruel Conservatism, some become more fearful and batten down the hatches, whilst others open the doors wide and welcome alternatives – as a way of seeing the possibilities of the radical, resistance, freedom in operation, inclusion, community, or just new or different ways of seeing.

In Higher Education, whilst some Drama departments are returning to conventional perspectives of theatre, others are widening their understanding. In Fine Art education performance practice is popular with students because of its immediacy, amongst other things, and offering them the layered histories has re-emerged in consciousness.

I also see more academic material being published, symposia, and a concern for re-visiting or programming UK performance artists whose practice began in the 70s and 80s, many of whom continue to stun, shock, consider, and move

us into questioning and action. The 90s onwards is more difficult. Academics are still focusing on the explosion of the overt and explicit, and whilst this is exciting and imperative work, the minimal, quiet and the slow are still under represented, and contemporary art museums, galleries and curators have an even further way to go to redress omissions.

As an artist who began my practice in the late 80s, I have understood the ebb and flow of popularity and disengagement, and popularity again. Persistence and passion are at the heart of putting your body and materials in the frame, and these attributes are also needed to continue arguing for comprehensive and multiple histories.

'Taxonomies of UK Performance Art: Absence, Eradication and Reclamation' was originally written by Helena Goldwater for the *Exhibiting Performance* conference, University of Westminster, London, 1-3 March 2013.

Catching Up On Our Own History:
Performance Art and Cultural Amnesia

Diana Smith

It has been 20 years since Anne Marsh's historical survey of performance art, *Body and Self: Performance Art in Australia 1969-92* was published. In her introduction, Marsh described her goal as addressing a "gap in Australian art history" and noted a certain "cultural amnesia" which had enshrouded certain types of art practice that extended beyond the boundaries of the art museum during the late 1960s and 1970s.[1] The year after Marsh's book was published, artist and academic Sarah Miller built on this point, noting the cultural amnesia evident in the "absence of any but the most fleeting (and typically dismissive) mention of performance art in art critical discourses over the past ten years (as any survey of art journals in this country clearly indicates)." This, Miller suggested, was "particularly fascinating given the plethora of performance art/performance activity taking place in Australia not only throughout the eighties but the nineties, particularly in Sydney."[2] Two decades on, nothing much has changed. *Body and Self* is still the only publication dedicated to performance art in Australia, and it is out of print. I found my copy many years ago at a second-hand bookstore. It was checked out of Marrickville Council Library in 2004, and today copies are so rare they're almost collector's items, costing around $400 through online booksellers.[3]

This cultural amnesia is particularly odd given the explosion in performance art internationally in the last decade. Last year, Amelia Jones observed the "wholesale resurgence" in live art practices, which "has verged on art world obsession."[4] In Australia there have been new levels of visibility for performance art in major institutions across the country and with it, as curator Reuben Keehan remarks, "a greater purchase among a younger generation of practitioners."[5] And yet Marsh's text still remains the only comprehensive study on performance art in Australia.

Marsh herself is perplexed that her work has produced so few descendants. In a recent email to me she noted, "it's astounding to me that *Body and Self* is still current in the field (published in 1993!) Why didn't someone else follow up?" As a performance artist interested in the history and lineage of the medium I practice, I find myself pondering this question quite regularly. Why, given the rich and vibrant legacy of performance art in Australia, is the history confined to one book, a collection of magazine articles, catalogue essays, artist monographs and the occasional mention of performance in books on Australian art, few of which reach enough depth to assist in connecting the past with the diverse and expanding array of contemporary practices? As Marsh commented in her email, it's "amazing that we need to keep catching up on our own history." After talking to Marsh, I began searching for the causes of this cultural amnesia in Australia.

The first potential cause relates to the ephemeral nature of the medium itself. Performance art, like many other conceptual practices of the 1960s and 1970s, developed within a particular socio-historic context that stressed, among other things, the 'dematerialisation' of the art object. The focus was on the 'live' moment and the unmediated relationship between performer and spectator. According to performance theorist Peggy Phelan:

Performance's only life is in the present. Performance cannot be saved, recorded, documented, or otherwise participate in the circulation of representations of representations: once it does so it becomes something other than performance.[6]

Perhaps this is why performance art has not been well documented and why, as curator Sue Cramer noted, it is "often hidden from view and not adequately represented in public collections."[7] Miller took this one step further, suggesting there are certain hierarchies in the art world that "continue to revolve around the primacy of objects."[8] Perhaps the lack of history was a byproduct of artists who saw the medium as inherently and exclusively lodged in the present, combined with an institutional structure that favoured collectable objects. Certainly these two factors would, in combination, explain the absence of documentation.

If this is the case, it is unusually specific to Australia. It certainly wasn't such a problem for historians in other parts of the world, where narratives of the medium have been developing since the 1970s. In America Lucy R. Lippard's *Six Years: the Dematerialization of the Art Object* came out in 1973, documenting the work of artists from America, Europe, Asia and even including brief entries on Australian artists Mike Parr, Peter Kennedy and Tim Johnson. In 1974, Lea Vergine's *The Body as Language* was first published in Italy and documented the work of 60 performance artists from America and Europe, although no Australian artists were featured. In 1979, the first edition of RoseLee Goldberg's classic text *Performance Art: From Futurism to the Present* came out in the US and featured American, British and European artists but, again, no Australians. A revised edition released in 2001 acknowledged the existence of "Australian artist Stelarc", but only provided a single sentence of coverage. In her email to me, Marsh theorised that this dearth of serious critical interest in Australian performance is "primarily because generations of art historians have not chosen Australian art as an option." This is not surprising, given measurements of academic excellence (such as those outlined by the Howard government's Research Quality Framework and Excellence in Research Australia) tend to privilege English and American journals over Australian ones, thereby making it a disincentive to write about something as niche as Australian performance art history.

Accordingly, I began wondering if this lack of interest in our own histories might have something to do with an Australian provincialism, in which we still see ourselves as "a nation in which most activities are derivative and most new ideas are taken from abroad," a point Donald Horne articulated in *The Lucky Country* back in 1964.[9] Mark Davis repeated this point in 1997, arguing

that "even now, cultural contact with places other than Europe or the USA carries little weight among the cultural establishment."[10] Coverage of cultural activity produced within Australia is still seen as secondary to that produced, and imported, from overseas.

This perhaps helps to explain why Australian artists have been left out of the picture and why our histories are not being written. The relatively undocumented history of video art (the medium that often captures performance art) in Australia also supports this perspective. In 1986 curator Bernice Murphy pointed to the "repeated gaps in transmission" in the history of Australian video art.[11] In 2004 writer and curator Daniel Palmer summarised the same topic by remarking, that Australia's "history of video art remains to be written" as it has been "relatively poorly documented and subsequently little known."

Palmer used the same terminology as Marsh, finding that, with the exception of sporadic local histories buried in a few magazine articles and catalogues, video and performance art had been the subject of "cultural amnesia".[12] This helps to explain why most of my artistic references from the canon of performance art are imported from elsewhere, from Yoko Ono's *Cut Piece* (1965) to Carolee Schneeman's *Interior Scroll* (1975) and Marina Abramović's *Rhythm 0* (1974). Whilst these works took place in a markedly different context, it is relatively easy to encounter them (most are visible online), and read their history and critical discussion of their context and impact. By contrast, it is extremely difficult to find comparable discussion regarding artists who directly influenced the development of performance art in Australia, for example Bonita Ely, Joan Grounds or Lyndal Jones. Ely was one of my lecturers at COFA in the early 2000s. I didn't encounter her influential performances *Dogwoman Communicates with the Younger Generation* (1982) and *Dogwoman Makes History* (1985) until after I'd graduated, when I saw her do an artist talk in Korea.

Notably, Bonita Ely, Joan Grounds and Lyndal Jones share another feature in common to many performance artists beyond the relative obscurity of their work. Anne Marsh notes that performance art was an attractive medium for female artists because "it was not entrenched within the art world hierarchy and as a new medium could be used by women to analyse their position in society."[13] Charles Green, also writing from an Australian perspective, found that women were "dominant in this arena" which did not bring with it the "patriarchal history of sculpture or other more traditional art forms."[14] Another Australian, Nick Waterlow, furthers the suggestion that performance art was a form in which women were particularly prevalent, arguing, "although male artists such as Stelarc, Parr, Danko and Kennedy are central to the narrative of performance, so are equally complex artists such as Bonita Ely, Joan Grounds, Lyndal Jones and Jude Walton."[15]

In the USA, Moira Roth notes that performance and the women's movement went hand in hand:

By 1970 women artists had discovered that performance art – a hybrid form which combined visual arts, theater, dance, music, poetry and ritual – could be a particularly suitable form in which to explore their reassessments of themselves and other women. Thus, increasingly over the decade more and more women artists channeled their creative energies into this new medium and in the process transformed its content and form.[16]

The high presence of female artists practicing performance art during the 1970s and 1980s may, in itself, suggest another driving force behind the cultural amnesia. The absence of women in art history has been a key subject since the rise of the modern women's movement in the late 1960s. In 1971, Linda Nochlin posed the question, in her landmark essay of the same name, "Why Have There Been No Great Women Artists?" She investigated the social and economic factors that had prevented women from achieving the same status as their male counterparts. Nochlin advocated the need for a "feminist critique of the discipline of art history" and the entire education system. Her critique drew attention to the alarming degree to which women's artistic output failed to enter the canon and major institutions.[17]

Certainly, there were early suggestions that this absence had the potential to impact on performance art in Australia. In a 1984 collection of essays, compiled and independently published by Anne Marsh and Jane Kent, Kent observed that "performance art has been consistently left out of art history, which has concentrated on the art objects of the major art movements." She continued that, "as performance art has been concealed or omitted from history, women's contribution to performance has been hidden more so."[18] Whatever the rationale, the marked absence of critical attention around women's art can easily be argued to have impacted upon the wider histories of mediums in which they were perceived to be 'dominant in the arena.'

In exploring Marsh's question as to why her work had provoked so few descendants, it seems to me that Australian performance art has been lost somewhere between the ephemeral nature of the medium, a provincial reluctance to value our culture and the seeming invisibility of women's creative output. But equally I ponder why the medium, and women's participation in it, seemed to be undergoing a revival. As Bree Richards, curator at the Gallery of Modern Art in Brisbane, commented in 2012, "live and performative artforms are enjoying a resurgence internationally and, in an Australian context, particularly amongst early career and experimental women practitioners." As I personally take part in this resurgence, as a researcher, writer and artist, I ponder most of all what the critical fortunes of my peers will be and whether we, like Bonita Ely, Joan Grounds and Lyndal Jones will find our history consigned to sporadic catalogue essays and magazine articles. The concern isn't just how the cultural amnesia has obscured our history, but how it obscures our present and future work. We need to not only catch up on our history but to develop a narrative that connects the present with our past.

1. Anne Marsh, *Body and Self: Performance Art in Australia 1969-92*, Melbourne: Oxford University Press, 1993, p.1.

2. Sarah Miller, 'A Question of Silence – Approaching the Condition of Performance' in *25 Years of Performance Art in Australia*, Marrickville: Ivan Dougherty Gallery, 1994 (Catalogue), p.7.

3. Anne Marsh has recently released a digital version of *Body and Self*, which can be accessed on The Australian Video Art Archive website. http://dasplatforms.com/magazines/issue-26/catching-up-on-our-own-history-performance-art-and-cultural-amnesia/www.videoartchive.org.au/B&S/Body_Self_cover.html

4. Amelia Jones, 'The Now and the Has Been: Paradoxes of Live Art in History' in *Perform, Repeat, Record, Live Art in History*, ed. by Amelia Jones and Adrian Heathfield, Chicago: Intellect, 2012, p.13.

5. Reuben Keehan, 'Double Agents: Complication in Recent Performance,' *Art & Australia*, vol.47, no.1, 2009, p.450.

6. Peggy Phelan, *Unmarked the Politics of Performance*, London: Routledge, 1993, p.145.

7. Sue Cramer, *Inhibodress: 1970-1972*, Brisbane: Institute of Modern Art, 1989 (catalogue), p.4.

8. Sarah Miller, 'A Question of Silence – Approaching the Condition of Performance' in *25 Years of Performance Art in Australia*, Marrickville: Ivan Dougherty Gallery, 1994 (catalogue), p. 7.

9. Donald Horne, *The Lucky Country* (1964), Camberwell: Penguin Modern Classics by Penguin Group, 2005, p.101.

10. Mark Davis, *Gangland, Cultural Elites and the New Generationalism*, St Leonards: Allen & Unwin, 1997, p.186.

11. Bernice Murphy, 'Towards a History of Australian Video', *The Australian Video Art Festival 1986*, Sydney: Australian Video Festival, 1986 (catalogue), p.19.

12. Daniel Palmer, 'Medium Without a Memory: Australian video art', *Broadsheet*, 33, 2004, p.21.

13. Anne Marsh, *Body and Self: Performance Art in Australia 1969-92*, Melbourne, Oxford University Press, 1993, p.168.

14. Nick Waterlow, *25 Years of Performance Art in Australia*, Marrickville, Ivan Dougherty Gallery, 1994 (catalogue), p.4.

15. Charles Green, 'Words and Images: The Fate of Australian Performance', *25 Years of Performance Art in Australia*, Marrickville, Ivan Dougherty Gallery, 1994 (catalogue), p. 15.

16. Moira Roth, *The Amazing Decade, Women and Performance Art in America 1970-1980*, Los Angeles, Astro Artz, 1983, p.8.

17. Linda Nochlin, 'Why Have There Been No Great Women Artists', in *Art and Sexual Politics: Why have There Been No Great Women Artists?* ed. by Elizabeth C. Baker and Thomas B. Hess, New York, Macmillan Publishing, 1973, p.2.

18. Jane Kent, 'Performance Art and W.A.M: A Report', *Live Art: Australia and America*, ed. by Jane Kent and Anne Marsh, Adelaide, Anne Marsh and Jane Kent, 1984, p.8.

19. Bree Richards, *Contemporary Australia: Women*, Brisbane, Queensland Art Gallery, Gallery of Modern Art, 2012 (catalogue), p.173.

'Catching Up On Our Own History: Performance Art and Cultural Amnesia' was originally written by Diana Smith in *Das Platform* magazine, Issue 26, 25 April 2013. http://dasplatforms.com/magazines/issue-26/catching-up-on-our-own-history-performance-art-and-cultural-amnesia/

Man O Man

Mish Grigor

Man O Man is an ongoing residency-made project by Australian performance maker Mish Grigor. Sitting at the crossroads of performance, artist talk, installation and public meeting, *Man O Man* starts from the provocation: what would we say, formally, on the last night of patriarchy?

Over intensive residencies, revolving teams of women write speeches, together and alone. These speeches form a series of imagined futures, with multiple feminisms and disparate ideas. At the conclusion of the residency a town hall meeting is held.

Below are two examples of speeches that have come out of the process:

A SPEECH TO THE SECOND WAVE OF FEMINISM:

RADICAL CHANGE CANNOT HAPPEN THROUGH ART. The radical is extreme. Profound. Constitutional. RADICAL change cannot happen through art.

Artists will not change the world today.

As I look out into your sympathetic, interested, keen, engaged faces. I know. We all know. You are the converted and I, I, I am your preacher. And my words give you comfort and take away some of the unbearable pain of getting through the night. But tonight, tonight we will sleep. And tomorrow, the world that we wake up with tomorrow will be the same. The same same same as today.

We will not overthrow. We will not overcome.

Even if we speak our anger until we are blue in the face. Even if we give words to the unspoken. Even if we listen to the stories of the sick and the mistreated, the raped and the drowned. The ghosts of the murdered, the wronged, the spat on, the stupid. The expressions of those without voice or the speeches of them who were silenced.

We will not change the world today. Radical change cannot happen through art.

And it never has. I don't care how many of you are hairy legged, overall wearing, crochet knitting, vegan museli eating lesbians did agit-prop roaming street performances in the seventies. You thought radical change could happen.

185

You wandered around with your subversive haircuts and your mildly impressive physical theatre skills. You waved some banners around. You yelled at the world and then others applauded.

Well thanks a lot wom-yn. Not only did you fail, but you filled my generation with false dreams. Now we're still oppressed but we've got Beyoncé wearing a FEMINISM t shirt and pretending to like while she is fucked in the mouth by the big cock of patriarchy. Thanks a lot.

Radical change did not happen through your art.

Thanks a lot to all of you. And not just you. Thanks a lot to Germaine Greer. Gloria Steinham. Anne Marsh. Failures, the lot of you. What have you achieved? Writing things down. Getting angry. Shrieking amongst yourselves. And for what? Im still here. Im still worth less than a man. Im still hit on, and hit, and invisible.

Thanks a lot Suzanne Lacy, Helen Reddy, Judy Chicago. All of you. And not just you.... Pussy Riot, Brecht, Jill Orr, The YES Men, pvi collective, Version 1.0, Guerilla Girls. Thanks a lot Ai Weiwei. Anne Summers. Lena Dunham. I could go on but Im starting to bore myself. Thanks a lot to all of you, you know who you are .

The world is still fucked. You've all failed. We're still.... If we're women, and we're working class – we're fucked. We're just bodies here to be consumed and ejaculated into. We're nothing. We're still just mirrors to reflect. We're just objects to be used and abused and on display like trophies. Still. Still nothing. Still failing. Still flailing.

Radical change cannot happen through art.

And I'm a white educated Australian. I've got it pretty cushy. Fuck knows how the rest of them are getting through the day.

Radical change cannot happen in galleries, in theatres, in the site specific or the laneways or between the headphones.

Radical change happens outside, with weapons and with slaughter.

Radical change happens when one of you picks up a gun and goes outside and kills Tony Abbott. What would it take for one of us to do that? How many atrocities can he commit? We sit here, and we hate him together. We hate him together and we say oh oh oh the people are on Nauru or oh oh oh our land he digs digs digs and sells the coal and sells our souls along with it but oh I've got my fucking keep cup, I say no to plastic bags and I turn the lights off and I saw this really provocative piece the other week about rubbish where they just let fruit rot, the fruit rotted for a week and I had a good hard think about things. I had a good hard bloody think about things that day.

Radical change cannot happen through art. Why are you here? Why am I speaking? We are not changing anything. No meaning exists between you and I except for the warm fuzzy feeling that we are both on the same side. Well fuck you. I don't want to be on your side. Fuck you, and your complacent keep cup ways. I want the extreme. I want violence. I want to blow up the offices of people planning to blow up abortion clinics. I want to hold a knife to the neck of George Pell and make him beg the forgiveness of my queer brothers and sisters whom he has so disgustingly disrespected. I want to see Karl Sandilands cry as I rip open his ball sack with a fucking fork for the ridiculous things he has said to young women. I will spit in the face of Julie Bishop for her crimes against her sex – how dare she historicise feminism. How dare she conform? How dare she leave us flailing out here, in the ghettoes, in the loser's team.

And further, and more. I will take a spanner to the guts of the straight white men. There, deep. Rip. Each and every mother fucking one of you. Take it in the guts so that you can feel it, and you'll know, you'll know for one second. You'll know for one second what a lifetime of pain feels like, you insignificant fucks.

This is the only way forward. Radical change cannot happen through art.

I was born with an act of violence. I came into the world, ripped my way out of the womb through layers of skin and tendons. As I ripped my way out, and then lay there, covered in shit and fluid and red with the excitement of it all, that was the beginning of becoming. That was the first violent act. And Now, here, I call for the next one. And then, after the guns and the bombs, and the murders and the violence. Then, then we can sleep easy. Then we can turn the page. Then we can wake up, open our eyes on a new day. We can stand up, and look at each other. Then, and only then, will we be a full human.

Then, only then, we can start talking.

WHO IS WITH ME?

A SPEECH FROM THE POINT OF VIEW OF AN ARSEHOLE:

This speech was complied with quotes from North American politician Rush Limbach. Made in collaboration with Bron Batten.

I'm a huge supporter of women. Feminism is what I oppose. Feminism has led women astray. I love the women's movement – especially when I'm walking behind it.

I prefer to call the most obnoxious feminists what they really are – feminazis. The term describes any female who is intolerant of any point of view that challenges militant feminism. I often use it to describe women who are obsessed with perpetrating a modern-day holocaust: abortion.

A feminazi is a woman to whom the most important thing in life is seeing to it that as many abortions as possible are performed. Their unspoken reasoning is quite simple. Abortion is the single greatest avenue for militant women to exercise their quest for power and advance their belief that men aren't necessary. Nothing matters but me says the feminazi, the foetus is an unviable tissue mass. Feminazis have adopted abortion as a kind of sacrament for their religion/politics of alienation and bitterness.

You have to understand the mindset of a lot of these feminists. These women have paid their dues. They've been married two or three times, they've had two or three abortions; they've done everything that feminism can ask them to do. These kinds of women who have been attacking testosterone, who have been attacking traditional male roles.

We're not sexists, we're chauvinists – we're male chauvinist pigs, and we're happy to be because we think that's what men were destined to be. We think that's what women want. The definition of a misogynist is a man who hates women almost as much as women hate women. That's what a misogynist is.

Did you know that? A misogynist is a guy who hates women almost as much as women hate women.

And what is it with all of these young, single white women? Overeducated doesn't mean intelligent. I think this is the reason why girls don't do well on multiple choice tests – it goes all the way back to the Bible, all the way back to Genesis. Adam and Eve. God said, 'All right Eve, multiple choice or multiple orgasms, what's it going to be?' We all know what was chosen.

Universities have been chickified. Men aren't showing up in as many numbers as they used to. This is what we've done to boys and men. The feminists/feminazis have been working for years to this end: advance women by diminishing men.

Feminism was established so as to allow unattractive women easier access to society. They're out protesting sexual harassment when they actually wish it would happen to them. I'll tell you, you women. Why don't you just make it official, put on some burkas and I'll guaran-damn-tee you nobody'll touch you. You put on a burka and everybody'll leave you alone if that's what you want.

It's the same in politics. Female politicians get a pass on every aspect of their appearance. You would never have stories about how some female politician's fat – there are plenty of lard-ass women in politics and they get a total pass on it.

For example it doesn't look like Michelle Obama follows her own nutritionary dietary advice. And then we hear she's out eating ribs at 1500 calories a serving. I'm trying to say that the first lady does not project the image of women that you might see on the cover of the *Sports Illustrated* Swimsuit issue.

You may suggest that my comments are below the belt. Well, take a look at some pictures. Given where she wears her belts. I mean, she wears them high up there around the bust line. Isn't just about everything about her below the belt when you look at the fashion sense she has? And what does it say about women in politics when US college student Sandra Fluke goes before a congressional committee and says that women in her law school are having so much sex they're going broke, so the American tax payer has to pay for their birth control. So what does that make her? That makes her a slut right? It makes her a prostitute. She wants to be paid to have sex. She's having so much sex that she can't afford the contraception.

So Miss Fluke and all the rest of you feminazis, here's the deal. If you are going to get the public to pay for your contraceptives and thus pay you to have sex, we want something. We want you to post the videos online so we can all watch.

And now, I'd like to finish with a note about my cat Fluffy. My cat comes to me when she wants to be fed. I have learned this. I accept it for what it is. Many people in my position would think my cat's coming to me because she loves me. Well she likes me, and she is attached, but she comes to me when she wants to be fed. And after I feed her, she's off to wherever she wants to be in the house, until the next time she gets hungry.

She's smart enough to know she can't feed herself. She's actually a very smart cat. She gets loved. She gets adoration. She gets petted. She gets fed. And she doesn't have to do anything for it – which is why I say this cat's taught me more about women than anything in my whole life.

Thank you and goodnight.

'Man O Man' was originally written by Mish Grigor in 2014, and has not previously been published.

Fan Letter to Matthew Barney

Natalie Thomas

Cc: Norman Mailer and David Walsh

Dear Matthew,

I'm writing to say I love your work and I'm sorry you didn't get to meet me when you were out here recently for your **MONA** show. I wanted to see your new six-hour epic film based on the Norman Mailer book that nobody except **William Burroughs** rated. I love famous people and famous people love me too because I say interesting things. **Famous people are rich** from whatever they did to get famous and with all that money, they're, I mean you're, self assured and not at all easy to offend. Which I like. I like that you can just see the **money haemorrhaging** from your work. It's reassuring that artists can get funding to do crazy stuff.

Matthew, I reckon you like famous people as much as I do. You always put famous people in your movies and they come to your **Premieres**, which feeds the media. I wanted to ask you who is more famous: Matthew Barney, MONA, or Norman Mailer? **What do you reckon?** And then I wondered who has made the largest cultural contribution? Matthew Barney, Norman Mailer or MONA? Curly questions huh? Right out of the sun. Whose artistic oeuvre (I love that word, so French) embraces extravagance more? Yours, Norman's or MONA's? We'll need some time to work them out. **History always sorts all that stuff out though**.

We have a lot in common, you and I. You used to be a fashion model. So did I. **Tough gig that one.** Very objectifying. Limited shelf life too, modelling. Like art, you realise your career is dependent on others and how they see you. Anyway, if you had have met me (I was invited to your private cocktail dinner where, I was told, they served emu), what I wanted to talk to you about was your ex Björk.

I have a famous partner too. Some say we're a Melbourne Art Power Couple. I don't like the title, but hey, you can't stop people talking. His name is Morgan. He's a musician like **Björk**/I'm an artist like you. It's difficult being with Morgan. Every time I go out without him, everyone is always like: 'Where's Morgan, I want to see Morgan, we love Morgan, he's so funny and talented! What's Morgi been working on, when's he playing next?' And I'm like: **"What am I? Chopped liver or something?"** I know it's not a competition, but it makes me feel less interesting than him, even though when we're on the red velvet couch alone, we're very interested in each other... Even after 13 years! Being a creative couple is a minefield and that's before we get into **the whole creative ego thing**.

I thought I might reassure you Matthew and say: It's OK. I understand why you and Björk couldn't stay together. A small comfort I know, but thoughtful. Then I thought down deeper and **I thought you and Björk were like John and Yoko but with the genders switched round**. John and Yoko for a new era. Björk is the world famous music legend, like John was and you are the avant-garde artist, like Yoko, who, though well respected within a world of art, is forever doomed to live outside mainstream success. Its lucky Björk is a solo artist Matthew, or you could have been blamed for breaking up the Beatles! IMAGINE! See what I did there? That Björk. She's the talented elephant in the room.

Here's a great link to John Lennon's *Jealous Guy* from 1971. He's apologising to loads of different women for being a jealous guy. You should watch it. It's hard being the Yoko yeah? Poor thing.

https://www.youtube.com/watch?v=lOzqg1Z8rTU

After that (and this is where our meeting could have turned, but that really depends on you and how open you are to creative suggestions from complete strangers), I would have told you (if we had have met if I wasn't busy), that I think you could learn something from your former love in the duration department of your creative impulses. The short form (3-4 minute pop classic) vs. your 6-hour durational endurance ordeal videos thing. Maybe you're **a Tantric man like Sting**. The whole Telethon vibe.

Matthew, I think you might at least experiment with the shorter form, like a sketch, a summation of all your ideas expressed with brevity. Experimentation is good. At the planning stage, try asking yourself: **"what is it I'm trying to say and what's the *fastest* way to say it?"** Just try it the once, see if you like it. Please. Because all your work is so long if you don't **change it up a bit** occasionally, then people are going to be like: "Oh that Matthew Barney is a one trick pony. His works are always demanding so much of me; you know what I don't have another 6 hours of my life to give over to that! Sure there's moments of amazing insight, but can't he just edit out the excruciatingly indulgent bits and save us all the pain? I don't even really know what he's trying to say even! His work makes me feel dumb and when the operatic event which is really a film screening is over, when I'm sure I've survived, **I drink too much to numb the pain of sitting down for so long**. And I'm trying to ease back on the binge drinking. At the Pub, the talk is all like: "Yeah sure. I agree. I think the joke is on us!" **I don't think you want people thinking that Matthew. Just saying...**

River of Fundament, which I'm sorry I missed by the way, is about Death and Rebirth. That reminds me of the Björk song *There's more to life than this*

https://www.youtube.com/watch?v=0F0BZZ4FpF8

I like when she says: "Let's sneak out of this party, it's getting boring, There's

more to life than this". People getting bored and walking out. I like that woman!

https://www.youtube.com/watch?v=YqN3znKq_C8

Björk *Big Time Sensuality*

https://www.youtube.com/watch?v=KDbPYoaAiyc

Björk *Human Behaviour*

Matthew Barney. I'm glad that you're into humour. **I love a laugh too**. I liked when you said: "I'm definitely interested in humour, that humour that sits on the edge of discomfort, a kind of embarrassment, even if it's expressed through material ways."

A pooh wrapped in gold potpourri and fashioned into a penis, for example? Barney pauses for a long time. "Maybe embarrassment is too specific a word. It's more about the tendency for things to fail or for things to fall." I'm into that too.

Can you release your *River of Fundament* on Netflix or on Quickflix or one of those game changing platforms, so I can sit at home and watch it from the comfort of my house? Possibly do some fast-forwarding. I know you're really into exclusivity, but hey, one screening on a Friday arvo in Hobart is so exclusive its almost career limiting. You could be losing audiences.

Anyways, I'm almost finished with you, but before I go, I need to talk to you about Norman Mailer. I like Norman too; **I'm not one of these feminists who doesn't like the lads. I love the men. The good men**. I like Norman Mailer even. Not so much the stabbing-the-wife-with-the-penknife thing, but I like that he co-founded The **Village Voice**. That's way cool. I like that. Norman wanted to rescue Marilyn Monroe. From herself. Bit presumptuous. And his counter-cultural essays, *The New Journalism*. I'm doing something new too, like Norman did. I call it **the New Review**, it's an art review but sometimes I don't even see the art. Sometimes **my New Reviews are bigger than art**, other times they're not. I remind me of Mailer's *The White Negro*, radical, hip, a bit of a fashion victim.

I like how you put Norman in *Cremaster 2* as Harry Houdini. That's clever when you call up the old legends and put them in your work and then your names are forever associated. Funny really, cause that's what I'm doing to you now Matthew. **Warhol knew the power of association best.** The media, celebrity culture, notoriety, wow, they're big themes too.

So look. I'll just put it out there, if you ever need me to be in one of your movie's/video's, sure thing, I'll do it. A few people have said I look great on the big screen, though they wish I had worn a bra. My breasts bounced up and

down, up and down as I walk slowly toward the camera, following direction faultlessly. I was a welcome addition on the set, everyone was like: "Gee Nat. You're good on a set". Collaboration is great isn't it?

Anyway, Matthew, I've attached a link to an unexpectedly entertaining Interview from 1984 between Mailer and, wait for it, **Oprah Winfrey**. You're going to love it. It's better than that footage with Germaine and her friends that you've probably seen already. Oprah is young and holds her own. Introducing Norman to her audience you can tell she's excited. You can see how Oprah has been able to become an Institution. **Oprah really connects with her audience. That's what you've got to do.**

http://www.youtube.com/watch?v=Ft1gV-j3PDo

I don't believe for a second that Oprah's popularity can be put down to her ongoing struggles with weight and how that links her to a super large portion of Americans. Those rumours about her and Gail are just slanderous. They're friends for Christ's sake, nothing more. **Good mates**.

"In fact, the more you read about *River of Fundament*, the more it seems that admiration or hatred for it is divided along gender lines."

Alex Needham, The Guardian

'Fan Letter to Matthew Barney' was originally written by Natalie Thomas for Nattysolo. com, 23 December 2014, http://nattysolo.com/2014/12/23/fan-letter-to-matthew-barney/

Open Letter to an Open Letter

Ann Magnuson

Seriously? What the FUUUUUCK? You stare at me with your blank page staring back at me like some milky white ass flaps twerking for dollars on the agitated propaganda machine crying out for attention while masquerading your plea for help as a publicity stunt; a call to arms, to legs, beckoning to what is panting between those latex clad gams, those powerful pussy pants that can be sold for so many pieces of silver, gold and Bitcoins on the open market and defiling our father's house of prayer? Don't be fooled! It's a losing game! You think I'm going to fill up your empty void with self-righteous, self-promoting texting drivel, so much jaw-breaking jibber jabber, using this platform for a hectoring lecturing dickity dock to empower the pussy over the cock when all we're really looking for is more 'hits', more eyeballs rolling in the back of heads and onto websites to move more product? Give me a fuckin' break with your 'look at me I know the score, I've been around the block Good Woman of motherfuckin' Setzuan waiting all Godot-like for a royalty check that never shows because some industry spunk mogul spent it on a yacht in Anguilla' BULLSHIT! Because if I even hear one lame-ass vocoder note of that siren song, I'll fall for it and start trying to win at a losers game, getting my act together and taking it on the road, screwin' my head on right and no one is gonna tell me it ain't while running as fast as I can WHILE YOU continue to TAUNT with more whitespace to fill! This is a vortex THAT CAN NEVER BE FILLED; that oozing, gaping GOD SHAPED HOLE aching to be crammed full of cold hard plasmatic cash because it's not like the old daze when we could use paper and a simple yellow No. 2 pencil and begin and end a good bowel movement of a punk rock riot grrl rant with a couple of well crafted paragraphs. Nooooooo! Now it's all about fuckin' word count and bullshit font size and patriarchal borders and shadings and template-tipped bullets and mind-numbing page numbering! Those ever-continuing pages that require the never-ending numbers; numbers that stretch beyond the edges of the known universe, beyond human comprehension, waaaay past the event horizon to drive us star raving mad! And the hashtags! For the sweet love of Jesus, The HASHTAGS! #fuckyouall NOOOOO, these days we don't have time to sit at a simple wooden desk with our McGuffy Reader minding our P's and Q's, we have to PROSTITUTE OURSELVES on computers and iPhones and Humpty Dumpty Mumblety-peg Gadget Thingamajigs being thought up every day by Evil Game Changers in order to trick us into endless 'upgrades' and all the while we continue to be faced with one huge, theocratic mullah of a blank document that just goes on and on and on and on AND ON until the 12th of motherfuckin' NEVER! No matter what I say, no matter how much I type, no matter how fast I spew my vitriol, projectile-vomit, no matter how well I craft this well justified bile that NEEDS TO BE SAID I am still faced with having to do MORE. MORE! MORE! MORE!!!! All because of YOU, you Damnable Open Letter! You who will endlessly taunt me with more empty and infinite

GODDAMN white space!!!! This is why NO WOMAN can win at this game! Face the TRUTH: We're being used. Sucked into the tar baby vacuum, used as pawns in the Entertainment Game, being jerked over by The Man in our vain attempt to WRITE OUR OWN SCRIPT. We think this is a way to TAKE BACK OUR POWER? EPIC FAIL! It's all USELESS USELESS USELESS! So much cannon fodder grist for the mill like the sands through the hourglass these are the lies of our lives! Face the facts drones: There is always more to give, more to say, more to feed the insatiable beast, the one that weaves a deceitful web with our Facebook threads, our Tweetie Pie chicken shit cuneiform, our high horse hieroglyphics, our open wound expressionistic Esperanto; these walking shadow boxing matches full of sound and fury signifying not a heck of a lot when you get right down to it cuz all we are is dust in the wind. If – as our mother goddess role model Yoko Ono astutely sang – Woman is N*gger of the World, then You – YOU insidious Open Letter, are the White Supremacist Albino Dictator of The Internet and I say FIE! FIE ON THEE AND YOUR DEMON SPAWN!

With immense respect,

Ann Magnuson

'Open Letter to an Open Letter' was originally written by Ann Magnuson as a Facebook post which was reprinted by dangerousminds.net, 10 May 2013, http://dangerousminds.net/comments/ann_magnusons_mindbendingly_brilliant_open_letter_to_end_all_open_letters.
She has recorded it as a spoken-word-with-music track that appears on her latest CD.
© Ann Magnuson, Pink Fleece Music, admin by Electric Pacific Songs (BMI).

Facebook Posts

Wendy Houstoun

1.

i have set up my own company where everyone has such a lovely time and no-one ever disagrees with anyone- and we all just love moving- and dancing- and being lovely- and just sharing and caring for each other- and all we do each day is respect each other and just love the way we develop and are different and yet strangely similar in the way we think and move and dance and hope and love and respect each other from a distance and yet close up as well and we only have to look at each other to realise how similar and yet different and diverse we are and all this happens without a cross word and a nasty look or argument or any difference of opinion -or even the hint of any kind of power games because in our world there is no power- no-one takes decisions and yet things happen almost magically- as if they were a group decision- almost as if the group had one mind- almost as if we all thought different things but they were being channelled through the same place- a little like facebook but in real life.....anyhow. you will see us soon...but it might be messier than i am making out.

2.

Just back from an idyllic day in the studio. we were all so in tune we hardly even had to look where we were going or think what we were saying or listen to the music because we were the music and we were the dance and no-one went wrong because there is no wrong - or right-or even just a bit not as right as someone else and we didn't have to worry about what we were doing because we weren't actually doing anything or it felt that way because we were so at ease with what we were doing it didn't even feel like doing anything except for following the flow except we weren't following because there was no leader although one person got slightly upset i thought for a moment but i think it was just that they were moved to tears because of the together and yet separate way we had arranged our bodies in the space and when we all managed to go for a coffee break at the same time and found out we actually drank the same kind of coffee from the same kind of cup it was a weird moment of togetherness and everyone managed to do exactly what they wanted to do when they wanted to do it in the way they wanted to do it in and there was no feeling that it should have been better or worse because there is no better or worse although i did think there could have been a little bit more space given to some of the ideas i had but that was not important because we had to leave the studio at that point anyway. can't wait for tomorrow.

3.

new approach after the disaster of the last days trying to stop people laughing at our serious work means we tried a more socio political approach using the methods that the government have suggested we go for with the emphasis on economic return and the promotion of growth and competition mainly focussing on the competition thing so we set up a thing like the voice where

the audience all had their backs to us and went through our repertoire including swan lake done in morse code and our epic emotionally draining Scissor Happy Upstarts which is still in development but even though we cut 40% off all our efforts which meant skipping every fourth move in a group of ten and working in nearly a half of the space with 40% less emotion we could still see the backs of chairs shaking so we still have a lot of work to do but at least we got to speak to people after although its hard to have a decent conversation when you can't see people's faces so tomorrow we are going to change tack and see if we can stop this laughter using the really important priorities of economic return and growth which we feel are less intrinsically funny but at least we have cut our new work by 40% so it will be shorter quieter and not be so draining to do though I can't help thinking our promoters and producers and funders and publicists and marketing people are not going to be happy about it but we are off to plan how to get economic growth into our work tomorrow...we are not giving in.....yet.

4.
chaotic end to a difficult week. returned to science in the hope of getting somewhere with innovation- growth-productivity -competition and being taken seriously...

9 am. live streamed physical warm up personalised for netflix output -- audience texting each other with jokes.

9.30 pm- competitive group work focussing on harmonising energies and movements with new element of eliminating least harmonious person - audience downloading our new apps and sniggering.

10 am- innovative verbal tongue twisters sponsored by Big Brands and filmed by online resource dot com- audience twitching in seats and smirking at each other

10.02- quick fire production of gestures and breathing patterns for ad to eliminate stress and anxiety for people suffering from work pressures- audience chuckling at each others screens

10.04 -hyper linked contact work with slow development speeded up for trailer possibility- audience filming each other

10.05 - physical endurance sequence against blue screen for holiday advert and possible touring ads- audience in small group at back of the room

10.10- folk dance footwork from different countries for extending reach- audience sending own videos to each other

10.15- gymnastic session using delicate balancing for photo session by nhs direct to use as image for community awareness- audience japing about for their cameras in silly ways

10. 25- eyes closed work for image to be used for banking backers- hard to tell what audience was doing

11.15 - coffee - audience using the floor and messing about using all our props

11.30- attempting to run through carefully worked out sequence but audience getting in the way

12.30- managing to stay concentrated even though audience now filming themselves showing off and running around

1.pm- lunch= audience seem to have started up their own group and another audience arrive to watch them

2.pm- very confusing now as we return to our slow rehearsal but 1st audience now doing some kind of organised activity which they are copying from their phones and 2nd audience are sniggering

2.50 pm- post run discussion for 1st audience who have some costumes on and loud music and are doing a sequence for a local tv team they have managed to get along and 2nd audience is laughing very loudly at them

4.15- tea break - 1st audience out of control doing really stupid things with blindfolds and all our props and 2nd audience is filming them and each other for some spotify personalising sequence

5.15- we have long discussion about development and management, program design and administration, strategic planning, financial modeling, public relations and advocacy, marketing and branding, real estate development, commercial licensing, capital formation and fundraising, not to mention a talent for diplomatically balancing the interests of diverse constituencies and ways to keep or company going- 1st and 2nd audiences have joined forces and are doing what they like and turning it instantly into a netflix box set which will have personalised content and mainstream appeal...

6.15- we are packing up all the props and stuff and trying to make sure the insurance is still in place for third parties and leaving for the pub while the audience celebrate their good days work.....something seems wrong so we are going to nut it out and come back monday with a bold new approach... feel so grateful to have had the chance to experience this......can't wait tll next week..

These texts were originally written and published by Wendy Houstoun on *Facebook*, 2015, https://www.facebook.com/wendy.houstoun?fref=ts

The Audience Does Not Exist

A proposal by Vaughan Pilikian

Everywhere we go, we hear the same demand: art must open itself, make itself useful, respond to demand and critique, provide feedback, itemize outcomes, benefit the community, render itself transparent, accessible, interactive. The Audience must be allowed to exercise choice even after the tickets have been purchased, perhaps deciding the outcome of a piece through the click of a mouse or swipe of a smartphone.

In short, art must defuse, diffuse and dilute itself, until all that is recalcitrant, awkward, uneasy, antisocial, alien or autonomous about it has been purged from its body.

Art is now a service, like tourism or banking. The Audience is a stakeholder: it has bought the privilege to be entertained and that is its right. And like every stakeholder, the Audience must have a say in how the service it has purchased is provided.

What is surprising, upon reflection, is not the fact of the nature and ubiquity of this demand. It is the fact that artists have everywhere accepted and internalized it as orthodoxy.

In my work and thought, I take the opposite position. I argue that art is not a service, but something else entirely. It should close itself off, should make itself useless, should reject demand and ignore critique, should make no excuses, disregard outcomes, and sow discord in the world around it. It should retain its mysteries, rendering itself opaque, inaccessible, obscure. And it should present a series of dangers and traps for any who dare to approach it.

This has nothing to do with intellect or elitism. Quite the reverse. Art is a thing for everyone or no one at all. It seems most likely that in the present era it must become the latter.

What I am describing I believe to be a moral and aesthetic duty, a duty with metaphysical significance. A duty that pertains to the very future of the form.

The survival of art is under threat, and the forces that seek its destruction have dressed up their phantom stooge and sewn razorblades into the lining of its jacket and called it the Audience.

Art must declare war on this Audience.

It must do this not out of antagonism towards any individual audience member, whom it can never properly know, but out of antagonism towards

the instinct for casual association, mass prejudice, postmodern fascism and consumer demagoguery – in short, towards all the ways that the Audience exemplifies and enforces a society whose very existence is steeped in cruelty, greed and corruption.

For only in declaring war, in taking so total a stance, can we see through the lies and the cant and the doublespeak, and discern a fact that otherwise we might never have expected could be the case. Namely: that the Audience does not exist.

For a short outtake from a previous production – http://www.unruowe.com on the original performance – http://theyardtheatre.co.uk/show/leper-colony/ further information – http://www.youtube.com/watch?v=qUAx1uUGkfc

'The Audience Does Not Exist' was originally written by Vaughan Pilikian, September 2013, and has not previously been published.

Acknowledgement Speech of Frie Leysen receiving the Erasmus Prize 12 November 2014

Frie Leysen

A story from Seong-Hee Kim, a friend and colleague from South Korea. Millions of years ago the first creatures crawled out of the sea and onto land, became reptiles, and then mammals. But after a while one of them, probably a reindeer, changed his mind, anticipated the big crash of a meteorite, took a deep breath, and jumped back into the sea. He thought his chances of survival were greater there. The whale: one of the biggest, most intelligent, and most empathic animals on earth, and the only mammal in the sea. An illustration that taking a step backwards does not necessarily mean regressing, but can be the right thing to do.

I received this prize for the reasons you have just heard. I received this prize while I was in Vienna at the Wiener Festwochen, fighting a losing battle to defend precisely these ideas and values. It was a difficult time, and the fighting spirit went hand in hand with serious doubts and uncertainty. It was a battle I couldn't win in the end, since it is impossible to defeat dinosaurs. We should not waste any more energy on that. So I resigned my contract of 4 years after 9 months and left after just one edition of the festival. Back into the sea…

For me it was a curious moment of discord, driven to despair yet honoured at the same time. What does this prize mean in such circumstances, for myself and for the ideas and principles I stand for? I doubt very much whether I belong on the prestigious list of Erasmus Prize winners. In the past this prize has honoured brilliant minds and gifted artists. I am neither.

I regard the prize this year as an alarm bell. Do we realise exactly what we are losing in this climate of shifting to the right, nationalism and commercialisation?

This prize is presented to me by the King of the Netherlands, King Willem-Alexander. Your Majesty, your country has become a place where the arts can hardly breathe any longer,

- a country where the distinction between art, culture and cultural industries is scarcely made any more;

- a country where funding for culture and arts is being slashed. The theatre landscape alone has been thoroughly erased, rigorously pruned as though it contained a proliferation of weeds. What a pity, because it is precisely from there that renewal and change can come;

- a country where places of artistic creation, laboratories and research centres no longer exist;

- a country where conservatism runs rampant;

- a country where art is dismissed as a 'left-wing hobby';

- a country where the international circulation of artists and their work is reduced to a ridiculous minimum;

- a country where (almost) all theatres, with the odd exception, do the same: offer a bland programme containing something for everybody, the main goal of which is to reach targets. As a result, most of them have emptied;

- a country where artistic audiences are no longer satisfied;

- in short, a country where art and culture, and their audiences, are under severe pressure.

Not only in the Netherlands, by the way, but also throughout Europe, the attack on art and culture has been launched. My home country Belgium has also been dealt blows recently. There is one thing I don't understand. Belgium and the Netherlands are among the richest regions in the world, and in both countries the crisis has been relatively mild. Until recently, both implemented a highly stimulating and progressive arts policy. How is it possible that this policy, along with all that investment, could be abandoned just like that, with one stroke of a pen? I really do not understand that. Indeed, I refuse to understand it.

The changing political climate is one thing. But a time-honoured motto tells us it is good to look at our own heart, so there is no harm in some critical self-examination. Have the arts gone too far in political, economic, diplomatic, flirtatious logic? Aren't we trying too hard to serve political interests by attempting to solve problems that politicians have failed to solve, such as social deprivation, migration and racism? Problems that the arts will not, should not, and cannot solve. Not even the modish "participatory art", or the "everybody is an artist!". Not everybody is interesting, and everybody is certainly not an artist. Aren't we justifying ourselves too much with figures and economic arguments instead of with artistic substance? Haven't we reduced ourselves too much to entertainers, who obediently obey the rules of managers, marketers and accountants instead of remaining the sources of disruption and inspiration that we should be? Shouldn't we, just like the whale, take a few steps backwards again, seek some distance, retreat into the sea, in search of the right biotope to regain our clout?

Besides as an alarm bell, I view this prize as a plea for a free space for artists and their work. A free space in which artists can freely develop their visions and artistic vocabulary, can analyse our society critically, can point to its fault lines, and can inspire us, the audience. A free space that really is free of political, economic, social and aesthetic pressures and agendas. That's what this is about. That is the sea.

202

This prize defends artists, who are in danger of drowning in a bourgeois and artificial world of glamour, money, power, name-dropping, prestige, commerce, coquetry, compromises, unhealthy careerism and vanity. The Disneyland of the artistic 21st century.

This prize also defends the international circulation of artists and their work, at a time when borders are in danger of closing again and navel-gazing reigns supreme, not only in the Netherlands but also in Europe. How I miss the Ritsaert ten Cate's in this country.

This prize is also for new generations of artists and performers, from all corners of the world. We may not know them (yet), but they will offer us a totally fresh perspective on our time and our world, at least if we give them the chance to do so.

This prize also honours a critical, curious, demanding and adventurous public, an indispensable sparring partner for artists. People who need other visions and opinions, who are curious about new art forms and languages, far from commercial consumption and from the rapidly advancing culture industry.

This prize is about the very core of our work, about artists and their work, about engagement, about taking risks, about radicalness and change. It is about revising structures and ways of working, adjusting them to meet the needs of today.

During my life I have set up a number of new, tailor-made structures (deSingel in Antwerp, the KunstenFestivaldesArts in Brussels, and Foreign Affairs in Berlin), in order to realise my ideas and values. But just as crucial for me was to leave these structures on time, to hand them over to the next generation. Is there still space today for new structures? Has the landscape become too crowded in the meantime? I am not so sure. The point is that structures and art centres claim, and have been accorded, a timeless status. Initiatives of a temporary nature are seldom set up, yet new life must go hand in hand with death. We are bad at dealing with the notion of finiteness. More space is needed, mental and political space, to change structures from within. New generations must be able to take over existing institutions, change things around, revise and reshape them to reflect new insights.

In the political and economic arena, Europe no longer plays a role of any consequence. Our culture and arts still lead the way internationally, however, and we must continue to support them. Countering the tendency to reduce everything to the preservation of our past in museums, we must continue to invest in a climate of vibrant, open and innovative arts for the future.

This prize honours ideas, principles and ways of working now subjected to severe pressure, not just in Vienna and the Netherlands but also throughout Europe. I share this with everybody who helps to defend them: artists, colleagues, audiences, and even the occasional public official.

I dare to dream that this gesture will make the political world stop and think about where all this is leading the arts, for whom, how and why.

And so, ladies and gentlemen, I suggest we all retreat together into the sea!!!

'Acknowledgement Speech of Frie Leysen receiving the Erasmus Prize 12 November 2014', was originally written by Frie Leysen and published at *Praemium Erasmianum Foundation*, 12 November 2014, http://www.erasmusprijs.org/?lang=en&page=Nieuws&mode=detail&item=Speech+Frie+Leysen+online

In the Age of the Cultural Olympiad, We're All Public Performers

Claire Bishop

Visitors to Tate Modern in the past week will have noticed strange activities in the Turbine Hall. Rather than the usual flurry of cranes, cherry-pickers and engineers that signal the arrival of a new installation, there were 50 people of different shapes and sizes running around the concrete expanse: spiralling in loops, gathering in clusters, hurtling up and down the ramp. In the middle of them was the British-German artist Tino Sehgal, fine-tuning his performance – or as he prefers to call it, "constructed situation" – which opens to the public on Tuesday.

Sehgal's *These Associations* is a far remove from the overblown visual spectacles that usually make up the annual Unilever commission. At first sight you barely see anything. Then you notice strange ripples of movement across the concrete expanse as the 50 choreographed performers come into view. If you stand by and watch for a while, one of them might come up and talk to you, recounting a personal experience of when they felt they belonged.

Sehgal is well-known for participatory performances in which groups of non-professionals are trained to engage in conversation with the public. For this commission, more than 100 people have been recruited: the youngest is 16; the eldest are in their 70s.

His reliance on non-specialist performers is part of a broader trend since the mid-1990s towards participatory art – and is arguably its institutional apotheosis. For much of this time, however, participatory artists have been working outside the mainstream world of museums. It is only in recent years that the tendency has become high profile, in works such as Antony Gormley's *One and Other* (2010), when more than 34,000 people applied for a chance to occupy one of his one-hour slots on top of the fourth plinth in Trafalgar Square.

At the time the *Guardian*'s Charlotte Higgins referred to the work as "Twitter art", and she wasn't far off the mark: participatory art has proliferated in tandem with the feedback loops of Web 2.0 and social networking, while its fascination with eccentric laymen parallels the populism of reality television. All three tread a very fine line between cultural democratisation and incessant banality.

But participatory art has a long history, spanning the whole 20th century. Today it's an international phenomenon and arguably less political in orientation. It used to work against an absurdly inflated art market, on the one hand, wanting to empower those less privileged, on the other. But part of its recent popularity in the UK is a result of specific ideological motivations. In the mid-90s, New Labour commissioned thinktanks to evaluate the benefits

of social participation in the arts. Proof was found that it reduces isolation by helping people to make friends, developing community networks, helping offenders and victims address issues of crime, encouraging people to accept risk positively, and transforming the image of public bodies.

For better or worse, these pro-participation studies became the foundation of New Labour cultural policy and led to a climate in which participatory art and education became a privileged vehicle of the social inclusion agenda. Culture was valued because it created the appearance of social inclusion, even while government continued to erode those institutions that actually assure this – education and healthcare. This led to the contradictory condition of participatory art being embraced by radical artists for its unmarketability, while serving a Potemkin function for its governmental paymasters.

With the arrival of Cameron's "big society" in 2010, the terms of engagement have shifted once more. The Tories have little interest in the political uses of art, preferring to hand it over to the dictates of the market. (The result is Anish Kapoor and Cecil Balmond's Tatlin-on-crack sculpture, *ArcelorMittal Orbit*: a £19m monstrosity named after the private individual who funded 85% of its construction). Mass creativity is supported only to the extent that it is self-generated – and self-funded. In keeping with big society doctrine, wageless volunteers are asked to pick up where the government cuts back. In this climate, participatory art acquires a different resonance, more akin to the sacrifices of unpaid labour. It is no coincidence that a large percentage of the Cultural Olympiad relies on such volunteerism: Marc Rees's *Adain Avion*, for example, asks local community groups in Wales to be content-providers for a mobile art space made of aircraft fuselage, while Craig Coulthard's forest football pitch in Scotland needs to be "activated" by amateur teams, wearing strips designed by local children.

Herein lies an important difference between Tino Sehgal in the Turbine Hall and the do-good community-based participatory art so rife in the Cultural Olympiad. Sehgal isn't particularly interested in empowering people; those who work for him are paid performers who serve his ends (an enigmatic work designed to reflect on the museum as a space of simultaneously individual and mass address). But what Sehgal does have in common with the majority of participatory artists is a tendency to place an emphasis on everyday (rather than highly skilled) forms of performance.

In so doing, his pieces, like so much other participatory art under neoliberalism, serve a double agenda: offering a popular art of and for the people, while at the same time, reminding us that today we all experience a constant pressure to perform and, moreover, this is one in which we have no choice but to participate.

'In the Age of the Cultural Olympiad, We're All Public Performers' was originally written by Claire Bishop for *Guardian*, 23 July 2012, http://www.theguardian.com/commentisfree/2012/jul/23/cultural-olympiad-public-performers Copyright Guardian News & Media Ltd 2016.

Iniva: Fit For Purpose?

Morgan Quaintance

In July of this year the Institute of International Visual Arts (Iniva) sent a group email to associates with what was received by many as sad and shocking news. 'Colleagues and partners,' it opened, 'we wanted to be in touch to let you know Iniva's position following last week's announcement by Arts Council England.' Defeatist, flat and oddly conciliatory in tone, the message was that, following a 43.3% slash off Iniva's National Portfolio Organisation grant in 2012/13, ACE had decided on a further 62.3% cut this time around, effectively reducing Iniva's 2015/18 allocation from £1,762,486 to £685,032 – that is, £228,344 a year. Consequently, Iniva will cede management of Rivington Place (the organisation's £7.66m purpose-built premises completed in 2007 thanks to a £5.97m contribution of ACE capital funds) to the building's other NPO occupants – and recent recipients of a 96% grant hike – Autograph ABP (the Association of Black Photographers). Furthermore, Iniva will have to vacate the building by April 2015 and has been advised to return to its former status as an itinerant agency.

How did this happen? Looking beyond individual accountabilities, it is clear that Iniva's current fate is as a result of institutional forces outside of its control, forces that continually push susceptible organisations in the art world towards homogeneity in structure, culture and output. For anyone who has taken more than a passing interest in Iniva's activity of late, these recent additional cuts could be seen coming from a long way off. Plainly speaking, once the initial bombast and controversy surrounding Rivington Place's construction died down, regard for Iniva has been allowed to slide from recognition of its initial iconoclasm and brilliance to an informal consensus about its current inconsequence and irrelevance. The problem was that established London-based institutions (Tate, Whitechapel Gallery, South London Gallery, Camden Arts Centre etc) introduced a tentative internationalist stance into their own programmes. This had three detrimental effects: first, it absorbed Iniva's operational territory and remit, which pushed the organisation towards redundancy, given that the reversal of institutional colour and occidental bias in the UK was its core goal. Second, it reduced and repackaged Iniva's initially radical agenda as the hollow rhetoric of the global. Third, it exposed the fact that Iniva's programme has, since the mid 2000s, existed in a state of arrested development, a position of stasis made all the more apparent by the accelerated rate of social, economic and cultural change during the period – most notably the partial dissolution of cultural hierarchies facilitated by the world wide web, and the emergence of strong grass roots arts activities and young independent organisations operating, for however brief a period, outside the mainstream.

Who is at fault for Iniva's deterioration? In a move not entirely unjustified, eyes are turning to senior management. Disgruntled observers feel that Iniva has been steered on a course of ever-decreasing activity by a somnambulant directorship from Tessa Jackson OBE. In all fairness, it is an accusation supported by events during Jackson's tenure. Since 2008 Iniva – watched over with Olympian detachment from the organisation's hesitant board and a succession of ineffectual chairs post-Stuart Hall's resignation – has seen high staff turnover and the dissolution of its outstanding and well-respected publishing arm; the suppression of certain key education initiatives and a reduction in significant public events; the development of an exhibition programme that is, broadly speaking, uninspiring; and a separation from its original partner organization, Autograph ABP.

But the crucial point to recognise is that Iniva's current condition is ultimately the product of historical forces that transcend personal failings. The organisation has run into difficulties because it adopted and continues to follow an old and unfit-for-purpose institutional model, a prefab bureaucratic framework standardised through decades of professionalisation in the field. In the process, what Iniva has been pushed towards is a condition of institutional mimicry, the goal being to reach a standardised state of operations akin to what is maintained by Margot Heller at the South London Gallery, Iwona Blazwick at Whitechapel, Penelope Curtis at Tate Britain and Ralph Rugoff at the Hayward. These mid-to top-level capital city organisations, showing primarily mid-career to blue-chip contemporary artists, have been able to function in a standardised mode because their remits, exhibitions and public programmes are essentially interchangeable. They exist to support and not challenge the status quo, and they observe the same western art historical orthodoxy and attendant academic system that is still singularly and anachronistically capable of conferring curatorial, artistic and theoretical legitimacy.

Iniva, on the other hand, was created to continuously introduce difference into a homogeneous field; it has to be new. The idea of internationalism was revived when it was set up in 1994 but in the first decade of the 21st century that lobby metamorphosed into the more abstract objective of attaining diversity. According to Iniva's 2013 report, the idea is to question 'existing positions and hierarchies within visual culture [...] so that a greater range of voices can contribute and be heard', to engage 'with new ideas and emerging debates [...] reflecting in particular the cultural diversity of contemporary society'; none of which has been convincingly borne out in its programme. The reality is that Iniva has been prevented from becoming the type of organisation that could achieve those crucial and necessary goals because such goals call for a radical new way of operating as an institution. Instead, external pressures – pressures that were perhaps unconsciously felt by Jackson, the board and ACE – have shaped Iniva's staff structures, pay grades, rhetoric and practices in the image of those institutions it was created to be distinct from.

This dynamic belongs to the world of inter-institutional influence, and significant research into this phenomenon has been carried out via the branch

of organisational theory – that is, the study of formal organisations – known as sociological institutionalism. According to US sociologists Rosemary CR Taylor and Peter A Hall's influential 1996 paper 'Political Science and the Three New Institutionalisms', sociological institutionalism is the school of thought that stipulates institutions – that is, societal norms and rule-governed formal organisations – not only 'influence behaviour by specifying what one should do, but also by specifying what one can imagine oneself doing in a given context'. It is the theory that organisations are subject to forces of contextual and cultural influence that define and demarcate how they can and should operate, and it emerged at the end of the 1970s.

Taking their cue from the more dystopic prognostications in Max Weber's *The Protestant Ethic and the Spirit of Capitalism* – specifically his belief that the spread of bureaucracy would ultimately create an 'iron cage' of rationalist order in which mankind was imprisoned – sociological institutionalists maintained that standardisation took place because institutions adopted the same practices as other organisations in their given field, frequently to their detriment, in order to be recognised as genuine. Hall and Taylor explain that 'organisations embrace specific institutional forms or practices because the latter are valued within a broader cultural environment'. This is because of a tacit inter-institutional understanding that, according to US sociologists John W. Meyer and Brian Rowan writing in the 1977 text *Institutionalised Organisations: Formal Structure as Myth and Ceremony*, 'organisations which innovate in important structural ways bear considerable costs in legitimacy', they frequently 'fail when they deviate from the prescriptions of institutionalised myths'. In their cogent 1983 essay *The Iron Cage Revisited*, US sociologists Paul J DiMaggio and Walter W Powell labelled this process of influence and homogenisation, where organisations come to resemble each other regardless of their specific remits, as institutional isomorphism. The duo explain: 'Isomorphism is a constraining process that forces one unit in a population to resemble other units that face the same set of environmental conditions.' They also identify three types of isomorphic pressures: coercive isomorphism, that is conformity through force, persuasion or collusion; normative isomorphism, resulting from an organisation's entry into a standardised professional field; and mimetic isomorphism, where 'uncertainty is a powerful force that encourages imitation' and organisations with ambiguous goals model themselves on other institutions.

How do we know institutional isomorphism was the cause of Iniva's ills? That it continued to operate contrary to its best interests after the initial budget cut in 2012 is evidence enough. Looking deeper, its status as the new institution on the block in 2007 – as *AM* reported at the time, Rivington Place was 'the first new-build public gallery in London since the opening of the Hayward in 1968' – also created the optimum conditions for the syndrome to take hold. DiMaggio and Powell maintain that uncertainty and goal ambiguity, especially in relation to an organisation's fiscal and procedural matters, engenders the isomorphic impulse. In relation to money, the duo explain that 'government recognition of key firms or organisations through the grant

or contract process may give these organisations legitimacy and visibility and lead competing firms to copy aspects of their structure or operating procedures in hope of obtaining similar results'. And in relation to procedure, they write that 'the more uncertain the relationship between means and ends the greater the extent to which an organisation will model itself after organisations it perceives to be successful'. In the first case, Iniva's reliance on ACE as the primary grant giver meant that its organisational structure was under pressure to mimic those of other mid- to top-level London-based organisations whose regular ACE funding was secured. In the second, given Iniva's unprecedented and ambiguous goals, tentative and risk-averse senior management which was under pressure to deliver again used pre-existing programme models. Finally, if that didn't ensure mimesis, Iniva's reliance on other museums, galleries and collectors for the loan of artworks would have put pressure on Iniva to adopt their institutional procedures in order to be recognised as a legitimate venue for exhibitions of contemporary art. To paraphrase Weber, the art world was an immense cosmos of institutional rules of action that presented itself as an unalterable order of things into which Iniva was born, became involved and conformed.

Established institutions are able to exert this powerful influence through unvoiced, subliminal and tacit pressures simply by existing and operating as they do because we are influenced, by their hierarchical power structures and austere ambience of tightly policed behaviours, to believe they function according to some transcendent institutional rationality. They don't. While it is incontrovertible that some procedures exist because of their tried and tested efficiency, it is also clear that others are adopted because they are the done things, because everyone else in the field is doing them too. In amongst all of this, it is important to remember that contemporary art galleries are all relatively young institutions. They are, in effect, built from and maintained by a number of recent professionalisms that have themselves been subject to isomorphic processes in their early formation. These professionalisms – that is, curating, and both the practice and criticism of contemporary art – are now, in their own ways and at varying degrees of severity, facing crises or at least tensions between what they are officially supposed to be and what they may become in the 21st century that have been brought about by standardisation.

DiMaggio and Powell identify two characteristics of professionalisation as important sources of isomorphic homogeneity: 'the resting of formal education and of legitimation in a cognitive base produced by university specialists' – which in the case of curating, criticism and art making also forces subjects that arguably cannot be taught into restrictive frameworks so that outcomes are predictable and progress towards proffesionalisation can be monitored and assessed – and 'the growth and elaboration of professional networks that span organisations'. Since 1987, the year Paul O'Neil has noted that 'Le Magasin in Grenoble, France launched the first curatorial training programme in Europe' and the 'Art History/Museum Studies element of the Whitney Independent Study Programme was renamed Curatorial and Critical Studies', the proliferation of courses purporting to teach curating

has increased dramatically. Where curating contemporary art was once an occupation one fell into as a matter of practical necessity, it is now an exclusive and conservative field with strict rules of entry, codes of conduct, restrictive conventions of dress, address and communication. As such, there are procedures and norms that must be observed in order to gain the necessary accreditation, and there is an orthodoxy that must be swallowed and then regurgitated if your exhibitions and temporary projects are to be accepted as legitimate contributions to the field. Art criticism, with the proliferation of art writing courses, is also suffering the same fate of standardisation and academicisation. And the making of contemporary art has been locked in combat with professionalisation since at least the mid-20th century, with the recent trend in practice-based PhDs ('Rebel Without a Course' *AM*345) – both in artists seeking them and their being needlessly required by universities for teaching posts – seeing the balance tip further towards standardisation, or what some refer to as the practice and propagation of institutional art. Organisations that specialise in showing well-established mid-career and top-level artists are ill equipped to push curating, art making, criticism and historical study beyond this state into untested and innovative territories. This is because they rely on and present the results of standardisation and are by nature and design unable to spot, foster or support change from the bottom up. Iniva, on the other hand, was built to work against and challenge hierarchies and homogeneity, to drive and not follow discourse. In order to do so it has to shrug off its dependence on detrimental forms of 'best practice'. This can be achieved in a number of ways.

Perhaps the single most crucial alteration the organisation must make is in modifying the approach to its central goal of presenting international art: it must shift from a geographical to a subcultural perspective. The geographical perspective in relation to curating international contemporary art essentially follows the biennale model, with curators dropping into locations to find out who the most visible, successful and often enculturated artists are and then bringing them back to the UK for display. Curating international contemporary art from a subcultural perspective must look deeper into the cultural context of a specific location, to go beyond the surface in order to engage with emerging artists and collectives who may not already have large national reputations, and to engage with forms, practices, tendencies and philosophies that might be at odds with what is in vogue or institutionally sanctioned on these shores. In order to take this approach, a rotating team of curators would need to be able to embed themselves in specific communities for a period in order to develop relationships and a significant body of local knowledge. This necessitates dismantling the hierarchical, pyramid staff structure that Iniva has adopted from other institutions, starting with replacing the current board.

Following such change, the single position of director could be dissolved and replaced with three permanent curators. A glaring example of institutional isomorphism at Iniva is the fact that its current director receives £70-80,000 per year for a four-day week, in which eight staff are overseen. This sum is

the institutional standard and salary baseline for directors at the Whitechapel Gallery, South London Gallery and the ICA (although it is grossly inflated at the Serpentine for Julia Peyton Jones and Hans Ulrich Obrist – Artnotes *AM373*) but these spaces have staff teams at least triple Iniva's size and yearly budgets that are significantly larger to boot. With a budget of £228,344 each year for the next three years, the organisation cannot afford to spend a third of its yearly reserve on a single individual bringing a limited offer to the table – whoever the director may be. By dividing the directorial salary into three equal parts, Iniva would be able to employ three curators at an average of £25-27,000 per year (two focused on exhibitions and one on public programmes). Of course it is not enough to attract 'star curators', but the UK is bursting with young curatorial talents who are more knowledgeable about emerging fields and platforms than the out-of-touch directors and senior curators they are often paid a pittance to advise, assist and prop up.

In addition to maintaining the position of education curator, another full-time curator of public programmes would need to be appointed (bringing the quota up from zero to two), which could be achieved by allowing that position to replace the current role of chief exhibition curator. Perhaps more crucial than its exhibitions and education initiatives, Iniva's management of public programmes will be its most effective tool in engaging the diverse communities that surround the gallery and ensuring its continued public relevance in the capital. All five curators would be responsible for the overall identity of the institution as opposed to the programme being the concrete expression of the will and ideas of a single, highly paid individual.

The last recommendation there is room to sketch out here is that Iniva resist reverting to its former status as an itinerant agency. It should instead seek out a smaller space in the location that was originally rejected as the site of its capital build: Peckham in South London. In contrast to the dead-aired commercialism of Shoreditch, Peckham is an incontrovertibly multicultural area, sorely in need of an arts organisation with a strong, internationally focused curatorial team. So far – and this is not a value judgement, just a statement of fact – various independent curatorial collectives, alternative club nights and private galleries have sprung up in the area and catered for an audience of predominantly, but not exclusively, white British middle-class students, graduates and young professionals who make up the area's transient population of renters. However, Peckham's heterogeneous population comprises Polish, South American, West and North African, Indian, Chinese, Korean, and white and black British working-class and middle-class resident communities. To suggest small projects and galleries cater their programmes to address these various communities would be a ludicrous and counter-productive move, nor should they be demonised for catering to a specific racial and culturally homogeneous demographic if that is who their programmes largely attract. Iniva, however, has internationalism and civic responsibility as its core values. Currently restaurants, bars, bakeries and property prices that exclude Peckham's diverse population – and will ultimately force out students and graduates – are driving gentrification in the area. Through its

public programme Iniva could be the established organisation that lobbies for and shifts the tenor of development away from gentrification to a culturally driven regeneration that preserves Peckham's international character and homogeneous population.

In sum, I have used the concept of institutional isomorphism to draw out overarching structural and operational faults that have emerged in Iniva's attempt to establish itself, through mimesis, as equal to mid- and top-level public arts institutions in London. It is my contention that institutional isomorphism may, in the words of DiMaggio and Powell, 'help explain the observations that organisations are becoming more homogeneous [...] while at the same time enabling us to understand the irrationality, the frustration of power, and the lack of innovation that are so commonplace in organisational life'. It will be a challenge, but if the reversal of fortunes at the ICA is anything to go by – a turnaround driven, in my opinion, by public events, screenings and talks programmed by the institution's younger staff – Iniva is perfectly capable of resurrecting itself. What's more, in contrast to the ICA's predominantly Euro-US remit, the restructuring of Iniva could provide a working example of a new type of institution for the 21st century: a non-hierarchical institution that really engages and unifies diverse publics through rigorously curated international exhibitions and events informed, for the first time, by a deeply embedded, subcultural perspective.

'Iniva: Fit For Purpose?' was originally written by Morgan Quaintance for morgabquaintance.com, 22 December 2014, http://morganquaintance.com/2014/12/22/iniva-fit-for-purpose/

Show Me
the Money

You Show Me Yours...

Bryony Kimmings

Afternoon Arts Bods,

So there is a little thing going on, on Twitter.

Which I guess could be said about any subject, from cute cats to misogynistic trolls, all day long. But this one is fascinating to me so I am blogging. I haven't ranted in a while about art, I have been too busy ranting about the rest of the world...

It's cold, I am in my draughty flat in East London. As we speak I am doing my finances and budgets for the next quarter. I am also trying to sort out how I am going to make my income for the next 6 months, it's always a panic moment when I do this... it's like I hide from it for a while and then have to bite the bullet and weigh up my options, weigh up the jobs I love doing with the ones I have to do just for cash.

I am super busy all the time and often feel like a headless chicken but yet I rarely make ends meet. At the moment I am deciding if I can have any staff next year (I am yet to be able to do this in any kind of permanent capacity and do the work of 3 people most of the time: Artist, Producer and Administrator) and where that money might come from. Luxury, that sounds like to most artists, but I work 14 hour days 6 days a week now and my work life is unraveling.

I want to talk about money. More importantly about making a living as an artist that has a good chunk of their income come in from touring and gigs, and the problems we face. As an artist and as a human being I want to lay my worries right out there. The conversation on Twitter was about venues haggling over show costs, trying to wear you down to fit into their tight budgets and it is something that seems to be a big problem, not really talked about. So if I am the soothsayer, if I pride myself on being brave in theatre, then I always tell myself I have to be brave in the real world to.

I am going to actually talk about money...

So let me lay it out straight. Make a cup of tea, its a long rant.

This year I have been on a budget of paying myself £1500 a month after tax. That is a salary of £22,800 per annum. £900 of this is my outgoings (debts, rent, phone, studio, bills etc). The rest is MINE for food, entertainment and travel. This might sound a lot but I live in LONDON. £150 a week for the OTHER category is not much at all in this city, and £35 of that is travelcard, £40 of that is food budget. A night out in London is usually about £75 (more if you are flashy like me!) drinks, taxi's etc so you go figure how much FUN I

can have with the rest of my allowance. 70% of my paid work is in London, so moving out is not an option.

I am 32 years old.

When I was the Artistic Director of Chisenhale Dance Space 3 years ago now I earnt £30,000 per annum. The first year I was self employed I made £9k to pay myself, the second year around £16k.

I am an "award winning" artist.

I charge £150 a day for my time if I am out of the office.

I charge £100 a day for my time in the office.

I charge £100 per half day of mentoring.

I charge £350 a day for a workshop with me.

I charged £500 for *Sex idiot* touring 2010/11, £750 for *7 Day Drunk* 11/12 and now £1500 for *CLSRM* 13/14 (as it's a two hander and tours with 4 people instead of 2!)

I charge on top of this for travel and accommodation... but mostly this doesn't happen, it gets lumped into an all inclusive fee no matter how hard you ask.

But of course, I do not have paid work everyday, that's what being self employed is. That's why day rates might make you think "oh she is rich!" But of course you work full time, but you are not paid full time.

I do not own a property OR have any savings. I am beginning to try and save £100 a month. But its pretty hard. I want us to have children soon and would love to own a house one day. For everyone else I know who isn't an artist this is happening, for me... it seems a very long way off.

I don't have a pension.

YET I am seen as a relatively established and successful artist now. Not in any way saying this to sound like a twat... but success wise it has been a good year, you know that... so why am I still finding it hard to get a venue to pay me properly is beyond me. Even with a show that has won 4 awards and 5 star reviews?! That just sold out 3 whole weeks in Soho Theatre (the best theatre of all time, in terms of artist treatment as far as I am concerned). I am not even touring that much, I didn't send out packs as I have little time with Taylor because of her exams, I usually do over 50 dates on tour I am doing only about 5 venues, yet it's the same old story. I am bored of it. The whole scene, the whole thing.

PLEASE DON'T think I am not paid that much money because I am not a good business woman... because I would say I am one of the best. I worked for a long time on the funding side of arts, the Arts Council use me as an example of a successful and excellent application, I negotiate hard but I am friendly, I am GOOD at planning, selling and marketing. I pride myself on that. It's just there isn't much money in theatre, not at my scale or for something deemed more experimental (yet you are wheeled out constantly as a leader of trends when it suits).

NOW I am constantly asked to de-value my art work by venues, education establishments, independent producers and sometimes even funders. Not ACE, I am a massive advocate for their GFTA work. Fuck you if that makes you hate me.

This is my list of bug bares and experiences... by putting this out there I hope to somehow encourage artists to join me in speaking openly about working conditions and to somehow seek out a culture change even in an age of austerity. It is realism that is needed. And compassion.

I am not speaking for the emerging artists of the world. I AM speaking for artists who have proved their weight, cut the mustard and who have fans and supporters in cities across the UK, who get good slices of funding and whose work is in demand. The term "Mid-Career" (I hate this term) Artist. Someone else blog for the emergents, poor fuckers.

I am also only talking about TOURING... so going out into the field (as the paleontolgists call it), not making work, or getting commissions or residencies or scratch night problems, or R&D etc.

This is my top 5 hate list....

1) **I hate being asked to come and do stuff FOR FREE**. Why on earth would I do this?! The other days I challenged a south London university who was asking me to schlep to the arse-end of nowhere just for the privillage of speaking to its 30 students for FREE. I love talking to students, its brilliant but why would I PAY out of my own pocket to do it. They promptly offered me £27 for the 2 hours work (not thinking about the prep time or travel time it would take, I would actually cost this at half a day...seeing as it would take HALF A DAY AND ALL!) and my train paid for. I didn't even bother replying to the email.

2) **The never-ending HAGGLE**. (Oh sorry I didn't know I worked in a market!?) Artists aren't greedy folk, generally. When I tell a venue my fee the first thing they do is haggle. It is VERY rare they just pay it. Sometimes they don't even haggle, they just tell you its too expensive and that there is a fee THEY want to pay and that's that. I cost my shows out very fairly and don't ask for much... so why does this invite the constant de-valuing of my wares and work.

EVERY FUCKING TIME.

Here's how my costing for *CLSRM* works...

(This is based on one night touring – which is not cost effective but often all a venue wants)

My performance fee (Equity min) £150

Taylor's performance fee £150

Stage Manager (who also works as legal carer) £200

Technician £150 per day (the actual time to drive down, do the get in and the show is 2 days for Equity) £300

Van hire £100

Petrol £50 (ish –hard to say)

Accommodation for 1 night, 3 rooms £250 (ish – hard to say)

Gun hire (yes this exists for our show) £50

Perishable props £30

Portion of insurance £20

Portion of LX design for tour £50

Portion of PR (a person I cannot tour without, its pointless) £200

Per diems @ £10 per head for two days for 4 £80

Printing (inc a little for flyer design for a tour, split between venues) £70

Admin (booking the gig, organizing licenses for Taylor, buying props, organizing the travel, the acc, chasing and checking the contracts, doing the marketing (including filling out the pesky form that ALL venues have to save THEM time but to waste YOUR time!), organizing rehearsals – I would say about 2 days work) £200

TOTAL TOUR COST is £1900 (so you better hope you get that travel and accommodation extra else you are already £400 out of pocket!!

BUT OH this isn't ACTUALLY THE TOUR COST IS IT... I stupidly don't add to this rehearsal fees, overheads or my writers fee (which we are all entitled to but rarely stake claim to). If I did, I would love to add an extra £500 to this in the real world. To pay myself, my tech, the carer and Taylor for a portion of the 3 days I spend in the studio before I go into touring to hone the show

again, for the office I pay for out of my own salary etc. (Notice I get paid £150 so does Taylor yet we are away from home the best part of 2 days) BUT If I did this I would literally price myself out of the market. HONEST TO GOD!

Perhaps there should be a standard fee for a show. But how the fuck would that work?!

3) **A venue just expects you will be applying to ACE to make up THEIR deficit.** This is why our system is so fucked. The party line is that you have to get tour funding to ACTUALLY cover the cost of a tour. This is like a secret unwritten clause in a venues mind, that ACE will mop up the rest. BUT my line is that **I** manage my relationship with the Arts Council VERY carefully and on my **own** terms. I have a 100% success rate with them because I am good at applications but also because I do not bite the hand that feeds me. As a good business woman I know income cannot come from one client or customer... this is dangerous investment tactics. You have to spread income, constantly find new sources, think commercially, earn it yourself. Spread the risk. I will ask the Arts Council for the money I want to ask for... not be told by a venue. 50% of my annual income comes from them, 50% is from elsewhere. That's good business. They are the largest funder in the country so they are my biggest (NOT ONLY investor). I won't be told how to manage my business relationships.

4) **I don't do box office splits. Unless the gains are commercially sized it's NEVER worth it. Stop asking me Dammit!** I am a self employed person, have NO regular funding. I do not have a bank account with more than about £500 (if I am lucky) buffer before all hell breaks loose... so WHY would I ever do a box office split. Why should I, a lowly human being, take as much of a risk as an RFO venue. This is bollocks. I am amidst a negotiation at present that means if my show didn't sell (heaven forbid!) I would walk away losing £1200 in 4 days. Remember my monthly wages is £1500, so why the fudge would I ever gamble that sort of cash with a venue. We all know that venues audience development teams are RARELY any good, if they exist at all. We all play to houses of 20 every once in a while because a venue is too stretched or just SHIT at marketing. So why would I trust THAT KIND OF DEAL. Stop asking me to share your risk in such an unfair way. I will do ALL I can to get bums on seats, I hate playing to empty rooms more than you hate hosting them... but if I live 200 miles away, don't know a soul in your area and have no budget how can I really effect anything!

5) **I don't know YOU!** This is about having to constantly explain why I don't stay in "digs" when asking to be put up when away from home. I tour with a child. She is 9. I need 3 rooms, me and my sister share, the tech is a bloke and Taylor has her own room... in a hotel. I don't know your venue's rich supporters or people with spare rooms, why would I sleep in their house?! I was greeted at a digs door in Plymouth once by a man with a replica rifle. NEVER AGAIN, don't ask, just provide proper accommodation. I am not a dog. I am a human being.

I don't make art for fun, or as a hobby. Why do I feel like I am constantly at the bottom of the heap.

There is so much more to say but this is an essay already.

What I am trying to do with this blog is to shed some light on what I would call a total false economy. I am seriously being offered things from all different sectors at the moment, I am being offered much better money to leave this theatre malarkey once and for all. I have less and less time for a network of venues who do not value how AMAZING theatre makers are... yet pride themselves on presenting great work by great artists. There are more cost effective ways to be creative in this world, so we artists hit about 33, 34 (women more than men I have to add) and we leave to work in better paid industries elsewhere... you see it all the time. The drop off point. So most theatre is shit and made by inexperienced people.

The artist is always the one squeezed. I am sure venues will say that they are squeezed too... so stop with the false economy, be realistic with your funders about what their investment gets them, stop bowing down. BUT my concern is that the artist's voice is the one with the least power but the one vital to keep art alive...so this is essentially bullying to keep bigger businesses afloat.

Some venues are BRILLIANT. But believe me a lot are AWFUL and it's not always the little ones with no money that try to fuck you over... in fact some of the kindest and fairest are the little ones. And the worst... the big ones. I often do favours, cut prices or just do shit because I love the people and ethics of an organisation or venue, or because it's for charity or on a topic that I love. I mentor and meet for free all the time, ask anyone!!!! BUT don't assume I will do this, especially if I don't even know you.

I could name and shame, but I actually daren't today. I need work, so I am stuck between a rock and... erm... er... a big jobless pile of shit!

I will show you mine if you show me yours?!

Art is a shit job, I am going to write films instead and teach business for a few years. Goodbye.

Love you.

Bryony x

'You Show Me Yours...' was originally written and published by Bryony Kimmings at *Bryony Kimmings Ltd*, 21 November 2013, http://thebryonykimmings.tumblr.com/post/67660917680/you-show-me-yours

How to Make a Living as an Artist Action Hero

James Stenhouse, action hero

Some of this advice may appear contradictory. It may also be wrong and/or uncertain. That's because I live in THE WORLD.

1. Make good art

This is always the first step. What 'good' means is of course subjective but I can't be arsed to go into that. Many artists attempt to legitimise themselves by setting themselves up as a company, or making a fancy website, or creating an infrastructure around them, but the only thing that will ever legitimise you as an artist is the art that you make. So start with that (see point 8).

2. See it as a political act

I have always viewed the attempt to make a living as an artist as a deeply political act. For me, being an artist is about playing a role in a philosophical shift that pre-empts political change. The act of being an artist and being paid for it shifts how we think about value, how we think about labour and how we view ourselves as human beings. There may be people (other artists included) who will see the desire to make a living as a somehow less authentic way of being an artist. This is bullshit and you must ignore it. It's important that you make a living making the art that you make, not the art that gets you paid or the art that other people want you to make, because then it's no longer a political act. Stick to your principals, make the art you want to make and then make a living from it. (see point 4)

3. Find cheap rent

The easiest way to make a living is to make sure a very small amount of money counts as a living. The first year I quit my 'other' job (van driver) to go full time as an artist I earned just over £5000. This requires making many sacrifices and letting go of certain romantic notions about what it means to be an artist. For example, the arty parts of town are the most expensive to live, London is the most expensive city. Driving a VW campervan might make you look like an artist but it will also make your living costs too high to be an artist in the first instance. The hardest challenge on the way to making a living as an artist is the point at which you make the jump. There is a point where we must leap into the unknown and stop earning money from our other jobs and it's hard to know how/when to do this. Reducing your living costs pragmatically allows you to reach this jumping off point much sooner and you're a lot lower to the ground should you not quite make it. After you've jumped off is the time to start thinking about campervans and arty parts of town but not before.

4. Set the agenda

There is no model. You are in charge of designing the model for how your art will make you a living. Many people will tell you that in order to make a living you have to 'get real' and 'diversify' or whatever. Don't listen too much to these people. Start with the art, then design a way to make it pay. This will mean forcing the agenda in lots of ways. When we started out we were told we wouldn't be able to make a living because the only way to make a living was via regular funding from the Arts Council which was about to be removed as an option. We didn't give up and it turns out they were wrong. We found a way to do it without regular funding partly because we demanded it was possible (see point 2).

5. Make friends

Otherwise known as networking. If you don't like someone, don't be their friend (like real life!).

6. Call yourself an artist*

It took me years to summon up the courage to call myself an artist. This is just fucking wrong-headed. Call yourself an artist immediately.
*or theatre maker, or director, or jazz poet or whatever it is you want to self-define as

7. Immerse yourself in the work of others

A very simple step but vitally important. Go and see as much work as you can. Go to all the shows in your local theatre, all the exhibitions in your local gallery, go to music gigs, read novels, travel and see art in different countries, watch TV and films, see as much as you can in as many different formats. Be a massive geek about it. Good artists who say 'I never see any other artist's work' to make themselves look cool and authentic are BIG FAT LIARS.

8. Be patient

It's massively rare, if not totally unknown, for artists to pop out of no-where with beautiful art. The culture of 'next big thing' and artists 'breaking through' is a falsehood. It takes a long time to learn how to make art and you will make lots and lots of bad art before you make anything good. So take your time, make the bad art, be honest about where you're at. If you've just left university its unlikely you can make world-beating art. Place yourself in different contexts, go and see the world, do some living (see point 7), make lots of work and grow your practice slowly. Be patient with yourself.

9. Do it yourself

No-one is going to do it for you.

10. Talk your own language

Artists shift the way we think about the world. That includes shifting the way we think about the artworld. Don't feel like you have to talk the language of the funders, or the venue programmers, or other artists, or even your audience. Talk your own language.

11. SHARE

Small pots of money and limited opportunities makes for a seemingly competitive environment but don't be fooled. You will be stronger and you will make better art if you share. Share information, share knowledge, share ideas, share successes and failures, share your fears and your worries. Set up an artist collective and share resources.

12. Recognise jealousy

ART jealously is a useful tool. If you feel jealous of another artist it can help you acknowledge what it is you want your art to do. But make sure you know your jealousy comes from an appreciation of the work of that artist.* Don't resent other artists their successes.

*Sometimes artists make shit work and do make a living and that can make us jealous too. There is clearly a shortage of good art (because it's v.hard to do) so continue trying to make good art as your priority. Don't be fooled into thinking you have to make shit art in order to make a living. Seeing shit art can help you make better art so thank them for it, don't resent them.

13. Work hard (but know what work is)

You need to be a bad-ass maniac to make a living from your art. The task will consume you. It is a fucking mountain of graft. But don't perform your hard work for other people's benefit. Don't feel like you have to prove yourself by working too hard. Learn what work can look like if you're an artist. Emailing is not the only kind of work. Conversation can be work, going for a walk can be work, sitting down and thinking can be work. There are some assumptions about what constitutes work that as an artist you can be responsible for changing (see point 2). It's also important to know that you are not a worse artist if you aren't working. Taking 3 months off to go to Asia, or taking the day off to watch the whole of *Friday Night Lights* on DVD could be the best thing you ever do for your art (see point 8).

14. See limitations as possibilities

Making a living as an artist is hard to do. Making art is hard to do. There are lots of limitations. But limitation is an important tool in the creative process so you can use the fact that its hard to your advantage. Limitation will impose structure and rules on your process which can actually facilitate more

freedom of thought elsewhere. Don't believe the 'starving artists makes better art' bullshit (peddled by people who should know better) but it's ok to have some hurdles (and hurdles are one thing you can count on).

15. Make the work you want to make

Don't let ANYONE tell you what kind of work you should be making. EVER.

16. Get paid

Some places might want to put on your art. Some of these places will be institutions that pay salaries to their staff and receive income from subsidy, ticket sales, philanthropy and pre-existing assets. Some of them will be artist-led projects run on alternative models, exploring the different kinds of value we might place on art. You need to recognise which is which. Don't let yourself be exploited by not getting paid. If there is a system that is paying people enough to live and your work is needed by that system, you deserve to be paid enough to live too. There may be people who try and convince you otherwise. Do not listen to these people.

17. Talk to artists who make a living and ask them how they do it

I've been making a living solely from Action Hero for 5 years (ish). I count this as one of my proudest achievements. But 5 years is not that long and the sands shift everyday. I talk a lot to other artists who make a living to help me find ways to navigate the tricky territory and find new models all the time to allow it to continue. Some artists have been doing it for 20 years or longer. They are good people to talk to. It's not easy but I keep trying because I believe we should expect that artists can make a living from their work. We don't have to if we don't want to of course. But it should be possible (see point 2).

'How to Make a Living as an Artist Action Hero' was originally written and published by James Stenhouse at *Action Hero*, http://www.actionhero.org.uk/2013/12/how-to-make-a-living-as-an-artist/

Death by Luxury: The Threat to Culture and the Power of Coffins in the Street

Ben Walters

When sorrows come, they come not single spies but in battallions.

Lately, it seems that barely a week goes by without news of one of London's seminal underground, alternative or queer venues being closed or threatened with closure: the Joiners' Arms booted out, the Vibe Bar shuttered, the Buffalo Bar closed, the RVT sold to property developers, the George Tavern in jeopardy. And now, perhaps most brutally of all, Madame Jojo's is no more.

Brutal in more ways than one. The catalyst for the closure of Soho's most iconic surviving cabaret space – which has been operating under its current name for more than 30 years – was a violent incident on October 24 involving the venue's bouncers and a member of the public. This led to the suspension of its license; last week came the news from Westminster Council that it would not be allowed to reopen.

The incident sounds truly nasty and few would question the need for repercussions. Yet these took place: the venue management promptly investigated and replaced its security staff and seem to have cooperated fully with the police investigation. Other venues have been the site of more serious and regular violent incidents without being shut down. But the axe fell on Jojo's with shocking speed: no appeal, no stay of execution. Done.

So long House of Burlesque, Finger in the Pie, Magic Night, Cabaret Roulette, Tranny Shack, the Folly Mixtures, White Heat and the other rowdy and experimental nights of burlesque, variety, drag, magic, music and freakery to which the venue was home. Some have found shelter at Shadow Lounge over the road; some have their sights set on new homes; the fate of others remains in question.

On the afternoon of Saturday November 29, at the instigation of performer Abigail O'Neill and others including producer Alexander Parsonage, a vigil was held in Soho, ostensibly for Madame Jojo's itself but more generally for the area at large. Around 100 performers, producers, workers and audience members from the cabaret scene gathered in funereal garb to bear a coffin and wreaths from Soho Square down Greek Street, pausing at the offices of Jojo's landlord Soho Estates, then down Old Compton Street through Tisbury Court to Rupert Street, facing the entrance to Madame Jojo's on Brewer Street, where the funeral trappings were laid.

So how did this happen so quickly? It seems possible, to say the least, that the landlord of Madame Jojo's had no interest in keeping it open. Soho Estates, which was founded by 'King of Soho' Paul Raymond and is one of the most lucrative property owners in the UK, successfully applied for planning permission last year to knock down Madame Jojo's and surrounding buildings on Walker's Court, an alley notable as one of the few remaining sites where Soho's iconic associations with sex and sleaze remain a reality.

The plan is to construct in their place a high-end retail and dining quarter with no discernible connection to Soho's transgressive history except as a brand to be exploited for its perceived cachet.

It should go without saying by this point that commercial exploitation of central London space is the unifying factor to the fate of all these venues. Some people respond to these closures by noting that London has always been a place where things changed – where areas had certain characteristics and certain uses and, over time, for whatever reason, those characteristics and uses have come and gone.

This is true on the face of it: dynamism is in the city's DNA. These processes of change are the subject of a terrific new verbatim theatre show, Jonny Woo's East London Lecture, which I saw at the Rose Lipman Building the evening following the vigil. As the title suggests, the show is not about the West End but the East End – specifically Shoreditch, and how in the 1990s the party scene around the Bricklayer's Arms sparked a social and creative explosion and a sea change in mainstream perceptions of the area, from dingy and dangerous to the epicentre of cool.

One of the particularly smart things about the production – in which Woo speaks the words and embodies the characters of numerous inhabitants of the area – is its acknowledgement that Hackney was not, in fact, a wasteland before the cool kids moved in and is not, in fact, a hopeless case now that it's hipster central. The show attends without sentiment or judgment to the voices of those who lived there before and have moved there since. A space is used in many ways by the people who live, work and play there, and the fact that these ways and these people change over time is not inherently good or bad. It's what cities do.

But there is, I would suggest, something different about the changes taking place at the moment in London. (Not that they're exclusive to London by any means, but it's the place I know best.) I really don't think the tension over Soho's future is, as one *Guardian* article suggested last week, a case of a split between "neophiles and neophobes, optimists and pessimists".

The problem is that the current hyperinflation of real-estate prices is not driven by people and the way they use cities at all. It is driven by the treatment of urban space as a form of capital, to be invested in, sat on and offloaded for profit without ever actually being used.

That is to say, the purpose of a luxury flat is not to be lived in but to be bought and sold. That's what gives us sights such as the Tower at Vauxhall – the one that looks like a giant aerosol can – which is at once the tallest exclusively residential building in western Europe and, to judge by the level of illumination after dark, a place where hardly anyone lives.

The current changes to London are not just the latest shift in the city's ever-shifting history. These changes are a threat to the idea of change, at least in the fertile, productive sense on which communities depend. They are the urban-planning equivalent of paraquat. They make dead zones.

The more square footage large-scale high-end projects gobble up to be sold at luxury prices, the more urban space is removed from actual use – living, working, playing – by the city's residents and the more property prices, and by extension rents, are pushed up. There's a simple elegance to the market logic at work here: under these conditions, practically every site in London is worth more if it's redeveloped as luxury residential property, or failing that as commercial or retail space conceived to service the luxury sector or, at a pinch, mainstream commerce.

In the absence of any meaningful construction of homes for people without access to six-figure sums, it spells disaster for the city as a place for the pursuit of social and cultural fulfilment as well as profit and consumerist prowess. It's bad news for a city if high-end property sales and chain stores boom but experimental performance and alternative social spaces are squeezed out, because culture – real culture that provokes thought and fellow-feeling – needs mutation and innovation to flourish.

By contrast, market consumerism thrives on stasis and the inculcation of envy, insecurity, alienation and even violence. It is ultimately a nihilistic, dehumanising creed. Look at the fighting that marked the arrival of Black Friday sales to these shores – the feral consumerism of the 2011 riots given license under a veneer of legitimacy, with cash tills ringing in the background. Say hello to shopping as blood sport.

That's why it's so depressing looking at the architectural plans for the current site of Madame Jojo's (and Escape, a gay bar which was also unceremoniously shuttered last month). There's something unabashedly soulless about the co-option of the iconic Revue Bar signage on high paired with the replacement of Jojo's entrance with generic shopfront signage saying simply SHOP. It might be standard design-mock-up shorthand but it starts to feel less like a description than an order: SHOP, monkeys, SHOP!

It's enough to bring to mind John Carpenter's 1988 science-fiction action satire *They Live*. The movie is set in a near-future world of rising environmental decay, inequality and poverty; alien entrepreneurs live among us in luxury, controlling the police and media, while a docile populace, trained to aspire

only to a quiet life and the occasional morsel of luxury-branded "divine excess", is kept in check by drone surveillance and subliminal messaging.

It's tempting to be pessimistic about the current situation – even fatalistic. But I think there are still ways to push back. London property is not the only form of capital whose currency has skyrocketed of late: another is spectacle. And that one is home turf for cabaret and the arts. The vigil on Saturday, starring Madame Jojo's coffin, was a great example.

Everyone from Miley Cyrus to ISIS knows that delivering compelling visuals aligned to a simple message is a hugely effective way of grabbing people's attention and getting your point across. And if the people with power perceive you as enough of a nuisance, or as a threat to their interests, they're much more incentivised to listen to what's important to you and make concessions, even if just for the PR value. Failing that, you still up your chances of attracting like-minded people to your cause.

I was impressed by how many professional photographers turned up to the vigil on Saturday – at least a dozen, perhaps two – and I couldn't guess how many photos were taken on mobile phones by people who just happened to be nearby. This was the power of an intriguing spectacle in operation.

But I was also impressed by the potency of the funeral imagery and the solemnity on the faces of those involved. Most of them were performers whom we're used to seeing having and inspiring fun, and playing roles. Here they both were and weren't play-acting. It wasn't a genuine funeral in the sense that there wasn't a corpse in the coffin. But the sense of loss was real, and this event was a powerful way of making that loss visible.

The vigil procession expressed anger and solidarity through peaceful creative expression. That speaks for itself in a way that transcends a specific interest in cabaret performance. It also offers a model for other sites facing comparable challenges.

Why shouldn't there be a funeral for every viable arts venue closed down by rapacious property development? Such displays affirm that these places matter and make their loss public in a way that outsiders can instantly understand.

They also point up their connection with all sorts of other closures that are coming about in the name of public balance sheets as well as private profit margins.

Throughout the country, not just in relation to the arts, things are being lost that help people come together, feel better and get empowered. If these losses were given material form in the manner of Madame Jojo's coffin, were displayed at the site where a valuable resource of whatever kind has been lost, and were witnessed by others at the time and afterwards on social media (a

230

good hashtag would be crucial), it might help to make the cumulative scale of these losses more visible.

And the more visible such loss becomes, the harder it is is to deny or ignore, and the easier it is to feel solidarity with others who are feeling its effects. And when more people communicate about their anger and frustration over these losses, who knows what new ways forward might come to light?

That's the hope I saw in Madame Jojo's coffin. That's how the spectacle of loss might offer a strategy of resistance.

'Death by Luxury: The Threat to Culture and the Power of Coffins in the Street' was originally written by Ben Walters for *Not Television*, 1 December 2014, http://www.nottelevision.net/death-luxury-threat-culture-power-coffins-street/

A Live Art Gala

Mary Patterson

If you are going to hold a fundraising gala, this is how to do it: four hours of singing, dancing, glittery, semi-naked, magical, moving, cross-dressing live art performed, auctioned and otherwise distributed around the Royal Vauxhall Tavern in south London. This was 'A Live Art Gala' (ALAG), a fundraising event held for the Live Art Development Agency (LADA) on 2nd October, to raise money for the organisation that supports, nurtures and experiments with Live Art across the UK and beyond.

As Lucy McCormick said, shimmying on stage in a backless PVC mini-dress that was part-homage to the artist Joshua Sofaer (who gives performance lectures in a bumless-suit), and part-Countdown hostess from an S&M universe: the night was like the Live Art Oscars. The great and the good of the Live Art world were out in force, eager to contribute to LADA's work and its future – whether through original artworks donated for auction, a performative take on security and toilet personnel, or the dizzying line up of live performances that played out like a greatest hits album of cabbage orgasms and gorilla suits.

Because this was A Live Art Gala, however, the not so great and the positively un-good were welcome too. As David Hoyle pointed out, LADA will take your call, " ... whether you're ethnic, gay, lesbian, or there's just something wrong with you." Wearing his sarcasm as effortlessly as his leopard print dress, with that statement our inimitable host reminded me of just how exhilarating it was to discover Live Art in the first place. Here was a part of culture that celebrates difference at the same time as community, humour at the same time as outrage, long term relationships at the same time as intellectual curiosity. Here was a culture that puts old, young, male, female or other bodies on stage to explore the empathic chemistry of simply being present in space together. Here was a culture that invites dissent, listens to it and turns the experience into something beautiful.

I could be talking about *Negrophilia!*, George Chakravarthi's dance performance in which he transforms from an ape to a chorus girl, skewering the histories of racism, evolution and exhibitionism in one long, seductive move. I could be talking about *Hanky Panky*, Ursula Martinez's legendary and captivating strip-tease-conjuring-trick. Or I could be talking about French & Mottershead's *Microperformance*, a series of instruction cards given out to audience members to choreograph their interpersonal interactions. (My instructions at ALAG were to stroke someone's arm and tell them they had nice skin. 'Nice tits?' misheard the first two people I tried it on.)

Indeed, I could be talking about all or any of the experiences at ALAG – which included the private, the spectacular and the profound. If there was a theme that united the activities at this event, it was perhaps Marcia Farquhar's dictum to 'know your place.' "*Not*," she said sternly, with a flick of her peroxide fringe, as in "know your place" in the pecking order of society. But instead, know "your place" – understand your body. And with that, Marcia ducked under the table to take an 'intimate casting', promptly sold at auction by star auctioneer, Joshua Sofaer. Yes, in his bumless suit.

Live Art, as defined by Lois Keidan at LADA, does not conform to any form, function or mode of presentation. Instead, it is strategically interdisciplinary – a way of approaching the world with an open mind and attention to detail. Live Art is an attitude, rather than a product. And this is what underlies LADA's approach, too. Dominic Johnson, one of their board members, pointed out that much of the Agency's work happens behind the scenes. Just as important as events, publications and workshops, LADA's effects are felt in the form of advocacy, support and kindness. All of which has a powerful impact on the rest of the sector. LADA's work not only supports artists and excites audiences; it also sets a high bar.

But perhaps you know all of this already. Perhaps you were one of the people there at ALAG, rubbing shoulders with other audience members to glimpse the stage – at once an actual stage, replete with glitzy lights and glamorous red curtains, and at the same time a symbolic gesture (inside a pub next to a railway bridge) towards the potential of the other worlds promised by performance.

Perhaps you are one of the people who, like me, has spent hours thumbing the archive of DVDS, books and videos in LADA's Study Room, or who has argued fiercely inside a reading group at the Agency's office, or has taken part in one of its DIY workshops – peer to peer professional development in which artists explore their practice in the context of collaboration. Perhaps you laughed a little bit too hard at the part in the performance by The Famous Lauren Barri Holstein and Martin O'Brien, when the angel of culture descended, naked, to impregnate the art world of the future, and the angel was wearing a face mask of Lois Keidan.

"It's like *This is Your Life* for everyone who walks through the door," said Hannah Crosson, as more and more artists, curators and producers greeted each other with a hug and a shriek. We were there because we know how important LADA is to the Live Art sector, and by extension to culture as a whole. The problem for the fundraising committee (ALAG was organised, voluntarily, by a group of high profile artists, curators and academics) is that we already support Live Art through our professional lives and our (relatively small) bank balances. Members of the audience dug deep at ALAG – the tombola sold out quickly, and the live auction leapt through the room – but we are not a wealthy demographic. We work in the publicly funded art world, where fees and salaries have not risen in over a decade. "Many artists don't

have a pension," Sofaer said as he described items up for auction, "So consider one of these an investment in your future."

Sofaer was right – the objects of Live Art do have a monetary value, sometimes an enormous one. Most notable in ALAG's auction was the original, signed mirror used by Marina Abramović in her recent performance at the Serpentine Gallery. Beautifully presented and packaged, the mirror is unique as both an object and a trace of an event from a global art superstar.

But the currency of Live Art lies, most often, in the realm of experiences instead of objects. Even the value of Marina Abramović's mirror stems from its relationship to *512 hours*, an extraordinary, durational residency in which the artist invited visitors to join her inside a gallery and carry out simple tasks, like staring at a wall or walking backwards. Other auction items at ALAG included 'taking time' with the writer and artist Tim Etchells, going to a spa with the artist Brian Lobel, and swimming the Thames with the artist Amy Sharrocks.

Unfortunately, you will not be able to rely on one of these experiences to subsidise your retirement. While an object can often be reproduced, loaned or otherwise shared, an experience has to be – quite obviously – experienced, in order for it to have meaning. This reduces both its transfer value and its capacity to generate a passive income. It's the reason that theatre actors earn less money than film stars, and it is also why Live Art has a problem financing itself within a market economy.

Of course, this is not really a problem for Live Art – more like a tactic. In the context of an overwhelmingly consumerist culture, paying attention to the passage of time, the relationships between people and the possibility of change constitutes a gentle but insistent challenge to the status quo. This is what Hoyle was referring to when he sneered at the thought of a wealthy donor emptying his pockets into LADA's bank accounts. "Why would the rich want to pay for their own demise?"

ALAG was a response to the increasing pressure on Arts Council funded arts organisations to raise money through commercial and philanthropic means – or, as Hoyle pouted it through his sparkly lips, to turn ourselves into pimps and prostitutes in time for the next general election. As Hoyle suggests, the problem with commercial and philanthropic means is that they will, inevitably, support commercial and philanthropic ends. At best, this heralds an endless reproduction of the established order, with no room for dissent. At worst, it invites the amoral compass of corporate life to sear its brand onto the beating heart of culture.

In either case, it means side-lining the principles of presence, equality and experiment that made Anne Bean and Richard Wilson's chorus of noise, electricity and matter in *The place where the skin meets the air* such a visceral, unpredictable and transformative ten minutes of my life. (These ideas are also amongst the founding principles of the Arts Council England – an arts funding

body that is unique in the world, being both at arms length from government and designed in the public interest.)

The Royal Vauxhall Tavern is more normally the home of *Duckie*, an Oliver-Award winning performance night run by Simon Casson (who was stage-managing ALAG). Amongst the supporters in the pub that evening were Professors, OBEs and internationally renowned artists. Live Art, in other words, is an important and influential art form. It is influential precisely because it roams the edge lands, the in-between spaces and the twilight zones. From here, Live Art and its strategies can reimagine culture and start to influence the wider world (at which point, inevitably, none of this is referred to as Live Art anymore, but as politics, society or, simply, life).

What I am trying to say is that there are some kinds of art that can slip smoothly into the hierarchy of philanthropy, but Live Art is not one of them. There are some kinds of art that produce and reproduce wealthy patrons, but Live Art is not one of them. And there are some kinds of art that are so ossified in the cultural mainstream that the pinch of commercialism will leave no bruise. But Live Art is not one of them. Live Art is a shape-shifter. Its power lies in the fact that it cannot be captured, copied or, indeed, poked for long enough for anyone to decide what it means. This is how we change the world. And this is what the similarly shape-shifting, responsive and maverick Live Art Development Agency makes possible.

Fun, brave and bristling with energy, ALAG was a joyous reminder of how important this work is, in the margins and beyond. It was also a reminder of how fragile the systems are that support LADA, of how money is linked to power, and that how you make money is political.

I am not quite as pessimistic as David Hoyle about the future of the Live Art Development Agency under commercial pressure. Firstly, I remember Susanna Hewlett's busty security guards roaming the RVT, and how Live Art makes me question the nature of identity. Secondly, I remember Ansuman Biswas magically summoning a flickering dancer to life with the power of his drumming, and how Live Art moves me beyond myself. Thirdly, I remember how the Live Art Development Agency supports artists, people and cultural practices that ask awkward questions from awkward places. And I feel sure that before corporate or commercial models get a chance to change LADA, LADA and Live Art will change them first.

Mary Paterson is a writer and curator working across visual art, text and performance.

'A Live Art Gala' was originally written by Mary Paterson for Live Art Development Agency, October 2014, http://www.thisisliveart.co.uk/uploads/documents/Mary_Paterson-_A_Live_Art_Gala.pdf

My Housemate Works in Arts Fundraising

Megan Vaughan

My housemate works in arts fundraising. She's very good at it because she can talk to the rich and the ultra-pro classes without swearing or referencing sex or rave culture. At times people have asked her what the point in chasing £20 donations is, writing individual thank you notes for each one, when they should be chasing the big corporate money. Then Alice will send them a Christmas card, a birthday card, an invite to a drinks reception before a Handel recital because she remembered that he was their favourite composer. She'll chat to them on the phone about the concert the next day (without swearing, still no references to sex or rave culture). Before the end of March she might receive another cheque for a couple of hundred quid, out of the blue this time. She'll call them to give a personal thanks, ask how their daughter's 18th birthday party went. (By the way, all this time Alice is coming home from work every night and telling me about her day and I'm standing in the kitchen in my Primark pyjamas drinking milk from an intensive dairy, scoffing about how we've turned culture into capital and there's no room for the little man anymore, no room for dissent because we're all having our feelings sold back to us by John Lewis... something something Marx something something Adorno, blah blah.)

Fast-forward a couple of years and Alice's £20 donor has given £10k in that time, plus Gift Aid, and is in talks to make her law firm an official corporate donor. Big money.

This isn't supposed to be a post about fundraising, not least of all because small-scale theatre and performance companies can't compete for funds on the same scale as internationally-renowned classical concert halls. But there is something about Alice's cultivation of a donor that interests me. ("Cultivation of a donor", ha. #filth)

This morning on Twitter, Vinay Patel was talking about audience development, which is something I feel very strongly about. (Perhaps my strongest feeling about it is that I'm completely fucking impotent and there's nothing any of us can actually do to make people like stuff they're not interested in liking.) Vinay was responding to Janet Suzman's comments about BME theatre and BME theatre audience (which I won't go into at length because I'm no expert, but this is a great response from Naima Khan on *Exeunt*) and he said:

"we need to be talking about theatre like it's there to be consumed as culture not cherished as art"

There's a significant part of me that is immediately like *Noooooooooo* CHERISH IT CHERISH IT CHERISH IT. How will theatre ever be the best it can be if

it's beholden to capitalist systems of sales and dissemination? (Adorno Adorno Adorno, Marx Marx Marx etc blah change the record yadda yadda till I die.)

Then another part of me is like, how the fuck else is anyone going to come to cherish anything if they can't access it the way they access every other fucking thing in their whole entire lives?

There's a potential confusion here because the word "consume" has come to mean "buy" in so many contexts. We are "consumers". To consume is to ingest, to use up, to deplete what remains for others. But it doesn't have to be that. It also says something about appetite. The Audience Agency's latest segmentation research identifies "experience seekers" as one of the most highly engaged groups currently accessing the arts. I'm naturally cynical about "experience seekers". They're the people who will go to a cocktail class one night, an urban exploration walk the next, a Punchdrunk or Secret Cinema show at the weekend. In my mind, according to my prejudices, they don't engage very deeply, or think about the work beyond its value as entertainment. They wouldn't go to *Our Town* at the Almeida. Or a Secret Theatre show with no listed title. At my very worst I might say: "Oh, yeah, *experience seekers*... LOL. They won't see something that they can't show off about at work the next day."

But I used to be that person. That was *my* journey into it. Gigs and clubnights 5 nights a week until Manchester International Festival showed me, through genre crossover and – crucially – free access through volunteering, how theatre and performance could make me *feel*. Then I spent 2 years booking for every single thing I could find that described itself as "immersive". I was *seeking experiences*, and I when I found them I was consuming them. Ticking them off, comparing, learning, understanding myself and my own taste better every time. Seeking out more, and more, and more. Sound and Fury's *Kursk* showed me the importance of writing within experimentation (shout out to Bryony Lavery), Gob Squad showed me more form and less narrative, Twitter pointed me towards plays – actual PLAYS – that would never have otherwise been on my alt.radar.

I saw *Jerusalem* in the West End on my 26th birthday.

Text from a mate back home in Manchester: "Happy b'day Meg! Hope it was a messy 1! Miss you tons xxxx"

Me: "Hiya! Miss you too :(Saw this amazing play in London for my b'day. Dude drank a raw egg on stage. Best show ever!"

Them: "Haha what? Is this u meg? Who is this?"

I spend a lot of time thinking about my place within this whole audience development game. I think about it with my blog and with tweeting about the work I see. I look at what Maddy and Jake are doing with Dialogue, and how

they're trying to level a playing field for audiences as well as theatremakers. And then Vinay and Naima speak about what it's like the walk into a theatre building with dark skin, and Alice tells me how someone she's been talking to for 2 years has finally contributed to her capital campaign.

And I'm like: I've been going about this all wrong. Maybe it's not about trying to convince people that *Pomona* is incredible, or that *Hope* totally works as a Christmas show, or that there's this amazing new Australian version of Ibsen's *Wild Duck* that's performed in a glass box. Maybe it's about learning through *consuming*. And making it easy for people to consume *lots*. About making it feel like going shopping at the same time as we make it totally free. Making it feel more like a gig, or more like Westfield or more like Netflix. Then give people the autonomy to consume as they want to without judgement.

That doesn't mean a commercial model or corporate sponsorship all over everything. It means choice and support and opportunity and access. And work that keeps at least some of those things in mind, at least some of the time.

(The way I want to finish this post is to suggest that maybe some of those people will graduate to work like the kind of work I'm seeing, but "graduate" is a cunt of a word. Who cares if they do? Who says the kind of work I see is the kind of work they *should* be seeing? Telling people what's worthy of their time and what isn't is one of the worst things about the arts, about arts criticism, about snobbery in general. I am not going to be that person. But of course I feel a flush of excitement when someone I know also comes out of *Pomona* buzzing with excitement, or puts *Quizoola* on to see what the fuss is about but then can't tear themselves away. I'm always going to be there to celebrate those high five moments, I just need to keep reminding myself that it's ALSO FANTASTIC when someone discovers their newfound love for Sondheim.

2015: DOWN WITH SNOBBERY, DOWN WITH ELITISM, QUESTION EVERYTHING.)

'My Housemate Works in Arts Fundraising' was originally written by Megan Vaughan for *Synonyms for Churlish*, 16 December 2014, http://synonymsforchurlish.tumblr.com/post/105349007048/my-housemate-works-in-arts-fundraising-shes-very

Art at Work

Rachel Porter

In Hunt & Darton Cafe everything is art. The menu is art, the waiters are art, the customers are art; each piece of cake is a piece of art, the bills, the gross profit or the loss – all of it is art. It's important that you realise that this is not the performance of a café.

This is a café. It's a functioning workplace with a manager, a kitchen porter and a very decent avocado and bacon on toast. But it's still art – functioning art if you like. This is art at work, art at your service. Newcomers to the Cafe are often confused, perhaps because it is unclear how much of their participation may be required. But what I enjoy most about the Cafe is you can take from it what you like – you might stay there all day doing jigsaws and ordering the set menu (a triage of performance performed by the hostesses themselves) or you might just grab a coffee to go, whilst holding a giant cardboard placard stating 'THIS PERSON IN TAKING AWAY, OKAY' while you wait. Although the occasional customer is scared off by Hunt & Darton's trademark pineapple headgear, most are won over by the unique charm, general absurdity and the beans on toast.

What I find particularly clever about Hunt & Darton Cafe is the way it subtly presents the similarities between hospitality and performance – something that every artist who has ever worked as a waiter knows all too well. Yet through its playful presentation the Cafe is also saying something more serious about capitalist economy, about art as commodity and systems of exchange. This can be illustrated in the ways the Cafe fails to fulfil certain expectations.

For example, Hunt & Darton never really smile. They don't scowl, but it's a definite distinction from the sugar coated sweetness you often find from waiting staff. These two are stern but fair; they are happy to oblige but don't aim to please. The business is broken down and exposed on two giant blackboards where you can see exactly how much money the Cafe is taking, or losing. Complaints are not necessarily greeted with a solution, and almost never with an apology. Instead they are placated with the sincere yet futile declaration that: 'we knew it wouldn't be good enough'. If the customer is still unhappy then the complaint is written up on the blackboards for all to see.

By establishing a café and then distorting and disrupting the normal interactions that occur in this capitalist space of labour, Hunt & Darton point at the act of service and ask their customers to consider the exchange that is taking place. Are they customers or are they an audience? Can they be both? Theatre and Performance theorist Nick Ridout writes extensively on the complex relationship between labour and performance (brace yourself for some academic writing):

'Performance in the service economy discloses the full commodification of human action. Far from being the paradigm of authentic self-expression, performance reveals itself as exemplary commodity (it commodifies action, not just things) and as the site for a critique of its own commodifying processes.' – *Performance in the Service Economy: Outsourcing and Delegation*

OK! Now, let's apply that critical theory to the case study in question: A performance of a café, or rather a café that is a performance, makes the commodification of human action more obvious than usual. A waiter in a café is a waiter, a waiter in a performance is an actor, but a waiter in Hunt & Darton Cafe is somewhere in between the two, and it is in this liminal space that the customer recognises them as a human commodity, a person at work, art at work. And, it is this recognition that encourages the customer to think about the nature of human commodity and capitalist economy. Thus the café as art becomes social critique.

Well done. We made it.

Interestingly service economy related performance is becoming increasingly prevalent in the live art world. The Haircut Before The Party plays with notions of commodity and exchange by offering free haircuts as long as you talk about social politics instead of your holiday destination; similarly, Open Barbers decided to put their clients in control of the service, offering non-gender specific haircuts on a pay what you can basis; whilst Katy Baird's *Cam4* and Oreet Ashery's *Say Cheese* make fascinating allusions to the sex industry, each offering one-to-one encounters where the audience member dictates what the performer will do. These artworks, or 'art at works', make us reconsider traditional Capitalist structures and systems and perhaps encourage us to think of alternative economic models.

Hunt and Darton are doing just that by remodelling their own structure for the UK tour of the Cafe. They are outsourcing the artwork by employing new Hunt and Dartons who will run the cafes in their place. By delegating their performance Hunt and Darton are allowing other artists a level of agency within the work. It's not dissimilar from having shares in a company. These new Hunt and Dartons are invested in the project and as employees have much to gain from the success of the Cafe. In turn they prolong the life of the Cafe and improve its productivity, as with multiple Hunt and Dartons there is the possibility of having multiple cafes open at once. Perhaps this outsourcing also has something to say about the way we value authenticity and originals over copies and replicas. But you'll have to ask Hunt & Darton about that – just make sure you pick the real ones...

'Art at Work' was originally written by Rachel Porter for *Exeunt Magazine*, 28 February 2014, http://exeuntmagazine.com/features/art-at-work/

Boycott Zabludowicz

BDZ

[Headnote: the following text was written in July 2014 at the time of the Israeli assault on Gaza. It was first published on Tumblr, and then re-published the following October at www.metamute.org, and is reprinted here with minor changes. Since it's publication the BDZ GRP has continued to publicise and organise the boycott of the Zabludowicz Collection in solidarity with the Palestinian fight for justice and the goals of the BDS movement. This has culminated with the on-going public pledge to boycott the Zabludowicz Collection signed by over 190 signatories that was published in November 2015. We invite readers of the *Almanac* to support and observe the boycott statement published at boycottzabludowicz.wordpress.com, to be a signatory email: bdzgrp@riseup.net.]

Mute is hosting this statement in solidarity with the call for a boycott of the Zabludowicz Foundation. It was originally published online a few months ago during the latest round of violent atrocities committed by the Israeli state against Palestinian people. We fully support this boycott and call on our readers and writers to join us in solidarity.

1. Art and Art Patronage

Who are the Zabludowiczs and why do they need to be boycotted immediately? The answer: Guns + Real Estate → Israeli State = London Art World. The answer: The Zabludowicz Foundation has played a central role in supporting emerging artists in London over the past few years, but their cultural 'patronage' isn't as selfless as it seems. It involves laundering some very dirty money through the labour pool of young, London-based artists. As the public-relations front end for historically one of the largest suppliers of arms to the Israeli state and Chairman of the UK-based Pro-Israeli Lobby group BICOM, the Zabludowicz Foundation represents a direct link between the opportunities for careers in art for young people here in London and the current bombing and ongoing genocidal oppression of Palestinians in the Occupied Territories.

2. How did Zabludowicz get so rich?

Short answer: through arms dealing and, subsequently, property development. Zabludowicz's fortune derives from the Tamares Group, which has large real estate interests and casinos. Earlier his activities were coordinated through Soltam, the Israeli arms manufacturer set up by his father Shlomo Zabludowicz, who sold arms to the Israeli Defense Forces.

Via his chairmanship of the Pro-Israel lobby group, BICOM, Zabludowicz has a pivotal role in shaping opinion formation in both the UK media and parliamentary spheres. This gives him a say in the determination of UK-Israeli

241

relations. Via his real estate interests, he helps to assert Israeli control and sovereignty over Jerusalem. Apart from his activity with Bicom, Zabludowicz also makes large donations to the Conservative Party.

3. What can you do? Boycott!

We call upon artists to uphold the BDS / PACBI guidelines and to boycott the Zabludowicz Collection. We ask artists, cultural workers and producers not to sell or show their work with the Zabludowicz Collection in the future and/ or to withdraw the 'conceptual content' of their work from the Collection. We ask artists to respond to BDS/ PACBI and refuse to sell their labour to the Zabludowiczs or to those operating in their network of interests.

We cite the PACBI guidelines and reiterate that these campaigns have called for a 'picket line' to be formed around Israeli-affiliated cultural institutions internationally. We support this demand in recognition of the fact that these institutions are 'complicit in the Israeli system of oppression that has denied Palestinians their basic rights guaranteed by international law, or has hampered their exercise of these rights, including freedom of movement and freedom of expression'. 'Cultural institutions', the guideline states, 'are part and parcel of the ideological and institutional scaffolding of Israel's regime of occupation, settler-colonialism and apartheid against the Palestinian people'. [1]

We call on artists not to scab and to act in solidarity.

This is direct solidarity with the communities under assault in Gaza, victims of state terror on both sides, and with resistance movements in both Israel and Palestine.

4. Rise of private funding in London

The decline of public funding, along with the ongoing capture of public funding by the neoliberal dogma of 'philanthropy', has the same toxic effect today that it has always had: glorifying the rich, whether directly or 'autonomously', becomes the task of art, while government cutbacks structurally and ideologically legitimate the social inequality and exploitation which makes people rich enough to 'donate' money to the arts. While neither private capital nor the state can offer autonomy to artists or anyone else, it is still possible to distinguish between sources of support.

For anyone involved in the field of contemporary art, boycotting Zabludowicz is not a piece of moralizing theatre. It is a withdrawal of labour. The Zabludowiczs' have enough friends in high places; you don't need to do their PR for them. And that's all participating in Zabludowicz-funded projects is – PR and the desperate bleaching of some very nasty money.

5. Patronage vs Autonomy

Some people may want to shrug their shoulders and say that, in the end, it doesn't matter where the money comes from, so long as something good can come of it: art. But what kind of art? Artists need to recognise that the places where their work is exhibited, the money that makes it possible, and the interests it can be made to serve all make up a part of its aesthetic content. Even the most 'autonomous' or 'critical' artwork exhibited in the Zabludowicz gallery instantly transforms itself into the merest piece of tinsel trailing off the back of the freight ships that even now are transporting the weapons that will be used to murder more Palestinian civilians.

Aesthetics and organisation are not comfortably separable. Should private patrons seek to fund the arts, then we welcome them to close their institutions and unconditionally to deliver over all their money, property and resources to artists and everyone else, who can perfectly well distribute, self-administrate and self-organise themselves: We want the money!

Footnote

1. http://www.pacbi.org/etemplate.php?id=1047

Further Links

http://www.theguardian.com/world/2009/jan/04/bisco...
http://www.thefreedomtheatre.org/news/36377/?utm_c...
https://www.academia.edu/5061190/The_Britain_Israe...
http://www.artiscontemporary.org/features_detail.p...
http://www.theguardian.com/stage/2014/aug/05/tricy...
http://www.trayner.org/boycott_web.pdf
http://www.pacbi.org/index.php
http://www.bdsmovement.net/

'Boycott Zabludowicz' was originally written by BDZ in July 2014. It was first published on Tumblr, and then re-published the following October at www.metamute.org. It is reprinted here with minor changes from boycottzabludowicz.wordpress.com, 1 October 2015, https://boycottzabludowicz.wordpress.com/2015/10/01/boycott-the-zabludowicz-collection/

High Art in Low Places & Low Art in High Places

How can a Tattoo be seen as a Work of Art?

Dominic Johnson

In late October, the tattooist Alex Binnie will create the second of two tattoos upon the skin of my hands, in a live performance called *Departure (An Experiment in Human Salvage)*. We'll be accompanied by three guest artists, whose performances will complement – and perhaps complicate – the attempt to shed new light on the status of tattooing as a practice on the contested border between fine art, folk art, or craft.

How can the procedures of tattooing – the painful depositing of layers of inks below the surface of the skin – be reframed as performance? How can a tattoo be seen as a work of art? The use of tattooing in performance relates to a broader use of body modification techniques in visual art – usually painful acts such as piercing and scarification – most notably in the work of London-based artists Ron Athey, Franko B, or Kira O'Reilly.

While such work is sometimes misread as a symptom of the artist's masochism, the pain involved is somewhat incidental to the production of a lasting image: as a spectacle that has a lasting effect on its audiences, but also in the sense of a permanent trace on the skin of the artist. Tattooing takes its place alongside other similar techniques for puncturing, cutting, or otherwise marking the skin towards the production of strong imagery in art and performance.

Commercial tattooing has undergone a boom in popularity over recent years, with the number of tattoo studios in Great Britain reportedly doubling in the last three years. This may suggest an increase in the acceptability and visibility of tattooing, partly due to the distancing of custom tattooing from their somewhat archaic association with sailors, soldiers, criminals, hookers, and other supposed ne'er-do-wells, and also partly thanks to the growing prevalence of tattoos on the bodies of celebrities.

However, the use of tattooing in or as performance is less familiar, but draws on an older, rich tradition of exhibition and display of tattooed persons in European culture. These include: the little-known figure of Jean Baptiste Cabris, a French sailor who exhibited his heavily tattooed body around Europe at the turn of the eighteenth century, after being tattooed in the Marquesas. Or 'the Great White Chief' John Rutherford, an Englishman who was exhibited as a 'living specimen' in aristocratic circles in the 1820s and 1830s, after supposedly being captured and forcibly tattooed in New Zealand. These histories of exhibition and display inspired me to develop a performance that put the experience of tattooing centre-stage, as it were, by privileging the live action of permanent mark-making, and the piece was first shown at Fierce Festival in Birmingham in March 2011.

The framing of tattooing as the defining technique of an art practice has more immediate precedents, and constitutes a small subcultural history of visual culture. Indeed, the art historian Matt Lodder recently discussed some art works involving tattooing, reading them in terms of the ways they articulate the theme of affiliation and social bonds in interesting ways. He mentions an infamous performance by Santiago Sierra – *160cm Line Tattooed on Four People* (2000) – in which the artist commissioned a tattooist to draw a permanent line across the backs of four participants. Sierra's piece provokes serious and unresolvable ethical questions, and indeed this may be the key achievement of his practice (Claire Bishop argues as much in her recent book on participatory art, *Artificial Hells*). Other artists have appropriated tattooing in performance towards more ethically agreeable ends, in powerful and visually striking works.

Over a series of performance-installations, Sandra Ann Vita Minchin has commissioned a tattooist to recreate a painting by the seventeenth-century Dutch artist Jan Van Davidz de Heem. The resulting image – which took 120 hours to create – is a massive permanent image of the painting across her back. The theme of permanence is key to the work. The work's title, *Ars Longa, Vita Brevis* ('Art is Long, Life is Short'), reminds us of the odd status of the tattoo as a living artwork, whose permanence conflicts with the ephemerality of performance.

The images created in tattooing may well seem disconcertingly permanent – which provokes anxiety and hand-wringing among commentators – although its volatile permanence is generally limited to the life of the wearer, which is often shorter than that of conventional drawings and paintings (a problem Minchin has overcome by arranging for her skin to be preserved after her death). If the prospect of archiving skin seems macabre, it's worth acknowledging that similar preserved tattooed canvases are available for viewing at medical museums, such as St Bartholomews Pathology Museum at Queen Mary, University of London, and the Wellcome Collection.

In another striking series of performances, Mary Coble has had her whole body tattooed – without ink – using tattooing as the basis for a provocative feat of physical endurance. In *Note to Self* (2005), Coble collected information about homophobic attacks, and had the name of the victim and the location of her or his assault tattooed in a monstrous list across the back of her body, from her neck down to her legs. Coble intimates the physical hardship of a minority under continual attack, and she uses the controlled violence of tattooing to memorialise the suffering of others.

In the second performance, *Blood Script* (2008), tattooing acts a metaphor for psychic endurance. She amassed an archive of words used in verbal assaults, and had them tattooed, verbatim, on the front of her body, in a large and bold gothic script. Tattooing without ink produces a crisp bloody line, and the marks fade with time to leave subtle scarring. However, as with all scars, Coble's flare up in coming months and years, reddening under heat or cold (she tells me that the word 'Bitch' often emerges in a hot shower). I see this as

a perfect metaphor for the experience of verbal assault, where the insult might leave a meagre (metaphorical) wound, but its aftereffects return to haunt the victim when one might least expect it to.

In these and other examples, tattooing suggests a novel means of expanding the repertoire of artistic tools of the trade. These developments will make some audiences feel squeamish. Such discomfort should not suggest that artists are out to shock, or out to impress. Rather, the concomitant emotional or physiological reflexes – the flinch, the shiver, the grimace – are some of the potential feelings that might usefully take their place among an expanded range of sympathetic responses to the use of new techniques in art and performance.

'How can a Tattoo be seen as a Work of Art?' was originally written by Dominic Johnson for independent.co.uk, 17 October 2012, http://blogs.independent.co.uk/2012/10/17/the-art-of-tattooing-or-tattooing-as-art/?utm_source=twitterfeed&utm_medium=twitter

Unfinished Revolutions: Oreet Ashery's
Party For Freedom

Nathan Budzinski

"Somewhere between a travelling cinema and theatre troupe, a kiss-a-gram..." Read an interview with the artist and film maker about her multifaceted, confrontational *Party For Freedom* audio visual work. By Nathan Budzinski

"Have you met Oreet?" a friend asks me, "she's dressed fantastically today, like a superhero!" I'm at Copenhagen's Overgaden art space on a warm autumn evening. The artist Oreet Ashery's show, *Party For Freedom* is opening tonight. Crowds spill out onto the canal bank outside. On the opposite bank, people basking in the late afternoon sun are being asked to move off the barriers so another artist can stage a performance. A man hops onto a bike, bouquet of flowers in arm, he cycles along the barrier a bit and then launches himself into the canal, just missing two moored boats. Disappearing underwater for an uncomfortable while, he resurfaces, drenched bouquet in hand. It's a fey remake of the now mythical performance artist Bas Jan Ader's 1970 *Fall II* (where Ader filmed himself cycling into an Amsterdam canal, without bouquet).

"I think I enjoyed the lead up best. I thought it would never end..." Ashery tells me. We've traded a running commentary during the artist's extended negotiation with the sunbathing public. My friend's description of her is accurate: bespectacled and small, quick witted, she's dressed in a striking white vinyl jumper with yellow and blue vortices across shoulder pads and straight cut white trousers. We have the kind of conversation that goes from deadly serious to laugh out loud ridiculous and back again in a few seconds.

Ashery's *Party For Freedom* is a multivalent performance, video and installation project that's taken several years to unfold, with a DVD version recently released by London's Performance Matters project. Working with the Artangel organisation, other iterations have included concerts and screenings in London and elsewhere. The Copenhagen version consists of a video piece split across three screens in a darkened gallery. But Ashery describes *PFF* as primarily an audio-visual album, the commissioned music playing the biggest role in propelling the film.

For an hour I watch choppy sequences showing a range of actors in varying states of undress navigating through different scenarios: shots of the controversial Dutch politician Pim Fortuyn who was assassinated in 2002, spouting Islamophobic babble ("the army of Ali Baba here in Europe") counterpointed with images of a woman dressed in an apron, her naked bottom sticking out and numerous chopsticks inserted in her hair

porcupine-like as she wanders about a kitchen swatting flies; a chapter called "Civilisation: After Niall Ferguson", the neo-con historian and polemicist, features animated collages of chalk white busts of ancient Greek heads with red eyes rolling, moss covered stone crucifixes in a graveyard are set to baroque pipe organ music and pastoral flute airs. In another chapter a naked woman and man recline in a verdant church yard, the woman with an apple in her mouth, feet and hands wrapped in aluminium foil ready for roasting as a BBC accented male voice instructs on the legal ins and outs of pig slaughtering at home in Britain. One segment features a man playing an increasingly speedy piano concerto while giving another man an equally rapid rim job. Opposite the pair sits a woman on a laptop with a glass of wine scrolling through a Facebook timeline, her face lit blue against the dark interior of a large salon room. Most everyone who appears in *PFF* is in some state of undress.

Driving the hour long video along are songs specially made by feminist girl group Woolf, the composer and accordionist Timo-Juhani Kyllönen (whose mission statement reads "I want to help mankind at the battle between goodness and evil with my compositions"), vocalist Chyskyyrai from the Republic of Sakha-Yakutia in Siberia (collaborators include percussionists Z'ev and Ken Hyder) and musician and writer Morgan Quaintance. Woolf is a four piece group who've been active on London's underground queer scene for the past few years. Playing a brand of ragged and short noise-pop tunes and what they call "proto inept hardcore", their songs form the backbone to *PFF*, acting as manifesto-like introductions to each track.

I'd heard of *PFF* during its pre-production through a call out for participants: "Somewhere between a travelling cinema and theatre troupe, a kiss-a-gram" *PFF* was looking for willing bodies to take part in one beginning strand of the project, *Party For Hire* that would eventually become the finished video piece, *Party For Freedom*. In a series of events, the troupe performed in private homes, workplaces, pubs and clubs, art schools and art galleries, starting with an event staged at the British Conservative Party campaign headquarters at London's Millbank Tower on 1 May. The performances were based on Russian artist, poet, playwright and socialist Vladimir Mayakovsky's radical satire, *Mystery-Bouffe: A Heroic, Epic, And Satiric Representation Of Our Era*. Written right at the early years of Soviet times, it's a parable of global meltdown and fracture that Mayakovsky prefaced with the proviso that "in the future, all persons performing, presenting, reading or publishing *Mystery-Bouffe* should change the content, making it contemporary, immediate, up-to-the-minute."

... Why is this playhouse in such a mess?
To right-thinking people
it's a scandal, no less!
But then what makes you go to see a show?
You do it for pleasure –
isn't that so?
But is the pleasure really so great, after all

if you're looking just at the stage?
The stage you know,
is only one third of the hall...
From Vladimir Mayakovsky's introduction to his *Mystery-Bouffe: A Heroic, Epic, And Satiric Representation Of Our Era*

Ashery and I meet several months later in London. This time dressed in an oversize cotton jumper with a white tiger's head depicted in glittering sequins, she explains what drew her to Mayakovsky's play: "I felt that the story encapsulates a picture of the world, it's like a schema, something that you can adjust to anything. It's a long play but I was just interested in the beginning, where an Eskimo puts his finger in the ground [to stop a leak of water] and says, wow, it's depressing, the world is flooding."

Mystery-Bouffe is centered around two groups of people, the Clean and the Unclean, with a cast of international characters: The Clean: "An Indian Raja/A Turkish Pasha/A Russian Merchant (Speculator)/A Chinese/A Well-Fed Parisian..." The Unclean: "A Lamplighter/A Truck Driver/A Miner..." Based on national clichés, the cast signals the ascendant globalisation happening in the early 20th century, alongside social and economic divides which still remain: the world is flooding and the Unclean – proletariat – build a boat to save themselves. The privileged Clean, who are too lazy and lack the skills to build their own boat, ask for help from the Unclean. Once safely in the boat they take it over, eat all the stored food, but then are thrown back overboard by the Unclean.

Ashery found Mayakovsky's play during research into radical collectives and performance: "I was looking at that idea of the unfinished revolution. Things like race, things like gender, all these things that were fought over – we're still so far away from getting anyway near being liberated in that way. So this avant-garde work, this collective work, this experimental work from the 60s and 70s, I think in the West we so much take this for granted as a heritage, a lineage... Those ideas of changing the world, making it better, or liberating oneself. And art and music as a counterculture, within those I think that there's quite the same kind of issues of race and gender, the same patriarchal structures, and I think that those really echo in *PFF*, that whole gender discourse, that everyone's white, I really wanted to say that freedom is white privilege, and that all those things are, not only in a politically real way, but also in art – all those things still have a long way to go."

Ashery's also interested in trash aesthetics, something that she sees as a powerful current running through music and art – like in Woolf's inept proto-hardcore or Kyllönen's corny, accordion powered battle against evil – and politics: "I was looking at all kind of different access points for trash aesthetic... I was looking at a lot of the hippie movement, batik and tie-dye, language of protest, I went to the Occupy almost every day when they were at St Paul's, just looking at how they decorated the tents. There's a certain type of cheap production value that goes with that that we identify with freedom or liberation, the left wing."

Ashery also links this trashiness to far right wing politics: "... all these anti-Islamic, far right sites and blogs used to be incredibly trashy. Or if you look at the *Innocence Of Muslims* film, or at *Fitna*, the film that Geert Wilders produced, it has this soft edge, brown vignetting, soft focus shots. There's also a lot of cheap aesthetics that goes with some of the content of those websites. But now, some of them have changed quite drastically, they are a lot more minimalist, they look a lot more serious, I think more dangerous for that reason."

Brought up in Jerusalem in the 70s, Ashery says that she's always been drawn to DIY and tatty things, cluttered spaces: "It was all plastic, everywhere, everything was dirty, underdeveloped. It's an aesthetic that I can't shake off... In my parents' house it was only posters on the wall, or trashy objects. All the characters in my videos are dirty, their clothes are dirty..."

Ashery left Israel in her late teens – a dramatic shift documented in *Why Do You Think I Left?* in which she interviews her family who obviously resent her departure, treating it like a schism. Her brother tells her "I always felt that you, and all your friends, were such a blank generation," and elsewhere says he feels Ashery had "a deep need to root yourself somewhere else that is not your natural place..."

In earlier works, Ashery responded to the pressure-cooker social dynamics and divisions of growing up in Israel, creating an alter ego character called Marcus Fisher, taking on the persona of a Hasidic Jewish man – complete with unconvincing beard and suit – "he was really trashy, in everything he did. Literally, the suit I haven't washed for years." In a 2003 video, *Dancing With Men*, dressed as Fisher, Ashery attended the male-only orthodox Jewish festival of Lag B'aomer in northern Israel: "It's divided into stages, so you've got the Sephardic Jews, from Yemen, Morocco... All of their music is samples and techno, and they have MCs. They take sentences from prayers and sample them. Then you have the Ashkenazi from Eastern Europe, and their more traditional, sung, music. It's interesting being in two very different arenas which are ethnically divided... It's a big music scene in that way. People are literally at a rave. But women aren't allowed in, it's just men."

Most of her early work took the form of small interventions in public spaces, "I'd just do something and people around wouldn't necessarily know that they were part of an artwork." Slowly, Ashery's work grew in scale, taking on collaborators and performers at the same time as moving away from focusing on herself as an interloper or transgressor, feeling that she had over exposed herself. By the time Ashery started on *PFF*, she had set up a situation where she was working with a host of performers, artists, musicians, camera people, editors.

But rather than this being a collaborative buffer from over-exposure, Ashery found the opposite: "*PFF* was the most exposing thing that I could do. I didn't know that at the time... I thought that if I take myself out of the work, I won't be exposed. But so much of it is about the unconscious, and I think it allowed me to go almost misguidedly to myself... Because I felt safe that I'd not be in

the work, in a way that ended up a lot more exposed, in terms of the content." I ask her how *PFF* is about the unconscious: "It's been a long process... I tried to listen to the voices in my head that I wouldn't usually listen to... I spent months of zoning into that lower frequency... in your stomach, those lower sentences, sensations, thinking with your senses – listening to those very low frequency type sounds in your head. Usually I would use my thinking mind, but I was really careful to not do that."

I say that it reminds me of a new age fascination with tuning into an inner, authentic, animal self. Ashery responds excitedly, telling me how during the editing of *PFF* she mounted a dismembered black pig snout on a golden card and hung it on her studio wall. She claims that throughout editing, the snout would squeal loudly, "so it's more paranormal than new age... Now it's completely quiet." When I sceptically ask if she's being metaphorical in some way, she answers "No, it's real! My friends thought I was crazy because every time they came, it was quiet, but I've recorded it... Later some friends came, and actually heard it, it's a really loud squeaking from the middle of the wall... So that's what I mean by tuning into this unconscious, I was in that zone for some time."

PFF is a romp through an unconscious of cavorting nudist performance artists, analinguist musicians, gender bending and hippie aesthetics, but it's also populated by the forces of right wing populists like Wilders and Niall Ferguson, the encrusted remnants of a global war on terror, white supremacism in Europe and bloody animal sacrifice. "One thing in my mind was a bad trip, you want to come off of the drugs but you can't come off... I wanted people to have to allow themselves to let go into the experience and just see what happens... I think as a result some people say that there's no clear political position, that there's no clear political message. But that was a part of it, not to have that – to have a slippage, a sense of slipperiness."

Though Ashery's work is full of references to ideas and histories, she says that she wanted the work to be first and foremost sensorial: "I wanted [the audience] to feel it. So they feel the music, they feel the space. To feel, in the live performances, the naked bodies, they feel the concerts... the concerts were quite big things to put on but it was important for me to have a live concert, not just a video... to experience the music live is completely different."

As a result of Ashery's focus on making *PFF* aesthetically appealing, some responses to the work criticised it for not explicitly taking a political position, or even saw it as a betrayal of the work done by previous generations of artists and musicians committed to social change. But for me Ashery's *PFF* is an ecstatic expression of frustration with the current status quo of political ambivalence and a feeling of ineffectualness in general culture – trying to cut through the miasma of relativism and the current ambient fear of taking any position at all through the tried and tested method of taking everything in one's mind, mixing it all up and seeing what comes out.

Ashery seems to agree: "My position was a bit gloomy when I made it. Disillusioned with politics, feeling like we don't really know what's going on... that we are in a real transition between an established world order in Western democracies, from left and right into something quite different. I think that a new counter-culture movement is not yet clear. And it's that real limbo state that I really wanted to bring across."

There's a mythic type of currency that both contemporary and experimental art and music worlds trade in: one of an inherent progressive, leftist, avant guardism. By simply stepping away from a general aesthetic of mainstream culture, art and music are aligned to a radical, leftist continuum. So much creative activity makes reference to radical politics and its cultural, aesthetic world, especially from the 60s and 70s – it gets replicated, remade, rehashed – but rarely does anything take on the discomforting, confrontational, even aggressive, present self of that project.

Though Ashery claims that *PFF* is "definitely not something that says that people in the right wing are bad" explicitly, in its ecstatic energy and frenetic tumbling through of the artist's and collaborators' collective unconscious, it brings focus to the core dynamic at stake in wider culture, that between the mind and its body, and how it expresses passiveness as well as activeness: "always in my work is a sense of an increasing state control over bodies, a lot of order, a lot of fascist control over what we might think are our free bodies and free existence... I think in *PFF*, the mood of kind of not knowing, of not finding a counterculture outlet, it's very strong, that mood of vagueness, of somebody who's been in the peace movement and marching since I was 13, where things were quite clear, suddenly finding this kind of apolitical mood."

It's a mood of vagueness, but *Party For Freedom* is definitely not at peace with that ambience. It is an attempt to punch through it forcibly, with feeling.

Party For Freedom is out now as a single channel DVD by Performance Matters

'Unfinished Revolutions: Oreet Ashery's *Party for Freedom*' was written by Nathaniel Budzinski and published at thewire.co.uk, March 2014. Reproduced by permission, http://www.thewire.co.uk/in-writing/interviews/oreet-ashery_s-party-for-freedom

CHRISTEENE's 'Drag Terrorism' Is Creating a Cult Following

Amelia Abraham

My journey into the world of CHRISTEENE began with a barrage of cryptic texts messages. "See CHRISTEENE, it will change your life," they read, like Bible belt billboards. Why were all my gay friends acting like crazy evangelists? I Googled it. "CHRISTEENE is an American drag queen, performance artist, singer-songwriter and rapper, noted for untraditional, 'terrorist drag'," it read. "What the hell was 'terrorist drag'?"

When CHRISTEENE burst onto the stage, I thought my fears had been confirmed – I felt like I had been ingratiated into a weird underground sect. CHRISTEENE was like a ratchet, drag version of all the nasty shit from *True Detective*; the accent was from the Deep South, it looked like a creature that had been in captivity for 20 years, and the audience's adoration was almost cult-like. Without giving too much away, the performance that ensued was high-octane mixture of rap, rim-job inspired dance routines, and costumes that conjure up all your childhood nightmares.

Musically, it was a bit like Chris Lilley doing a hardcore porn infused parody of a Mykki Blanco or Die Antwoord set. In which context, CHRISTEENE could be viewed as the artist at the forefront of this gender-fucking rap movement. And yet, it was so much more. Like a perverse Deep Southern preacher, between songs CHRISTEENE rallied the crowd with a gospel for the outsider. When really incensed, and forgetting to do an accent, CHRISTEENE reminded me of David Wojnarowicz – the voice of a queer generation. And then suddenly this angry creature would morph back into the coy, childlike CHRISTEENE, and sing an a capella ode to Oprah that almost moved me to tears.

Desperate to make some sense of the madness, I spoke to Paul Soileau, the man behind CHISTEENE's terrifying mask.

Hi Paul! Can you tell us how CHRISTEENE came about?

Paul Soileau: CHRISTEENE was like this little stank voice whispering in my head that I couldn't shake. Those voices usually come when when environments shift, when there is a lack of something important to you, or an overabundance of a good or bad thing. This cocktail was served to me containing the ingredients of being thrown about by Hurricane Katrina, finding myself in Austin after the winds calmed, feeling the need to create something quick and sharp like a switchblade, having a job that sucked ass, and not finding any dick anywhere to ease my achin' heart. I was feelin' it, and this little voice starting singin' a song to me called "Fix My Dick".

"Fix My Dick"

What were your inspirations?

Honestly, what inspired me about CHRISTEENE was the fact that I had plugged into that theatre fag inside of myself and realised that I had struck on something that encompassed so many things that made me go cray when I was a little kid. Costumes, wigs, music, dancing, prancing, dangerous women, dirty things, boots with heels – you name it. This creature was a golden nugget to me, and a scary one at that. I honestly had no clue what I was turning on... and I still fucking don't.

How would you describe CHRISTEENE, musically?

An electronic buffet of emotion.

And her look?

Homemade.

Would you class yourself as a drag act? Or is CHRISTEENE just kind of alter ego? I feel like there is some CHRISTEENE in all of us...

I think there is definitely some of CHRISTEENE in all of us... like it or not. That's a good thing, by the way. It's definitely a strange breed of drag, but it doesn't operate as traditional drag does. I'm not very present when the wig goes on. It definitely has a life of its own that I quietly regard from the backseat. I guess I'm weary of calling it an alter ego. It's more of a... possession, like I've fallen victim to this really intense relationship that is tearing me through and through in all the right ways.

You often get called a "drag terrorist", is that because you're pushing the boundaries of taste? Is this an intention?

I think that I am simply getting out there and wrecking away at all of the safe, sane and normal shit that we are constantly fed. It's not my intention to push your boundaries of taste. It's more my intention to create a very dangerous and exciting space that I, personally, would like to walk into if I were attending a gathering or show. I'm hungry for so many fucking things, and I'm really tired of waiting for someone else to feed them to me.

Your a cappella ballad about Oprah and Gayle really moved me. What's your favourite song in your set and can you tell us about it?

I like "Tears From My Pussy" and "African Mayonnaise". The both really hit hard with the audience in two completely different ways. And they are two of the songs that I can look out and see the bright faces singing along too. Or scared faced... or crying faces.

In your music video for African Mayonnaise, you storm a Scientology bookshop. Are there institutions you want to fuck with? And is CHRISTEENE a good means of doing that?

Hell yes. I think CHRISTEENE is a fantastic machine to roll out into the city streets or the sacred halls of our homes and institutions. I definitely loved the idea of fucking with the Scientology people because they play the power game. They have strong fucking fingers in very dangerous pies. They met CHRISTEENE and they did not like it at all. PJ Raval – the director of the videos – and I laid out a list of the places in Austin, and surprisingly Paris, that we felt needed a sweet kiss from the stank C. It was really, really exhilarating and pretty dangerous at times.

Have you ever had a bad reaction to CHRISTEENE? Can you tell us about it?

Of course. Not everyone likes the same damned things, although the big shits upstairs sure would like it if we did. CHRISTEENE has definitely struck a nerve with tons of groups who have very strong feelings about this character. I've been called everything. If you don't like it, don't fuckin' watch it. But if you start trying to shut it down completely because it just doesn't ring right with you... well, we then have a big problem.

Is it hard to get funding or get booked at big institutions because your show features rimming, your penis and songs about crying vaginas?

No. That's the best part of it. People are hungry for something right now and many of us are really fucking sick of what's being fed to us. The game is up and there is a lot of anger and a lot of counter culture kicking strong. We've have many successful funding projects happen for us, and we have been damned lucky enough to perform in a spaces like Ficken 3000 in Berlin to the Soho Theatre in London, with some University of Texas in the middle.

When I came to see CHRISTEENE, you mentioned Dawn Davenport and Grace Jones. Who's your inspiration as a performer?

I'm inspired by those out there who let themselves be completely vulnerable and free. Dawn Davenport and Grace Jones, sure. They have huge rooms in my heart. There's many more.

Who are your backing dancers, how did you choose them, and what do they bring to the performance?

Their names are C Baby and T Gravel. We found each other in Austin about six years ago. The chemistry was there immediately. They are really wild rascals, especially when together, and I asked them if they would like to be in the first video for "Fix My Dick". They said yes, they showed up in panties with trucker hats and cowboy boots, and I knew we were meant to make magic.

When my friend came to see your show, she decided to quit her job, I think it was CHRISTEENE's freedom of expression and rousing anarchic speeches. Do you think CHRISTEENE could be some kind of leader? I do.

I think CHRISTEENE speaks on many things that we are all feeling deep inside, but is just "decorated" in a way that brings it to another realm – almost not human. I would like to think of CHRISTEENE as a gatherer of emotions and hawt hawt rumblings from within.

Where do you see CHRISTEENE in the future?

I can't make out what in the hell the future holds for CHRISTEENE. I just want to continue to dig deep into all my shit and pull up the best and worst for that character to chew on. I want to share the work with as many people as I can, and I want to meet other artists similar to myself who have or can inspire me and show me strange realms that I could never have found.

Thanks Paul.

'CHRISTEENE's Drag Terrorism is Creating a Cult Following' was originally written by Amelia Abraham for Vice.com, 17 July 2014, http://www.vice.com/en_uk/read/christeene-drag-terrorist-amelia-abraham-465?utm_source=vicetwitteruk

'MUSIC IS LIKE A BIRD IN MY MOUTH DAT I DIDN'T KNOW I HAD': CHRISTEENE TELLS BEN WALTERS ABOUT ART, FASHION, CHICKENS AND THAT 'EMPTY BUCKET FEELIN'

Ben Walters

Over one filthy-gorgeous weekend this time last year, London audiences got their first taste of Christeene, the alt-drag rapper who looks like shit and shines with love. Coming out of Austin, Texas, she's the real deal, bringing an onslaught of freaky-eyed guerilla performance that combines seriously tight tunes such as *Tears from My Pussy*, *African Mayonnaise* and *Workin' on Grandma* (check out the videos below) with booty-shaking, umbrella-twirling back-up from two-man trailer-park chorus line T Gravel and C Baby. Created and performed by Paul Soileau, she's a sacrificial lamb in soiled-bedclothes couture, an intense, unmissable one-off takin' it hard for all us sinners. As she prepares to return to the UK for runs at Soho Theatre and the Edinburgh Fringe, I caught up with Christeene over email. To give you an authentic sense of Christeene's distinctive way with words, we've left her replies exactly as we received them.

Ben: Hi Christeene, how are you? What are you up to right now?
Christeene: Ohh Haaaaaaay Ben! My feelinz r fuckin flyin all OVER da place cuz uh diz tour gittin ret too slap my dick. Whut am i up tooo? Riyeet now i am whisperin to my chickenz in da yard about personal thangz.

Ben: You were in London last year. How did you find the city? What are you looking forward to about coming back?
Christeene: i wuz indeed in Londontowne laz year an it wuz fuggin AMAZE BALLZ. We got to perform ferr my baybeez Simon [Casson] an Dicky [Eton] at DUCKIE which blew my fuggn mind an my pantz off. an Derr iz this place called Vogue Fabrics an dey were so nice an Lyall Hakaraia let us into his basement to destroy ourselves an East Londontowne too. We met da most amazing people like Princess Julia an Lavinia Co-Op an Bari Goddard an [Soho Theatre programmer] Steve Lock an some gurl in da bathrooom stall an we met you toooo!

i cant fuggin wait tooo get back an see all deez beautiful strange people an i cant wait to git my hands on sum London ass cuz IT.IZ.HAWT. X

Ben: Your live shows are pretty wild. What should newcomers expect?
Christeene: Expect nothin an brang everything.

Ben: Tell me a little about your home and upbringing.
Christeene: peeple tell me dat i just appeared one day. dats how i feel an dats really all i can remember. i dont have no memory of a mama an daddy. i dont have no memory of a home. i juz remember feeelinz. I remember my Boyz T Gravel an C Baby an [DJ and songwriter] JJ Booya laughin in a room

somewherr. i remember da smell uh trees an i remember chickens.

Ben: You have a very distinctive style. What do you consider when putting together a look?
Christeene: i look at all da fuggin shit people are wearin an i think derr is no fuggin way im gunna git dat kinda shit so i dig deep in my closet inside my head an den all da pieces start too appear in front of mee in my dayz activities an i start to put all da pieces together. panty hose. pillow cases. plumbing equipment. dirt. My best lover friend RICK OWENS teaches me a lot about makin majiik outta scraps. he has witch powers in his long beautiful hair.

Ben: How did music come into your life? What does your own music allow you to do?
Christeene: music is like a bird in my mouth dat i didn't know i had. It woke up in my mouth one day an spread my lips open wit its wings an told mee thingz. it iz a most delicate bird an a very tricky bird. it allows me to say da things that whisper in my head an wake me up at night. it allows me to demand attention an hold hearts and souls in my hand for squeezin.

Ben: You've been known to spit at audiences. What's that about?
Christeene: dat is my bird kissin you. it iz a most wonderful thang to recieve

Ben: There's yearning or sadness in a lot of your songs. Do you think you've had a raw deal?
Christeene: no no not at all. well sometimes yeah. But everybody got those thingz inside them an many times it dont matter whether or not we all got da same thingz we dealin with cuz no matter whut it iz still da same feelin. Da same sadness or empty bucket feelin. I git sad sometimes yeah.

Ben: What puts the biggest smile on your face? When are you happiest?
Christeene: when i git on dat fuggin stage wit my boyz an i feel da fire of dat crowd i can do anything an i feel like kathleeeen turner in dat movie romancin da stone when She gits to take her clothes off and git nekid wit Michael Douglas.

Ben: Anything else we should know?
Christeene: i like to eat gross thingz before i go to sleep

'MUSIC IS LIKE A BIRD IN MY MOUTH DAT I DIDN'T KNOW I HAD: CHRISTEENE TELLS BEN WALTERS ABOUT ART, FASHION, CHICKENS AND THAT 'EMPTY BUCKET FEELIN'' was originally written by Ben Walters in *Run Riot*, 17 June 2014, http://www.run-riot.com/articles/blogs/%E2%80%98music-bird-my-mouth-dat-i-didnt-know-i-had%E2%80%99-christeene-tells-ben-walters-about-art-f#permalink

Camp / Anti Camp

Vaginal Davis

FRIDAY, APRIL 20, 2012

WIR HATTEN SCHON BEFUERCHTET As I write this my head is spinning
from drinking Macrobiotic Vegan Vodka in the form of a Chlymidia cocktail.
The first day of Camp/Anti-Camp was a smash success! Sold out SRO crowds
that like Jack Smith!Live Film brought a lot of different scenes together. The
Foodgasm installation of sexy Liz Rosenfeld and humpy Ozzie Sam Icklow
was beyond brilliant with the smells of gourmet delicacies wafting throught
the HAU 2 foyer. The Chicks on Speed girls and their narcotics den of inequity
The VooDoo Chanel Alter Bar was also very popular. The late George Kuchar
began the program with his hilarious masterclass on acting film from 1977,
followed by beautiful co-curator and intermedia actress Susanne Sachsse
hilariously reading timely tomes on camp backwards. Handsome Marc Siegel
gave a powerful denouncement of the patriarchy system in the German
theatre scene in his welcoming remarks, but what warmed everyone's hearts
was seeing living legend and treasurer of treasures Miss Hollywoodlawn
performing with Daniel Hendrickson and John Blue on Cello. The three
of them spun a magical thread of relevance and texture that gave me
goosebumps and their interplay with each other was wonderous. Holly shined
like only a true star can and looked divine with hair and make-up design by
genius genius Tan Binh Nguyen who made the 65 year old starina look like a
freshly scrubbed Warholian youthquaker. There were so many celebutants in
the audience that it is impossible to name them all but it was a joy to hobnob
with the dapper scholar Douglas Crimp, who use to be Holly Woodlawn's
New York roommate in the 1970s. Crimp's lecture "Camp Reflections From
'Our Kind of Movie' The Films of Andy Warhol was the talk everyone was
anticipating. I had to get into hair and make-up so I was only able to hear
snippets in the dressing room intercom system. I also wasn't able to see New
York star Narcissister as she went on right before me and I was still getting
a face beat on, but Love Camel reported to me that she was SENSATIONAL,
doing a Gydra performance with multiple heads, that morphed into a reverse
strip with various sundry items popping out of her vagina and giant Afro
Wig. The Camel was really impressed by her inventive video art one short
subject featuring a kinky treadmill where she is whipped, anally plugged and
chugged. Narcissister when not performing is sweet, charming and simply
ravishing, it's exciting that there are some hot new performers out there to

take the place of us old veteranas and Ms. Narcissister has one hot boyfriend who I wouldn't mind getting to know in an intimate manner. My talk show installation VD is SFTD was messy and chaotic just like I expected, but did have some engaging moments like my opening song with Daniel Hendrickson at piano, my co-hostess Carmelita Tropicana who makes everyone fall madly in love with her plus a playfully hilarious Theodora Tabacki in mesmerizing Serbi Tropi-Camp drag with Evi "Bear Boy" Ruesseler who premiered her new film which despite technical difficulties was thoroughly engaging and the hit of the evening. Our Living Sculptures Toby, Max, Xavier and Vassily kept the audience aroused with their antics and my favorite band Leiseylento performed some incredible songs for Miss Woodlawn who the evening show was dedicated to with the theme What Would Holly Do? and a cocktail named in her honor Classy Holly-itis. Miss Woodlawn's companion Nikko was supposed to keep her from drinking too much and he did a good job at that as she was very lucid and sharp on stage, but Nikko needed someone to keep him from drinking. Tonight we will have Stefanie Schulte Strathaus the Empress of the Arsenal presenting 16 mm films, Weiland Speck, Landgraf Klesse, Love Camel, Foodgasm, the divine Kembra Pfahler and Gio Black Peter. Oops forgot to mention i saw Patty Aldrich of A Walk on the Wildside Boutique of Toronto, the great Corolla Graumann of Kinotek Asta Nielsen, Jose Munoz, Richard Move, Gavin Butt & Baby Diaper Joel Gibb just to name a few of the luminaries at Holly Woodlawn's epic performance. NOTE TO NIKKO Holly's devoted companion and confident: The audience only needs to see The Great Holly Woodlawn nix the band Tangowerk. The female singer was ok in an 1980s sort of way, but the funny looking guy with the frizzed hair playing computer (which is quite the oxymoron) and those dreadful videos----please, i beg of you NEVER AGAIN.

SATURDAY, APRIL 21, 2012

HUMOR IST, WENN MAN NICT IMMER LACHT It is now the third day of the art festival Camp/Anti-Camp: The Queer Guide to Everyday Life and it's a sterling success on all counts. Congrats to curators Susanne Sachsse & Marc Siegel and guest Tropicamp curator Max Jorge Hinderer Cruz. Yesterday there were packed lectures with a program beginning at 12:00 noon. The gorgeous scholar Juliane Rebentisch hit it out of the ballpark with her talk on Camp Materialism and the Tropi-camp section of Camp/Anti-Camp was also feverishly mobbed. Carmelita Tropicana's performance "Meine Box Berlin" had the New York legend conquering Berlin with the same charm and dexterity that is so apparent in the 1993 film by her sister Ela Troyano YOUR KUNST IST YOUR WAFFEN. It was amazing seeing a young Alistair & Julie Tolentino make cameo appearances in that film as well as posters on the East Village streets advertising a Voluptuous Horror of Karen Black performance. Unfortunately for the Vagimule doll my issues with losing my voice emerged so I didn't get to see any of the lectures or performances, but got a reliable first hand account from Jewish Muslim Daniel Hendrickson and The Love Camel. I had an interview with a German television station that was supposed to be for only 30 minutes that went on for almost two hours and

that tuckered this old gal out but the TV interviewer was nice and bubbly and her cameraman and soundguy were kindof eye candyish. Beggars can't be choosy. I didn't get a good sleep Thursday night so I spent most of Friday in my dressing room drinking tea with honey&lemon and sucking on lozanges. I tried in vain to take a disco nap to catch up on lost sleep but that didn't work too well. VD is SFTD went over very well on Friday with my new co-host Nanna Heidenreich who was just brilliant and looked very sexy in her skirt made from men's suit pant ensemble. Stefanie Schulte Strathaus the lovely Empress of the Arsenal made a very unique and special 16mm presentation on the show which was quite a hit with the crowd, and it was grand to have the 16mm projector buzzing along musically in the cavernous HAU2 space. Special thanks to Arsenal senior projectionist Bodo for handling the celluloid reel changing duties. The Love Camel proceeded to offend many with his selection of German Educational films from the early 1970s and Wieland Speck was his dashing self telling stories of the glory days of Berlin in the early 80s running around with Jayne County, Zazie De Paris and Romy Haag. The evenings proclitities were dedicated to Jayne's raucous spirit with the subtitle Jayne County's In Love with a Russian Soldier and the drink special: If You Don't Want to Fuck Me Baby Fuck OFF and Die featuring once again macrobiotic and vegan vodka and my special Chlymidia cocktail. Nice moments on stage with Sam & Liz of Foodgasm who presented the guests and some lucky audience members some tasty food samples from their installation in the HAU2 Foyer and a hilarious moment with Landgraf Klesse and his concept of the Court of Good Taste. Wieland Speck also accepted the CHEAPY Award on behalf of Jayne County who was supposed to perform with the band The Lazy from Munich, but couldn't come to Berlin as she takes care of her elderly parents who are in their 90s and her mother became deathly ill. We also presented a CHEAPY to Kembra Pfahler of the VHoKB who wowed everyone with her stream of conscienceness philosophy on Future Feminism and the decrepid state of affairs in New York and the US of A in general. In the words of Kembra and I hope I am quoting her correctly, "People in New York who you run into will say they are fasting, but the actuality is that they are starving". The late nite ended with sexpert Gio Black Peter singing one of his hit songs from his album The Virgin Shuffle. While I was being painted as Venus in Furs by our Akshunist painter Yorgos the Greek Aktive Byzantine Ottoman. Gio Black Peter assaulted the audience with his lovesexy ways and wound up prancing about completely nude and the Vagimule Doll got caught up in the naughty Jayne County moment and wound up fellating the New York art and music star. Being the Lesbian that I am, of course my blow job wasn't very good and so I wasn't able to ignite that huge sea monster he keeps between his legs. Oh welp! I tried my best. My lesbiana girlfriend Carmelita Tropicana doesn't mind when i fool around with boys. Thank god she is so open minded. Our Living Sculpture boys Toby, Max and cute Greek beauty Vassily were adoreable on stage, and we had the addition of Richard Gersch (curator Susanne Sachsse's teenage son and his friend Georg doing a kickboxing demo on stage as installation that looked amazing and sent all the chicken hawks into a cardiac arrest at the sight of nubile buff teenage high school boiganzas. Tonight is the last night of the talkshow/installation and

with the Karen Black concert afterwards we are going to try to make the show zip along at a record pace. Our guests are the writers Travis Jeppesen and Eli Lev'en from Sweden with a video presentation by Love Camel of Turkish re-makes of American Mainstream Box Office Hits. Yowza!

FRIDAY, APRIL 27, 2012

EINSATZ FUER DEN TATORT VORSPANN I am exhausted! The Camp/ Anti-Camp and Rising Stars, Falling Stars: We Must Have Music re-launch has knackered me out like something otherworldly. I don't know where to begin in writing about the last week or so. Berlin has been an utter whirlwind of activity. Well my screening of George Gershwin's Porgy & Bess starring Dorothy Dandridge, Sidney Portier, Pearl Bailey, Diahann Carroll and Sammy Davis Jr. was a huge hit and the perfect way to jumpstart the RSFS series with a new spark. I even liked how the print was turning a reddish pink. It made this Hollywood Golden era film take on a decidedly more experimental aura. Re-vamping RSFS would have been impossible without the tireless efforts of Arsenal Empress Stefanie Schulte Strathaus, Daniel Hendrickson, the Jewish Muslim with help from Markus Ruff of Living Archive Project and of course Jeffreyland Hilbert of Kustom Kreative the genius of design wizardry who created the postcard fliers and posters that has everyones mouths agape. Jeffrey is a genius. After the screening Warhol Superstar Holly Woodlawn dropped by as a special guest star during the wine reception held in Kino II. Of course it is always a joy being in the presense of such an astounding talent, but I felt her companion Nico should have let the great lady rest a bit in preparation for her long plane trip to Los Angeles. Her fans were of course excited to catch one more glimpse of her divinity. On hand were Blue Bros kJohnny & Tim who is leaving Berlin permanently in a few weeks and returning to Portland, Oregon, delicious Toby Rauscher & French hotsy totsy Xavier who were so wonderful as my living sculpture boys in my talk show/ installation VD is SFTD, they were joined by Little Alex of Macedonia, art video maven Nguyen Tan Hoang, Jonathan Berger and his cute NYU student Joy, Senol Senturk, Mikki the sprightly C/A-C stage manager, gorgeous Nazli Kilerci, Romy Haag, with singer Billie Ray Martin, Piero Bellomo, New Zealand scholar Pete Limbrick, Kyle Keyser, Susanne Sachsse & Marc Siegel, curator Hannah Keller, Verena von Hodel, Lars Denicke, video artist Bjorn Melhus, Salome Gersch and handsome Uli Ziemons. Everyone was talking about how faggoty Sammy Davis Jr. was in the film Porgy & Bess playing Sportin' Life. Well Sammy is a well known womanizer but he also had some sugar in his proverbial tank and that is a fact many don't know about the Rat Packer who also packed quite a penile punch in his tiny frame. Funny lady Pearl Bailey was a hoot playing Cat Fish Row wiseacre a Mariah. Of course the beauty of Dorothy Dandridge couldn't be denied, and she somehow conveyed a modern edge to her low key performance. Sidney Portier has such a masculine voice and ardour and Diahann Carroll made to look plain and ordinary also packed quite a wallup. The Last night of Camp/Anti-Camp was a marvel with the concert performance by the music and art kollektive The Voluptuous Horror of Karen Black starring the amazing Kembra Pfahler who

had the audience revitted. It was so wonderous hearing the Karen Black hit songs again. I haven't seen the band play in almost a decade. The extra Karen Black treat was guitar god Samoa returning to the lineup. No one short of Glen Meadmore plays guitar like Samoa. He defines the Karen Black sound and seeing Kembra & Samoa together was my ultimate fantasy come true. The Lady Kembra is a consummate artist and one of the planet's smartest and most gifted women. Every move she makes is perfection personified, and Berlin was able to experience a rare treat. I was also happy to see Tenderloin perform and Dagmar Hopfisterei the teenage lead singer was in good form despite having almost OD'd just a few hours before the gig. The crowd seemed to really enjoy their music and songs like Empty, Eat Me Like The Good Book Sez, Salome's Last Dance which takes text directly from Oscar Wilde, Cheeseburger, No Soul, Octavia and Incitement to Discourse. I especially loved the animated text behind the band that was created by Jean Y. Kim who also did the video for SFTD. Joel Gibb of the Hidden Cameras is quite a good drummer and he also managed to play keyboards and guitar at the same time, plus Felix Knoke and Landgraf Jan Klesse are very attractive on stage and had lots of the girls going wild over their manly appeal. Tenderloin's next gig with VHoKB is August 10th in London England during the Olympics when Antony of Antony & the Johnsons curates The Meltdown Festival. The last day of C/A-C featured celebrity sightings as diverse as Peaches and The Pet Shops Boys, Wolfgang Tilmans, Katy Perry, and Jens Friebe the German indie pop singer/songwriter. The last SFTD was a speed talk show/installation that was over in 27 minutes and featured as guests a playful Tim Studkin masquerading as a former Bel Ami porn model turned scholar and activist, Swedish poet Eli Lev'en and good time Charlie of a writer/journalista Travis Jeppesen who has very pretty bare feet that the Vagimule managed to shrimp as the packed audience squeeled uncomfortably. The Love Camel aka: Andrea Novarin of the BFI didn't offend anyone with his video selection of Turkish film remakes of Hollywood Blockbusters like Star Wars and the Exorcist. Co-hostess Nanna Heidenreich was sublime. It seems like everyone's favorite SFTD evening was the Friday salute to Jayne County that featured Arsenal Empress Stefanie Schulte Strathaus and her dynamic 16mm film presentation. This evening also had everyone talking about the kickboxing demo by Richard Gersch and Georg that was so earnest and sexy in a quiet way and of course the nude rapping by New York sensation Gio Black Peter that featured just a bit of analingus and felatio, not to mention a mock Court of Good Taste by Langraf Jan Klesse with an inspired Liz Rosenfeld of Foodgasm. Kembra Pfahler and Wieland Speck (accepting a CHEAPY Underground Über Alles Award for Jayne County were other highlights of Friday, and everyone was admiring the beautiful set that was designed by Jonathan Berger and Senol Senturk that featured a fetching wall of cacti. Catching every moment of the three day festival: Peter Limbrick, New Zealand film scholar who lives in San Francisco, Pet Shop Bears Disco Club proprietors, Mobile Academy's Hannah Hurtzig, Sophia of Plan b, Katja Sander and artist Phil Colllins with their gaggle of art students in tow. Plus the lovesexy Angela Melitopoulos, Jan Kunemund of Sissy Magazine, Piero Bellomo, Sabeth Buchmann the wonderful art theorist who teaches in Wien, Dragan Asler and the Serbian Art Mafia, the Great Alessio who did a

splendid make-up job on Teodora Tabacki making her look all Serbi-camp, Koen Clarehout, Maeke Harmsen, Katrin Dod the Beauty of HAU, Steffan Faupel and his music writing partner, Art shtar Ming Wong, scholars: Anja Michaelson and Kimiko Suda, supermodel Akira Knightly with make up artist Tan Binh Nguyen who not only beats the face of curator Susanne Sachsse, but Vaginal Davis and Holly Woodlawn, DJane Olga Damnitz, Angie Anderson, Christina the hot Romy Schneider looking girlfriend of sexy Sasha, dancer Asaf Hochman, Earl Dax of Pussy Faggot, Juan Luis Mielgo Castellanos, the sexy Spanish teacher, academic Todd Sekuler and Hanno Stecher of Catchfire blog.

'Camp / Anti Camp' was originally written by Vaginal Davis for *Speaking from the Diaphragm*, 27 April 2012, http://blog.vaginaldavis.com/2012_04_22_archive.html

267

Truth in Gender: Wu Tsang and boychild on the Question of Queerness

Hili Perlson

Artist and filmmaker Wu Tsang explores the relationship between the self, identity and the narratives that construct them while focusing on subcultures and sites of cultural resistance. In her club performances, boychild channels a raw, genderless being, whose muscular body contorts as if guided externally, while lip-synching to dark electronic remixes of Beyoncé and Rihanna. The artists collaborate in film (they recently premiered *A day in the life of bliss* in Berlin), photography and performance. Sleek caught up with the duo on Skype while they were preparing for a performance at the MCA, Chicago.

Sleek: Let's talk about the importance of nightlife to your work. Wu, you did a line of parties called Wildness with DJs Nguzunguzu and Total Freedom at the Silver Platter, a 60s landmark bar in L.A. that became home to the Latin/LGBT immigrant communities. The club was the subject of your first feature film, "Wildness", and your installation at the 2012 Whitney Biennial. And boychild, your performance grew out of the San Francisco drag scene.

BC: Nightlife is important for my work because it creates a space for me to exist; nothing contextualises my performance the same way as these places do. It's my world, my existence in the underground. Also, I exist in a world that comes after the internet, so my adolescence was spent finding things there. The underground exists on the internet for me. As far as the way that people experience and perceive my performance, they'll just see it at a club and I think that's special, magical and spontaneous in a way that it's not in other places. I performed in drag spaces, but the most drag thing about my performance is that I lip-synch. I never really felt like a drag queen even though I always really wanted to. [Laughs]

There's also a thing about the sincerity of nightlife; people are so present and unpretentious in a certain way. You're on the same level with the performance and the viewer; you're on the floor together having the experience. I performed in festivals with several hundred people and there it's more important to create boundaries in the dynamics of performer and viewer.

WT: It's creating a shared space versus dominating.

BC: Yes!

WT: I agree that nightlife is important to my work in different ways, though I share a lot of the appreciation that boychild does. There's a tradition of queer night life spaces being places that people needed, to figure out who you are, not having a support group or a family in a way, and some of the communities

that have come out of that. It's queer people starting a club to have a place to go basically, a safe space. And a lot of the clubs that we go to may not function like that in general, but the people that throw the parties are people that come from that.

That's important to me that there is a queer paradigm, and I say queer meaning maybe the party is super mixed, but they have some relationship to where the music comes from and how those clubs started. What I love about those spaces is that when you go in, you can leave a lot of things behind. You can just be a certain kind of person in that space and share it with people and there's some kind of sincerity, of letting down a lot of social roles.

You both appropriate mainstream tropes in your work. Appropriation is a vital practice for any subculture seeking subversion.

WT: For me, appropriation means something very specific; I work with appropriation in a lot of my films, quoting material and recontextualising it. Cinema has such a rich tradition, whenever I make a film I'm aware that everything I do will always bear a relationship to things that have been done in the past. I'm always looking at what the continuities are and trying to acknowledge that they exist, and acknowledge where the inspiration comes from.

BLIS [boychild's film character] is very much a character that I created; I don't see her as boychild. In sci-fi, if you're going for a genre, there are a lot of tropes that work very well to embrace. A story about a character is only really interesting if she has flaws. So BLIS is a superhero, and it's a special day, the day she discovers she has this mutant superpower. It's a superhero origin story.

I built her character around thinking about what some of the obstacles might be in the world and how she might overcome them. And it has to do with looking. In the film, the surveillance system is this AI called the LOOKS, it's about looking and being looked at. She has a dual relationship to that activity. She enjoys the attention, but it can be really scary how fans obsess about her. Also, some people "look" out of appreciation and fascination and some "look" with disgust and fear – it's the spectrum of that experience. These emotional experiences are very universal, showing ways that we might all relate to social media. And also being queer in the world and how it feels to be stared at.

I think the term queerness has come to represent, rather than specifically gender identity politics, also a way of being in the world that is a heightened form of critique alongside cultural production.

WT: When I was doing *Wildness*, we always had a performance and we liked that it was a drag bar with a drag stage lighting and décor. We'd invite people and tell them everything can be drag, because we're all basically performing social roles. people talk about "realness", how real can you be this or that. or how you're completely not these things. In that sense I was always excited

about boychild's performance and I also thought about it as drag, though, as she said, she's not "drag queen" drag but drag as in all the different ways that we might channel cultural references and combine them.

Drag is like the art of appropriation in a way, how you pick and choose references and put them together. And especially now, that the internet has broadened our spectrum of references, it's interesting how we pick and choose. It's not just the one thing that you can find, it's everything you have access to. It can be overwhelming but it can also create amazing art. The music is also really important whenever we talk about nightlife and the underground. [DJ] Total Freedom talks about how being a DJ is not just about giving people the feed, like the pop culture feed, but showing them where the feed comes from. I feel like boychild's performance has that quality to it too.

BC: There's a number of people whom I'm very lucky to call my friends, who have a way with sound similar to what I have with the body. Wu and I did this exercise together, in the first stages of understanding each other and our respective work, where I tried to explain my performative language and movement; there's a way in which sound moves me that is essential to my work and also correlates to the things Wu wants to say. I love the way that certain DJs will take a pop song and make it totally gruesome and dark, but also super alive and emotional.

WT: Like the pop diva's voice, and what makes us all obsessed with someone like Rihanna or Beyoncé. Total Freedom will somehow capture that, but then also capture some feeling like you're falling or being sucked into a vortex. Both those experiences are in a remix at the same time. I feel like boychild's performance is like that too: the things about pop and spectacle and fantasy which are why we're all wrapped up in that kind of culture production, but also the feeling in our bodies and ourselves of being grounded on the earth, hurting in pain, suffering.

BC: Life sucks! [Laughs]

WT: The whole industry manipulates us. The internet exaggerates our celebrity obsession, it gives us distractions but it also gives us constant reminders of how fucked up the world is. We're living in this constant state of distraction and of feeling hopeless and emotional. At least that's how boychild and I feel.

BC: It's also my relationship to music because it's my way of being. It's more fun, instead of work ing against pop culture, to work within it, recontextualise it and appropriate things. Relating that to my queer identity, if I were fighting the mainstream or the non-queer world I'd constantly just be fighting, instead of enjoying the really wonderful things about life, you know? And that's the nightlife too, there are people and projects that might not identify themselves as queer, but represent some new ways of breaking down the structure of the mainstream in a way that feels very queer to me.

WT: Talking about subculture and my interest in it and the idea of counterculture as being against the mainstream, that's a model that doesn't really work anymore because it's a dead-end idea that the world is black and white, and that you can resist the things that are capitalist and patriarchal. That's just the moment we live in. There's a lot of irony in the way people appropriate pop culture and embrace corporate aesthetics, like normcore and all these things. There's a lot of irony but it also comes from ambivalence about what the fuck to do. We have a love/hate relation ship to these things, because if we reject them all, we will be paralysed, so there has to be a way to move through it, and to make art.

You also perform the work *Moved by the Motion*, where Wu is the voice and boychild the mover. There's a spiritual element to it, like an Ur-form breaking down to a bodiless mind and a guided body.

BC: Each iteration of *Moved by the Motion* is different depending on the space. Tonight's performance is in a black box theatre and is a lot more theatrical. I'm excited because my performance works in these settings, with channels and spirits, my makeup and the lights. It feels a lot more spiritual to me in that sense; it really accentuates the dichotomy of the voice and the performer or the body. Would you agree?

WT: Uhuh. We each represent dimensions of the psyche of the character of BLIS. She has this dream, and we each play different parts of her persona that come up in the dream. When we first started working together, we came up with this idea of different characters associated with different types of boychild's movement. And so the voice and the mover is really about thinking about body language versus verbal language, and how we can create a space between us that evokes certain emotional states. like, how a word can affect our understanding of the experience, but also how movement creates an emotional experience that might be outside of language.

There's also a series of photos, and the one titled *A Child and a Man on his Deathbed in One Body* deals with duality, of the two of you being two sides of one thing.

BC: The photos in the exhibition are the physical embodiment of the four aspects of BLIS' character. The one you're referencing shows a character called *The Jester*; it's about the thing in your consciousness that are two things pulling at you. For me it represents the ambivalence that I have towards pop culture. The jester is about what's happening in your mind, those battles, trying to translate information that exists in the world, the internet and on the feed...

WT: ...and sort of like anarchy and total destruction, the part of you that enjoys the pain of others. The Joker in Batman represents this kind of almost philosophical point of view, that there's nothing precious to hold on to. These archetypal figures, I think, are in all of us.

Wu, a short film you directed for PBS [the US Public Broadcaster], *You're Dead to Me*, just won an IMAGEN award. How's film-making different to you than art-making?

WT: The biggest differences are audience and context. Films circulate differently than art works. Art is for me very site-specific, and allows a more full body experience; how you walk into a room, what the sound feels like, how big is the image. You can really affect people on a lot of levels with scale and volume – but it also limits your audience. Films can circulate on a lot of different platforms, they can be shared or people can encounter them in a personal, individual way.

Or collectively. But they require different things narratively. I'm also interested in that tension – they're almost antithetical to each other. It's almost impossible to do work that functions as both. We're now working on a version of *bliss* that will be a bigger feature film, where you can follow the character of BLIS from beginning to end, for the whole day.

'Truth in Gender: Wu Tsang and boychild on the Question of Queerness' was originally written by Hili Perlson for *Sleek* #43, September 2014, http://www.sleek-mag.com/print-features/2014/10/truth-in-gender-wu-tsang-and-boychild-on-the-question-of-queerness/

Mykki Blanco interview: 'I'm basically just doing glam rock'

Steph Kretowicz

The moment his hotel room door swings open, Michael Quattlebaum is chattering about the unprofessional journalists he's met so far. It's the sixth date of a gruelling month-long European tour, and when I ask if I can turn my recorder on, he seems surprised I even had to ask. "It reminds me of something that I would have done if I was a teenager," he back pedals, without pause, about the "sneaky people" posing as reporters only to offer him Xanax and invite him to parties. "But then, when you're in the situation, you're just like, 'oh, come on!' Like, I'm tired."

Quattlebaum certainly looks exhausted. Wearing a grubby white hoodie with 'SUSHI' printed across it, suede pink tights and slightly chipped fluoro nail polish, the poet-cum-rapper talks non-stop. Weaving in and out of any given conversational thread, usually of his own choosing, he's interrupted by a phone call from live producer DJ Open1one about sound check at one point, and by frantically searching for his contact lenses at another ("I slept in them. I shouldn't have slept in them").

I'm nestled on a couch between a pile of clothes and a limp blonde wig slumped on an armrest. "I need to brush it," he says, smoothing it out with his hands after I ask if it's real hair: "I wish". Quattlebaum's preoccupied, slightly erratic behaviour comes in contrast to his focussed dialectic on his art practice, which he delivers with almost terrifying eloquence. He speaks clearly, with a slight lisp, using repetition as a rhetorical device, while getting distracted often and digressing more, "What was I talking about? I kind of veered off."

But he doesn't always realise when he's deviating. Instead, pausing and re-starting any given answer, he gives the illusion of control as he re-articulates and edits himself mid-sentence, making it seem as if physical time doesn't actually operate on a continuum. Lapsing into linguistic fillers less than others, the only time the "likes" and "you knows" flow freely is when he gets excited, be it recounting an interaction with a trans woman sex worker "Rosalinda" the night before, or saying something he hasn't recited already: "You can either go around griping to yourself, 'Oh, I wish I was on a major so I can have more money to do certain stuff', or you can just fucking do it. You know what I mean?"

And Quattlebaum has certainly fucking done it. In the three years since donning a dress and introducing the art world to 'Teen Raptress Mykki Nicole Blanco', the struggling New York runaway, originally from North Carolina, has rocketed into the public consciousness with his exhilarating amalgam of grimy electro and rap, sprung from a root of gender-bending performance art and transgressive urban poetry. "Last year, talk about kicks like a speeding

273

bullet," says Quattlebaum about his unforeseen beeline into life as a career musician, "There are times when some people have looked at us and they're just like, 'you guys are crazy'," referring to his partnership with manager and UNO label owner, Charles Damga. "But the thing is that I don't think that we've moved at a speed that's been maniacal or creatively unhealthy," he says, before qualifying: "it was hard. It took a toll sometimes. Literally, I felt like I was going fucking insane because there was just so much going on."

When talking to Quattlebaum, there's certainly a sense of the chaos of Mykki Blanco. Thrust into the spotlight when shocking the Web with the creepy video for *Join My Militia (Nas Gave Me A Perm)*, produced by Arca, a reappropriated Auto-Tune function creates a vocal effect that's as wonky and weird as the image of a rapping, bewigged Mykki Blanco in a bikini reeling drunkenly in the dark and wearing a dead squid. That track was originally thrown in with his debut EP, 'Mykki Blanco & the Mutant Angels', meant more as a progression from his No Fear performance art that mingled poetry with a live Riot Grrrl, No Wave and industrial rock aspect than pursuing any real pop intention. Since then, though, the interest in Quattlebaum "doing the cute little rap" has been so strong that those elements of his punk background have faded out of the musical component and transpired more in his consciously provocative and DIY approach to staged self-construction. "The combination of what would be the 'Mykki Blanco Project', a black boy in drag being a punk performer but then rapping also, that's when I realised that people's interest was really through the roof."

It's from this point that Quattlebaum launched his career as we see it today: transitioning from a video art project with him "pretending to rap as a teenage girl" in different gay clubs and bars around the city, to 'Cosmic Angel: The Illuminati Prince/ss' mix tape, dropped in November last year to widespread praise. "The second half is all the stuff that I originally made. That's all my little lo-fi stuff, just me on my laptop. I put that on there so that it shows the chronology of the whole entire project." An online search will reveal that those latter pieces have been floating around the Internet for one, two years. If it isn't words from MB's First Freestyle on Glasnost NYC documentary 'Cosmic Angel', then it's the brilliant tween-age eye roll of existential poetry, *Mendocino California*, produced at home "with the little pitch-shifter on GarageBand."

That very mixtape features a whopping nine of some of North America and Europe's most interesting electronic producers, but for the follow-up EP 'Betty Rubble: The Initiation' (also a reference to an early octave experiment appearing on 'Cosmic Angel') Quattlebaum has nearly halved the line-up. "I would have to be on a Rihanna-level of money and coordination for me to ever work with nine producers again," he laughs. But in numbering five, including A-Trak, Sinden, Supreme Cuts and Sinjin Hawke among his latest legion, it's not that much of a step down in terms of workload. The outcome so far is a track like *Feeling Special*, produced by Matrixxman, where the bilious withholding of strained top notes are jerked into an undertow of a leaden bass line, pulling its listener through that very "rabbit hole" of surreal experience

and psychosis that Quattlebaum's words evoke. "A good Mykki Blanco song is hard-hitting, combative and aggressive but also the lyricism is psychedelic and trippy and spaced out," he explains, "Last, it's sassy, biting and hyper-feminine. It's those elements combined that, when I say the lyrics, it sounds so rough and then I come right back and it's so sassy and so bitchy."

It's that multiplicity that makes Mykki Blanco such an exciting prospect. If it isn't "shirtless Michael, with the head shaved, screaming into the microphone," in contrast with the Madame Libertine of the *Wavvy* video, then it's a blue-eyed "genderless third" introduced in the consciously macho play on gangsta rap in Brenmar's exquisitely scattered *Kingpinning (Ice Cold)*. Here, Quattlebaum eulogises his fellow freaks with an unlikely call for acceptance in, "I roll with all types, real niggas, real dykes, white boys with them yarmulkes, model chicks with a million followers."

The problem is, according to Quattlebaum, that a lot of people have misconstrued these plays as some kind of original alter ego, rather than drawn from a long and obvious line of gender-bending characters, from Bowie to Boy George, Dennis Rodman and Ru Paul. "Can we stop being so text book psychology? Let's get back to the basics of show business, which is it's a stage name," Quattlebaum says, iterating that these alleged "personas" – from Mykki Blanco to Betty Rubble, Young Castro and Black Sailor Moon – are only theatrical devices employed to examine life's complexities, a technique going way back to avant-garde poet Jean Cocteau. But then, with the onus on journalists and cultural critics being in quarrying cultural novelty, Quattlebaum adds, his performances have been represented as something much more original than they really are. "I think the way that it's packaged is so provocative and new-seeming, that they would rather negate the lineage. I'm basically just doing glam rock."

It's this idea of re-definition, or, more specifically, de-definition, that Quattlebaum is exploring. "You may not know it yet but Mykki Blanco isn't just female Mykki. Mykki Blanco is Mykki Blanco 'female', Mykki Blanco 'male', Mykki Blanco with blue eyes, Mykki Blanco with three eyes. I'm probably eventually going to do a video where it's not Mykki, where it's completely genderless, where it won't be Mykki 'boy' or 'girl'." That ambiguity, ambivalence even, is easily lost on some. Because, despite the provocative nature of Quattlebaum's work, its lyrical content comes, less as a conscientious political position, and more a rendering of those words – loaded with implication and used as an agent for confining and marginalizing specific groups – ineffective. That's why you'll hear Mykki Blanco drop *"bitch niggas gone retardo"* in *YungRhymeAssassin* and reference shock comic Lenny Bruce in *Feeling Special* without so much as a flinch.

As a poet, having already published *From the Silence of Duchamp to the Noise of Boys*through LA Gallery OHWOW in 2011, Quattlebaum literally trades in playing with words and their meanings. That's not least through his insistence that all his press refer to Mykki Blanco as "she", whether coming accompanied

by a typically masculine image or a consciously feminine one, and the world has yielded accordingly. "I made that decision, not just for gender play, but because, kind of in that way that Lil B named that album 'I'm Gay', I wanted to continue to fuck with people." Quattlebaum says, elaborating that it has a lot to do with his interest in the term "Pandora's box" because, as an idiom referring to the idea of a seemingly inconsequential action having huge implications, it relates directly to his faith in the future "feminisation of society". "There's that phrase by Yoko Ono, 'the woman is the nigger of the world'. Honestly, I do believe that's a large part of the problems of the world. Homophobia comes from misogyny, the hatred of women. If you can't see the connection between homophobia and the hatred of women, you're blind."

About Mykki Blanco, a friend once said to me, "you know he's full of shit, right?" She'd interpreted Quattlebaum's transvestism as a harmful parody of women, echoing a history of disagreement between trans and some feminist groups over drag performance. What complicates the predicament surrounding Quattlebaum even more, is that he's a relative newcomer to the cross-dressing scene. Beginning as late as 2010, when he was 24-years-old, there have been rumblings around Mykki Blanco, questioning her legitimacy and labelling her a phoney. That begs the question: does Quattlebaum actually consider himself a transvestite?

"Yeah, because I am," he replies directly, already aware of the potential for criticism, especially within the discourse among trans activists and advocates censuring the very use of the term. "They're talking about a whole entire body of ideas, and a meaning, and message that is specific to them. If you look up the term transvestite, I am a transvestite... I apologise if we are still in a time in society when having that word makes some people feel as if saying it is a regression but I've always been a very blunt person and I am a transvestite. I am not transgender and I am not transsexual. And I don't get dressed up all the time, so that makes me even more of a transvestite!" he adds laughing.

The contention regarding the legitimacy of Quattlebaum's cross-dressing is one that can be applied to most any lifestyle, from sexuality to vegetarianism. The first thing people tend to ask is, "how long for"? Implying there's a certain trial period one must go through to prove their conviction. In a recent interview with Dummy, fellow Harlem-dweller A$AP Rocky dismissed Mykki Blanco as outside the greater rap cultural discourse, for that very reason: "I think he's been rapping for like a year now so, what 'scene' are you talking about?" Which begs the question, at what point does one "qualify" as a rapper, in the same way as they "qualify" as a transvestite? "I started rapping because people told me I was good at it." Quattlebaum says frankly, "I was a poet and if you're good at writing poetry, you're a good rapper; you make words rhyme." There has been endless debate – explicitly centred on things like traditional rhyme schemes but implicitly pointing to cultural norms – levelled at Quattlebaum and other purported pretenders, like Das Racist and Le1f. But when it comes to semantics, it isn't a question of whether someone lives up to that ever-subjective idea of what is "good" or "bad" rap, but whether it is rap at all.

"Right now I think of myself more as an artist working with rap," qualifies Quattlebaum, no doubt conscious of the heritage that he, as a performer starting in poetry and visual art, appears to be threatening. But, whether intended or not, Mykki Blanco "raps", therefore he is a "rapper". And that's not to mention the clear history of disruptive innovation in the very genre that he's referencing. "I want to really build the Mykki Blanco mythology and make an original space for myself, like so many hip hop artists have done in the past. Whether they're, in the end, regarded as underground or mainstream, they still did it. I look a lot to Wu-Tang Clan and I look a lot to Ghostface Killah, my favourite rapper, because he creates his own mythology within his raps and I see a similarity in what I like and what I can do."

That's because Quattlebaum isn't just deconstructing gender, he's deconstructing what it means to be a rapper, what it means to be a musician, what it means to be an artist. Echoing the contemporary situation of an expanding art world, cultural diversification and interdisciplinarity, the Mykki Blanco project is a defiantly circumstantial work-in-progress. "I think that definition will change with experience," Quattlebaum says of self-identifying as "an accidental rapper". Because, for him, "the journey is the reward" and it's pretty apparent he's been loving the trip so far.

"So I'm, like, wearing this latex and lace dress," he says, jumping on his bed and burying his chin into his pillow while recounting a crazy night with new friend "Rosalinda" behind a De Wallen window in Amsterdam. "A guy actually ended up coming 45 minutes later, or an hour later, and we had to get kicked out but it was so much fun. It was so much fun. I love stuff like that. I love stuff like that happening. It was cool," he shrieks, kicking up his feet and squeezing his pillow tighter. "I was, like, *standing in the window for a minute*! With *Rosalindaaa*!"

That's where the interview ends. But as I'm watching Mykki Blanco performing that very night, wig attached, make up applied, and tank top flung off for a fierce rendition of *Wavvy*'s "*it's a war out here, the real versus the gimmick*," I briefly wonder, "*who's the 'real' and who's the 'gimmick'?*". That's when it occurs to me that I'd never asked Michael Quattlebaum whether he'd always felt like cross-dressing. But then, who cares? A vegan's still a vegan, animal lover or not, and Mykki Blanco is a black, cross-dressing rapper performing to a packed room that is going wild and singing her words. If that isn't progress, then I don't know what is.

'Mykki Blanco interview: 'I'm basically just doing glam rock'" was originally conducted and written by Steph Kretowicz in *Dummy Mag*, 28 March 2013, http://www.dummymag.com/features/mykki-blanco-interview-i-m-basically-just-doing-glam-rock

Kembra Pfahler On Her Performance Art Class, Feminism, and Redesigning the Planet

Tea Hacic

"I ruined my career when I sewed my vagina shut," says Kembra Pfahler, between puffs of a cigarette. She was standing outside a gallery in Soho, talking to a group of women who were watching her with the wonder typically reserved for Spice Girls reunions. "Now I'm free to do what I want!" Pfahler was referring to her scene in Kern's *Sewing Circle*, where she got her vagina sewn shut because she was feeling "upset" with how men in her life were trying to claim her body. She's said before that her work has caused problems in all of her relationships, even with her most understanding lovers, who always felt that her body wasn't hers to decide what to do with. She's always made a point of proving them wrong. You may know Pfahler from her band, the Voluptuous Horror of Karen Black, her painted performances, transgressive films, or your own gothic teen daydreams. I recently met with Pfahler in her blood red painted apartment to discuss her new school, the future of feminism, and how we can rescue the planet from its grim future.

How did you decide to start your performance art class? Why is it so important to do it yourself?

The DIY philosophy is something that became popular when I was a teenager through punk rock in LA. I'm glad to see that so many people are doing DIY projects via the internet and being individualistic and avoiding big companies and being self-starters. It's a great time for that. It's a new age of enlightenment for artists and people in general, people of all walks of life can really make their dreams come true in a very realistic way. "Availabism," making use of everything available, is a principle that I came up with when I was really young to describe my artwork. I've been doing it for so long, this is like my third decade of being a practicing artist, so I was thinking what I would want to share with other people from what I've learned over the years. Availabism has to do specifically with materials, not having a hierarchy of systems, or of what's better or worse to use. Is it better to make a movie with super8 or 35mm or iPhone? The content is more important than the material.

Do you think everyone is capable of becoming an artist as long as they have the right tools, or does it require talent as well?

I don't think being an artist requires talent. I think it requires courage and audacity and discipline. It's not that I think that most people are or

278

aren't artists – I think some people do or don't want to work all the time. I would never presume to give any titles away of being an artist or not, that's something they have to figure out on their own. But as far as what people are, everyone is fine just the way they are when they sign up for this class. It's an experiment with time, and I've noticed that in NYC time is a luxury. I thought it would be a great experiment to spend concentrated amounts of time just talking about a student's work.

Tell me about the Future Feminists.

Future Feminists are a group of women I'm working with. They're my favorite artists, the ones I identify with most in the world. We initially got together because we wanted to have an art show, so we started by doing workshops and retreats where we worked seven days in a row just writing and creating what led to our Future Feminist tenants. We decided that those, the writing we did and the time we spent together formed what could possibly be the seeds of a new movement. We realized that these thirteen tenants themselves were the show. We're going to have thirteen nights of curated performance art with other people we admire and who have influenced all of us, so that will be fantastic. The show will be at the Hole gallery in September.

If somebody wanted to join your class how could they?

I found my students by word of mouth and through internet! I'm on Instagram, Twitter, Facebook, everything! You can also email me at Kembra1@yahoo.com. I do a simple interview to find out what they're doing and see if I can have what they may need in terms of providing them with a personal course syllabus. I want to make this class everything my art school experience wasn't.

Ultimately, what do you want your students to walk away with, aside from new art skills? What kind of message do you want them to keep? So if they're in a challenging situation they think, "what would Kembra do?"

I would hope that they wouldn't do what I would do, but I hope that they would have developed the courage to do exactly what they want to do. It's very important to me that we don't impersonate each other. Being original is one of the very most important premises of the class.

Marina Abramović once said that she's not a feminist because she thinks artists shouldn't have gender. I think it's harmful when powerful women denounce feminism. I'm confused by it. How do you feel about that?

When someone says that they just want to be a person, that's cool, but I think that's like living in denial. We have vaginas. I am a female. And I feel that in the year 2014 to remain neutral and in denial about what we are is as destructive as, say, not recognizing that there are racial problems. We need power in numbers. Through the internet, communication, or work, this

club has to be big. Having as many people as possible is where we'll get our strength. Statistically there are more women than men, but we aren't the majority in anything! With the rise of our consciousness around not wanting to be neutral, we could be the main gender, it could be more she than him.

Many pop stars like Katy Perry, Lily Allen, and Taylor Swift are either saying anti-feminist things or just being completely apathetic. When a woman with success and power talks down on women or completely ignores the struggles of women around the world, what are girls without their power supposed to think?

I think this has to do with commerce, because women have to work so hard to get where they've gotten that if they do become wealthy and powerful, they don't want to lose their material wealth by saying the "wrong" thing. Materialism causes fear in people. Especially with pop stars, that are designed to remain mute with their real identity because it will affect their pocketbooks. Once those are filled, maybe they'll become true to their feelings. I think my new kind of extreme thinking was pivotal to the feelings around global warming and the environment. It's changed drastically and we've had Katrina and all these really intense elemental disasters that made me think all the harm that's been caused is the result of patriarchal values gone too far. There wasn't time left to worry about commerce and our own personal gain. It just seemed to me unavoidable all the harm that's been caused and the direction that things are going. I feel like things are so drastic with the environment that unless as artists and feminists we start to powwow and come up with radical changes, I can't envision how it will get better.

The number one problem in the world is overpopulation. And that happens in places where women have the least access to education, personal freedoms, and of course, birth control. It's proven that in places where women have less power, they have more children they can't afford to take care of. It's affecting not only the women and all of the people in their society, but the environment as a whole.

Overpopulation is one of the issues, but clearly we know, living in New York, the effects of corporate values. I was having a discussion recently about indigenous cultures and how they made decisions much differently. There was a principle of seven generations. Grandmothers would sit around considering how decisions would affect the tribe several generations away, and now tiny groups of corporate hierarchy are sitting around making decisions that aren't considering anybody else or the preservation of where we are living! It could be really fun to be around in the next few decades, since essentially, we need to re-design the planet. From the way the political systems are run, with one dude at the top, the others scrambling below him, and a few ladies trying to squeeze their way in. That needs to be changed. There's no exclusivity for future feminism. It requires the participation of all women and men, all different people need to get together and pay attention to the harm being done.

It's a difficult thing to talk about because people get offended, and regardless of how ridiculous a belief may be or how negative the results of it are, people are like, "you have to respect other people's religion." I don't think any religion deserves respect.

We're completely devalued by it. I can remember being a child and being regarded by men and feeling stabbed by their gaze. It hurt so much to be devalued because I could sense they thought, "too small, she won't, she can't, not important, never mind." And I remember that feeling pervaded my childhood until I was a boiling pot that started to boil. And I decided to fight back. Anyway, this is new to me. I haven't always talked about this. My artwork has been based on these issues, but talking about it like this and trying to find the language to describe what I'm feeling rather than just doing the Wall of Vaginas or sewing my vagina shut has been a new experience for me. But I'm excited about educating myself.

'Kembra Pfahler on her Performance Art Class, Feminism, and Redesigning the Planet' was originally written by Tea Hacic for *Bullett*, 19 May 2014, http://bullettmedia.com/article/kembra-pfahler-on-her-performance-art-class-feminism-and-redesigning-the-planet/

Ali G With an MFA: Q+A With Hennessy Youngman

Brian Boucher

The latest phenomenon to sweep the Internet is the "Art Thoughtz" videos of a young Philadelphia man who goes by the name Hennessy Youngman. His moniker combines references to Henny Youngman, "the king of the one-liners" (originator of "take my wife – please!") and to Hennessy cognac, a status drink among hip-hoppers. The creator of "Art Thoughtz," who is black, styles himself in one of his videos as "the pimp of the one-liners." His sign-off at a brief stand-up performance viewable on YouTube: "Take my bitch – please."

Youngman (played by artist Jayson Musson) offers screamingly funny and sometimes sharply critical observations on the art world in the form of instructional videos. Topics range from the perils of copying Bruce Nauman ("You into torture? Shit, I'm into torture. Shit, you know what? Too bad. Bruce Nauman, he *owns* torture!"), to understanding relational aesthetics, to how to be a successful artist. Over the last year, 10 videos have been posted, all in the same genre, some purportedly responding to requests and comments from viewers.

The edgiest video is "How To Be a Successful Black Artist." Youngman's first suggestion: be angry. To get angry, he says, you might view Internet videos of pit bulls fighting, or of the Rodney King beating, or photos of Emmett Till in his coffin. Each example is illustrated; the Till photograph is not for the faint of heart. Trying to define the trendy concept "post-black," even the "row-house raconteur" is at a loss. "Did someone from the future come back with that term, and niggas is, like, pink in the future?" As a coup de grâce, this last question is illustrated with David Hammons's 1998 *How Ya Like Me Now?*, a painting of a white Jesse Jackson.

The works recall Alex Bag's 1995 video *Fall 95*, in which an art student gradually grows up over the course of her eight semesters at the School of Visual Arts, but Youngman assumes the voice of a supposed outsider to the art world. This aspect of the work recalls the 2009 art-world spoof *(Untitled)*, whose protagonist, an avant-garde composer, finds his way into a wacky

contemporary art scene populated by YBA knockoffs and a cynical, sexually voracious dealer. Musson's blackness allows for added polemics.

In a recent e-mail conversation, Youngman offered *AiA* some information about his background, sympathized with arts writers, and confirmed that artists are not real people.

BRIAN BOUCHER: What's your background? Did you go to art school? How did that work out?

HENNESSEY YOUNGMAN: You mean like, what I did in the past that gave me the experiences that would be considered relevant to my videos? I don't really know, I've been a limo driver, I've cleaned houses, I've been a guard at the Philadelphia Museum of Art, oof . . . Let me tell you, there is nothing more painful than slowly passing your day away by watching packs of tourists coming into to contact with the monolithic spire that is art history. Rapunzel, chilling at the top of it not even wanting to come down, but she's got the audacity to ask people at the bottom to throw food up for her to eat.

In the end, I guess I'm just a nigga that loves rap, and digs fine art. But did I go to art school? That's a silly question. Why would I do that when everything anybody could ever want to find out about any type of art is on the Internet? I'd rather pay Comcast $60/month than some school 20k – 30k a year. I will admit though that I got a few friends that have gone to art school, and from time to time I "borrow" some of their theory readings and they never seem to notice that they're missing. I guess those readings don't have much bearing at their restaurant jobs.

BOUCHER: Good point. So do you think of this as an art project? Or as art criticism? Or both? Or neither?

YOUNGMAN: If one believes that dialogue can be art then in a sense "ART THOUGHTZ" is my art. It's also criticism, but not a direct criticism of specifics works of art. It's more like when you're a kid and your parents are arguing with each other at the top of their lungs, then all of a sudden your aunt gets involved with the fight and she starts yelling too; there you are, just some kid surrounded by a bunch of yelling adults and you just want everyone to shut the fuck up, and you just can't take it anymore so you burst out in tears and suddenly all the adults stop yelling at each other and feel ashamed at what their behavior's done to a child. That's "ART THOUGHTZ," the tears of a child in room full of screaming adults.

BOUCHER: I see. In your video "How to be a Successful Black Artist," you counsel aspiring black artists to "be angry." How angry are you, on a scale of 1 to 10, where 1 equals slightly miffed at the ongoing disparities in income, life expectancy, incarceration rates and other vital statistics as a legacy of Jim Crow and slavery, and 10 equals, in your words, ready to "punch crackers in the face"?

YOUNGMAN: I'm not sure. Some days I'm at a solid 8, then some days when I see a fine-ass white woman I'm at a 1. I would never be at 10, would never assault random white people on the street because I got previous warrants and can't risk getting arrested again. In general though I'm normally pretty angry and feel overwhelmed by my disenfranchisement from the vast amount of capital that flows through the art market. And since I'm on the critical end of things in the art world I'll never have any chance of seeing that money. Like you as an arts writer, you gotta feel the same way, dedicating yourself to elevating the critical understanding of art, but getting paid crap and busting ass to make ends meet. Meanwhile Rachel Harrison can fart in a jar and make Scrooge McDuck scrilla. (That means money.) Do you have Arts Writer Rage?

BOUCHER: Not rage, though I do have a fair amount of envy.

In your "Post-structuralism" video, you mention that this is not a concept you'll hear "real people" use in conversation, though you might hear some artists use it. Interestingly, artist Tania Bruguera and critic/curator Lucy Lippard expressly maintain that artists are not real people. When it rains, do they not get wet? If you prick them, do they not bleed? Care to comment?

YOUNGMAN: I like Lucy Lippard. Her name always makes me think of Lucy Lawless, which makes me think of *Battlestar Galactica* and that I'd probably have sex with a robot if it had real enough skin. But this has nothing to do with your question. Artists are not real people. There's this Jerry Saltz lecture somewhere online where he's talking about the sublime and during the lecture he makes an analogy about how non-artists are like dogs in that they deal directly with the world: you ask a dog to come to you and it will. Whereas artists are like cats, y'know, you call for a cat and that cat is not fucking coming to you; they'll take a stroll around the fucking room, rub up on a bunch of shit, then rub your tiny ankle and be off. And the Saltzer, he said artists are like that in that they have an indirect way of dealing with the real world, through the making of art, artists create this system of occupying the world in this indirect, yet very distinct way.

BOUCHER: You've commented in your videos on many art world phenomena but we haven't yet heard Hennessy Youngman's observations on one serious thread, which is feminist art. Is there a video on feminist art in the works, or would you be willing to share some thoughts on that?

YOUNGMAN: Art is the terrain of heroic God-Men who struggle against the accepted values of their time in order to deliver their society unto the thresholds of a new world. Wielding brush, chisel, and Adobe Creative Suite, these God-Men do the work of shaping our society in order to relieve the rest of us from this arduous task, allowing us the free time to enjoy the vision created by their respective hours spent in their respective studios. This process is very daunting, something akin to what Mickey Mouse went through in *Fantasia*, but instead of magic brooms, these heroic God-Men must rely on imbecilic assistants who always manage to use the incorrect pigments or

improper drill-bit size to aid them in their Yahweh-ian quest. This is all very hard so I have no idea why women would want to partake of this task. Do they not trust these God-Men? Pesky women! He clearly said, "Pay no attention to that man behind the curtain!" yet they keep trying to pull the fucking thing back! Don't touch that button! Leave that lever alone! What is this . . . this Riot Girl music you have put on!"

I haven't really planned on making a video about Feminist Art but I might consider it.

'Ali G With an MFA: Q+A With Hennessy Youngman' was written by Brian Boucher and was originally published on *artinamericamagazine.com*, March 24, 2011. Courtesy of Art News S.A.

The Resurrection Game: How Dickie Beau Brought Marilyn and Judy Back To Life

Dickie Beau

Bringing the dead back to life is a tricky business – look at what happened to Jesus and Dr Frankenstein. With the aid of considerable acting talent and some original audio recordings, Dickie Beau gives the words of long-deceased icons a hauntingly powerful physical presence which, like the best cabaret, has to be seen to be believed. His inspirational story shows the lengths he went to, the trials he undertook and some of the people who helped him realise his dream.

About seven years ago, whilst communing with the cosmos on magic mushrooms, I was introduced to some notorious tapes of Judy Garland speaking into a dictaphone, ostensibly making notes for a memoir that was never written. These tapes are perfectly compelling because they are by turns wittily humorous, privately poignant and very, very angry. I was haunted for a long time after listening to them by the naked human need I'd heard in the tapes, and how they captured the denuded emotional entropy of a 'fallen idol' who was in exile, not only from society, but also from herself.

Some time later, whilst finding my feet on the performance art circuit, I returned to these tapes and, discovering them to be just as much of a "trip" the second time around, I edited them into a three-act theatrical vignette, framed by the music of Britney Spears and Sakamoto. I performed the culminating piece, in nightclub drag terms, as an "epic" lipsynch, for experimental performance forum *UnderConstruction*, at Bistrotheque. The aim was not so much to impersonate Judy Garland, as attempt to embody the rock bottom of a dying swan. I omitted explicit references to her identity in the material, and presented "Judy" as a cross between Dorothy Gale and a washed-up marionette, with a clown-face. I called the piece, in a nod to vaudeville, *An Episode of Blackout*.

Apparently, it worked, and a big part of what made it work was the spectral presence of Judy's voice – it turned out to be a piece of theatre in which the lipsynching aspect, conventionally framed as a "low-culture" activity, supposedly belonging in the back alleys of nightclub drag, actually elevated the piece and was essential to it.

This got me thinking, and I started to explore the idea of developing a series of neo-vaudevillian vignettes, or "blackout skits", using existing audio artefacts of the voices of our most troubled pop culture icons, to play out the dysfunctional dramas that seem to make them so compelling. Duckie commissioned me to be artist-in-residence and I created an additional two "Blackouts", one based on Marilyn Monroe, the other on a fusion of Amy Winehouse and Judy Garland.

As I scouted around for soundtrack ingredients I learnt of the existence of tapes containing Marilyn Monroe's last interview before she died, poignantly published in *Life* magazine only a day before her demise, in which she talks candidly of her troubled childhood and the trials of fame. Some of this material had been used in a documentary called *Marilyn on Marilyn*, which I discovered in my research. Through the producer of this film, Paul Kerr, I tracked down the journalist, Richard Meryman, who had conducted the original interview. He is now an elderly man living in New York.

I made a telephone call to Mr Meryman in the summer of 2008. Intrigued by my approach, he agreed to let me listen to the tapes, but was reluctant to give me a copy of the material outright, so he regretted that I would have to be in New York to hear them. I held a fundraiser at the Royal Vauxhall Tavern to raise money for a flight and several of my peers, including David Hoyle, Timberlina and Ryan Styles, showed support by generously performing for free. I was successful in covering the cost of a flight and went to New York in October 2008.

Across two afternoons, in Mr Meryman's West Village living room, I listened to the five-hour interview, originally conducted nearly 50 years ago across two afternoons in Marilyn's living room at the infamous address on Fifth Helena Drive in LA where she died. These tapes are not as viscerally dramatic as the Judy tapes, because Marilyn was giving an interview to a journalist and, having been fired from *Something's Got to Give* in the weeks before, was doing the interview as a PR exercise. But, nevertheless, there are authentic glimpses of her fragile humanity – mostly in the moments that might be considered too banal for broadcast in a conventional documentary (and after she'd supped a few glasses of champagne). It was a thrilling privilege to be one of very few people in the world who have heard this final interview in its entirety (in fact, Meryman told me later that I am the only person he's ever allowed to have full access to the tapes).

Although understandably protective of the tapes, Mr Meryman's curiosity was sufficienty aroused for him to confirm a willingness to let me use some of the material, upon agreement of a fee. At the time I didn't have the means to make a transaction, however modest, so I thanked him for his time and told him I'd be in touch. I went off, continued developing my ideas, and during a three-month sabbatical as a nanny in the Australian outback in 2010 I wrote an Arts Council proposal for a grant to "write" a digital audio "script" – using not only the words, but also the voices, of both Judy and Marilyn to construct the narrative of a soundscape by which I might then re-member them (literally, put them back together) in performance.

The Arts Council awarded me a Grant for the Arts in the summer of 2010 and I returned to New York in October 2010.

When I had first conceived this show, to be written in found sound, I imagined it was simply a show about Marilyn Monroe and Judy Garland, whose voices

are its major stars. As it transpired, when I met Richard Meryman for a second time in autumn 2010, and recorded a further interview with him about his experience of meeting in Monroe, I found another perspective. It became apparent that he was helping me – and giving me exclusive access to his interview tapes – because he was reminded of his younger self in me; meanwhile, I became haunted after meeting him by the image of something like the future face of me.

Meryman thus became a third voice – the principal voice, in a way – of *Blackout*. By recasting his voice and his memories of meeting Marilyn 50 years ago I have created a kind of queer *Krapp's Last Tape* where, rather than listening back to a younger self, I listen forward to a future self, about 50 years from now, remembering my encounters (in my head) with Marilyn and Judy in the present. It is a show that's like a dream, which is not all a dream, starring all the characters on my journey, each becoming one another's afterlives...

'The Resurrection Game: How Dickie Beau brought Marilyn and Judy back to life' was originally written by Dickie Beau for *This is Cabaret*, 16 July 2013, http://www.thisiscabaret.com/the-resurrection-game-how-dickie-beau-brought-marilyn-and-judy-back-to-life/

Reviews

Criticism

Andy Field

1

I'm somewhat reluctant to contribute to the neverending story of the wellbeing of performance criticism, as talking about talking about live performance seems a peculiarly niche thing to do at any time, least of all when we're about to start bombing the same country for the third time in my lifetime. But a few days ago a good friend of mine said that criticism is all terrible these days, and then some other people disagreed and then someone else wrote very articulately about how they were both right, with reference to the structural problems with the conventional reviewing formula, particularly in the broadsheet media. All of which got me thinking a bit about the responsibility artists might have for the quality of the critical landscape they make their work in.

Yes, we can blame particular reviewers for their lack of quality or perhaps their lack of empathy. And we can blame newspapers for ransoming off the space to think about art and culture in their last deckchair-rearranging attempts at keeping their sinking business models afloat. And we can blame capitalism for the insidious power it has to denature the way we think about and interact with beautiful things. But should we as artists bear some responsibility for acquiescing too easily to these forces? Is a helplessness that leads too often to petulance really the best we can contribute to the attempts by some brilliant writers to transform the critical culture in this country? Are we sometimes at fault for slagging off the worst conventions of theatre criticism with one hand, whilst continuing to participate in the reproduction of those exact same conventions when it suits us? I am asking myself these questions as much as I am asking anyone who has bothered to read this far down the page.

For example, perhaps one simple thing we could all do, is to stop printing uncontextualised star-ratings on the front of flyers and posters. Star ratings are the very worst – nuance's kryptonite – tiny nuggets of sadness harvested in the darkest heart of consumer capitalism and sent to cling grimly to the surface of art like old shopping bags floating down a river. Yet there they are, whole constellations of them scattered across the front of every piece of publicity – each one a quiet concession to a version of our work, and a relationship to an audience, that I think most people I know would barely recognise. But equally I know the reason they're there is because we want people to come and see our stuff, we perhaps even need them to come, and its hard enough to get people to give up an evening and money they barely have to come and see some art they know little about without sacrificing one of the best means you have of gaining their curiosity. In doing so however we're helping to perpetuate a thinness to the way in which people can engage

with our work, and the means they have of navigating their way through it. To an extent, the very stars that we use to attract people are actually perhaps limiting the number of people who will engage with our work and the ways that they have of engaging with it. It's a vicious circle, but the point is, we are part of that circle, not simply it's victims.

The other immediate thing that artists could do to help change the critical culture in this country is to actually actively contribute to that critical culture, by which I mean artists could and should be writing more about each other's work. There is no more imaginative, more positive and more practical contribution that artists could be making to changing the way we think about criticism. Some of the most exciting, thoughtful responses to work I've seen in the last few years have been by artists. People redefining the nature of the relationship between event and response or artist and critic, such as in Harun Morrison's articulate and unselfconscious responses to the work in his own festival, or artists finding compelling new vocabularies for writing about performance, such as James Stenhouse's pseudonymous review of Laura Dannequin's *Hardy Animal*. I want to challenge artists to find their own way of writing about live performance, ways that challenge who we think has a right to speak and how and when. We could learn a lot from brilliant writers like Megan Vaughan about how unlike a review a review can look. We should see their work as a thrilling challenge to find our own different, more appropriate ways of saying what we want to say, and the less it looks like a review perhaps the better, the more so to contribute to a burgeoning, widening, polyphony of critical voices that are helping redefine the ways we have to think about the work we see and the work we make.

There are plenty of reasons to feel frustrated with criticism in this country, and certainly we should celebrate the great voices like Lyn Gardner who do so much within a difficult system, as well as championing writers like Megan and Maddy Costa and Catherine Love who are contributing so much to finding alternatives to that system. But I want to believe that artists themselves can play a larger part in that re-organising process, both by making our own imaginative critical contributions and being more diligent at refusing to participate in the shittiest parts of the current orthodoxy.

'Criticism' was originally written and published by Andy Field at *Ephemerous*, 26 September 2014, https://andytfield.wordpress.com/2014/09/26/criticism/

Tempting Failure 2013

Natalie Raven

Tempting Failure 2013 promised 'an immersive experience of live art & noise'. It certainly delivered. Curated and produced by Thomas John Bacon, the festival is now in its second year.

The setting? The Island, a disused police station situated at the heart of inner city Bristol. The site itself stank of a rich history of authority and social control, rules and regulation. I found this provided the perfect backdrop against which to transgress a multitude of borders and boundaries. Narrow, dank and dirty cells housed intimate and durational performance works, whilst larger areas such as the Main, Holding and Isolation spaces offered room for set-time pieces to be witnessed. Every functioning area was transformed into a usable space, with live, video, noise, participatory and installation works showing simultaneously. Programming concurrent works did leave me a little disappointed that I couldn't see everything, but on the upside I was continually drawn to investigate everything and anything, not wanting to miss out on viewing something beautiful or grotesque, shocking or sublime.

Traumata's *Achillia* was a set-time piece, performed in the Isolation Block, an empty, whitewashed room with flaky floors and peeling paint. A circle of spilt milk gently trickled across the dirty floor. It glistened poetically in artificial light. The female performer entered, half clothed in a long white gown which trailed the floor. Scar tissue on the performer's exposed upper torso bore the marks of performances past; a body in trauma which lived to tell the tale. Milk began to bleed upwards into the fabric as faint drops of crimson blood spotted the robe, hinting at an underlying injury. Slowly, and with conviction, she bound her wrists. The skirt was gradually lifted to expose needles which pierced her skin above each knee. After mental preparation, the performer walked to her left. She squatted, back straight against the wall in a seated position, arms above the head. The position was held for an extended period, during which the physical manifestations of a body struggling against exhaustion begun to take form. Skin reddened, thighs shook, face contorted; signals of a body in pain, desperate to resist its own weakness. I was transfixed. I felt an almost sadistic pleasure in watching her muscles begin to weaken and shake, violently. Internally, I screamed over and over for her to continue: 'don't give up!' I longed for her to win the battle against herself. Inevitably, she slumped to the floor having lost. Standing up, she walked to the centre of the space, stood within the milk once more and removed a needle. Blood tickled down the leg and swirled itself into the white liquid at her feet; a moment of visual pleasure, abject horror and corporeal transgression. For me, Traumata's performance was about the feminine struggle against a history of patriarchal tradition and virtue. I saw the performer as an ideological feminine figure, both maternal and virtuous. Draping herself in white linen and surrounding

herself with milk, she was both Mother and Virgin. What I enjoyed the most about this performance was the complete deconstruction of these socially fashioned feminine roles. She displayed an 'other' femininity, both carnal and strong.

Similarly, Rachel Parry's *Blind Breath* was a visual spectacle of private suffering and feminine strength. *Blind Breath* charted Parry's torment at the loss of an unborn child. Carving a heart-shaped insignia into her chest, Parry used her own blood in a desperate attempt to give life to an ice head sculpture, cast from her own face. The emotional exhaustion she experienced in the piece led her to wailing uncontrollably as she exhaled with each breath. Hearing her voice break stirred a highly emotive response from members of the audience, which left many with empathetic tears trickling down reddened cheeks. The inevitability of the ice head melting away during the live performance poignantly highlighted the sense of loss the performance was portraying.

Angela Edwards' *Surrenders Destruction – Acéphale, Part 1 2013* also took place in Cell Two, an old police holding cell which had in the past been used to house the arrested. As I entered the space, I smiled as I wondered what the authorities would make of this scenario: a naked female body, wrists bound, blindfolded, lying on a dirty steel bed; an objectified body to be used and abused. To the left were a series of implements Edwards invited the audience to use upon her: knives, sex toys and condoms. As I entered, two people were knelt before her, slowly tickling her skin with butcher's knives. The suspense at this point was quite high; a little slip of the hand would bring blood oozing to the surface, seeping out of the audience inflicted wound. It was at this point that an audience member entered and declared 'I'm performing an intervention', took off her coat and covered Edwards' naked body. The performance changed at this point, and it was never able to bring back that sense of tension, fear or immediate danger. Audience members entering the space now chose to nurture the performer, clothe her, stroke her hair and talk softly into her ear. To the performer, who obviously hoped to invite the audience to participate in a series of sadistic actions upon her body with the implements she provided, it might have seemed that the performance failed. The lack of control being exerted by the performer paradoxically led to the audience feeling the need to take control of the environment, make it a safe space again. This warmed me actually, and I felt a genuine sense of compassion being exerted by the audience.

Yiota Demetriou's *Love Letters* also took place in a cell. Demetriou invited audience members to write a note to a loved one, both on paper and on her own body. Examples of different types of love were printed off and hastily sellotaped onto the walls. It looked scruffy and I didn't feel compelled to read what it said. The real saving grace of this performance was in the final action. Demetriou invited her audience to blow red or blue powder paint over her face and body. Scooping a good handful, I took a deep breath and steadily blew it upon her. It was such a satisfying gesture, as the fine consistency of the powder meant that it clouded up and lingered in the air, engulfing the

performer in the space, vibrant colour whirling about her body. It was a truly magical moment. I was transported into an enchanted space, spreading fairy dust, making a wish, painting the landscape. The performer smiled at me as I stood back and watched the colourful dust settle upon her skin. I loved her! I stood back and watched others perform the same action. It was such a visual delight. Transfixed, I watched it many, many times over. Leaving the space, my hands were still stained from holding the powdered paint. I felt a sense of connectedness with other audience members who were drifting through The Island with sullied hands. They too had shared in the magic.

NW's *Cup* was a noise piece which delivered a delicious mix of screeching sounds and boundless, childlike energy. NW, a male performer, knelt before a mixing desk. Silently, and with a beaming smile upon his face, he dedicated the time to 'cheers' every single member of the audience with his plastic cup which came complete with attached contact mic. As he poured water into the cup, sounds of the glugging liquid were projected around the space via his connected speakers – a simple action transformed into an audio event. As the performer drank from a water bottle, he held the cup to his chest; the sounds of the liquid moving downwards along his internal digestive tract was heard around the space, the internal now becoming external. Because he was topless, and I was sitting behind him and viewing his back, I was able to witness the inner workings of his body; lungs, diaphragm, muscles, expanding and contracting as he thrashed about on his knees. As the energy built, NW began to breathlessly moan into the cup. The audio was edited, extended and exaggerated within the space, delivering a deeply melancholic sound which eerily lingered in my mind. As the sound grew to an almost unbearable level, the performer stood up and began to rock back and forth, forcing breath into the cup, skin sweating, eyes bulging, energy expelling from his every pore. As he fell to the floor, screams of exhaustion could be heard faintly in the background of this audio symphony. For me, the joy of this performance came from its apparent simplicity; one man and his cup. The use of silence and stillness at the start of the performance was contrasted well by the extreme energy and high intensity of the enveloping soundscape. I was extremely pleased to see the performer firmly position his own body at the heart of his performance, as all too often noise artists hide behind their various technologies. Here, technology and the body came together in order to produce a well-crafted performative piece with a strong dramatic curve.

Hannah Millest's *Run to Run* was a participatory, durational piece that engaged audiences throughout the evening, set up at the back of the Main Space. Millest's interactive project required participants to stand upon a square table and run. Sensors picked up on the pace of the runner, which in turn moved an animated figure on screen through various life journeys. If the pace of the runner slowed down too much, the figure suffered from a premature death. Starting with birth, the figure goes through adolescence, loves and losses, university, buying a house, marriage, having a child, middle age and eventually... I never got that far to find out! Wanting to see the eventual outcome of my stick figure's life, and the sheer frustration of not being able to

keep up the pace of running for that length of time made me come back and try again and again. This piece was addictive. Each time I tried that little bit harder, and each time I seemed to fail right at the last hurdle. If ever a piece encapsulated the term 'tempting failure', it was this.

There were many 'failures' I witnessed during Tempting Failure. Traumata failed to win the battle against her own body whilst repeatedly squatting against the wall, and Parry inevitably failed to give life to her ice head sculpture which slowly melted away to nothing, without trace. Both of these performances, along with Millest's *Run to Run*, embedded failure within the performance. They invited it. Tempted it. In a wider sense, I think Temping Failure provoked me to consider live art as a medium which embraces failure by its very nature. The artists body, which sits firmly in the frame of most live art practice, is a problematic vessel. The body is weak, frail and tires easily. It decays, withers and eventually dies. I find the performance work which tries to challenge the body and its frailties engages me the most. Work which fights failure, or at the very least attempts to.

Tempting Failure gave me access to a vast array of live art, noise and performance work over its marathon nine-hour showcase; works which captivated and challenged, shocked and saddened, traumatised and transfixed me. The Island's rich architectural history brought a contextual background to the table which affected my understanding and interpretation of all the works I'd witnessed, realising a whole other level of contemplation and complexity. Traumata's battle against feminine conformity, and Edwards' invitation to abhorrently abuse her naked form, seemed all the more poignant in this space. I'm not sure if I would have felt the same level of visceral subversion, had I seen these pieces in a pleasantly lit theatre space for example. And I think this is key. The success of the event was in part down to the genius of programming work within the building itself. The Island posed a space in which to continually disgruntle 'The Establishment', and I look forward to more deviation from Tempting Failure in 2014!

'Tempting Failure 2013' was originally written by Natalie Raven for *Total Theatre*, http://totaltheatre.org.uk/tempting-failure-2013/

Dana Michel: *Yellow Towel*

Selina Thompson

Where to even start with this work?

Maybe I could start by telling you what happened? I could tell you that over a space of time that sometimes absolutely creaked by and at other times felt almost breathless in its pace, I watched Dana Michel create – a series? Or was it one, constantly growing, mutating, shrugging off before reforming, refitting, reshaping, learning, evolving, at times crushed under the weight of it all, half-formed – something... a creature? An animal? Characters or personas? Some kind of magical, or – a – I don't know, some kind of –

No, that won't work.

Maybe I could start by telling you all the things it made me think of? Trying when I was little to force my mouth to learn how to kiss my teeth (the ultimate rite of passage, I felt, for a young black woman), David Lynch's *Dumbland*, about somebody asking the question, "when do children first learn that they are black?", the ongoing (and shameful) internal sigh at the sight of silky, silky –

NOPE.

Maybe I could start by telling you about how the audience at times, plain couldn't deal? How even when she wandered out into the seats a little, she still didn't feel like part of us? How there was one moment when I felt the whole audience move forward? That over the next few days, when I asked people how they felt about it, they would splutter incoherently? That they didn't know if it was OK to laugh (and that I really took pleasure in that tension)? About myself and the guy sat next to me not wanting to leave the space? How we didn't know when to clap? How some people will just not 'get' this work?

Maybe I could start by telling you just how virtuosic it was? Or that the single most breath-taking moment was when she came out to bow? How, stood, back straight, exhausted, but calmly-full-of-power, she looked us dead in the eye. And I realised that I'd hardly seen her face the whole time, that she'd hardly stood up the whole time. Just how much tension was being held in her body, the extent to which she had literally made it look like those personas couldn't fit inside her body?

But that was at the end.

Maybe I could start by telling you how her use of food literally made my heart sing? A bloated stomach that was never full: slices of banana placed into the mouth and spat out; her hands trapped in sticky white all American,

sugar-sweet Fluff as she cried out for 'Shaniqua'; milk, dribbling across her black tracksuit onto the stark white of the stage; the sound of biscuits being crunched, a constant feed with no nourishment –

NAH. I wouldn't have the time or space to then touch on how the simplest colours became malevolent, how ripples in a white curtain felt like the very fabric of an identity that was liquid, fragile, constantly shifting, opaque, like the performance itself was being shaken. I wouldn't have time to communicate to you the eerie sense that there was something outside of that white space putting something into it or absorbing something from it – a being that we couldn't see, beyond the stark white of the floor and walls – that I'm still not sure how she did that.

Maybe I could start by telling you how frustrated I find myself about the use of the word 'uncompromising' at this point in time? We've got to stop using it, but I can't find a word that communicates the extent to which Michel is just not here to make it easy for you. You are in her dreamscape, a landscape where maybe – just maybe – you can understand some of the signifiers, but if you can't get them all? If you have to work? If you're wrestling with it forever? Tough. Good. You can take it or leave it, because you're seeing the landscape of someone's inner psyche – them learning how to negotiate the world, learning how the world negotiates them and where they fit, and how they fit, where they will situate themselves. It's not terrain laid out for your judgement. Michel rarely makes eye contact, rarely makes it easy for you to see her entire face. But the refusal to do this, her constant evading of that easy way in, is almost as confrontational as if she looked you in the eye the whole way through. Before us, but not for us, on the edge of words.

But if we need a better word for uncompromising, we also need a better word for compelling – another word that just doesn't feel like it does this performance justice.

Maybe I could start with the yellow legged creature that Michel has left inside my head, which I am wrestling with but also rejoicing in the recognition of its familiarity? The moments when I knew exactly what she was getting at with my heart, and with my guts – even if I didn't know with my brain?

I need you to understand... I love it. But communicating it to somebody else, who maybe didn't see it?

Where do I even start with this work?

'Dana Michel: *Yellow Towel*' was originally written by Selina Thompson for www.thisistomorrow.info, 18 October 2014, http://thisistomorrow.info/articles/fierce-festival-dana-michel-yellow-towel

Is He For Real? The Blurry Boundaries of Contemporary Performance

Amy Sherlock

AN ODD THING just happened to me. I am writing this essay at a desk in a public library, the British library, no less, the largest public building built in the UK in the 20th century. I'm sitting, in silence, in a busy reading room, surrounded by literally hundreds of people. Most of us are tap-tap-tapping away at their computers, each in our own world, near enough to hear one another's breathing and yet entirely isolated in our silence, the contractual silence that is the condition of our being here. Not that this is anything out of the ordinary. The "funny thing" happened outside in the café, where, having eaten alone and also in silence, an unknown man at a facing table called me over as I was leaving and asked, in flagrant contravention of unspoken library protocol, what I was working on. He invited me to sit, which I did, and we proceeded to chat with the superficial, stilted brevity of such awkward encounters, until sufficient time had elapsed that I felt able to take my leave without appearing rude. Now installed at the silent haven of my desk, I'm trying to work out what to make of this unexpected, unsolicited encounter. I was uncomfortable, and wary about why this stranger called me over and the demands he might make of me. I was also slightly irritated, unfairly disinterested, from the outset, not wishing to confide or to be confided in, eager to return to myself and my own thoughts. I also had the niggling suspicion that this was some kind of set-up, a trick to make a fool of me or to get something out of me. I was waiting for the punch line to this protracted, unfunny joke; for him to ask for my money, or my number; for his friends to appear and make a scene. Perhaps cynically my first thought was "is he for real?"

And, all those feelings – they could be ascribed to contemporary performance art. There's been a huge surge in performance's popularity the past few years. This summer Tate Modern opened their Tanks as a dedicated space for performance and video installations, while in the museum's Turbine Hall Tino Seghal staged *These Associations*, the first live art piece to be performed in the towering, empty space. In 2010, his *This Progress*, spiralled up the central rotunda of the Guggenheim Museum, and there were 77 days of Marina Abramović's mute, immobile presence in MoMA's atrium (*The Artist Is Present*).

Here on this side of the pond, the Hayward Gallery in London staged *Move: Choreographing You*, while this year a whole floor of the Whitney Biennial was given over to performance, and in LA, there's even a new gallery set up by hip young artists dedicated to, guess, yes, performance.

The Abramović phenomenon in particular has come to exemplify the complicated alliance between performance, the museum, and institutional and commercial gallery spaces. For all its professed immediacy and the emphasis on the ephemeral "present," MoMA did a good job of packaging up "the moment" and circulating it. There are photographs, official catalogue and the feature-length film. And, then there were the follow up shows later that year across both of Lisson Gallery's London spaces exhibiting documentation from earlier Abramović performances. All of which seems to scream, precisely, that the artist *is not* present. However you choose to evaluate the work and despite any reservations you may have about the mythical status of the artist or the art institution as a sanctified space, what's undeniable is *The Artist Is Present* celebrated the face-to-face one-on-one encounter. And, that exchange is at the heart of the performance revival.

The week the Tanks opened, the Tate's chairman Nicholas Serota talked in the *Independent* about how the space responded to people's desire "to have an experience of the art of 'with'... to be with something." He went on to explain: "That kind of new form of interconnectivity is what performance is providing. We are a little bit fed up with people and organizations doing things at us. Maybe that's why we are looking for something." The emphasis is all on the *"with"*. The idea is performance goes a step beyond merely asking us to be engaged spectators, instead it offers the possibility of response, of interaction – of connection. It's me facing you and something passing between us, something experienced directly and even sometimes violently. Something real. But why are we looking for these things now? And why do we think that performance can deliver them?

It would be easy to point the finger at the rise of the internet and Facebook and the like. Also in our globalized era you can blame multinational capitalism, with its emphasis on individualism, and the abstract ease with which capital flows over borders while production and consumption become increasingly isolated. Thanks to communications and transportation the world and its markets are always "on." We're up-rooted and hyper-connected. The implicit corollary? Community is virtual, real neighbors disappearing. This fear underpins British Prime Minister David Cameron's "big society" rhetoric. His suspicion is shared by big and little 'c' conservatives, and many others too – possibly even the world of performance art. And, now when we spend so much time looking at monitors, the idea of looking into someone's eyes, is rare – even maybe fetishized. In fact, so many people cried while sitting opposite Marina Abramović during *The Artist Is Present* that a whole tumblr was dedicated to them. (It's interesting, though, that to provoke such a charge, Abramović had to become less like a human and more like a piece of art: silent, passive, immobile, registering no emotion at all.) The potential *"with"* that

performance can offer, and indeed sometimes promises is for "real" contact with other people.

But this is tricky territory. Firstly, the very idea that performance is "authentic" or "real" seems perverse or, at least, somewhat counter-intuitive. "Performance art" is called that to distinguish it from "life" and to mark it out as a stylized, hyper-codified way of acting and interacting. Even though, "real life" itself can be reduced to a series of daily rituals and performances, most people are keen to distinguish (perhaps erroneously) the roles they play from the people that they are. The promise of the unique and personal "connection" or "exchange" offered by performance is therefore conflicted or contradictory, since it relies on a repeatable and rehearsed formula. This was my issue with *These Associations*, Seghal's piece at the Tate (described so well recently in *The Weeklings* by Miranda Pope). Rather than experiencing the enriching, emotional exchanges I'd read about in countless reviews, both times I went, I felt isolated. I was alienated from both the private logic of the group and everyone watching from above or the side. All the time a little voice in the back of my mind was asking the performers ("interpreters," in Seghal-speak), "How many times have you told this story?" and "Does it matter what I say in response?" The exchange's brevity and anonymity was inhibiting (and intimidating) rather than liberating. I'm sure I would have felt the same sitting opposite Abramović, with those big, dark eyes boring into me, surrounded by curious onlookers and impatient queuers. In fact, I can imagine few things more disengaging than being herded along at a security guard's instruction in an interminable, shuffling line ready to take my place, framed in a perfectly symmetrical composition in the middle of MoMA's glaringly bright atrium. This is always the contradiction with any participatory performance, particularly those like *These Associations* or *The Artist Is Present*. I can only be a part of the audience by becoming an actor. So, if there are just the two of us, who is spectator and who is spectacle? Who is performing what for whom?

Maybe my experience of *These Associations* wasn't representative. Maybe I'm being unfair and happened to catch those particular performers on off days. Or, more likely, my lack of engagement was the result of my own social ineptitude. But banal exchanges and stiffness aren't bad. I don't mean this as a criticism of the work. In fact, that's what made it most interesting. By highlighting the day-to-day awkwardness of human interactions, *These Associations* expresses the awkwardness human interactions. An exchange with a "real" person, in whatever situation, can be a redemptive or enlightening – but just like my coffee-shop exchange, it's equally likely to be uncomfortable, humdrum and frustrating.

If performances like *These Associations* or *The Artist Is Present* can be called intimate, it is because they're also seductions. The promise of a union always held at a distance. The very title of *These Associations* implies something that isn't fixed but a slippery hop, skip and jump across things and between them, coming together and moving apart, flighty and never fixed. One's associate. Not friend; not lover. It has the slightly cold, slightly negative edge that

manages to convey very precisely the ambivalence I experienced during the piece. Which, *in reality*, is probably exactly to be expected. Because that's how relationships are and that's how communities are. Complex and conflicting; hesitant and unpredictable, and this is true as much for the embodied and the local as for the far-flung and virtual.

Fetishizing, as Serota seems to do, the "*with*" of performance as the restoration of a broken social bond also seems to diminish performance's potential to be willfully oppositional or "against." Since the early 1960s, when they began to be known as such, performance artists have used direct engagement with their audience to be confrontational, flying in the face of the art world and its institutions, but also of social conventions and expected ways of interacting. Take the Viennese Actionists pissing in the street (Otto Muhl, *Piss Action*, 1968) and VALIE EXPORT's *Tap and Touch Cinema*, where members of the public were invited to touch the artists naked torso through the curtain of a 'theatre' box covering her upper body, through to Chris Burden asking a friend to shoot him in the arm from a range of fifteen feet (*Shoot*, 1971); Vito Acconci masturbating under a wooden ramp as visitors walked above (*Seedbed*, 1972); Gina Pane carving makeup into her face and bleeding as she watches herself in the mirror (*Psyche*, 1974); or Abramović herself, standing naked in the small front room of a gallery in former Yugoslavia, next to a table of objects offered to the audience to use on her as they pleased (*Rhythm 0*, 1974). The history of live art is littered with famously transgressive, intrusive and violent works. These performances also made the spectator complicit in them, taking the form of accusations, rather than dialogue. What does it say about you to watch a man be shot, even if it is at his own instruction, and not stop it? Does it imply a perverse pleasure in the pain of others? A cold, clinical disinterestedness? An abuse of responsibility? What is an appropriate response to total passivity? What's being offered? Who has the power?

It's no coincidence that most of these famous pieces took place in the 60s and 70s, a time of intense social upheaval: the civil rights movement, gay rights, feminism, Vietnam protests, student protests across Europe.... All of them questioned the established the social order, and all of them staged massive public performances on a grand scale (and, what is a demonstration, if not a performance?). Voila: oppositional collectivity.

So, why now, at another moment of political and social unrest? Why are so many big institutions, opening their doors to performance, and why are they all so nostalgic? Not only are they reviving old performances, but also in this appeal to a redemptive "*with*," they seem to be trying to restore a notion of community that's seen to be under threat at the moment.

Take the most recent example: Martha Rosler's "performance," her *Meta-Monumental Garage Sale* at MoMA. (In the same atrium that hosted Marina Abramović two years ago). A literal garage sale, it's the last in a series that she's hosted in galleries since 1973. From her early video works such as *Semiotics of the Kitchen* (1974-75) through to her photomontages in which images

from the war in Iraq collide with domestic interiors (*Bringing the War Home: House Beautiful*, 2004, itself a reprieve of an early series from 1976-72 about the Vietnam War), Rosler's work has sought to politicize the domestic, or domesticate the political. Holding a tag sale in a space more accustomed to displaying works whose value is so abstract and far removed from day-to-day financial transactions as to be almost meaningless makes a timely statement about the fickle nature of value. It's all made more poignant by recent events in New York. But there's something undeniably kitsch about this piece in an era of eBay and Amazon marketplace. What's most interesting about the haggling and bartering here is the idea that an item's price has a narrative dimension, which allows its personal and affective value to be taken into account. But price, ultimately comes down to the same thing – the mechanics of desire, which determine how much someone is willing to pay.

I also bristled at MoMA curator Sabine Breitwieser's description of the show in the *New York Times* as "a collective action." Post-Sandy, there are probably numerous other projects in communities across the city far more worthy of the term. *Meta-Monumental Garage Sale*, for all its digs at abstract economics, involves a basic financial transaction: a $25 ticket fee for the chance to meet a famous artist. It's funny how, after two decades of attempts by participatory and socially engaged practices to knock down the ivory tower, this strand of performance is almost idolatrous, with the authentic exchange promised by the performative "*with*" relying on the Artist, either directly (Abramović) or indirectly (Seghal), for validation.

A review in the *New Statesman* uses the word "hagiographical" to describe the film of *The Artist is Present* released earlier this year, a sentiment I've heard echoed elsewhere. I haven't seen the film myself. I'm not sure what it could add to my (non) experience of the piece other than adding to this process by which Abramovic is gradually crystallizing into legend, which sits uneasily with my understanding of what her practice has always been about. But, I do know the movie has been wildy popular, both here in the UK and in the States, where it was first shown on HBO and is now on Netflix. Which is interesting, when you think about it, since on-demand television implies a kind of interconnectivity that's about as far as you can get from the kind in her original performance. Yet, there's a sense in which the film itself constitutes a kind of shared performance, even when viewed from the comfort of one's own armchair. It performs in a different way, but it still offers the potential for emotional engagement, and it also becomes a shared reference point for conversation and communication.

Safely back in my quiet library seat, I'm surrounded by a pile of catalogues and performance documentation – and I'm wondering if I was too abrupt with the guy in the coffee shop. Did I leave too quickly? Should I have let my guard down a little and taken as a gift this unasked-for moment with someone who seemed genuinely interested in me and my work. Exchanges like this don't happen all that often. But, here's what it comes down to: as much as we may sometimes yearn for "real" connections with "real" people, just as often we are

happy to experience this "withness" from the comfortable distance of our own space. Not everybody who was moved by the Abramović movie would have been into the performance and vice-versa. What our hyper-connected age gives us is the possibility of interacting on a number of planes, none of which need necessarily be prioritized. Then there's not interacting at all because sometimes, as Marina herself would doubtless confirm, you need the time and the space to be left alone with your thoughts. And, I'm sure that is as true now as it ever has been.

'Is He For Real? The Blurry Boundaries of Contemporary Performance' was originally written by Amy Sherlocks in *The Weeklings*, 17 February 2013, http://www.theweeklings. com/asherlock/2013/02/17/is-he-for-real-the-blurry-boundaries-of-contemporary-performance/

Project O Goes Large: *SWAGGA* and *Benz Punany*

Charlotte Richardson Andrews went down to Rich Mix in London to experience dance like never before

Charlotte Richardson Andrews

Most of what I know about dance comes from watching pop videos. I do this in a professional capacity, when I have my music journalist hat on, but dance as a stand-alone art form, a practice, is not something I have any specific, professional language for. So when Project O creator's Alexandrina Hemsley and Jamila Johnson-Small launch their *Benz Punany* act with a recreation of an iconic 80s pop video, I feel a frisson of delight, and connection. Wearing matching boiler suits and long, plastic wigs, their bodies are half turned towards the audience, facing a laptop that's showing them the same thing the audience is viewing on the large screen stage right: Janet Jackson's 1987 video for 'The Pleasure Principle'. As the music fills the room, they mimic Jackson's moves, imperfectly, never completely in sync with each other nor totally faithful to the video's stylized choreography, but bobbing and popping bedroom-dancing style, like young girls inexpertly copying their favourtie pop star's moves. It feels punk to me, this inexactness: more about do-it-yrself than perfection. I find myself shimmying my hips and shoulders to the beat; next to me, my girlfriend is nodding her head.

Imperfectness and DIYness are also part of the opening act, *SWAGGA*, described as "a new dance of dissent and gentle, raging empowerment starring Kay [Hyatt] and [Dr] Charlotte [Cooper] — all round extraordinaires and girlfriends of seventeen years." Cooper has blogged about her experience of "becoming a dancer who is also fat, old and becoming disabled" and that sense of risk, excitement and purpose fills the room when her and Hyatt perform. There are obvious differences between the dancers: Cooper and Hyatt are white, older, fat, queer, amateur; Hemsley and Johnson-Small — who have choreographed and directed *SWAGGA* with Hyatt and Cooper — are younger, women of colour, professionals in this craft. And yet *Benz Punany* and *SWAGGA* overlap in many ways. There is skill, strength and realness in both acts – othered women showing off, getting busy, working their bodies in un/expected ways; faces, limbs, hips and torsos twisting, flexing, grinding, sliding, jacking and bouncing.

SWAGGA is a radical, electrifying thing: teeth are gnashed, grins are bared and fists are raised. Cooper wields a bullwhip, lashing the floor from the back of the stage where she turns The Fugee's 'Ready Or Not' into a menacing seduction song while Hyatt gets up close with the audience, cruising the front rows. Later, the pair circle each other to a track by The Knife, entwined, always touching, winding two separate, evolving dances into an duet of bodies and expressions: sexy, scary, monstrous and, in places, joyously crude. A pre-recorded backing track plays a spoken word piece, Cooper's voice calmly listing all the people

in her extended family who are "appalled" by her. The pair perform a wild, pumped up hip hop-style dance set to Coolio's 'Gangster's Paradise'. What a sight! For their last act, a series of declarations are shouted at the audience against a growling, noisy backing track, as Hyatt leaps across the stage with a microphone stand in hand, cock rock style: "I LIKE PUPPIES! I HATE GENTRIFICATION! I HATE PEOPLE THINKING I'M THE NICE ONE!"

After a short interlude, *Benz Punany* begins. Throughout the performance, random audience members are intermittently invited down onto the stage to read pre-written texts - designed to give the act added context — while the dancers do their thing. They are agile, fast, strong — a fierce pleasure to watch. Everything they do feels daring, subversive and defiant – particularly when they turn their backs on the audience for a lazy, low-impact twerk to Konshens & J Capri's 'Pull Up To Mi Bumper'. Their soundtrack brims with the colourful voices of unfuckwithable women: Sade, Ciara, M.I.A. They dart into the audience throughout the performance [to invite people to read], crossing this invisible dividing line until it no longer exists. I think about safety and permission and how their dance fucks with these things. Later, more audience members are invited onto the stage to daub black polish onto the dancers' poised, statue-still, semi-nude bodies – an act so loaded I feel my whole body tense up. Like *SWAGGA*, *Benz Punany* is a series of small acts, and in between each one, while they gather props or strip off yet more layers of clothing, the duo pant and sweat and stretch freely, the exertion and fatigue as blatant and central to the dance as their stamina. At the end, the duo abandon the stage entirely to sit with us in the audience, and share extracts from their respective diaries — intimate realtalk about identify, race, burn-out, suicide and healing. It's an unexpected end song, this sudden switch from physical movement and muteness to stillness and voice.

When the lights come up, I'm not entirely sure what I have witnessed, but I know that I am blown away by the power of these performers, the potency of these othered bodies, faces and voices in action. I am exhilarated, buzzing and greedy for more. I wonder at how I have interpreted these dances, and what my readings might reveal about my own queer, white, working-class, [mostly] able-bodied gaze. My girlfriend and I bubble into conversation about what we have just witnessed and how it made us feel: tense, turned on, righteous, guilty, challenged, joyous, inspired. Later, I read that Hemsley and Johnson-Small define *Benz Punany* as "a performance lecture" – a description that feels entirely appropriate, while Project O itself is "a refusal, a necessity, a revealing, a call to arms, a fetish, a contemplation, a delight, a conversation, a throw, an acceptance, an outrage, a dance."

I've never seen anything like this in a pop video.

'Project O Goes Large: *SWAGGA* and *Benz Punany*' was originally written by Charlotte Richardson Andrews in *DIVA magazine*, 12 June 2014, http://www.divamag.co.uk/category/arts-entertainment/project-o-goes-large-swagga-and-benz-punany.aspx.

Big Hits – GETINTHEBACKOFTHEVAN, Soho Theatre [or: review as object lesson in why self-reflexivity isn't as good as getting to the point]

Andrew Haydon

There are a million different ways I might start this review. Each plausibly reflective of a different facet of a show that is variously "essential viewing", "funny, sexy, frightening" or "smart, hard, awesome"; caustic, casual, obscene and innuendo-riddled. Instead, I already seem instead to have reflected the fact that it is a bit overlong and perhaps unsure where it's going.

I might also start with a "what I did with my weekend" approach: I came to *Big Hits* straight from DIALOGUE at the BAC. I was terrifically wired on coffee, and probably hadn't had enough to eat. I had also been talking to some incredibly smart theatre makers and fellow writers-about-theatre all afternoon, so perhaps my critical faculties were also buzzing a bit too hard.

Mention could be made of the fact that I didn't see company GetinTheBackofTheVan's inaugural production *External* – a response to Ontroerend Goed's *Internal* – robbing me of the chance to chart the company's development as Matt Trueman surely will.

All these things are relevant. And none of them make for a good intro.

There's also the temptation to start off with smut: "Last night ended, as so many nights do, with me staring up the naked bumhole of a performer." etc. So I'll stop trying to introduce the thing cleverly, or with writing, and will just get on with the thing and stick this in as an appendix.

(Thinking about it, though, the above is more or less exactly how the show itself starts – self-consciously talking about itself as a show and not getting started.)

Big Hits opens with Lucy McCormick dressed in a little black dress – all plunging, gauzy neckline, visible bra and white high heels – and Jennifer Pick in a massive rabbit costume with a microphone gaffer-taped to her head (Lucy: "I said 'Why not dress as a bunny girl?'..."). They're introducing their show *Big Hits*. Their show *Big Hits* is "on a mission. [We'll] learn SELF-IMPROVEMENT with [them] here tonight and [we] will COMPLETELY improve [o]ursel[ves]. That way [we] can be better in the world".

They want a show with balls. Enter the hapless Craig Hamblyn – stripped to the waist and covered in blood in a way that suggests he's just stepped out of Thalheimer's *Die Orestie* – as their bearer of the aforementioned necessary actual and figurative extras.

You've grasped the aesthetic, right? No set; visible *means* (microphones, speakers, iPod, floodlight and disco ball); that tacky arthaus kinda thing. The kind of thing I have plenty of time for, but of which I have consequently seen a lot. If you want a shorthand, think: the carnage at the end of an imaginary Gob Squad office party; an existential vision of artists photocopying their bums wearing animal masks.

One of the things discussed at DIALOGUE yesterday was the relative redundancy of "theatre criticism" containing an "assessment". But then there are interesting side-effects of the non-judgement-wielding or -yielding review. No, I won't star-rate *Big Hits*. I don't star-rate anything. And I can avoid talking about what might or might not specifically have worked (or: worked-for-me). But, for reasons that will shortly become apparent, a description of the "plot" or even the arc of the show isn't *much* use for a consideration of the work...

What happens is that Lucy sings Leonard Cohen's song *Hallelujah* about a dozen times while __ hops about in the rabbit suit, performs a rabbit death and then continues on stage as a kind of browned-off compère figure. Craig also remains on stage enacting his own trajectory of dejection, performing a series of increasingly difficult tasks, mostly involving the holding of some very heavy-looking speakers. Lucy's performances of *Hallelujah* become increasingly desperate, "attention-seeking" and sexualised. By the end, she has shown us her right breast, simulated a considerable amount of aggressive sex, spanked herself so hard that, by this final performance of the group's week-long run, her derrière looks rather badly bruised, and finally has presented us with a long view up her bottom.

In light of the non-judging review, the interesting question with which these antics leave this self-reflexive critic is what the hell one does say about them.

I might start by positioning myself in relation to them (no, that's not a double entendre, although this is a show dripping with them). Reassuring you, my clever, unshockable, avant-garde reader, that I was not in the least bit offended by anything I saw.

I might go further than merely reassuring you by showing off: that I have seen every single one of these elements on a stage before (ok, not specifically Lucy's bottom, but bottoms like Lucy's); or even more show-offy: I lived in Berlin, dammit: this sort of thing is just a quiet night in a club there. I could point to specific artistic precedents – the "cake-fucking scene" in Dave St. Pierre's *Un Peu de Tendresse – Bordel de Merde*, the performance of *Smells Like Teen Spirit* in Superamas's *Big Third Episode* – and note that both go a lot further. But that would be missing the point.

But instead, let's go back to the first principle of trusting that the company know what they're doing and talk about what they have done.

Perhaps the most obvious influence (to an outside eye) on the genesis of the work could be seem to be the ever-more-ubiquitous TV format of the talent show. To position myself as a critic in relation to that: I can say with pride/appalling-cultural-ignorance/unashamed-snobbery that I haven't seen even five minutes of a single one of these shows.

I couldn't give a fuck about *X-Factor, Strictly Come Dancing, Pop Idol,* or *Britain's Got Talent.* Obviously, having lived in the UK for a while, I do have a peripheral awareness of Simon Cowell's existence, and of Alexandra Burke's hideous version of Jeff Buckley's massive improvement on Leonard Cohen's *Hallelujah.* I am also aware of that godawful version of *Heroes* that some maniac thought would be an appropriate song with which to try to raise money for the British Army. I could even make the pat observation/attempt-at-witticism that the only line in *Hallelujah* that might have any relevance in its new-found status as a squawky anthem for the godlessly godawful is: "But you don't really care for music, do ya?"

I am, however, aware of the critical discourse, and the *social* discourse, around this sort of programme (I might not watch the programmes themselves, but I do still read newspapers and listen to the news, so they're more or less unavoidable. Which I profoundly resent), and it is an interesting subject on the macro level. On the other hand, I'm not sure that talent shows are so pervasive in our culture yet that the best response isn't just to ignore them – that making theatre/Art *against* them (if that's what this is; which certainly isn't the whole story, if it's any of the story) doesn't just dignify the wretched things far more than they deserve and that ignoring them altogether wouldn't be a better solution.

But *Big Hits* goes a lot further than just being a witless critique of the TV Talent Show format. Really it's "about" (difficult word) the commodification of human (particularly female) sexuality, the way sexuality is sold back to us through pornography, television and advertising, about labour in general and about performance. Well, that's some of what it seemed to be about to me. Perhaps largely because of my British desire to pin things down to a purpose and some sort of utilitarian comment function. Maybe it wasn't meant to be *about* any of that and was just a strange, wild and oddly *readable* bit of art that I should have been thinking about in a totally different way.

That said, if it was about those things, we might, as critics, be able to discuss the extent to which the piece brought something/anything new to the table of that discussion, or to the artform.

As Mark Ravenhill said on Twitter: "Last performance tonight at Soho Theatre of *Big Hits*. I urge you to see it. Funny, sexy, frightening, essential." perhaps because of the relative rarity of work like it in a mainstream UK performance space.

As Matt Trueman, also on Twitter, said: "Institutional context: an arsehole on a stage at the ICA is a very different proposition to an arsehole on a stage at the Soho Theatre."

And, I think both writer/director and critic are right. Ecologically speaking I'm pleased that this show exists.

I do think, however, that side-effects of this ecological context had a lot to do with how I wound up watching it on Saturday night.

That is to say, I'm not sure this is the sort of show that benefits from the above sort of bigging-up. I saw it with an expectant sold-out audience – though of what they were expectant was less clear. Some people had definitely decided it was going to be a funny show and laughed at all the jokes. Loudly. Other people were presumably watching more intently for the meaning behind the jokes. As an audience it felt fractured, and slightly frustrated as a result of that fracture. (That sense of at least two factions in an audience mentally tutting at, or worrying about, their co-audients' audible responses/lack-of-audible-responses. We've all been in those audiences, right? We sometimes can't help but be in one or other of those factions, right?)

Big Hits feels like a show that would do well for being discovered for itself, rather than being sold out on a wave of probably un-meet-able hype. i.e. – if I'd seen it for myself as a matter of course rather than going on the recommendations of three notoriously hard-to-please friends, then I'd have probably been going wild about it too. Instead, I went pre-armed with all these slightly unqualified recommendations. So, the position one goes in with tends to wind up being modified to: "Well, it was fine, but I'm not sure it's as good as everyone else said it was." And I don't think it's just critics who have an instinct to bridle at hype.

Difficult.

I still haven't said anything meaningful about the show, only about my experience of sitting in it and thinking about other peoples' responses to it.

So, to get back to the show...

Plainly the most striking thing in the show is the extent and nature of Lucy's self-abuse (to which I will return). However, in an interesting way I found the difficulty of Craig's tasks far more absorbing. There was some astute use of dual/triple focus where, while Lucy was doing something absurd and sexual, and Jennifer was being a wryly cute or cutely wry rabbit, Craig would be in real pain undertaking some actually physically painful labour. There's an available reading that would note about what a very Victorian-to-the-Sixties model of masculine and feminine roles. Sure, people can argue that these roles still hold far too much currency, and that Victorian women weren't really

encouraged into high heels and belt-length skirts to snap up a mate. At the same time, hard physical labour seems to be something of which we see less and less as Britain's economy moves away from any kind of manufacturing. I don't suppose the piece was intended as a comparison between lap-dancing and labouring, but it's an available critical endgame, I think.

Primarily, though, it does seem to be aimed at eviscerating (or perhaps *re*viscerating) the contemporary picture of female sexuality. Or rather, not sexuality, so much as the performance of it in the service of the entertainment industry.

Looking at the elements here, we have the idea of the narrative, the sub-misery-memoir backstories that are much beloved of the TV talent show – the end-of-the-line bastardisation of the idea that one has to suffer for one's art. Part of Lucy's character arc is the questing to perfect her performance of *Hallelujah* by putting herself through some suffering. This includes an incredibly uncomfortable ten minute (?) "domestic violence" routine, in which Craig repeatedly stage-punches her in the face. While one could easily accuse it of trivialising violence against women, I think it transcends the accusation by the way that Lucy plays the scene – continually looking over her shoulder between each punch in that staple cliché of pornography, and, in this context, a way that suggests she's just checking we're still watching her. But with wide eyes that disturbingly recall that most tasteless of pop titles "*He Hit Me (And It Felt Like a Kiss)*" (which in turn recalls both the Adam Curtis/Punchdrunk collaboration and the more recent news stories about Chris Brown, his new album, that review of it that went viral, and his deeply strange new neck tattoo).

This emphasis on being watched and on the lexicon of pornographic semiotics form the cornerstone of the piece. Lucy's non-stop stream of filthy double-entendre and incredibly graphic gesticulations – so graphic that you might well choose to believe that that can't possibly mean what it looks like – clash interestingly with Craig's joke-puncturing shtick and Jennifer's slightly more wide-eyed, clownish stare into the audience – her face always looking only two steps away from breaking into a smile or giggles.

So that's the stuff that's in the show. A sort of story about someone beating themselves up in order to feel the pain so they can sing Hallelujah better, assisted and then turned on by a 5'-something bunny with a spooky voice, that dies before the end and is reincarnated as a kind of talent show judge, and a bloke holding heavy speakers at arms length whilst trying to avoid looking like Christ (Paraphrase: "There's enough religion in the song already" – which is some neat irony right there, given Cohen's (obvious, pronounced, ancestral) first-half-only approach to the Bible.)

So, yes. What does it all mean? Pretty much what you like. Obviously there are some strenuous pointers. Definitely some really interesting material in there. Almost certainly to slightly over-long feel of it is deliberate in order to bang home the point (fnarr) and to make you feel the repetitions.

I suppose (on a personal note), I'd have liked it to maybe tell me/suggest some stuff I haven't thought of before. Or to have gone just that bit further into The Unacceptable, so that I had been genuinely appalled. But if that's not what GetInTheBackOfTheVan wanted to do, it felt fine that it wasn't what they'd done.

Basically (and this is an assessment. Sorry), I liked it (in retrospect more than in the watching, although there was enough smut, jokes and near-nudity to keep me entertained). I look forward to seeing more of their work. It feels like a great (almost) starting point for a young company. Perhaps some of their shtick will start to feel a bit less borrowed in time (That Gob Squad, and slight Forced Ents debt could do with fading a bit, maybe – although it's an interesting question whether that debt is actual or just a result of talking in quite a deadpan way into a microphone.)

...fades out...

...lights suddenly shut off...

'Big Hits – GETINTHEBACKOFTHEVAN, Soho Theatre [or: review as object lesson in why self-reflexivity isn't as good as getting to the point]' was written by Andrew Haydon for *Postcards From the Gods*, 26 September 2012, http://postcardsgods.blogspot. co.uk/2012/09/big-hits-getinthebackofthevan-soho.html

Camera Lucida, a Truly Spine-tingling Experience

John O'Mahony

Right at the back of the Barbican's Pit theatre, a glowing green fluorescent table seems to magically float in the velvety purple darkness. Downstage, three actors – two male, one female – sit in the eerie reflected glow, twitching, gurning, flailing, as if possessed.

But by far the most ghostly and troubling element of *Camera Lucida* – a radical multimedia seance that opens on 28 October and will channel the voices of the dead into the Pit over Halloween – lurks unseen, right above the audience. Looking like a corrugated cruise missile and operating at an audio frequency 18.9 hertz, this is what is known as an infrasound device.

It won't be heard conventionally by the ear, but will instead resonate in the tendrils of the digestive system, the medulla oblongata of the brain and the myelin sheath protecting the spinal cord – inducing ethereal trills, mystical vibrations and supernatural shivers in members of the audience. This production will be metaphorically and physiologically spine-tingling.

Its creator – the intriguingly named Dickie Beau – has emerged from the world of underground cabaret to produce shows of dazzling weirdness and experimentalism, and has been credited by some with the foundation of a new genre called "playback performance", building performances around existing sound archives.

Starting life under the rather more sober moniker of Richard Boyce, he emerged from the gay club scene and transformed himself in the noughties into his current incarnation, performing covers of Nina Simone as well as his own outre compositions, a period he now calls his "bewilderness years".

It all changed again when he stumbled on recordings that Judy Garland made in the 1960s for her never-to-be-finished autobiography – late-night rants full of bile and spite and self-loathing: 'I'm the one who's had to live with me!' runs one notable self-lacerating line.

Beau ditched the songs and began lip-syncing to the Garland archive, dressed in the full carroty-pigtail outfit of *The Wizard of Oz*'s Dorothy. He expanded it into a full show, entitled *Blackouts: Twilight of the Idols*, where the Garland tapes were presented alongside Marilyn Monroe's final interview: "This is the drag show at the end of the world," wrote one critic.

He followed up Blackouts with the much more complex work *Lost in Trans*, which combined Ovid's *Metamorphoses* with stories about transsexual experience. By now, he had perfected the technique of channelling every nuance of the archive voices: "I first do an impersonation of the voice out loud so that I can develop the movements and the facial expressions," he says, "Then I take it away, reduce it to a whisper and eventually the voice is entirely gone."

Moving around the Pit, Beau whispers instructions to the tech crew. In many respects, his everyday persona – from the shaggy jumper to the crunchy post-structuralist terminology that he often employs to explain his work – appears to be a deliberate reaction against his cross-dressing "drag clown' alter egos. The tattoos on each forearm reveal his club-performer origins: one a thorny red rose, the other a dagger and a fluttering ribbon.

The inspiration for *Camera Lucida* was disarmingly straightforward: "One reviewer said that Dickie Beau is the closest thing this country has to a genuine medium," he recalls. This plunged Beau into a frenzy of research and reading, ranging from Roland Barthes – whose 1980 work about photography and mourning gives the piece its title – to the history of the Victorian seance, with all of its theatricality, mysticism and charlatanry. Behind the shrieks and the shifting glasses, Beau saw a real, hard social function: "The whole objective was to make the dead available again," he says, "to resocialise them."

The resulting work, which will be the first time he has employed other performers, uses extraordinary audio archive to raise three figures from the literary mausoleum: Virginia Woolf, William Burroughs and the cultural critic Terence McKenna, all of whom he chose because of their unique relationship with death. "Woolf killed herself and McKenna, the cerebral intellectual, died of a brain tumour," he says, "William Burroughs killed his wife, so walked around with death looming over him."

But if this all seems wilfully macabre, it is offset by a multimedia torrent of lighter, comedic moments: the infamous recording of the Houdini Halloween seance in 1936, and the testimony of a 50s housewife on LSD.

And then, of course, there is the infrasound device. It was inspired by an allegedly haunted laboratory in the University of Warwick: "People began seeing weird things, seeing ghosts and feeling that there were presences in the room," says Beau. The culprit turned out to be defective extractor fan, which was emitting a frequency of 18.9hz, right in the infrasound spectrum: "It was precisely the right frequency to make the eyeball vibrate, producing hallucinations."

While the device in the Pit will be considerably less powerful, Beau does hope that it will complement what is happening on stage, making this a singular theatrical experience: "I want it to enhance the performances," he says, "Some of these infrasounds are around anyway – they are deep in the tunnels of the tube, for instance. But you will feel a perceptible resonance. You 'hear' it in the most unexpected places – in the tips of your fingers."

Kein Applaus für Scheisse at IBT13

Maddy Costa

What it is to be young: a rough patchwork of pop songs and outrageous behaviour, of adopting and discarding different possible identities, of alcohol and drugs and piss and puke, and falling in love so hard you want to stitch yourselves together for ever. Being young is exhilarating, messy, and – you forget this, sometimes, when you're older – bloody hard work. In *Kein Applaus für Scheisse*, Florentina Holzinger and Victor Riebeek perform their own youth with an intensity that makes them repulsive at first, then so charming you want to give them a hug as you leave the room. That warmth takes a while to build, because it's hard to tell whether their opening provocations comment on white privilege or re-enact it, subvert female subjugation or reinforce it.

They enter the stage wearing African robes and colourful feathers; wrapped in his hair are matted strings of fur like dreadlocks. They skank their way through Rihanna's 'Man Down', then Holzinger pulls her dress above her naked hips, settles in a chair with her legs upstretched, and waits patiently while Riebeck extracts a bright red string from her vagina, holding the audience's gaze all the time. In an era when women removing their pubic hair has become the norm, it's delightful to see that Holzinger's remains intact, a voluble statement of non-conformity.

But that feminist stance is problematised by the scene that comes after: a double-exorcism that begins with her shedding her robe and ends with him vomiting Slush-Puppy-blue liquid over her bare stomach. When, a few minutes later, he stands naked over her prostrate body and lets out a stream of urine, her subordination seems complete. One person walks out, then two more. As it happens, their lack of patience is the problem, not Holzinger and Riebeek's willingness to push uncertainly at boundaries and at themselves.

Because what's really happening here is a fluid – yes, possibly too fluid – exchange of roles. Between the puke and the piss is a deadpan scene in which they play out the insecurity of love: she accuses him of not wanting to touch her any more, he accuses her of not being there in an hour of need. There is a rape, a pregnancy, a death – but they belong to his role, not hers. Experience is shared so equally that when Holzinger takes in a mouthful of Riebeek's piss, she doesn't swallow it but lets it trickle into his mouth so he can instead.

This is the moment when *Kein Applaus* transforms: from a challenge to its audience it becomes a communion with them. She puts on a blonde wig and sings 'The Greatest Love of All' while he cuts her fake hair. He talks to us about money, love and his six-year relationship with Holzinger, while she performs an elegant aerial routine on the silks. A small bottle of vodka is passed around the audience (usually it's a joint, but weed has been peculiarly hard to come by in Bristol), to the throbbing psychedelia of Devendra Banhart's 'Rats'. They are earnest, open, friendly, relaxed – silly, too, because this zen atmosphere is ruptured by the firing of a bazooka that splatters Riebeek in ultraviolet paint. Reborn, he hands Holzinger an acoustic guitar and to her faltering chords they sing Marina Abramović's *An Artist's Life Manifesto* as though it were an ages-old folk song, handed down from the elders to give succour to the young. Which, in a sense, for artists finding their way, it is.

Walking out, I knew I felt beguiled, but I wasn't sure I'd caught the "generosity" of the piece identified by others in the audience. At 6am I was jolted awake by an appreciation of how carefully constructed *Kein Applaus für Scheisse* is. Within that was a recognition of their willingness to get things wrong, to do that in front of others, and experience rejection because of it. An awareness, too, of their trust in the audience, to join them on this journey, and see their world, their relationship, their youth, through their eyes. I'd found its generosity – and it made my heart glow with love.

'*Kein Applaus für Scheisse at IBT13*' was originally written by Maddy Costa as writer-in-residence with IBT13: International Festival of Performance, and published by *Exeunt Magazine*, 15 February 2013, http://exeuntmagazine.com/reviews/kein-applaus-fur-scheisse/

Let's Make Love and Listen to Death from Above; This is How we Die for a Second Time; A Third Time

Megan Vaughan

Let's make love and listen to Death From Above, 18 June 2014

I've been whinging about not being challenged enough recently. Not being scared or winded or stamped on by performance, not like I want to be. I've been complaining about twee: shows with live illustration and home-made instruments and beards and knitwear and ukuleles. String and brown paper. Overhead projectors, bunting. Fucking PUPPETS.

You guys, I have a new hero.

Christopher Brett Bailey.

When he came out and took his seat on the stage I was like "IT'S THAT GUY!" He's one of those people you see everywhere and know straight away that he's an artist just from his hair but who'd have known WHAT AN ARTIST – WHAT. A. FUCKING. ARTIST – he actually is.

My god. MY GOD.

Christopher Brett Bailey is Allan Ginsberg and Hunter S Thompson and Saul Williams and that big red-lipped mouth from Beckett's *Not I*. He's Josef K and Gregor Samsa. He's Christian Slater in Heathers, he's Tim Roth in *Pulp Fiction*, he's Woody Harrelson in *Natural Born Killers*. He's cinematic drugs like mescaline and peyote. He's cigarettes. He's the taste of cigarettes on a kiss. He's the revolution that will not be televised. He's your most fucked-up dream where it turns out the guy you're fucking is made out of cold tapas meats. He's Godspeed You Black Emperor. He's Nine Inch Nails. He's Aphex Twin in a bikini. He's everything ever released on Sonic Cathedral. He's a circular saw, blood spatter, crumbling teeth. He's diabetes and a thyroid problem. He's the sound of breaking bones.

He's written a show about dying, in which he sits at a desk and talks for an hour, and which is absolutely positively what dying actually must really be like.

And let me tell you it is fucking incredible.

This is how we die for a second time, 30 October 2014

There's a moment towards the end of *This Is How We Die* by Christopher Brett Bailey, where he recreates the sound of an audience going wild by shaking his head from side to side in front of the microphone, and doing this noisy, stage-exhale. Like, ssshhh-sssshhhh-ssshhh.

Which is funny, really, because both times I've seen it now the audience has just kinda sat there in stunned silence at the end. It takes ages for anyone to clap. Much more so than that split-second of weirdness you get at any given normal night at the theatre, when everyone's a bit like "is it done?" At *This Is How We Die* it's more like ten seconds – ten long seconds – where nobody does anything. Because they can't.

When I was about 14 I convinced my Dad to come to Alton Towers with me. I used to go pretty regularly with friends because it wasn't that far from Macclesfield but it was the exact opposite of the kind of thing that my parents did. But one day Dad weakened and off we went up the A523.

Dad had one go on Nemesis and had to go for a lie-down under a tree for the rest of the day. He'd aged 5 years in that 90 seconds. The adrenalin rush had totally done for him. T-shirt over his face for hours. He wobbled over to the teacups at about 4pm but we both knew it was a token gesture, bless 'im.

I was thinking about that as I stumbled down the stairs and out of BAC tonight. I felt like I'd just jumped out of a plane. No, fuck that. I felt like I'd just been pushed out of a plane. Since I first saw it in June, I've tried to recall the finer details of *This Is How We Die* so many times. So. many. times. I've written thousands of words. Awful, teenage words. Undelivered love letters, pseudo-academic hypothesising, an embarrassment of fan-fiction. 500 words on why Chris Brett Bailey is (air horn) the greatest performer of our generation. 2000 words on how Schopenhauer's theory of Will is evident in CBB's final moments of extreme noise terror. The outline for a photostory in which he referees a live torture-porn death-match between Edward Scissorhands and Robert Mapplethorpe. Last night I dreamt that I was a contestant on *Strictly* and my routine was choreographed to a recording of the bit where he fucks himself. Not even joking.

I almost couldn't bear the thought of seeing it a second time. What if knowing what was coming just ruins my whole buzz? What if those images had solidified too much in my imagination, don't move so quickly or shapeshift so unpredictably? What if he's ill, or something goes wrong, some tech thing fails? What if the word 'jism' just refuses to surrender its meaning?

I managed to follow the narrative for about 40 minutes tonight, I think. The last bit of dialogue was still a bit of a jumble of piss and cum and decapitation in my head, and I'm still not sure if it was the priest or the Jesus that got spiked on a cactus, or what happened to the kid listening to Bowie, but by that point I was kinda gulping for air through clenched jaws because I was going to scream/sob/scream-sob/sob-scream if I didn't. I was like my Dad on Nemesis. The cars are going where they're gonna go and as fast as they're gonna go there, and you can clench your fists while you travel or you can let yourself be pushed backwards into the seat, it doesn't really matter. The only thing you know for certain is that he's in control, and you're gonna need a long lie down to get your shit back together again.

xxx

I do not think I could love anyone who does not wish to see *This Is How We Die.*

swishes from side to side in front of the microphone

Ssshhhh-ssshhh-ssshhhh

A third time, 13 November 2014

BEEN TO SEE THIS IS HOW WE DIE AGAIN STOP IT WAS EVEN BETTER THIS TIME (IF YOU CAN BELIEVE THAT) STOP HE SMASHED HIS GLASS WHEN HE GOT A BIT WRONG STOP I THINK IT MIGHT BE BECAUSE HE'S COMING DOWN WITH A COLD STOP I COULD TELL BECAUSE I AM BECOMING TUNED TO A CHRIS BRETT BAILEY FREQUENCY STOP OBVIOUSLY I CAN'T SLEEP NOW STOP HERE IS A VIDEO I'VE BEEN WATCHING INSTEAD OF SLEEPING STOP THERE ARE A COUPLE OF ANNOYING TYPOS IN IT AND SIGUR ROS IS NOT THE RIGHT MUSIC BUT IT IS MOSTLY AN EXCELLENT VIDEO STOP

https://www.youtube.com/watch?v=M3zBsDIvH7U&feature=youtu.be

‘Let's Make Love and Listen to Death From Above’, ‘This is How we Die for a Second Time’, and ‘A Third Time’ were originally written by Megan Vaughan for *Synonyms for Churlish*, 18 June 2014, http://synonymsforchurlish.tumblr.com/post/89196456338/lets-make-love-and-listen-to-death-from-above; 30 October 2014, http://synonymsforchurlish.tumblr.com/post/101299058173/this-is-how-we-die-for-a-second-time-theres-a; 13 November 2014, http://synonymsforchurlish.tumblr.com/post/102492276268/a-third-time-been-to-see-this-is-how-we-die

Paper Stages at Edinburgh

Daniel B. Yates, Catherine Love, Lois Jeary, and Rosanna Hall

Paper Stages was a small book released by Forest Fringe for this year's Edinburgh festival, available in exchange for an hour of the reader's time. Featuring Tim Etchells, Bryony Kimmings, Kim Noble, Chris Goode and others it was designed to be read and performed throughout the city. "This is not a book" reads the inside cover, "this is a festival."

Entr'acte: Balerno to Leith, Chris Goode. pg.21. *reviewed by Rosanna Hall*

To walk the excess of twelve miles of the Water of Leith at the andante pace suggested by Chris Goode's piece in *Paper Stages* would take upwards of 6 hours, yet by juxtaposing the map across manuscript he suggests another way of getting to know it, via music, an urging to understand the river in a similar way to a musical performance.

According to the manuscript the river should depart Balerno accompanied by the double bass, with the 'cello, viola and violin grasping the thread of the rivers melody, with no instruments in unison but blurring into another the smudge of the rivers periphery on the map, from Currie to Colinton, to Roseburn to Stockbridge adopt a different timbre. While the melody meanders, cutting across clefs and sprawling through the pitches of strings, brass, woodwind and percussion, it forges a trail made centuries ago but which, as rivers do, is slowly eroding a new path.

Reviewing a manuscript is a difficult task, reliant as it is on ones imagination, but Goode's offering allows what for many is a city unexplored out-with the central fringe belt, a context which tries to explain the composite parts of Edinburgh. The thread of water which runs through the city becomes mirrored by music, an appropriate symbol for the festival month. By putting a map to music, Goode challenges us to intellectually evaluate how we represent space and place within our own mind – what places sound like, how we take home a mental imprint of the sound of a city, similar to a picture in our memory of our place within it, the world rushing past with the metronome of our own footsteps remaining constant.

Of course it requires compliance to bring the manuscript to life, you must be willing to conduct the mental orchestra waiting in the wings, and it is ultimately in the hands of the reader as to whether – and how successfully – this river melody breaks the banks of feeling a bit of a dafty and bursts into sound. Yet, this coupling of space and music begins to offer something new to how a place becomes illustrated in our memories, and even as the river

flows out at the Leith Docks, [I've always thought an oboe sounded like a duck singing] the part of the flute remains unwritten, looking out into the mighty Firth of Forth, and to Fife, then Northerly, a wilder place urging to be explored, a wilder music, urging to be written.

(Not THAT Kind of) Doctor Lobel Cures Horrible Performance, Brian Lobel. pg 16-17. *reviewed by Lois Jeary*

Poor Doctor Brian Lobel. Mere hours after his thesis defence for his PhD, the seeming futility of years of work and dedication in the field of Drama and Contemporary Performance was made painfully apparent. What good is a Doctor who can't deliver babies in an airplane, administer lifesaving CPR on the roadside or apply a tourniquet to a severed limb, he wondered? Well, (Not THAT Kind of) Doctor Lobel is good for something – he understands that the theatre community are a delicate bunch, that 'with every horrible show, a bit of our soul slowly dies', and that after a month of well-intentioned but artistically challenged performance Fringe-goers might be in need of his assistance.

For anyone who has not yet discovered the therapeutic joys of criticism this virtual consulation with the doctor could prove deeply rewarding. A critic knows that revisiting a theatrical experience some time after the event momentarily reignites the feelings felt during performance, whilst analysis and explanation can provide a much-needed sense of closure to an experience either good or bad. Doctor Lobel's invitation to put a Horrible Show in context, explain why it was so bad and how you feel now is an, albeit formulaic, excuse for all theatregoers to start to analyse their own experience and reception of shockingly bad theatre.

I can only assume that my symptoms didn't sound fatal, as the good Doctor failed to respond to my consultation email at all within the 24 hour window his automated email of a po-faced secretary outlined. An artistic comment on the state of the NHS perhaps, or the sign of a particularly devastating outbreak of dodgy theatre in the latter half of August, either way, without the Doctor's guidance it lies with me to self-medicate my way out of this particular mess. A rant, a drink and a solemn vow to never step foot inside *cough* venue ever again should suffice, but of course I knew all that already. Who needs Doctors anyway?

The Incidental Plays, Andy Field. pg. 14-15. *reviewed by Catherine Love.*

Urban embraces and concrete barriers are the substance of Andy Field's elusive collection of miniature plays, to be performed "in a city by an indeterminate number of people for an audience that does not quite realise it is an audience". These pieces, composed not of directions or dialogue but of poetically constructed observations, also paradoxically contain within them the impossibility of their faithful re-enactment. Composed from the texture of city life, they exist as scores without adequate musicians.

Despite their inherent difficulties, there are some actions that might successfully be undertaken from these lyrical descriptions. The idea of occupying the coldly impersonal space of the department store and blithely using its wares with no apparent purpose is particularly appealing in both its childlike naughtiness and the two fingers it implicitly holds up to the capitalist culture of consumption, as is the activity of chasing one another "aimlessly" through the streets.

Throughout these fragments lingers the ghost of intimacy, often longed for or obstructed. The awkward waiting for a text message, the figures quietly catching one another's eyes, the individuals at the crossing staring over the road at one another, unable to bridge the gap. They speak of an inability to connect with the people with whom we share our streets, an inability that is fittingly reflected in the concept of an unwitting audience and performance pieces that cannot quite be performed.

Perhaps the performative element of the exquisite pieces that Field has wrought is not as solid or straightforward as a simple following of cues and instructions. Rather they might be viewed as a beautifully insubstantial set of blueprints for retracing the city, for challenging the urban space's inscribed values of capitalist acquisition and false intimacy. It is rebellion through the pursuit of materially worthless beauty; revolution via the subversive act of aimlessness. Incidental, but incidentally vital.

Bank Robbery?, Tania El Khoury. pg. 51-52. *reviewed by Daniel B. Yates*

Lecturer in architecture at the University of Innsbruck Armin Blasbicher set a task for his students to plan the robbery of a bank. Claiming it as a "bold attempt to run an academic course as a profit making business model", participants were instructed to take on alter-egos and as part of what was described as a 'performance' survey 21 banks within the Innsbruck area. And where some questioned the legality ("Architecture is always illegal" was Blasbicher's reply) another described in virtuosic detail the theft of a chained ball point pen ("that icon of worthlessness and petty communication strategies") while another, taking Brecht's quote "what is robbing a bank compared to founding a bank?", laid out a strategy for of a hedge fund which would bet on the successes of bank robberies in some deftly absurd futures market.

This latter approach is the one Tania El Khoury brings with Bank Robbery? 400 words of injunction to detourne the unblinking facades of banks, with their app-like colour schemes, their appearance of global facility; their talk of community while implicating us in hegemonic financial systems, sucking money from the localities they squat in. She begins discussing a bank robbery in Lebanon, relaying the ambivalent comments below the articles ranging from xenophobia, to egging on (the folk spirit of "getting away with it" that has criminals as enduring counter-cultural icons) to the stark "robberies are the only solution left for us."

This presented a question; what is the status of a bank robbery in the current climate of late-capitalism, where a populist accelerating sense of their evil is one of the defining political sentiments? Rather than answering, El Khoury seeks to make that question visible. Recto is printed a graffito template, "bank robbery?", with instructions to blow up to A3 and spray on the frontage of any given bank. Verso a picture of a branch of the Lebanese Swiss Bank, revealed and cowed by the small line of graffito smartly marked under its logo by El Khoury and her associates. As with the UK riots, the Paris Commune attacked financial institutions that had distorted their community; and yet the Communards ended up borrowing from the Bank of France, just as Blasbicher ended up accepting money from the banks he targeted. Perhaps the strength of this kind of intervention from *Paper Stages* is that the meme floats, unrecuperable, a mark of terror, an instance of imagined action and possible action.

'*Paper Stages* at Edinburgh' was originally written by Daniel B. Yates, Catherine Love, Lois Jeary, and Rosanna Hall for *Exeunt Magazine*, 30 August 2012, http://exeuntmagazine.com/reviews/paper-stages/

Review of *Access All Areas: Live Art and Disability* and *M21: From the Medieval to the 21st Century*

Petra Kuppers

Access All Areas arrives in my hands as a tactile, sensate bundle: it's a thick cardboard-covered collection of delicious miscellanea, spiral bound with blue wire, and to open it is to engage in treasure hunting: you have to carefully undo the Velcro buttons that bind a flap around the book. And who does not enjoy playing with Velcro? On the front cover is a naked young white man, sprinkled with gold dust, spitting into a small sample container. I am both repulsed and attracted, intrigued by this mixing of medical content, the fabulosity of the gold sparkles, and my own sensorium that finds spit hard to stomach. Welcome to the world of avant-garde disability art: this is not a collection of pride art, clear and message-full. There is no inspiration here, either. Instead, the reader/viewer/unwrapper finds herself challenged to make meaning, and to play in uncharted territory.

The book contains a wealth of documentation of live art practices by UK-based practitioners, as well as two DVDs, one of live art events, one of video work, wonderful resources for the classroom. "Live Art" as a term is not very familiar in the US: this work emerges out of performance art, sculptural practice, and visual art discourses, but has a stronger research and theory component than much "old school" performance art. The Live Art Development Agency in London holds a wide variety of material created under this label, and *Access All Areas* collates much of it, making the collection an invaluable resource of cultural practice.

This is third-generation work, complex and thick in its references field, no longer interested in pride or entry into mainstream aesthetics. As I have found in my classroom, one needs quite a bit of disability arts cultural capital to get a handle on some of what is being shown: my students, when asked to assess the appeal of the material for a U.S. audience, often found themselves stunned. For example, one video by The Disabled Avant-Garde, *Amazing Art* (2009), pokes clever fun at the disability charity art market, whose discourses construct disabled people engaging in art practice either as "entrepreneurs," i.e., engaged in the neoliberal agendas of today's Arts Council discourses, or as sweet dears engaged in therapy. The video shows two disability arts veterans, Aaron Williamson and Katherine Araniello, engaged in actions that veer on the surreal, cleaving close to the somewhat embarrassing clay objects d'art that sometimes emerge from sheltered disability arts workshops. A running commentary gushes about the inspirational, amazing artists in the most patronizing terms, and shows Williamson "compensating for his hearing loss"

by drawing with a thick pencil attached to his ear. Meanwhile, Araniello makes hideous clay ashtrays in dark brown. Later, the artists sell jam by decanting supermarket-bought jam into new containers, and press these upon punters at art fairs, applauded for their courage and spunk by the commentator.

Amazing Art created a fascinating discussion in our Disability Culture classroom. Earlier in the class, students had already engaged with questions about who is allowed to laugh at whom, and what the politics of disability sarcasm might be, having discussed works including the *Scary Lewis Yell-A-Ton* by Mickee Faust and Terry Galloway (2004). The conceptual intervention of the Disabled Avant-Garde video, though, left my students stunned and a bit unsure of the ironic intent. It was quite easily possible to see this as misguided, nauseating, embarrassing reality, and there was nothing (much) that provided the necessary wink to let us in, and off the hook, to create the community of knowing sarcastic insiders. The discomfort experienced by many of us provided a wonderful basis for discussing, yet again, the differences between disability culture's sophisticated approach to social positioning, and the mainstream's perception of disabled people in public.

Productive discomfort continued as a guiding theme as our class engaged with another video from *Access All Areas*, *Undress/Redress*. In this performance, Noemi Lakmeier and Jordan McKenzie are in a box/room made up of thin walls, inside the gallery. Viewing windows allow the audience access to what is going on inside the box. Lakmeier is being undressed: she moves not a limb as McKenzie, dressed in a brown suit reminiscent of a 1950s middle-class clerk, matter-of-factly takes off her clothes, folds them, and then dresses her. We see the small adjustments and tricks that those of us who deal with paralysis and our helpers know about – but there is no medical information, and it is unclear if Lakmeier has no mobility, or acts limp. The performance engages themes of voyeurism, complex sexuality, care discourses, projection and secrets.

The book provides much framing material for the performance documentation: Rita Marcalo talks about her *Involuntary Dances*, presenting epilepsy as performance, and the intense public reaction her work provoked; and artists like Catherine Long, Doran George, Pete Edwards, Caroline Bowditch, and Brian Lobel reflect on their aesthetics and artistic approaches. Much of the material is presented in interview form, or in fragmented or performative writing modes, as many of the materials were originally Symposium provocations at *Access All Areas: Live Art and Disability*, Rochelle School, London, in March 2011. Together, these materials speak to the thriving energies of disabled art makers, their knowing engagement with their positions in the art markets and in the public eye, and to the continuing growth and diversification of disability and the arts.

Live Art tends to be urban, trendy, knowing, and relies on coding procedures, making things strange, and distancing its audience. But what happens when this confrontational method and medium occurs elsewhere, outside the art world? As a bonus, with *Access All Areas* the Live Art Development Agency

sent *M21: From the Medieval to the 21st Century*: Live Art interventions by disabled artists in the birthplace of the modern Olympic Games, May 2012. A cardboard folder holds a DVD, a booklet, and a series of postcards. Together, this material documents live art actions produced by DASH (Disability Arts in Shropshire) and commissioned by the Unlimited program, part of the London 2012 Festival and Cultural Olympiad. One of the actions documented here is Sean Burn's *Psychosis Belly*, in which he creates his own brand of Olympic Games, questioning ideas of "success," "spectatorship," and "fairness." In his "Depression Hurdles" action, he asks passers-by in the medieval little town in Shropshire to cheer him on as he tries to crawl under a white plastic hurdle, wearing a purple-and-orange outfit somewhere in the middle between a straitjacket and the ushers' uniforms of the UK Olympic Games. In the video documentation, we see some passers-by intrigued, and participating, while others turn away, unsure of what to do with the costumed people who are visiting their rural town. Things are shaken up here: from rude to cute (at least, until one thinks about it), from energetic to small, these actions shift a historic market town into a performance platform, allowing us to see how disability signifies in public, how strangers engage with each other, and the difference art makes.

'Review of *Access All Areas: Live Art and Disability* and *M21: From the Medieval to the 21st century*' was originally written by Petra Kuppers in *Disability Studies Quarterly*, 33.3 (2013).

Review of *Pleading in the Blood:*
The Art and Performances of Ron Athey
edited by Dominic Johnson

David J. Getsy

The potency of myth in Ron Athey's work is the problem tackled by this formidable new book. Edited by Dominic Johnson, *Pleading in the Blood* is the first near-comprehensive treatment of Athey's complex body of work. Athey emerged in the Los Angeles punk scene in the early 1980s and became known for his operatic-scale performances in which he inhabited the roles of saints, martyrs, and survivors. Many of these performances featured body modification, blood, and techniques borrowed from non-procreative sex and S&M practices. These elements were orchestrated in endurance works that allegorized the experience of survival, anger, and loss during the first decades of the AIDS crisis. Because of his interweaving of religious and sexual imagery, misrepresentations of Athey's work abound, and this volume is at pains to rectify these wrongs.

Across the 21 contributions that make up the book's narrative, recurring tensions between myth and verification irrupt. *Pleading in the Blood* strug gles to accommodate Athey's recalcitrant performance practice with the book's own revisionist and archival aims. Any account of such a body of work would necessarily evidence such an internal struggle, and Johnson's committed, affectionate, and generous volume does an extraordinary job of paying homage to Athey, of grappling with the complexities of live art, and of doing justice to the wildness of belief that is perhaps the key theme in Athey's work and in his contentious critical reception.

Different modes of writing rub up against each other in this lush and well-illustrated book. Johnson leads the way with an exemplary historical account of Athey's practice and of the public scandal whipped up over a 1994 performance Athey gave in Minneapolis with Divinity P. Fudge (Darryl Carlton), which drew national attention after it was misappropriated by arch-conservative Senator Jesse Helms in his attacks on federal funding for the arts. Johnson's history of this episode is extremely valuable, and this essay alone makes this book a significant contribution to the literature on art at the end of the twentieth century.

Arguably, the most important texts in the book are Athey's own, but these myth-making remem- brances of his youth prompt a resistance to the conventions of historical narrative. Raised in a fanatic and evangelical household by his grandmother and two aunts, Athey was prophesized to have the Calling before his birth and spent many years of his youth in training and in expectation of becoming a prophet. Writings by Athey about this are both tender and raw, and they contribute to the myths surrounding him and establish how faith in the unseen underwrites his practice. The historical

tone of this retrospective volume might prompt readers to try to see these as merely iconographic sources or a new spin on the genre of artists' youthful exceptionalism, but Athey's writings compel faith in the reality of these events (even as he voices his own skepticism about their meaning), leaving the reader in a state of suspension about his authorial intentions. These writings voice doubt about signs and omens, but they ask to be read as prefigurations for his art. They are remarkable texts that deserve sustained attention for themselves and for the ways in which they replay the structures through which Athey organizes his art and performance. Indeed, one wishes that more of Athey's writing was included in this book, but perhaps that will be its companion volume.

Also present in the book are many first-hand accounts from friends and collaborators. These are loving and illuminating, and we learn much about Athey's priorities, affections, and distastes from such important figures as Catherine Gund, Julie Tolentino, Juliana Snapper, Jennifer Doyle, Catherine Opie, and Guillermo Gómez-Peña. Beyond that, recollections from Bruce LaBruce, Alex Binnie, Tim Etchells, and Matthew Goulish and reprinted texts by Homi K. Bhabha and Lydia Lunch fill out episodes in Athey's history. Running throughout these affectionate memoirs and stories of sodality is the generous and committed personality of Athey himself. Indeed, cumulatively, these more personal statements provide the mostpowerful retort to Athey's critics (and to the historical record) that would cast him as merely shocking, extreme, and confrontational. These testimonials of Athey fight against the flattening scandal-mongering that determines his reputation amongst his critics and continues to drive his most obsessed fans. Against that myth of spectacle, these texts remind us that the work is not ultimately about provocation so much as it is about emotions (of all kinds), kinships, and survival. For an artist who has so often been instrumentalized as a myth, these texts are both revealingly personal and historiographically necessary. It is also worth noting that any scholar of the LA art scene or of performance art would do well to read this book for the document it presents of this supportive network in which performance thrived.

Detailed scholarly analyses of Athey's practice also participate in the book's reconstruction. To Johnson's credit, he has chosen scholars who find the complex emotional politics of Athey's work nourishing to their analyses. Athey's subject matter makes many historians or critics uncomfortable, and his practice more broadly embraces convictions that some would find difficult to assimilate – just as his own de-emphasis on completion or consistency fights against the idea of the 'finished' (and, consequently, closed) work of art. This is not the case with Jennifer Doyle, Amelia Jones, and Adrian Heathfield, who each offer compelling interpretations of Athey's work that attend to its emotional range, its moments of ad-hoc improvisation, and its eschatological and expiatory aspects. These texts, along with Johnson's own, offer models for writing about such work as Athey's and should be read for their methodologies by anyone interested in contemporary art.[1]

Pleading in the Blood offers a remarkable and enduring contribution to literatures on performance and contemporary art. If there was one thing that this book could be said to lack, it would be a fuller recognition of the negative deployments of Athey's work which, themselves, make up crucial parts of its history. In the earnestness of its defensive recuperation and in its desire to redress the decades of misrepresentation, the book (perhaps necessarily) devalues the virulent effectiveness of the Athey myths. Even though this does emerge as foil in some of the essays on the 1990s (most notably, Johnson's history), a document of Athey's career cannot fully shy away from the violent, prejudiced, and fearful misrepresentations that are part of its past. It's a delicate balance, since such texts as Helms's testimony, the factually erroneous 1994 article by Mary Abbe, or any of the host of other criticisms of Athey would enrage the authors and most readers of the book (myself included). Nevertheless, they would have given evidence of the potency of the negative emotions and threat produced by Athey's work. This book's loving attempt at credibility and authenticity disallowed inclusion of any of those powerful misrepresenta- tions and admitted only grudgingly their very real and long-lasting political consequences. (Beyond the specifics of arts funding, many in Athey's ardent non-art fan base thrive on his misrepresentation and the mythology of scandal.) I don't bring this up as an actual criticism of the book, for I think that *Pleading in the Blood* is a wonderful and rich example of how to do a history of performance art. I mention it as a reminder of what makes Athey's history so engaging and important: its fearless embrace of the abundance of emotions, meanings, and solicitations it produces. There is, in other words, more to be learned from and written about Athey and his history. Without a doubt, the stan- dard for any future writings on Athey will be the challenging, poly-vocal, and powerful testament offered by *Pleading in the Blood*.

1. I would add that a necessary complement to this volume in this regard is the valuable discussions of Athey in Doyle's book *Hold It Against Me: Difficulty and Emotion in Contemporary Art* (Durham, NC and London: Duke University Press, 2013).

'Review of *Pleading in the Blood: The Art and Performances of Ron Athey* edited by Dominic Johnson' was originally written by David Getsy in *Contemporary Theatre Review*, 24.3 (2014), 397-98, reprinted by permission of the author.

Dearly
Departed

Mike Kelley Obituary

Michael McNay

Artist who mixed bad taste and good ideas to become the big success of his generation.

Mike Kelley's art alarmed, seduced and appalled. He said he became an artist to embrace failure; in that, he failed totally, by establishing a career lived at hurricane force on both sides of the Atlantic, and becoming the big success of his generation. He has been found dead aged 57, by his own hand, according to the police.

From his early days he was also involved in music. He regarded the noise his bands made as rock sculpture, and drifted from music into performance art. He used collage, painting, photography, video, any medium that he could involve in improvisation. Kelley's creative intelligence took his work far beyond a cult following, and he was hugely admired by his own generation and especially by the disaffected young.

His last big show was at the Gagosian Gallery in London last September, and his work is due to be included in this year's biennial at the Whitney Museum of American Art, New York, the eighth time he would have been involved.

As a youngster, Kelley wanted to be a novelist, but he decided that, on the whole, an inability to master the language was an insuperable impediment. His involvement with music began at high school in Detroit, his native city, and continued at the University of Michigan in Ann Arbor. There he formed a band called Destroy All Monsters, which edged into performance art, and was noisier and more chaotic than most bands around.

He had read in his teens an essay called 'The Art of Noises', published in 1913 by the Italian futurist Luigi Russolo, and throughout his life carried with him the belief that noise music (that is, unmediated by technical skill) could be wonderful. "It's sublime," he said. "It's like a thunderstorm or an earthquake."

In 1978 he went to the California Institute of the Arts at Valencia near Los Angeles where he founded another band, the Poetics, and studied with the conceptual artist John Baldessari, who became a big influence on Kelley's thinking.

Yet at bottom, his art relates to his roots as the son of a working-class Roman Catholic couple in Westland, a suburb of Detroit heavily populated by workers at the city's big three car manufacturers, Chrysler, Ford and General Motors. As it happens, Kelley's father was in charge of schools maintenance, but his mother cooked for the executive boardroom at Ford. "Where you grew up, that's your inner world," Kelley said, and there is no doubt that his upbringing

333

determined his contempt for elitism in art – minimalism was one of his particular bugbears.

Kelley was eventually to make an art work for Detroit when, in 2010, he combined with Artangel, the London organisation committed to placing art outside walls wherever they can. It was his first work of public art and Artangel's first commission in the US. The city had fallen apart, almost literally, after the race riots of the 1960s and the departure of the white population. So Kelley rebuilt his family home, a white clapboard single-storey building with a portico and a little verandah with wooden railings.

He could not negotiate to site it where his old home had been, but the Detroit Museum of Contemporary Art provided land adjacent to its premises and Kelley mounted the new house on wheels, named it *Mobile Homestead*, and had it driven behind a truck to Westland and back. The interlocking personal and political imperatives behind this work are clear, and those between art and daily life.

Success had begun to roll in the 1980s, initially in France and Germany, but soon with a succession of shows in the US. In his review of last year's Gagosian show, Adrian Searle observed: "Kelley is one of art's conflaters, of high art and low comedy, popular and unpopular culture, theory and idiocy, bad taste and good ideas." One of his good ideas was oddly close to Marcel Duchamp's last "secret" work, *Etant Donnés*, a tableau of a nude in a landscape within a cave; Kelley's adaptation was to recreate Superman's city of Kandor, on the planet Krypton, with glowing glass skyscrapers – remote, icy, impersonal and indecipherable.

Kelley is survived by his brother, George.

Mike Kelley, artist, born 27 October 1954; found dead 31 January 2012.

Nigel Charnock 1960-2012
Lloyd Newson – DV8 Physical Theatre

Untamed artist who combined extraordinary physicality with acerbic wit.

Nigel Charnock the performer, director and choreographer has died, aged 52, after being diagnosed with stomach cancer in mid-June of this year.

I first saw Nigel perform at a Dance Umbrella gala in 1985 and was struck by this lithe, translucent and hyperactive creature. His energy and physical commitment were overwhelming. We met and discovered we shared disillusionment with mainstream dance and the superficiality that dominated the form. So I invited Nigel to work with me on a duet about male friendship and trust. The result was *My Sex: Our Dance* (1986) and the birth of DV8 Physical Theatre. Dancing with him remains one of the most joyous experiences of my life. He gave everything he had; emotionally, intellectually and physically – there were no half measures about the man.

For the next 6 years Nigel and I continued working together. His unsparing performance in *Dead Dreams of Monochrome Men* (1990), and tragic-comic character in *Strange Fish* (1992), subsequently captured on film, remain testimony to his extraordinary physicality and talent with text; he was touching, tragic, hilarious, honest.

Born in Manchester, Nigel studied at Cardiff's Royal Welsh College of Music and Drama and then went on to train at the London School of Contemporary Dance (1981) before working with Ludus Dance Company (1982-1985) and Extemporary Dance Theatre (1985-1986). After leaving DV8 in 1993 he created a series of solos for himself: *Human Being, Hell Bent, Original Sin, Resurrection, Frank* which all revolved around themes of love, redemption, loneliness and nihilism. Themes that recurred through his life's work.

He formed his own company – Nigel Charnock + Company – in 1995 but continued to make pieces for other companies in Britain and abroad.

At the time of his death he was working on TEN MEN for his own company, an excerpt of which premiered to great acclaim at the British Dance Edition showcase in February 2012.

Twenty-five or so years after I met Nigel he was still as vital as when I first saw him, *"the taut physical discipline of his fast paced energetic jazz dance routine would have been the envy of someone half his age"* (5 star review of Nigel's collaboration with Jazz musician Gwilyn Simcock in 2010).

In the world of contemporary dance to have your work referred to as a "jazz dance routine" would be an insult – not for Nigel. He took great inspiration from the philosophies behind jazz music and improvisation, and his later shows, the ensemble piece *Stupid Men* (2007) and autobiographical solo, *One Dixon Road* (2010) were largely improvisational. The only word from that review that he might have taken offence at was the word dance.

Nigel had a love/hate relationship with a lot of things, but dance as a form was up there in the top 5. He was critical about the lack of content in dance and most contemporary choreographers whom he believed hid behind a cloak of abstraction. For many years he tried to stop dance audiences from coming to see his work, particularly dance critics. *"They don't get it at all, for a start they don't think it's dance,"* he said. *"The best audiences for me, if I can get them, are ordinary people, the people who don't go to theatre"*.

There maybe an element of defensiveness in his statements but Nigel was scathing about the elitism of contemporary dance and ballet and this underscored his dislike of arty pretentiousness: *"I'm more of an entertainer, I make shows really, I make pieces, I don't make work."*

Prophetically he said last year in a filmed interview *"I don't take anything seriously, oh well here we go, let's do this – come on you're not here for very long, you could get cancer tomorrow, it's only life, its really not important"*. But if you believed every word Nigel said on stage you'd be fooled. He was a bundle of contradictions and embodied them. He took many things seriously and rallied fearlessly against religion, homophobia, bad hairstyles and whatever was topical that day.

In 2007, during a performance of his improvised solo *Frank*, he inadvertently caused a cultural furore by dancing on the Armenian and British flags. The Armenian Minister for Culture said *"it is unacceptable for us that someone who is considered a national treasure to Britain would bring such low-quality art to Armenia."* It was reported that some audience members likened the solo to a "strip act" and felt uncomfortable because it challenged their "conservative definitions of art". Thank goodness he did. I have only given a handful of shows a standing ovation and his *Frank* was one of them, and that was Nigel's power. When he hit the spot, and usually it was with his solos, he provoked and awoke audiences – there was nothing he wouldn't say or do. With incisive wit he spoke aloud his private thoughts and ours. Who is doing that today? Who will take his place? He was an original, so why should we expect a copy.

A week before Nigel died, emaciated, frail and heavily sedated with painkillers, he was photographed in the bath grinning ecstatically holding the Olympic

torch – yes the official thing. Later that day he was found in the hospice gym. Even until the day before he died he was there, on the static bike, trampet and treadmill. As the hospice doctor treating Nigel said, *"he's outside of my usual experience"*. I couldn't agree more.

Nigel is survived by his two elder brothers Andrew and Peter, and he died surrounded by his closest friends and partner, Luke Pell.

'Nigel Charnock 1960-2012' was originally written by Lloyd Newson at dv8.co.uk, August 2012, https://www.dv8.co.uk/pages/nigel-charnock-1960-2012

Rose Finn-Kelcey Obituary

Guy Brett

Rose Finn-Kelcey, who has died aged 68 from motor neurone disease, was one of the most imaginative and inventive artists of her generation. No two works of hers are physically alike; each represents a fresh challenge, often to attempt the seemingly impossible – for example, to build a machine that would produce a perfect cube of mist floating in the gallery air, as in *Steam Installation* at the Chisenhale Gallery in east London (1992). An acute blend of ironic humour and deep seriousness informed her work, whether it was a performance, a gallery installation or a public commission.

Finn-Kelcey belonged to the generation that was caught up in the feminism of the 1960s and 70s, and she set out to find her individual voice, both as an artist and a woman. In an early work, *Song Sheet* (1977), she appropriated English, French and Welsh phonetic translations of the 17 cries of the magpie and vocalised them as part of a performance called *Her Mistress's Voice*. Her socio-political aims were combined with avant-garde experimentation, which centred on the belief that a work of art could be made of anything.

One of Finn-Kelcey's best-known works, *Bureau de Change* (1987), illustrates this process perfectly. At a time when she was restricted, as the result of a knee injury, to easily available materials, she saw on the news the announcement of the sale of Van Gogh's painting *Still Life: Vase with Fifteen Sunflowers* (1888) to the Yasuda Insurance Company of Japan for £22.5m. The powerful desire to respond critically fused with the idea of combining the coins and the painting. Finn-Kelcey made brilliant use of the colour variations of the loose change, new and old, as they corresponded with Van Gogh's palette.

The result was an exemplary "political" work, an argument in the form of an object. No words are necessary. Meaning resides in the utterly convincing transubstantiation of oil painting into money. Finn-Kelcey's installation sums up with wit and precision the duality of the place of art in our culture. At the same time the transformation the piece brings about has a strange beauty and could be taken as an unexpected tribute to Van Gogh's creativity.

Finn-Kelcey had a rural upbringing in Buckinghamshire, as part of a large, old-fashioned, conservative farming family. She showed early talent as an artist, attending Ravensbourne College of Art and Design and later Chelsea College of Art in London. She quickly gravitated towards avant-garde ideas, both in art and politics.

Yet, for Finn-Kelcey, feminist empowerment did not preclude the feelings of vulnerability and lack of confidence to which everyone is prone. In *Book and Pillow* (1978), she imagined the unimpressive side of herself as a "small being" that continuously disrupted and manipulated her life. She commissioned a model-maker at the Natural History Museum to create an effigy of this being from her written descriptions. The result was a tiny homunculus, which Finn-Kelcey then mounted in a Perspex "book" lying on a pillow with a magnifying glass next to it. As you peered at the imp through the magnifying glass you leaned against the pillow, which activated the irritating sound of a fly buzzing about the room.

Finn-Kelcey was one of the few contemporary artists to tackle the issue of religion in their art. Many of her recent works explored this theme, among them *God Kennel – A Tabernacle* (1992); *Pearly Gate, Souls* and *Jolly God* (all 1997); *God's Bog* (2001); and *It Pays to Pray* (1999), a work in which contemporary "prayers" were available from chocolate-vending machines mounted outside the Millennium Dome.

What can God mean today? What is the spiritual in contemporary society, and where can it be found? Finn-Kelcey responded to such questions with a complex mixture of reverence and satire, debunking and venerating, in ways that have lost none of their capacity to surprise.

Finn-Kelcey fell ill just after the publication of a comprehensive book on her work, *Rose Finn-Kelcey* (2013). Such a guide was badly needed, not least because many of her works were ephemeral. She was a wonderful artist and a great person. Although punctilious in every detail of her performances and installations, Finn-Kelcey did not project an intrusive ego. She had many friends and was attentive to the well-being of each one. Of herself she said: "I work in the belief – or dare – that I can continue to reinvent myself and remain a perennial beginner."

She is survived by a brother.

Monica Ross: An Act of Memory

Lois Keidan

Lois Keidan is the co-founder and Director of the Live Art Development
Agency in London, and a member of the Advisory Board of Contemporary
Theatre Review. *The Live Art Development Agency advocates for Live Art in the UK
and Europe, advises artists, institutions, and curators, and publishes books and DVDs
on and by Live Art practitioners.*

This is an act of memory about *an act of memory.*

I had the pleasure of knowing Monica Ross since the late 1980s, when I
became immersed in the world of performance art through my work at
Midland Group, Nottingham; the Arts Council England; and the Institute
of Contemporary Arts in London. Monica was one of the most politicised,
uncompromising yet generous artists I've ever known – an artist who
used all the active ingredients of performance art – presence, process, and
participation – to create complex, experiential, and socially engaged works
whose impact registered in all kinds of ways. At home in the gallery, on the
street, in a range of charged locations, on the page, or the screen, her practice
set out all kinds of possibilities for what performance could be and what
embodied actions could do.

I want to remember Monica, here, in relation to one particular body of work,
Anniversary – an act of memory, which took the form of a series of recitations of
the *Universal Declaration of Human Rights (UDHR)* from 2005 until her death
in 2013. There are no big theories here, in my writing about this work – but,
rather, a personal account of an extraordinary project by an extraordinary
artist.

In 2006, the Live Art Development Agency (LADA) were Queen Mary
University of London's cultural sector partners on that year's Performance
Studies international (PSi) conference – *Performing Rights* – which focused on
the inter- sections of performance and human rights. The artistic programme
we curated, in dialogue with the conference, set out to reflect the kinds of
creative strategies artists were using to effect social, cultural, and political
change; to illustrate new models of relationships between art and activism; and
to consider the role and responsibilities of artists, curators, and performance
itself, in the understanding, enactment, and sustenance of human rights. It was
a no-brainer that we should invite Monica Ross to revisit a work she had made
in 2005, *Rights Repeated – An Act Of Memory.* In that year, in response to the
shooting of Jean Charles de Menezes by the police at Stockwell Station, she had
decided to try and learn the *UDHR* by heart and she first attempted to publicly
recite it from memory in Beaconsfield's *Chronic Epoch* season. For *Performing
Rights,* Monica performed *Rights Repeated* in the chapel at Queen Mary, and
then at Tramway in Glasgow when we were invited to present a mini-version of
Performing Rights for the annual National Review of Live Art in 2008.

From *Rights Repeated*, Monica developed *Anniversary – an act of memory*. The work was first presented at the British Library in 2008 to mark the 60th anniversary of the *UDHR* during the exhibition *Taking Liberties: The Struggle for Britain's Rights and Freedoms*[1]. *Anniversary* was a series of solo and collective recitations in 60 acts performed by Monica and hundreds of co-reciters that took place between 2008 and 2013 within a vast range of communities and contexts, and in over 50 languages, including endangered, Indigenous, and sign languages. Always the same but always different, there were recitations on World AIDS Day, Martin Luther King Day, and International Women's Day. There were recitations at performance festivals, within operas, in museums, libraries, universities and, community centres. There were recitations with refugees, artists, activists, children, and choirs. There were recitations in England, Scotland, Ireland, Spain, Germany, and Switzerland. The final recitation, *Act 60*, was performed at the 23rd session of the United Nations Human Rights Council in Geneva, Switzerland on 14 June 2013 – the day that Monica died.

In 2010, Monica and her then-producer Jason E. Bowman proposed that LADA publish a DVD series of film and photographic documentation of *Acts 01-30*, as part of our open call DVD on-demand series. This was exactly the kind of proposal we'd prayed for with the series – a beautifully conceived document of a hugely significant body of work, that in and of itself demanded to be seen by wider audiences, and which understood performance as a 'generative medium', and the new forms and strategies through which its ideas *could* be more widely and accessibly disseminated. As with everything else she did, Monica worked tirelessly and meticulously, editing and orchestrating the massive amount of material she had accumulated of and around the project for its new life as a DVD. We published acts of memory 2005–2010 in 2011 and it continues to be one of our most popular and influential titles.[2]

In 2010, I was asked to say a few words about the project and the relationships between performance and human rights as part of the *Act 30* collective recitation in King's College London Chapel during the College's *Inside Out Festival*, which invited the public to think about the ways violence and memory affect our lives.

I talked about the different Live Art contexts in which the *UDHR* 'lives' – about artists whose practice is driven by ideas of social and environmental justice such as the vacuum cleaner and other anti-capitalist activists; about artists whose work playfully confronts issues of human rights, like Richard DeDomenici who created a boy band with asylum seekers to influence teenage girls' attitudes to refugees (*Fame Asylum*, 2006); about artists who embody the lived experience of human rights violations, like La Pocha Nostra's rituals around post 9/11 body politics; and about artists who were working with the material form and declamatory content of the *UDHR* itself, like *LEIBNIZ* whose *The Book of Blood: Human Writes* (2006) invited audiences to donate a single drop of blood each with which to write one letter from the *UDHR*; and, of course, Monica Ross, and her internalization of the *UDHR* and her attempts

to recite it from memory as a collective act. That evening, *Acts of Memory* was performed by artists, lawyers, scholars, curators, campaigners, and community activists. Against the background of escalat- ing global injustices, and with the impact of the new UK Conservative Government hitting hard at home, each and every article of the *UDHR* was charged in a way I hadn't experienced before, and I felt the urgency of this work, and the potency of Monica's commitment to 'embody a struggle for personal and public memory and the attainment of human rights as a continual process of individual and collective negotiation and re-iteration'.[3]

My next encounter with the project was equally charged. It was Act 37, a collective recitation performed at LADA's then base, Rochelle School in Shoreditch, London in 2011, for Platforma's *Counterpoint Festival* of work by and about refugees. That evening the *UDHR* was recited entirely by migrants in their native languages, in an overwhelming powerful embodiment of *Counterpoint's* intention to 'explore Edward Said's idea that through their simultaneous awareness of different realities, exiles, refugees and migrants can create a uniquely plural vision of society, questioning the notions of objective reality and suggesting new ways forward'.[4]

Until today, my most recent encounter with *Anniversary – an act of memory*. was no less charged, but in different ways. It was on Saturday 14 June 2014, when we hosted a collective recitation by Monica's friends and family in our new base at The White Building in Hackney Wick, London, to mark the first anniversary of both Monica's death and the culmination of the project at the United Nations in Geneva.

Anniversary – an act of memory was an extraordinary project and one that I feel privileged to have been associated with, in some small way, since 2006, as curator, commentator, publisher, host and, best of all, witness. It was a project that represented everything that Live Art *can* do and *can* achieve – the strategies artists *can* use to effect social, cultural, and political change, to create new relationships between art and activism, and to test the role art *can* play in the understanding and enactment of human rights.

Acts of Memory was not art *about* politics, but *was* in itself an act of politics. On her death, Monica's partner Bernard G. Mills wrote: 'The sixty performances may have reached their conclusion as a series but it is a sincere hope that others may be encouraged and inspired to continue the endeavour to promote human rights throughout the world and if using *Anniversary – an act of memory* as a model or template, Monica would be only too delighted'. I know that many others do continue the endeavour, encouraged and inspired by the things Monica Ross made possible. She is a much missed artist, but her influence and impact lives on in *an act of memory*, and for this work alone she will never be forgotten.

1. British Library, 'Taking Liberties: The Struggle for Britain's Rights and Freedoms' <http://www.bl.uk/onlinegallery/ takingliberties/index.html> [accessed 25 March 2015].

2. Unbound <http://www.thisisunbound.co.uk/index.php> [accessed 25 March 2015].

3. 'Recitations', *acts of memory* <http://www.actsofmemory. net/> [accessed 2 April 2015].

4. 'Counterpoint Multidisciplinary Event', Platforma, 25 November 2011 <http://platforma.org.uk/events/ counterpoint-multidisciplinary-event> [accessed 14 April 2015].

Lois Keidan is the co-founder and Director of the Live Art Development Agency in London, and a member of the Advisory Board of Contemporary

'Monica Ross: An Act of Memory' was originally written by Lois Keidan and published in *Contemporary Theatre Review*, 25.2 (2015), 288-91, reprinted by permission of the publisher, Taylor & Francis Ltd.

R.I.P. Frank Moore June 25th 1946 – October 14th 2013: American Hero, Revolutionary Artist, Shaman, Poet, Wounded Healer & Great LUVeR

Susan Block

The world just lost one of its greatest artists. Frank Moore passed away this morning from the effects of double pneumonia. Frank was, without a doubt, one of the most marvelous people with whom I have ever had the honor and pleasure to work and play. Though I'm happy to hear he left this world peacefully, surrounded by his beloved family and friends – Linda, Mikee, Corey, Alexi and Erika – I can't deny the grief I feel, tears falling as I contemplate his loss.

Frank meant so much to me, to Max and to so many others, and so many wonderful memories are swirling through my head along with the pain of missing him. It's hard to know where to start with this little spontaneous remembrance. So please forgive me, as I'm sure Frank would, if I skip around a bit as I try to pay him tribute now, on the day of his passing, for the benefit of those of you who knew him, as well as those who didn't.

Frank was a man of tremendous, breathtaking accomplishment. An award-winning counter-culture hero, artist, poet, philosopher, rock star, filmmaker and happily married man, Frank was my U.S. Presidential running mate in our amazing 2008 campaign, the producer of *The Dr. Susan Block Show* on Berkeley public access TV as well as hosting and producing his own groundbreaking shows and an underground Internet radio station. Yet the first thing many people noticed when they saw Frank was his physical "condition." That is, in addition to being all of the above and so much more, Frank happened to be quadriplegic.

Born with severe cerebral palsy that rendered him unable to walk or talk, Frank conquered what some might call his extreme "disabilities" to become one of world's foremost performance artists, deep thinkers, political leaders and inspirational teachers. The Steven Hawkings of Erotic Theater, Frank coined the term "chero," combining "chi" and "eros" to express the physical energy of life. He also created the word "eroplay" to describe the physical interaction between adults released from the linear goals of typical sexual intercourse, often in the context of long, 5-48 hour ritualistic performances. These performances, which I was privileged to participate in when he and his wonderful family were my guests here in Bonoboville, were transformative experiences that melted the barriers between participants, performers and audience. As such, Frank Moore was the ultimate wounded healer, a differently-shaped medicine man, a spastic magician, a wild shaman and a trickster lover, inspiring so many people, from performance artist Annie Sprinkle to

Berkeley councilman Kriss Worthington. Of course, some folks feared his tremendous power, especially certain old-guard Republicans. In the early 90s, he rose to national fame as one of the NEA-funded artists targeted by then U.S. Congressman Jesse Helms for doing art that was labeled "obscene."

I first met Frank on the web back in 1996, when his LUVeR Radio was one of the first Internet radio stations (along with RadioSUZY1). I invited him on my show when we were broadcasting from the old *Villa Piacere* in the Hollywood Hills. It turned out to be an even more exciting evening than we expected, since we were raided by the LAPD! We weren't doing anything illegal, and we weren't charged with anything; the cops probably just wanted to check out some of the hotties in high heels and lingerie that were starting to frequent the show since our HBO specials. But, this being my first raid, I was nervous, and I distinctly remember Frank calming me down. As a committed artistic and sexual revolutionary, he was thrilled to be raided. Wiggling around in his wheelchair with a mischievous grin on his face, communicating through his pointer on a symbol board with the help of his amazing wife Linda Mac, Frank helped me to relax and take pride in doing a show that was revolutionary enough for the LAPD to pay me a visit.

We became friends, did some awesome live shows together in LA and Berkeley, and defended Berkeley Public Access from the kind of censorship that eventually took down Public Access in Southern Cali. We also enjoyed much eroplay together, including one rollicking night in 2005 when the Cherotic All-Star Band played on DrSuzy.Tv, and I rode Frank's rigid arm into an ecstatic industrial groove. Frank was a vibrator virgin, but being the open-minded and open-legged gentleman that he is, he agreed to give my Hitachi a whirl. At first, he wasn't too impressed, but when I sat on his lap as I rotated the vibrator between his legs, he gave it, on a scale of 1-10, a 12. Sometimes even the best machines need a human touch to make them hum. Frank was all about the human touch. He was also quite the Ladies' Man, always surrounded by sexy, often naked women. Whenever my male clients with disabilities complained about how difficult it was for them to connect with women, I told them to learn from the master, Frank Moore.

When Frank decided to run for President (yes, of the United States), he asked me to be his running mate. Of course, I accepted. I'd run for Prez myself against a different Bush in 1992, and I was happy to take a supporting role to Frank's vision this time. Of course, write-ins never win, though the *San Francisco Chronicle* reported that we got a whopping 6,566 popular votes across America. We're not sure how accurate that was, yet the point of our campaign wasn't "winning," but to inject an eroplayful, progressive shot of "hope" into America's bloodstream. Read Frank's platform, and you'll see what I mean.

Whether running for President or orchestrating a love-in, Frank always said he had the perfect body for doing performance art. It was true; you couldn't take your eyes off him. And then there was that wild mind – steeped in the ethos of the swinging 70s and the living theater of Antonin Artaud, Jerzy Grotowski

and Richard Schechner. He was also a painter who painted with a brush attached to his head before he started digital painting on the computer. But what may have moved me most about Frank was his poetry.

So I'd like to close this tribute with a re-post of one of my favorite Frank Moore poems. I read it on my Wonderful Weirdos show. The poem, *Mutation is Evolution*, seems to me to be about how weirdness – whether physical "disabilities," psychological uniqueness or sexual "deviance" – is a form of mutation which, as every elementary science student knows, drives the vehicle of evolution. Therefore, society represses and tries to eradicate weirdness at its own risk. Without the mutating power of the weird, we'd all still be single-celled organisms living in perfect, life-stultifying uniformity.

Mutation is Evolution
by Frank Moore

you foolish idiot!
You want to make
everything,
everyone
normal!
You want to cure
prevent
all crips,
freaks,
crazies,
oddballs,
slow ones
misfits,
bums,
artists,
poets,
and all other impractical
different looking
strange mutations
you fool!
How to condemn the human species
to extinction!
Look...
the game of evolution is
change by experimentation.
We freaks are the experimenters
the name of the game
is flexibly adapting
coping
leaping
risking into the unknown newness
of uncontrolled future

we crips,
we misfits have always been the adapters,
the leapers
hell,
I'm not wasting my time
talking to you about magic and such
just about evolution
well,
if you don't need us crips,
us misfits
if you don't need us no more...
our advice is
don't breathe deep
in your air-tight coffin
of normalcy
and move very slowly
very carefully
in your thin-skinned world
of ever increasing fragility
oh yeah...
good luck!

Good luck to you, Frank, wherever you are. With or without that perfect body of yours, I'm sure you're doing fine. As for me, I will miss you more than I can say. But I will continue to "freak" and experiment in your cherished *cherotic* memory.

And keep that arm rigid for me, Frank, I'll be riding it again any day now...

'R.I.P. Frank Moore June 25th 1946 – October 14th 2013: American Hero, Revolutionary Artist, Shaman, Poet, Wounded Healer & Great LUVeR' was originally written by Susan Block for *Dr. Susan Block's Journal*, October 2013, http://bloggamy.com/frank-moore

Ian White (1971–2013)

Emily Roysdon

TIME IS MOST ACCURATELY NAMED A *FORCE*. Yet to name something is to have power over it, and we have no power near time. We only know it through its effects. How it transforms subjects, objects, sounds, institutions, interests, friendships, bodies, and ideas. The force of time: dispersed and sensed. Ian White is a force. A particular combination of wit, integrity, intelligence, generosity, and ferocity that accumulates into force, a force with a smile. A force now known through its effects.

The last time I saw Ian we talked a lot about time. Not because he was stricken with terminality, but because we are always talking about performance. There were several themes in our conversations that never abated: the pleasure in a limit (he later wrote "limit as material"), an economy of means, construction of audiences, and the curatorial collaborative. These ideas would appear in different guises in different projects, but they were part of what attracted us to each other's work. And that's how we met. Emma Hedditch showed Ian my first video, *social movement*, 2003, and my memory of his response, albeit through Emma, was "this is weird, oblique, but I can't stop thinking about it." A sort of "just strange enough" to keep looking, looking at the twenty-four-year old-lesbian New Yorker.

I see now, in this retrospective activity created by his passing, October 26th around 1 AM, I think Ian was one of the first people who paid attention to my work who wasn't my friend. He knew *it* before me. And I see that since 2007 Ian and I have always had a date in our calendars. Always a bridge to an event for a conversation that turned into long-term collaboration. In the early years it was he organizing screenings with me. In 2009 I was able to commission a new performance from him for the "Ecstatic Resistance" show at Grand Arts in Kansas City, Missouri. On and on, every variation of working together, reciprocal invitations, top-bottom processes, and camaraderie.

The new performance he made in 2009 was called *Democracy*, and the first line of the obligatory statement was, "Democracy is about not having a choice, obviously." For this performance he stood on one leg while the BBC played live from a nearby radio. Soon started a slideshow of high British gardens: manicured, prescribed, natural. Ian waited a bit, took his pants down to one ankle and proceeded with a structured walking gesture that he continued until the legal end of the property. In Kansas City that meant he gestured through a parking lot and to a downtown street corner. In NYC, it meant out onto the sidewalk of the old Dia on Twenty-Second.

When Ian was diagnosed with cancer he started a blog, a little something for his fans. "Lives of Performers" it was called, after the famed Yvonne Rainer film. "Lives of Performers" punctuated his chemo treatments and his days

about in London: at the National Gallery with Gainsborough, films with Mike and Rachel, piano recitals with Grace, in Brighton with his love Harry, at the treatment center in Dagenham with his cackling swollen-ankled neighbors of yore. Ian faced his cancer with candor, saying, "For one thing, life is always lived under some condition or other. But what's more is that [the perspective 'life plus cancer equals minus life'] would be too much like not doing anything at all even though 'minus life' is no more 'death' than life without the minus is 'liberation'. I am not experiencing either of these right now anyway." He suffered as we all would, he wanted to live and I felt that so strongly, but the force of Ian pushed on, present in the struggle. Educating doctors who are "absurd because they have logic on their side and that's always kind of humiliating and disorientating." Continuing to work, to write, "writing as the theatre itself." Theorizing liberation and not looking for redemption. Occupying the margin of form, of institutions.

The last time I saw Ian luck was on my side. He had invited me to be a guest in his monthly Associate Artists Programme (AAP) meeting at LUX; a participating artist would present and then the guest, one hour each. The presenting student called in absent and to my complete delight Ian took the charge to reflect on his own method. "The work I'm interested in, and making, subjects to time what might not ordinarily be so. This is political." His method was to "accumulate without an attempt to persuade," to provide a "chance for re-ordering." The gaps, questions, affiliations, and permissions that emerged from his forms, these were the theater themselves.

On this harmonious day when we once again shared a vocabulary, Ian brought all the present working and writing and years of curating into the fold of his reflections. He went first, I after. And our presentations zippered together like the black and white keys on a piano. I was theorizing "discompose" and minor theater, and he suspension and a theater of separation. I have six pages of handwritten notes from that day. I have Ian's typed preparatory notes. I have what I heard, and what he said. We hadn't talked work in a while, a long time, and our dialogue was as tuned and intimate as ever. We hugged about our symmetries over a beer, he put me in a cab, and hopped on the southbound bus.

I fell for Ian's challenge and integrity. There was no escaping with him, no redemption, no cowardice, and nowhere to hide. I felt embraced by this fact, this force of realism, this impetus to glorious survival. Ian had a matter of fact-ness about struggle and complexity, of course, and so, nothing to do but do things right.

In the end you cannot name a force.

I can only acknowledge the effect it has on me.

'Ian White (1971-2013)' was originally written by Emily Roysdon for artforum.com, 5 November 2013, http://artforum.com/passages/id=43906

José Esteban Muñoz (1967–2013)
Jennifer Doyle and Tavia Nyong'o

THE WORK of José Esteban Muñoz – as a student, a teacher, a writer, and a friend – was electrified by his desire to tip the world toward something joyous in the face of intense opposition to that joy, toward a place that is more just and generous, but also more ferocious.

José's lifelong passion was to express the utopian gesture that responds to the awfulness of things as they are. The work of balancing hope against despair ran through his writings from the earliest to the most recent, and it was a work he associated with the queer, the minoritarian, and the brown. Under his attention, those terms became not generic categories but critical passageways. *Queerness*, for José, named the possible but also the "not yet." The "sense of brown" (both the title and the subject of one of his books still forthcoming from Duke University Press, and first theorized in a seminal essay on the playwright Ricardo Abreu Bracho) indicated a form of discontinuous commonality, "not knowable in advance" but actually existing as a world, in the here and now. He mined a Marxist tradition that included Althusser, Bloch, Adorno, Fredric Jameson, and Jean-Luc Nancy, and used this radical tradition to show how the affirmations in his work required negations of and deviations from the status quo.

"The challenge here," José writes in an essay on the LA punk band The Germs, "is to look to queerness as a mode of 'being-with' that defies social conventions and conformism and is innately heretical yet still desirous for the world, actively attempting to enact a commons that is not a pulverizing, hierarchical one bequeathed through logics and practices of exploitation."[1] There was something heretical about his own work in the academy, the art world, and everything betwixt and beyond them. In making a world for himself in which to flourish, he couldn't help but build one for others too.

Born in Cuba in 1967, brought to Miami by his parents as an infant, José Muñoz was always on the move. Leaving the Cuban-America enclave of Hialeah, where his youth played out to the sound of bands like X and the Gun Club, he studied at Sarah Lawrence College, where he first read Cherríe Moraga's *Lo Que Nunca Paso por Sus Labios* (*Loving in the War Years*, 1983), which became for him a touchstone (especially its chapter, "La Guera"). José then entered Duke University's doctoral program in Literature, which at that time was at a high point of prestige and influence. Under the guiding love and friendship of his mentor Eve Kosofsky Sedgwick, and among a precocious, brilliant cohort of fellow students, José, a rising star and only twenty-six years old, was hired to teach at NYU's Tisch School of the Arts. He brought the "symposium of Eve" to "the broke-ass institute," as his friend Fred Moten put it in a poem for José that appears in Moten's 2010 collection, *B Jenkins*.

When he arrived in Greenwich Village in 1994, José planted himself at the center of a circle of influence that would expand over a short two decades. His home functioned as a true salon. The most ferocious personalities conspired amid stacks of comic books and philosophical treatises, surrounded by punk ephemera, the remnants of late-night sessions, toys belonging to one of his adored animal companions, piles of manuscripts, and friends' artwork. "José had this endless stamina for socializing," friend and dramatist Jorge Cortiñas remembers. "It was a wonderfully seamless way of engaging with art and with artists."

José brought to the academy an archive of film, art, and performance that still astonishes readers of his first book, *Disidentifications* (1999). And he interpreted this archive using a sturdy theoretical apparatus that was never directed toward its own legitimation, but was instead devoted to the value of queer and minoritarian life, and to the mourning of queer and minoritarian loss. For José, experimental art, performance, and poetry were keys to "the practice of survival." Prescient readings of the work of Félix González-Torres and Isaac Julien (attending to the forms of queer exile that shape the aesthetic practices of both) sit alongside groundbreaking writing on figures who, at the time, had received little or no critical attention. From the very beginning of his development as a thinker, he formed intense and collaborative relationships with artists. Vaginal Davis, Carmelita Tropicana, and Nao Bustamante figure heavily in his thought, and he figured heavily in their lives as an advocate, a friend, and as a critic. "José's serious engagement with artists' lives, practice, and work," social theorist John Andrews observes, "has changed how many academics conceive the practice of theorizing. His work as a theorist countered the more rarefied modes of how academics and art critics use and produce theory."

The list of other artists whose careers José supported through his advocacy, his intellect, and his friendship is vast: Wu Tsang, Justin Vivian Bond, Kenny Mellman, Marga Gomez, Tony Just, Miguel Gutierrez, Jorge Cortiñas, Michael Wang, Kevin Aviance, and Kalup Linzy to put names to some. José sought links among artists few had the capacity to imagine as part of the same world. His second book, *Cruising Utopia* (2009), an exciting antidote to both mainstream gay and lesbian politics as well as to the "anti-social" turn in queer theory, set LeRoi Jones's play *The Toilet* in conversation with the philosophy of Ernst Bloch, the paintings of Luke Dowd alongside performances by Dynasty Handbag and My Barbarian or poetry by Frank O'Hara and Elizabeth Bishop. Some of the book's most moving passages grow from his familiarity with a wide range of gay scenes in New York City and beyond, especially those off the white, homonormative map. Underground and experimental social spaces were as important to him as Marxist philosophy and queer theory. He encouraged people to follow him, as a thinker and happy participant, into those zones.

In José's writing a performance, painting, photo, or literary text is not merely an "object of study" but a philosophical encounter, one that sits alongside other kinds of encounters, moments of collision and contact. For this reason, in his writing he did not lead with the information that facilitates the absorption of an artist's work into the academy (a defense of the work's relation to a canon, to art history

351

narrowly imagined, to a disciplinarian articulation of "performance"). He offered instead a language that invites the artist's work into the reader's life, by way of his thinking. He drew other scholars into conversation about his muses, his Furies; his experiences of their work were not intended to be "his" but "shared out."

José redefined the meaning of "academic superstar" in Warholian terms: He had a way of finding beauty in what others considered to be their own damage, recalls Jonathan Flatley, a friend and co-editor (with Jennifer Doyle) of *Pop Out: Queer Warhol* (1996). José quickly transformed the academy not only through his writing but through his mentorship of a generation of scholars, many of who now work at some of the country's most dynamic and prestigious departments.

And so we met the news of José Esteban Muñoz's death on December 3, 2013 with a collective howl. A constellation of artists, writers, curators, and scholars have spent the winter shaken by paroxysms of grief: José's lifework as a philosopher/critic, which includes his practice of friendship, has been so integral to this community that we feel as if the very ground beneath us has disappeared.

On February 8, at a memorial gathering at NYU, Justin Vivian Bond and Kenny Mellman reprised Kiki & Herb's rendition of "Total Eclipse of the Heart" in tribute to José. Later that afternoon, Carmelita Tropicana welcomed his friends to a Village basement bar, where filmmaker Guinevere Turner roused the crowd with a performance of her correspondence with José; the electronic duo Matmos staged a "Germ Burn for Darby Crash" in his memory; Miguel Gutierrez amplified a farewell "I love you" into a gorgeous sonic loop; Gus Stadler and Barbara Browning sang their cover of "Take Ecstasy With Me"; Kay Turner led a rousing reprise of *Cruising Utopia* as a punk anthem; and Nao Bustamante, wearing a nude body suit and veiled in the black cloud of a Vegas widow, planted herself face down on the stage and tore through "Lara's Theme." Nao peeled the skin off its lyrics ("Someday my love..."), marking out the distance between its sweet fantasy and the place we are in here and now. Then she rolled and crawled across the floor, from the front of the stage to the back of the bar.

Jennifer Doyle is a professor at the University of California, Riverside.
Tavia Nyong'o is an associate professor at New York University.

[1] José Esteban Muñoz, "'Gimme Gimme This... Gimme Gimme That': Annihilation and Innovation in the Punk Rock Commons, *Social Text* 31, no. 3 116 (Fall 2013), 95–110.

'José Esteban Muñoz (1967-2013)' was originally written by Jennifer Doyle and Tavia Nyong'o in arforum.com, 14 March 2014, http://artforum.com/passages/id=45540

Remembering Wojciech Krukowski (1944 -2014) the founder of Akademia Ruchu (Academy of Movement)

Krystyna Lipińska Illakowicz

In November 2013 Wojciech Krukowski still walked among New York crowds at Times Square when the members of Akademia Ruchu (Academy of Movement) were performing their action as a part of the Performa 13 project. His presence was also strongly felt during the performance of *The Chinese Lesson* at The Segal Center (even though he only observed it from behind a column of the theatre). The friends of the Segal Center and the Academy of Movement had a chance to talk to Wojtek for the last time after the performance of *The Chinese Lesson* this past November. He died not a long time later, in January 2014 in Warsaw, Poland.

All his life Wojciech Krukowski was devoted to a variety of unconventional artistic and theatrical events and in 1973 he created Akademia Ruchu that crowned his artistic ideas and at the same time became a point of departure into new, experimental ventures. Akademia Ruchu known as the "theater of behavior" combined performative actions and visual arts creating politically charged interventions in all sorts of public and sometimes private spaces. Involving regular bystanders, the actions politicized the society and to a great extent contributed to the erosion of communism.

After the fall of communism in Poland in 1990 Wojciech Krukowski, an art historian by profession, became a director of the Center of Contemporary Art, Zamek Ujazdowski, in Warsaw and he held this function till 2009. Since then he devoted all his energy to his creative activities.

It is hard to imagine experimental performance without the invigorating presence of Wojciech Krukowski, one of the most humble, but at the same time innovative artists and organizers of cultural life in Poland. His ideals and concepts will be continued by his wife Joanna, and the remaining members of his ensemble that decided to keep the Academy of Movement moving.

Krystyna Lipińska Illakowicz teaches Polish language, theatre, and film at Yale University. She writes on Polish-American cultural exchanges, theatre, and film. She has published both in English and Polish about Witold Gombrowicz, Bruno Schulz, Tadeusz Kantor, and others. Currently she is working on a book tentatively titled The Image of America in Poland *in the 1920s and 1930s.*

'Remembering Wojciech Krukowski (1944-2014), the founder of Akademia Ruchu (Academy of Movement)' was originally written by Krystyna Lipińska Illakowicz in *European Stages*, 17 June 2014, http://europeanstages.org/2014/06/17/remembering-wojciech-krukowski-1944-2014-the-founder-of-akademia-ruchu-academy-of-movement/

Professor Stuart Hall: Sociologist and Pioneer in the Field of Cultural Studies whose Work Explored the Concept of Britishness

Marcus Williamson

Tuesday 11 February 2014

The sociologist and cultural theorist Stuart Hall, who has died aged 82, was an intellectual giant and an inspirational figure in the field of sociology. He was one of the founders of what is now known as "British Cultural Studies", which Hall and his colleagues pioneered in the mid-1960s. Professor Henry Louis Gates of Harvard University called him "Black Britain's leading theorist of black Britain."

Hall saw Britain as a country which is forever battling, within itself and with other nations. "Britain is not homogenous; it was never a society without conflict," he said. "The English fought tooth and nail over everything we know of as English political virtues – rule of law, free speech, the franchise." He noted sardonically that "the very notion of Great Britain's 'greatness' is bound up with empire. Euroscepticism and Little Englander nationalism could hardly survive if people understood whose sugar flowed through English blood and rotted English teeth." To sugar can also be added tobacco and cotton, as commodities which remain as a reminder of slave-trade Britain and its cultural legacy.

Hall was born in Kingston, Jamaica, in 1932, one of three children of Jesse and Herman Hall, an accountant. "We were part Scottish, part African, part Portuguese-Jew," he recalled of his family background, while also speaking of his "home of hybridity", which gave him diversity by nature and curiosity by nurture.

Following studies at Jamaica College he emigrated to Britain in 1951 on a Rhodes scholarship to Oxford University, part of the Windrush generation of immigrants. The memory of sitting at Paddington Station after his arrival, watching the crowds, remained with him, accompanied by the eternal questions: "Where on earth are these people going to? And where do they think they are going to?". These questions and the quest for answers to them would characterise his life's work.

Hall commented on his time at Oxford that "in the 1950s universities were not, as they later became, centres of revolutionary activity. A minority of privileged left-wing students, debating consumer capitalism and the embourgeoisement of working-class culture amidst the 'dreaming spires', may seem, in retrospect, a pretty marginal political phenomenon." He also recalled that "I began not as somebody formed but as somebody troubled", suggesting that, "I thought

I might find the real me in Oxford. Civil rights made me accept being a black intellectual. There was no such thing before, but then it was something, so I became one."

The Universities and *Left Review* (later the *New Left Review*) was founded in 1957, with Hall at the helm for the next four years. Professor Robin Blackburn, a former editor of *NLR*, told *The Independent*: "Stuart was the first editor of *New Left Review*. As a young student, I was deeply impressed by him but didn't know him that well at the time. He gave these marvellous talks in the basement of the Marquee Club, with other members of the *New Left*. I was influenced by his explanations of the origins of racism and its cultural roots. He later developed an analysis of neoliberalism [in the review *Soundings*], showing that free-market ideas do have an enormous attraction but also have relatively fatal consequences. He was a profound thinker, who got people considering the challenge of a multicultural society and saw that there were great problems with the concept of a 'British' nationality."

Blackburn noted that Hall did not produce one major, defining single work but that his legacy, and brightest thinking, comes through in the collections of essays which he edited, and to which he contributed, such as *Stuart Hall: Critical Dialogues in Cultural Studies* (1996), which contains pieces by Hall and by those whom he had influenced.

Hall joined the Campaign for Nuclear Disarmament in 1957; in 1964 he married Catherine Barrett, who he had met on a CND march. The same year saw the first use of the term "Cultural Studies", by Richard Hoggart, and his establishment of the Birmingham Centre for Contemporary Cultural Studies (CCCS). Hoggart had read Hall's first book, *The Popular Arts* (1964), and invited him to become a director of the Centre. Hall later moved on to join the Open University as a professor of sociology in 1979, where he remained for the next 18 years. However, he retained connections with the CCCS until it closed in 2002, a victim of "restructuring" by the university's management.

Martin Bean, Vice-Chancellor of The Open University, said, "Stuart was one of the intellectual founders of cultural studies, publishing many influential books and shaping the conversations of the time. It was a privilege to have Stuart at the heart of The Open University – touching and influencing so many lives through his courses and tutoring. He was a committed and influential public intellectual of the new left, who embodied the spirit of what the OU has always stood for: openness, accessibility, a champion for social justice and of the power of education to bring positive change in peoples' lives."

In January 1979 *Marxism Today* published Hall's prescient, and now celebrated, essay, "The Great Moving Right Show", in which he discusses the early success of "Thatcherism", the term he coined for the then Leader of the Opposition's nascent policies. "The Heath position was destroyed in the confrontation with organised labour. But it was also undermined by its internal contradictions. It failed to win the showdown with labour," he argued. "It could not enlist

popular support for this decisive encounter; in defeat, it returned to its 'natural position' in the political spectrum..."

Hall suggested that, by contrast, "'Thatcherism' succeeds in this space by directly engaging the 'creeping socialism' and apologetic 'state collectivism' of the Heath wing. It thus centres on the very nerve of consensus politics, which dominated and stabilised the political scene for over a decade." Hall later said of Thatcher's policies: "When I saw Thatcherism, I realised that it wasn't just an economic programme, but that it had profound cultural roots. Thatcher and [Enoch] Powell were both what Hegel called 'historical individuals'."

In 1994 Hall became Chair of the Institute of International Visual Art (Iniva), now based at Rivington Place in London, which hosts solo exhibitions of British and international artists, including Kimathi Donkor, Hew Locke and Aubrey Williams. The Institute's library was named in his honour. From 1995 to 1997 he was President of the British Sociological Association (BSA).

Last year Hall was the subject of *The Stuart Hall Project* (2013), a film by the artist John Akomfrah, which premiered at the Sundance Film Festival. The film had its genesis in a three-screen gallery piece, *Unfinished Conversation*, currently showing at Tate Britain. Akomfrah told *The Independent*, "After working on *Unfinished Conversation* it struck us that there was a lot more material that we had not used. The idea was to see whether a single figure could sum up the post-migrant experience. Hall was last of the great titans, who fundamentally altered how we look at ourselves and how we lived. He was unfailingly kind, courageous and absolutely principled."

More than 60 years after his arrival in Britain, Hall's quest for cultural identity was still in progress. As he said in the film, "We always supposed, really, something would give us a definition of who we really were, our class position or our national position, our geographic origins or where our grandparents came from. I don't think any one thing any longer will tell us who we are." He noted with pleasure that, in asking anyone in London today the question of where they are from, "I expect an extremely long story".

Stuart McPhail Hall, sociologist: born Kingston, Jamaica 3 February 1932; married 1964 Catherine Barrett (one son, one daughter); died London 10 February 2014.

'Professor Stuart Hall: Sociologist and Pioneer in the Field of Cultural Studies whose Work Explored the Concept of Britishness' was originally written by Marcus Williamson for *Independent*, 11 February 2014, http://www.independent.co.uk/news/obituaries/professor-stuart-hall-sociologist-and-pioneer-in-the-field-of-cultural-studies-whose-work-explored-9120126.html

In Memoriam: Adrian Howells
(9 April 1962–16 March 2014)

Dee Heddon, Professor of Contemporary Performance Practice, University of Glasgow.

Suffering from a life-time of depression – a real killer of a disability – Adrian Howells chose to take his own life. If he were here, I am sure he would tell you about it.

As a performance maker, Adrian must have literally touched hundreds, if not thousands, of people. A trail blazer in the field of intimate performance practice, Adrian sought to use the shared time and space of live theatre to facilitate connections between people – often through dialogue and the exchange of personal stories (a confessional mode), but latterly, through the nuanced communication attached to touch.

I remember being greeted by him – in his persona of Adrienne – at the door of a kitschy 'living room' (erected in an abandoned shop), him holding my hands and asking my name. That evening, I collaborate happily with strangers to construct a collage of an 'ideal man' from magazine cut outs. (*An Audience with Adrienne*, 2006)

I remember having my hair washed by him and thinking of my mum. She washed my hair with a similar plastic jug. The memories flood back. We look at our reflections in the salon mirror and talk about aging. (*Salon Adrienne*, 2006)

I remember sitting with him on the sofa, his arm around me, being invited to choose a track from a box of CDs (I chose 'Hotel California', for nostalgic reasons). Then we spooned into each other on a double bed, lying in comforting silence for more than 30 minutes. I remember the weight of his arm, holding me close. (*Held*, 2007)

I remember sitting at a table in the Arches café bar, sharing memories about our mums – his now getting elderly and forgetful, mine long passed. (*The 14 Stations of the Life and History of Adrian Howells*, 2007)

I remember him washing my feet tenderly with his hands, taking my right foot and kissing it gently, saying 'Shalom' (Peace), then a kiss to my left foot and 'Salaam Alaikum' (Peace be with you). I walked lighter after. (*Foot Washing for the Sole*, 2008)

I remember sitting in a beautiful garden created inside Gilmorehill Theatre, eyes closed and pluck- ing strawberries gingerly from his fingers. For the first time, perhaps, I understood the utter strawberriness of strawberries. (*The Garden of Adrian*, 2009)

I remember dancing a slow dance with him, holding on tightly to each other as others looked on (but I don't remember the song we danced to). (*Won't Somebody Dance with Me?*, 2010)

I remember lying naked in the bath in a hotel room in Edinburgh, Adrian washing me carefully, and thinking 'this is what it will feel like when I am vulnerable and dependent'. (*The Pleasure of Being: Washing/Feeding/Holding*, 2011)

To be touched by Adrian was as metaphorical as it was literal.

Adrian wasn't always a creator of solo, intimate performances. Graduating with a BA in Drama and English from Bretton Hall in 1984, by the 1990s he was Assistant Director to Philip Prowse at the Citizens Theatre in Glasgow, and also began to perform with Nigel Charnock and Stewart Laing. In 1994, he appeared alongside Leigh Bowery and Ivan Cartwright in Laing's production of Copi's *The Homosexual*, at the Tramway and continued to support Laing as he launched his Untitled theatre company. In 2000, performing as Paradise Dupont in Mae West's *The Pleasure Man*, directed by Laing at the Citizens, Adrian met choreographer Linda Dobell. An invitation from Dobell to participate in a gallery show she was curating in London prompted his invention of Adrienne, an alter-ego Adrian described as 'less a drag queen than another version of me; a man wearing thick make-up and rather unglamorous, woman-next-door clothes'.

As Adrienne, Adrian began his quest for intimacy, a journey that he would continue for the next 14 years. Over time, the mask of Adrienne receded, leaving Adrian on stage – seemingly exposed in his realness; but we would be doing a disservice if we failed to recognize also Adrian as a consummately skilled and experienced performer. Whilst Adrian chose to make much of his personal life public through placing it within a performance frame, mostly, in its performance form, this was life reconstructed, given form and shape; life re-presented from a distance, with the benefit of hindsight.

The work was not without its risks and personal demands though, for there was no pretence in Adrian's care for and attention to his audience-participants. He wanted them to have what he referred to as genuine, real, and authentic moments of communication. He addressed each participant as an individual, and in his presence, in his absorbed and singular focus, you really did feel noticed and present. Leaving a performance, I always felt as though I had been carefully held, the weight passing from me to him. I left lighter. (So where, then, did all that weight go?) This was Adrian's generosity, his gift – and a gift he made to hundreds.

Adrian's intimate performance work has travelled around the world. He has tenderly tended the feet of strangers in Spain, Germany, Italy, Japan, Singapore, Canada, Australia, and Israel. This generosity extended beyond his performances too. Tweets and tributes left on Facebook testify to his impact on the lives of many students met through workshops he gave at the Universities of Glasgow, Lancaster, Queen Mary, Warwick, Royal Central School of Speech and Drama, the Royal Conservatoire of Scotland, La Salle Singapore, Helsinki Theatre Academy and The Jaffa School, to name just a few. Adrian also acted as a formal and informal mentor to many emerging practitioners – supporting them by believing in them.

Adrian's place in and importance to the academy is also marked by his spirit of generosity. An AHRC Creative Fellow at the University of Glasgow from 2006-09, and thereafter an Honorary Associate Researcher, Adrian collaborated with numerous academics, co-authoring articles, participating in research projects, responding to and meeting numerous PhD researchers, and presenting his own research at seminars and conferences. Repeated references to Adrian's work in recent issues of *Contemporary Theatre Review* give some – small – indication of his influence and impact; an influence and impact that will endure.

Adrian's belief in the potential of intimate performance to be a restorative force in our troubled world will, I am sure, be carried forward by those practitioners whom he touched so deeply – including his participating spectators. I only wish he could have applied some of his restorative magic to his own troubled soul.

'In Memoriam: Adrian Howells' was originally written by Dee Heddon in *Contemporary Theatre Review*, 24.3 (2014), 418-20, reprinted by permission of the author.

Ian Smith
Artist and performer
Born: January 2, 1959; Died: August 1, 2014.

Neil Butler

Friday 8 August 2014

Ian Smith, who has died aged 55 after a long struggle with severe depression, was an artist, performer, art gangster and mischief maker. He leaves a massive legacy of work and memories for the hundreds who have worked with him and his company, Glasgow-based Mischief La Bas.

If you have had your shoes washed by the Elvis Cleaning Company or seen a group of terrified Christmas trees being chased by a mad cartoon axe man, you will have seen his work. Or perhaps you attended a Festival Of Fudge or the Market Of Optimism or were lucky enough to be accosted in some far-flung Scottish village by a tribe of Vikings desperate to make amends for that burning and pillaging all those centuries ago.

Or maybe just last week you were astonished to see the Fan Families, six teetering towers of puppets moving amongst the crowds at the Commonwealth Games.

Ian Smith moved between making art and making entertainment with ease, confidence and charm. He was constantly creating and finding new ways of sharing his view of the world through every available medium: art to performance, radio and television to cabaret and circus.

He delighted in what he called weird and wonderful arty stuff and supporting those who experimented and challenged themselves with their art. But the hundred of messages that have flooded the internet following the news of his death talk not only of the extraordinary nature of his vision but also his generous, gentle soul.

He was born in London and decided at the age of 14, after a childhood of dressing up, that he was going to make his stamp on the world through performing. He was also a huge fan of David Bowie and had wardrobes full of T-shirts and Bowie paraphernalia.

He was a family man and he and wife Angie have given Stanley and Lily the most grounded, if surreal, family upbringing. He would kiss them goodbye and go to work – always immaculately dressed, whether in suit or perfectly

accessorised Hawaiian shirt, sometimes with a prop, such as a full-size triffid under his arm. Then he would come home and be a "pipe and slippers" dad.

Sometimes the children would be taken to work too – once to their delight being incarcerated in a cage as willing actors in his show *Painful Creatures*.

As one family friend said: "I have rarely met a dad who took such delight in his family. I loved the way he spoke about Stan and Lily as though he couldn't quite believe he and Angie had created such fabulous creatures. He took enormous pleasure in recounting their stories and was so very proud of everything they achieved."

In some ways, this family spirit was extended towards the entire madcap population of Dennistoun, most notoriously in the annual Smith family Guy Fawkes Party, which was famous for its anarchic and ritualistic display of dodgy pyrotechnics.

He and I met when, as a first year student, he came to help Roger Ely and myself run our Brighton Contemporary Art Festival in the late 1970s. We became close friends and over 35 years performed and collaborated together on hundreds of projects.

He and I toured the UK and Holland with solo shows, his band Birds With Ears, and the legendary Wild Wigglers that he had created with Liz Aggis and Billie Cowie.

In 1982, when we set up the Zap Club, it was inevitable he became master of ceremonies, a role he reprised as the hugely charismatic ringmaster of Archaos Circus and later as MC for the National Review of Live Art, where many young artists benefited from his boundless support.

But it was back at the Zap that he developed his extraordinary sense of timing and generosity to the artists and the long-suffering audience. He created the Tuesday Night Platform, a totally anarchic open mike event where he brought on performers of wildly varying talent with heart-warming enthusiasm. Whatever then transpired, Ian got them off stage with dignity.

We travelled together to Glasgow in 1988 to work on the Streetbiz Festival and then he and Angie ran away to join the circus and spent three years travelling the world before coming back to settle in Glasgow and form Mischief La Bas.

Some time later he wrote on the Birds With Ears page of www.punkbrighton. com: "We're all history baby! Warmest regards to all the survivors. Anyone wanting to check out our current nonsense can explore www.mischieflabas. co.uk, which apart from anything else might encourage "youngsters" to have faith in the fact you don't have to get a proper job or fall for the audition pop idol crap system – just form a band, dance company, circus whatever and get on with it. Make Mischief".

Mischief started in the Arches where he and Angie and artist Rachel Mimiec would make durational performance around the club, sewing each other into picture frames and endlessly peeling potatoes.

One of the highlights of their early collaborative relationship with The Arches' director Andy Arnold was the devising of *Metropolis*, a live multi-media project with 80 performers that used the whole building, another device he would use in subsequent projects. Over the years the company grew and with it a reputation in the UK and Europe.

He created a signature style of multiple characters and walkabout theatre that, while being entertaining and accessible, always carried an observational edge.

Building on the experience of *Metropolis* he created a series of commissioned large-scale indoor and outdoor shows, notably the crashing of a full-size space ship into Glasgow for the millennium. His solo shows were a revelation.

From the eccentric Hokey Cokey man filmed on a Sri Lankan beach, the beautifully delivered and poignant songs of Hurty Gurty Man, to the critically acclaimed intimate shows at Dance Base, his work was art of the highest order – performance becoming poetry.

He has brought us great joy and in the words of his Funny GI "and may his fame ever spread".

He is survived by wife Angie, children Stanley and Lily, parents Don and Heather and brother Alan.

'Ian Smith' was originally written by Neil Butler for *Herald Scotland*, 8 August 2014, http://www.heraldscotland.com/opinion/obituaries/13173806.Ian_Smith/

Joan Rivers

Karen Finley

Karen Finley

I love/d Joan. I was blessed to have a few conversations with Joan. After I was on her radio show – Joan took the time on occasion to reach out to me and talk to me. She was so audacious in her public life but very compassionate in her private life – we shared – and had a couple deep private conversations about the profoundness of life – suicide (her husband – my father) women comediennes – (especially Phyllis Diller) what women could talk about and how to present the (funny vs. desired) female body -comedienne – the audience gaze upon the female body – the funny woman – Joan had a very elevated conscious theoretical understanding about the gaze, the female declarative and mediating a space where the female voice could voice – but she also reached out to me to encourage me to continue to do the work I was doing – and to persevere – despite the consequences. I brought my students to see her work – her offensiveness – Joan didn't have to acknowledge me – but she did. I will try and be considerate of younger artists and reach out in Joan's memory.That is her legacy. I send love to Chip Duckett – just too much to bear – I am so upset at this out patient doctor debacle – and her wrongful death. My heart goes out to her family – Joan you took the time to acknowledge me. At that time after the NEA I did not have the opportunities and felt forlorn. But in that conversation you lifted me up. Thank you. I will try and be a better person in your memory.

Joan Rivers

This is my second posting on Joan Rivers

My first connection or what sparked Joan Rivers towards me was when I was speaking to her for an interview and I referenced Phyllis Diller – and spoke of the importance of Phyllis Diller. What we briefly discussed was that the female had to mediate the gaze (she used the term looking) of men without being too desirable…. We discussed how Phyllis Diller had to create a wacky unattractive body/presentation that wore outrageous clothes – so that she was distanced and not desired and othered yet not the other woman. And yes, Joan made that statement – she used the term the "other women." Female comediennes had to be aware of not being the other woman on stage. She told me "you couldn't be too sexy on stage." The other gazing was the wife watching the husband watching the "female" comedienne – and that viewing was considered trouble. Ms. Diller would deprecate herself – and her comedy heavily relied on the retelling of the fictional life and husband " Fang" to her audience. Ms. Diller became a court Jester – Harlequin and all.

363

What Joan Rivers challenged was to not to have to rely solely on the female connected/constructed to a male for qualification. While Phyllis Diller created a story line – where she was a butt of the joke with her not seen "imaginary" husband – Joan moved further from that small narrative to making celebrities, people in power the butt of her jokes. That transition was monumental for that placed Joan a woman in the position of authority. What her expression provided to a culture that is consumed with fame and money – is that she interrupted/subverted the fame, fortune and status of class. Disruptive Coitus Humor disrupted the class, the power and fame into the lives of ordinary people.

Her ability to hard hit and make fun of everyone and every stereotype was painful for me. And I imagine for you as well. And every time I saw her I would tell myself I would never see her again. Because I felt that my listening to the insults were participating with compliance. There were times I had to cover my ears. But that was the point – And when I was in the audience – many people knew what it was like to be laughed at off stage. In my brief conversations with her – She told me that if she was starting now in her career she would have more freedom to go beyond going for the laugh. To me that says that the laughter is in making fun of everyone, using every stereotype point where eventually everyone in the room gets made fun of – and that pain is to make you realize, aware of the hurt of others. And creates an opportunity through an inversion / compassion / compression.

But Joan had an additional otherness besides being a woman comic at a time when it was primarily men. She was a New York college educated Jewish woman comic genius – and the way she handled this was to deconstruct stereotypes and anti-Semitism by taking control of the response, mediating the thoughts and feelings of a Christian majority America. Can we talk?

Her construction of her own image was done before it was popular. That image is just that – skin deep. Her obsession and aggressiveness with a standard of presentation is only a mirror for living in a culture where the standard she grew up in was deferential, a small crucifix around the neck, blonde, thin and WASP. She could never remove who she was but she damn tried. A river runs through it. At the time Joan began her act – it was during the civil rights era she ventured from the mundane into the worldview. And although Lenny Bruce and George Carlin used the seven dirty words, Joan was the dirty word – a cunt. You better believe it.

Joan's war with Johnny Carson is pure sexism and misogyny. Joan refused to be deferential. "Yes, Mr. Carson. No, Mr. Carson. What do you want me to do Mr. Carson? "Why the hell did Joan Rivers have to be grateful and stay in her Kitchen guest spot – While Joan was Johnny Carson's fill in while the King was on vacation – Joan the hired help so grateful.... Other male hosts who had shows never felt the wrath such as Joey Bishop, Dick Cavett.... Because Joan didn't ask permission from Johnny. Because she didn't purr or just stay in her domestic role as fill in waiting for the calendar to open. Joan didn't know her place. The woman didn't know her place for she should be so grateful and

demure to be working for the charity, great benevolence and superiority of Nebraska man Johnny. What was Johnny to say yes? Was Johnny to say no? Exactly she did not need Johnny Carson to determine her self-determinacy and that was radical.

I didn't agree with some of Joan's politics – but her demand for equal access was bold and courageous. Humor is an allowed space when marginalized voices can express within dangerous contexts –and Joan took that opportunity for us.

Joan told Holocaust jokes. These jokes were horrifying – exactly – and to hear many of her jokes stung me. Yet Joan's husband's entire family died in the Holocaust. By taking linguistic emotional control of the destruction and murder through the replay of humor and language on her terms – deconstructs the absolution of the power evil – as if the laughing is at the taking down of the devil. She was totally aware of the taboo and offensive sentiment she insisted for us to listen too.

Her creative response to 9/11 takes apart the sentimental and rips apart with brutality and wit revealing the anxiety of tragedy.

Joan spit in the face of inhumanity by taking on the awfulness of human cruelties.

Recently her humor was about the aging of her own female body where her breasts got in the way of her walk. Her female body the sacred portal for laughter. The aging, dying body ...that we all live with.

From the reports Joan was having her throat, her voice checked for being so raspy. I just wish that at some point she could have felt that we loved her just the way she was. We loved that raspy voice. Joan, you didn't need to change a thing.

'Joan Rivers' was originally written by Karen Finley and posted to *Facebook* on 7 September 2014, https://www.facebook.com/karen.finley.144/posts/10204994347917268

The Live Art Almanac Volume 4

First published in 2016 by

Live Art Development Agency, The White Building,
Unit 7, Queen's Yard, White Post Lane, London E9 5EN
www.thisisLiveArt.co.uk

and

Oberon Books Ltd, 521 Caledonian Road, London N7 9RH
www.oberonbooks.com

Edited by Harriet Curtis, Lois Keidan and Aaron Wright

All images by David Caines

Designed by David Caines Unlimited

www.davidcaines.co.uk

Printed, bound and converted by CPI Group (UK) Ltd, Croydon, CR0 4YY

ISBN: 978-1-78319-322-6

Wherever possible contributions have been reprinted with the permission
of the author and/or publisher of the original contribution.

The Live Art Development Agency and Oberon Books would like to thank
everyone who submitted recommendations for the *Live Art Almanac Volume 4*,
the writers whose contributions are featured in this volume, and the publishers
who generously granted permissions to reprint selected articles.

We would especially like to thank Joon Lynn Goh, Tim Etchells, Finn Love,
and Daniel B. Yates and Diana Damian of *Exeunt*.

The first *Live Art Almanac* was published by the Live Art Development Agency
in 2008, the second in 2011 and the third in 2013 in partnership with Oberon Books.
All three volumes are available through Unbound.

www.thisisUnbound.co.uk

Financially assisted by Arts Council England.

Live Art
Development
Agency